VAN DYCK DRAWINGS

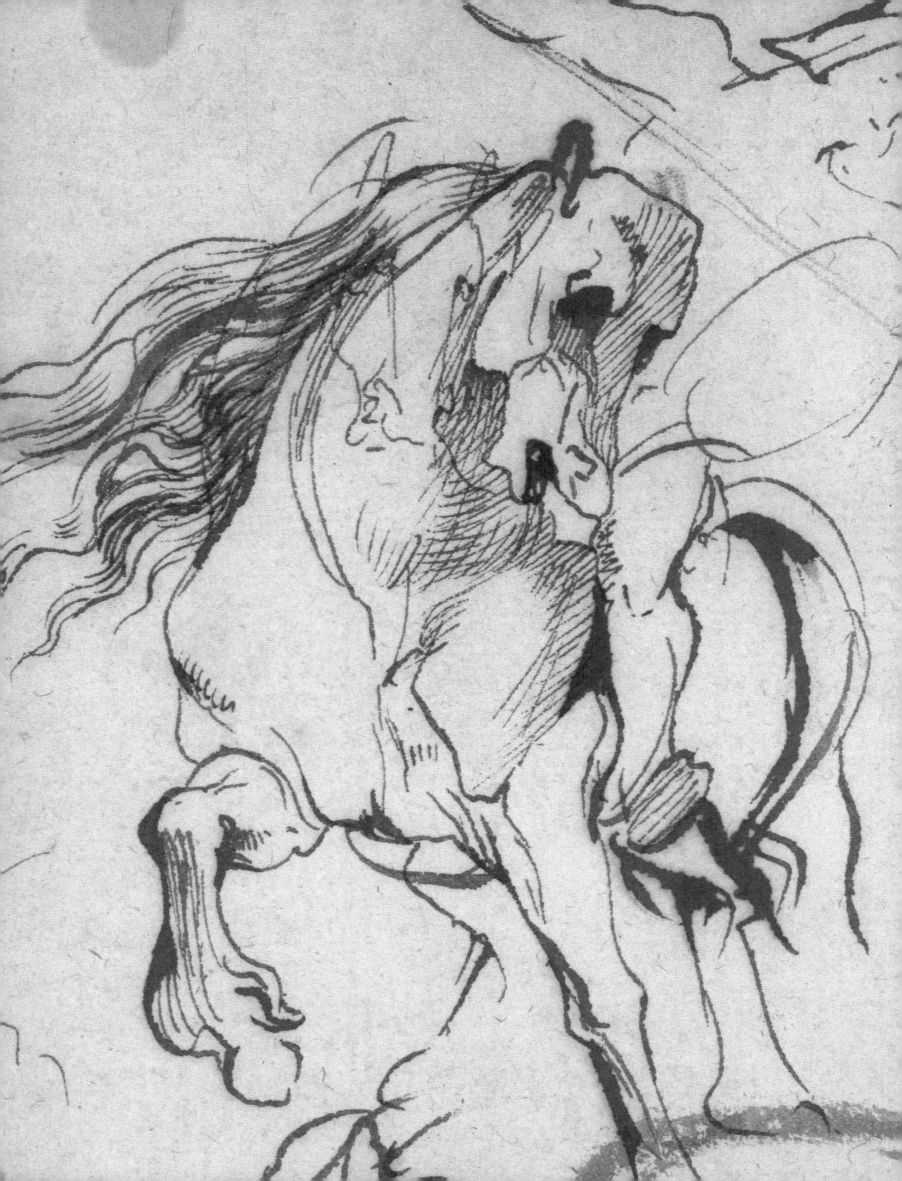

VAN DYCK
DRAWINGS

Christopher Brown

HARRY N. ABRAMS, INC., PUBLISHERS, NEW YORK

First published on the occasion of the exhibition
The Drawings of Anthony van Dyck, organized by
The Pierpont Morgan Library, New York, in association with
The Kimbell Art Museum, Fort Worth

Frontispiece:
Studies of a Man on Horseback and Three Horses' Heads [cat. 43], detail.
Rijksmuseum, Amsterdam, Rijksprentenkabinet

Library of Congress Catalog Card Number: 90–64167
ISBN 0–8109–3914–2
ISBN 87598–091–0 (pbk.)

Published in 1991 by Harry N. Abrams, Incorporated, New York
A Times Mirror Company

Designed by Louis Van den Eede
Production by Ludion, Brussels
Printed and bound in Belgium

Table of Contents

Foreword

When Anthony van Dyck died in 1641, at the age of forty-two, he was at the height of his powers and fame as the premier portraitist of Europe and court painter to Charles I. This year, on the occasion of the 350th anniversary of his death, we are pleased to present the first exhibition in America devoted to the drawings of this important and influential master.

The works that have been assembled enable us to trace Van Dyck's extraordinarily rapid maturation as an artist, from his earliest years in Antwerp as Rubens' gifted protegé to the final decade of his career at the English court. Representative examples from the full range of his artistic output, not only as a portraitist but as a gifted narrative painter as well, have been included; in some instances, it has been possible to reunite a number of surviving drawings for a single project—from first thoughts to final *modello*.

Considered as a whole, the drawings of Anthony van Dyck both confirm and contradict the artistic personality presented in his paintings. Despite the assurance of his canvases, we frequently find preparatory drawings that reveal intense effort, uncertainty, and experimentation. Elsewhere, particularly in his finished portrait studies, it is apparent that the artist's legendary virtuosity and sureness of touch were at times even greater with chalk than with brush.

"The Drawings of Anthony van Dyck" has been conceived, selected, and interpreted by Christopher Brown. We are most grateful that, despite the demands of his newly assumed position as chief curator of the National Gallery in London, he was able to devote the full measure of his time and expertise to the exhibition. The accompanying catalogue is the first major publication devoted to Van Dyck's drawings since Horst Vey's monumental corpus of 1962. Since then the literature on Van Dyck's activities as a draughtsman has increased considerably; problems of attribution and dating have been explored further; and a number of new drawings have come to light. This study of Van Dyck's drawing style is an important and much needed contribution to this field.

A project of this scope requires the cooperation of many individuals and institutions. First, we should like to acknowledge with gratitude the museums and private collectors who have so generously lent their drawings to this exhibition. Each lender contributed to the success of this exhibition.

The staffs of both participating institutions have played an important role in the planning and implementation of this exhibition. At the Morgan Library, Cara Denison, Robynne Dinkelaker, Peter Dreyer, Mimi Hollanda, Kathleen Luhrs, Carolyn Nesbitt, Evelyn Phimister, Patricia Reyes and the Conservation Staff, Stephanie Wiles, and David Wright were especially helpful. At the Kimbell Art Museum, Colin Bailey, Beverly Louise Brown, Anne Adams, and Wendy Gottlieb were supportive at every stage.

For the production of this catalogue we should like to thank Jan Martens, director of Ludion, and his associates at Artescriptum, Paul van Calster, Peter Ruyffelaere, and Anne Luyckx.

From the very beginning it was our aim to bring together the best and most representative examples that could be obtained. This was an ambitious undertaking, and it could not have been achieved with such success without generous grants from the National Endowment for the Arts and the Robert Lehman Foundation and an indemnification from the Federal Council on the Arts and the Humanities.

Charles E. Pierce, Jr.
Director
The Pierpont Morgan Library

Edmund P. Pillsbury
Director
Kimbell Art Museum

Preface

As the provenances of many of the drawings included in this exhibition make clear, Van Dyck has always been admired as a draughtsman and his drawings have long been avidly collected. Many of the greatest collectors of old master drawings in the seventeenth, eighteenth, and nineteenth centuries—among them Nicolaes Flinck, Everhard Jabach, the 2d duke of Devonshire, Pierre-Jean Mariette, Jonathan Richardson the Elder, and Sir Thomas Lawrence—owned important groups of drawings by Van Dyck. His drawings are those of a working painter and print designer, all being preparatory to paintings or engravings, and so it is not surprising that they should have been collected by painters: many of the English-period drawings passed through the distinguished lineage of Lely, Lankrink, Richardson, Hudson, Reynolds, and Lawrence. Despite their having long been admired on both sides of the Atlantic, this is the first exhibition exclusively devoted to Van Dyck's drawings to be held in America. It is entirely appropriate that it should open at The Pierpont Morgan Library which houses by far the most important American collection of the artist's drawings.

I was delighted and honored to be asked to organize this exhibition and to write the catalogue which is published in the series of Franklin Jasper Walls Lectures. The invitation was originally extended by William Robinson, the curator of Prints and Drawings, and Francis Mason, the acting director of the Morgan Library. It has been enthusiastically supported by their successors, Peter Dreyer and Charles Pierce, Jr. I would like to take this opportunity to thank them and their colleagues, notably Cara Denison, Kathleen Luhrs, and David Wright for their commitment and hard work. It is especially pleasing too, that this exhibition can also be seen at the Kimbell Art Museum in Fort Worth, and for this I thank Edmund P. Pillsbury.

The organization of exhibitions is the art of the possible and this exhibition, like many others, has had to be arranged within certain financial and technical limits. There are many absentees among the drawings—among them sheets from Besançon, Leningrad, Windsor, and Florence—which could not be requested because of the cost of bringing them to America—and others, notably those at the Institut Néerlandais in Paris, which were unavailable for loan. I believe, however, that there are enough drawings to give the visitor a clear idea of the development of Van Dyck's draughtsmanship from his earliest days in Antwerp to his last years in London. Among them are almost complete series of powerful drawings for the early religious paintings, the sketch for his single most important religious commission in Italy, drawings for *The Iconography*, portrait studies on blue paper from his English period, and a breathtaking group of landscape drawings and watercolors. Van Dyck had an intensely visual intelligence and in studying his drawings we can see that intelligence at work, admire it, and, I hope, to some degree understand it.

We have received particular kindness from those great European institutions with large holdings of the artist's drawings: the Kupferstichkabinett in Berlin, the Musée du Louvre and the Ecole des Beaux-Arts in Paris, the Museum Boymans-van Beuningen in Rotterdam, the Albertina in Vienna and, above all, the British Museum in London, which has lent no fewer than fourteen drawings. The duke of Devonshire responded to our request with characteristically enthusiastic support, lending the Antwerp sketchbook as well as seven individual drawings. Of the many other generous European lenders I would like to single out the Stedelijk Prentenkabinet in Van Dyck's native city of Antwerp and its director, Francine de Nave, who has been helpful and encouraging from the very beginning. American institutions and collectors—notably the Metropolitan Museum of Art, the Museum of Art of the Rhode Island School of Design, and the J. Paul Getty Museum—have been no less supportive of this undertaking. I am grateful to all the lenders, in Europe and America, whose names are listed on page 11.

The idea for this exhibition was born on a trip to Boughton House in Northamptonshire to see Van Dyck's grisaille sketches for *The Iconography* with

Egbert Haverkamp-Begemann, who has continued to oversee and guide the project. It is just the latest of innumerable kindnesses over many years for which I am indebted to him. As readers will soon realize, the catalogue—and the exhibition itself—entirely depend upon the work of the greatest modern scholar of Van Dyck drawings, Horst Vey. He helped me with the selection of drawings, discussed individual drawings with me, opened his files to me, and read the manuscript of the catalogue. This was all done in an immensely generous spirit of scholarly exchange. Without Horst Vey's published work, I could not have undertaken this task and without his kindness it would not have been as enjoyable. Ann-Marie Logan brought her extensive knowledge of Flemish seventeenth-century drawings to the task of reading my manuscript, and I have incorporated many of her valuable observations. Elizabeth McGrath and Justus Müller Hofstede also read the manuscript and made many incisive comments and corrections, which I have gratefully included. Michael Jaffé kindly commented on my initial selection, which I also discussed, to my great benefit, with Alfred Moir and Seymour Slive. Sir Oliver Millar was immensely helpful with the English-period drawings.

Museum colleagues have been especially kind, reading my draft entries and improving upon them: it is a great pleasure to be able to acknowledge the help of Bram Meij at Rotterdam, Peter Schatborn and Marijn Schapelhouman at Amsterdam, Christian van Heusinger in Braunschweig, Emanuel Starcky and Emmanuelle Brugerolles in Paris, Fritz Koreny in Vienna, Hans Mielke in Berlin, Lucy Whitaker at Oxford and, with particular thanks for his encouragement and support, Martin Royalton-Kisch in London. My entries on the Morgan Library drawings are closely based on those in the forthcoming catalogue by Felice Stampfle, which she kindly made available to me in proof.

As I traveled to study the drawings, I was everywhere treated with kindness and consideration, and I would like to thank all those curators who were so generous with their time and so tolerant of a curator of paintings learning about drawings. My final and greatest debt is to Julius Held. In conversations and in correspondence, which now extend over a good number of years, he has shaped my understanding of Flemish art, and I wish to record my profound gratitude by dedicating this catalogue to him in his eighty-fifth year.

The catalogue's introductory essay has deliberately been kept short: it is intended to give the visitor to the exhibition a readable introduction to Van Dyck's work as a draughtsman. Detailed discussions of particular projects and series can be found in the body of the catalogue. In the individual catalogue entries, I have not thought it necessary to describe the drawings in detail because of the excellent, full-page illustrations which accompany the text. My publisher in Belgium, Jan Martens, has inspired the project with his enthusiasm and drive. My Belgian editor, Paul van Calster, has been a model of conscientiousness and good sense, and my editor at the Morgan Library, Kathleen Luhrs, has contributed enormously to the handsome appearance of both text and plates and saved me from many errors. I am very grateful to them all. Sarah Perry gave generously of her time in preparing the manuscript and was also invaluable in helping with the translation of De Piles. Tom Henry enthusiastically undertook to translate Bellori's *Life of Van Dyck* which he did with great skill and sensitivity. My director, Neil MacGregor, was understanding of my need to travel and work on the catalogue while undertaking my new responsibilities at the National Gallery and has been a source of constant encouragement. So many people in so many places have been helpful that the catalogue seems like the happiest of collaborations. I remain, however, responsible for its shortcomings.

Christopher Brown
Chief Curator
The National Gallery, London
December 1990

Lenders to the Exhibition

Graphische Sammlung Albertina, Vienna
Amsterdams Historisch Museum, Amsterdam
The Visitors of the Ashmolean Museum, Oxford
Barber Institute of Fine Arts, Birmingham University, Birmingham
The Trustees of the British Museum, London
The Governing Body, Christ Church, Oxford
Courtauld Institute Galleries, London
The Duke of Devonshire and the Chatsworth Settlement Trustees
Ecole nationale supérieure des Beaux-Arts, Paris
The J. Paul Getty Museum, Malibu
Hamburger Kunsthalle, Hamburg
Harvard University Art Museums (Fogg Art Museum), Cambridge, Mass.
Herzog Anton Ulrich-Museum, Braunschweig
Collections of the Prince of Liechtenstein, Vaduz
The Metropolitan Museum of Art, New York
The Pierpont Morgan Library, New York
Musée des Beaux-Arts, Lille
Musée du Louvre, Département des Arts graphiques, Paris
Musée du Petit Palais, Paris
Museum of Art, Rhode Island School of Design, Providence
Museum Boymans-van Beuningen, Rotterdam
Museum of Fine Arts, Boston
National Gallery of Art, Washington
National Gallery of Canada, Ottawa
Nationalmuseum, Stockholm
Private Collection, The Netherlands
Private Collection, New York
Private Collection, USA
Rijksmuseum, Rijksprentenkabinet, Amsterdam
Staatliche Museen Preussischer Kulturbesitz, Kupferstichkabinett, Berlin
Statens Museum for Kunst, Copenhagen
Stedelijk Prentenkabinet, Antwerp
Teylers Museum, Haarlem
Collection of Mr. and Mrs. Eugene Victor Thaw, New York
The Victoria and Albert Museum, London
The Woodner Family Collection, New York

Chronology

ANTWERP 1599–1620

22 March 1599
Anthony van Dyck, the seventh child of the wealthy merchant Frans van Dyck and his wife Maria Cuypers, was born in the house "Den Berendans" on the Grote Markt in Antwerp. The family was very devout: his sisters Susanna, Cornelia, and Isabella were to become Beguines and his sister Anna, an Augustinian nun. His youngest brother Theodoor became a canon at the Abbey of Saint Michael in Antwerp and later a priest at Minderhout.

17 April 1607
Death of his mother

October 1609
Inscribed in the Antwerp Guild of Saint Luke as a pupil (leerjongen) of Hendrik van Balen, who was serving as Dean (opperdeken) that year.

1616–1617
Although still a minor, he is involved in legal proceedings to recover (with his siblings) part of the estate of his grandmother.

11 February 1618
Received into the Antwerp Guild as a master.

15 February 1618
Declared, with his father's agreement, to be of age by the *Vierschaar* (Tribunal) of Antwerp.

24 April 1618
In a letter to Sir Dudley Carleton Rubens says that a painting of *Achilles and the Daughters of Lycomedes*, which was valued at 600 guilders, was "fatto del meglior mio discepolo" and then gone over by Rubens himself. Although this pupil is not named, he has usually been identified as Van Dyck. The painting is in the Museo del Prado, Madrid (inv. no. 1661).

12 May 1618
Rubens writes to Sir Dudley Carleton informing him that the cartoons for the Decius Mus series have been completed and are with the weavers in Brussels to be woven. According to a document of 1661 (and his biographer Bellori in 1672, see below, p. 17), Van Dyck was involved in painting these cartoons from Rubens' designs.

29 March 1620
In the contract between Rubens and the Antwerp Jesuits for the decoration of the Jesuit church in the city, only Van Dyck among the master's assistants is mentioned by name (169... door van Dyck mitsgaders sommige andere syne discipelen"). Under the terms of the contract, thirty-nine ceiling paintings were to be delivered within nine months. It is also agreed that Van Dyck is to paint an altarpiece for one of the side altars at a future date.

17 July 1620
Francesco Vercellini, secretary of the earl of Arundel, writes to the earl from Antwerp informing him that "Van Dyck is still with Signor Rubens and his works are hardly less esteemed than those of his master. He is a young man of 21 years, his father and mother very rich, living in this town, so that it will be difficult to get him to leave these parts, especially since he sees the good fortune that attends Rubens."

LONDON 1620–1621

20 October 1620
Thomas Locke writes to William Trumbull from London: "Van Dyck is newly come to towne ... I am tould my Lo: of Purbeck sent for him hither."

25 November 1620
Toby Mathew writes to Carleton informing him that "Van Dyck his [Rubens'] famous *allievo* [pupil] is gone into England, and that the King has given him a pension of £100 per annum." He was said to be living with George Geldorp.

16 February 1621
Van Dyck receives £100 as a reward for special service performed by him for James I.

28 February 1621
In the register of the Privy Council is the entry: "A passe for Anthonie van Dyck gent his Maties Servaunt to travaile for 8 months he having obtained his Maties leave in that behalf as was sygnified by the E. of Arundel."

ANTWERP 1621

March 1621
Returns to Antwerp.

ITALY 1621–1627

October 1621
Leaves for Italy and arrives in Genoa, at the house of Cornelis and Lucas de Wael, in late November.

February 1622
Travels by sea to Civita Vecchia and then to Rome. He remains in the city until August. In Rome he paints the portraits of Sir Robert and Lady Shirley (Petworth House, Sussex), who were in Rome on a diplomatic mission to Pope Gregory XV between 22 July and 29 August.

August 1622
Leaves Rome and travels to Venice where he joins the countess of Arundel. He remains in Venice until November.

November 1622
Travels with the countess of Arundel to Mantua, Milan, and Turin, which they reach in late January 1623.

1 December 1622
His father dies in Antwerp.

January 1623
Leaves the countess of Arundel's party and travels to Florence and then Rome.

March 1623
In Rome, where he remains until October or November.

October or November 1623
Returns to Genoa.

Spring 1624
In the spring, perhaps in April, he travels to Palermo where he remains until September. He paints the *Portrait of the Viceroy Emmanuel Philiberto* (Dulwich Picture Gallery) and receives the commission for *The Madonna of the Rosary* (Oratorio del Rosario, Palermo). There is a severe outbreak of plague and Van Dyck receives a number of commissions for paintings showing Saint Rosalie, patron saint of the city, as intercessor against the plague. (The viceroy dies of plague on 3 August.)

12 July 1624
he visits Sofonisba Anguissola, making a drawing of the artist in his Italian sketchbook (British Museum, London) and recording their conversation about portrait painting.

13

September 1624
Returns to Genoa.

27 September 1624
His brother-in-law declares that Van Dyck is abroad.

July 1625
Said to have traveled to Marseilles and to Aix, where he is supposed to have visited Nicolas Claude Fabri de Peiresc. (There is no mention of a visit in Peiresc's correspondence with Rubens and others.)

12 December 1625
His brother and sisters in Antwerp declare that he is abroad.

ANTWERP 1627–1632
18 September 1627
His sister Cornelia dies in Antwerp. Van Dyck may have arrived back in Antwerp by that time. (George Vertue noted having seen "a peice of a letter written by Vandyke in Italian with some sketches & thoughts, sign'd Antonio Vandyke & at bottom dated July 1627 at Antwerp.") The *Portrait of Peeter Stevens* (Mauritshuis, The Hague) is inscribed with the date 1627. (The companion portrait of Stevens' wife, Anna Wake, whom he married on 12 March 1628, bears the date 1628. It is also in The Hague.)

6 March 1628
Makes his will in Brussels.

8 April 1628
The payment for the "Madonna of the Rosary novamente fatto nella citta di Genova" (recently made in the city of Genoa) is made to his representative in the city, Antonio della Torre.

May 1628
Joins the "Sodaliteit der bejaerde Jongmans," a Jesuit confraternity of bachelors. He is to paint for the Sodaliteit the *Virgin and Child with Saints Rosalie, Peter, and Paul* in 1629 and the *Mystic Vision of the Blessed Hermann Joseph* in 1630. (Both paintings are in the Kunsthistorisches Museum, Vienna.)

27 May 1628
The earl of Carlisle writes from Brussels to the duke of Buckingham saying that he had missed Rubens at his house but had met him on the following day at "Monsr Vandigs."

December 1628
Receives a gold chain worth 750 guilders from the Archduchess Isabella for a portrait of her.

5 December 1629
Writes from Antwerp to Endymion Porter saying that the *Rinaldo and Armida* (Baltimore Museum of Art) has been handed over to his agent and that he has received £72 for it.

20 March 1630
The city of Antwerp raises a loan of 100,000 guilders. Van Dyck subscribes for 4,800 guilders.

27 May 1630
Van Dyck describes himself as "painter of Her Majesty" ("Anthonio van Dijck, schilder van Heure Hoocheyd") in a power of attorney given to the painter Pieter Snayers. He receives an annual salary of 250 guilders but continues to live in Antwerp. (The Court was in Brussels.)

9 December 1630
The restorer J.-B. Bruno, in an introduction for a visitor, mentions Van Dyck's collection of paintings.

8 May 1631
The Raising of the Cross for Courtrai, the sketch for which was sent to Canon Rogier Braye, is rolled up in order to be sent. (It is still in the Church of Our Lady.)

10 May 1631
Van Dyck stands godfather to Lucas Vorsterman's daughter Antonia.

30 June 1631
The Plantin Press delivers 114 copies of the *Officium van Onser Lieve Vrouw* and the *Diurnale Romanum* to Van Dyck. (The payment was made on 12 November.)

4 September–16 October
Maria de' Medici is in Antwerp, accompanied by her second son Gaston d'Orleans. They both sit to Van Dyck. J. P. de la Serre, the Queen Mother's secretary, records her visit to Van Dyck's studio and the artist's "Cabinet de Titien."

16 December 1631
Balthasar Gerbier sent Lord Weston a *Virgin with Saint Catherine* by Van Dyck as a New Year's present for Charles I. Shortly afterwards, in a letter to George Geldorp in London, Van Dyck declares that the painting is a copy. On 13 March 1632 Gerbier says that Rubens believes the painting to be an original and the vendor, Salomon Noveliers, attests to this in a notarial document. (The documents concerning this curious affair were published in Carpenter 1844, 57–64.)

28 January 1632
Van Dyck paints Constantijn Huygens in The Hague. (Huygens wrote in his diary: "Pingor a Van Dyckio.")

11 March 1632
Huygens supplies Van Dyck with three mottos for portrait engravings (for *The Iconography*).

13 March 1632
In a postscript to the letter discussed under 16 December 1631, Gerbier mentions that Van Dyck is in Brussels and plans to go to England.

LONDON 1632–1634
1 April 1632
Van Dyck is in London staying with Edward Norgate, who (according to a Privy Seal warrant of 21 May 1632) receives 15 shillings a day "for the dyett and lodging of Signior Anthonio Van Dike and his servants." Shortly after, Van Dyck moves to Blackfriars, which was outside the jurisdiction of the London Painter-Stainers' Company, and is also given a summer residence in the Royal Palace at Eltham in Kent.

5 July 1632
Van Dyck is knighted and appointed "principalle Paynter in ordinary to their Majesties."

8 August 1632
Van Dyck is paid £280 for ten royal commissions including the portrait of the king and queen with their children known as the "Greate Peece".

20 April 1633
Receives a gold chain and a medal with a value of £110.

7 May 1633
He is paid £444 for nine portraits of the king and queen.

27 August 1633
The date of his *View of Rye* [cat. 73].

17 October 1633
Van Dyck's annual salary is said to be £200.

1 December 1633
The Infanta Isabella dies in Brussels. Prince Thomas-Francis of Savoy-Carignan is named as the temporary regent of the Spanish Netherlands.

ANTWERP AND BRUSSELS 1634–1635

28 March 1634
Back in Antwerp, he purchases an interest in the estate of "Het Steen" at Elewijt, which Rubens was to buy in May 1635.

14 April 1634
He is in Brussels and authorizes his sister Susanna to administer his property in Antwerp.

18 October 1634
He is made honorary dean of the Guild in Antwerp, an honor which previously only Rubens had received.

4 November 1634
Cardinal-Infante Ferdinand, the new regent of the Spanish Netherlands, makes his triumphal entry into Brussels. He sits to Van Dyck. (On 16 December 1634 the portrait is said to have been "recently painted.")

16 December 1634
Van Dyck is said to be living in the house "In 't Paradijs" behind the town hall in Brussels.

5 January 1635
He is paid more than 500 *pattaconi* for two portraits of Prince Thomas-Francis of Savoy-Carignan.

LONDON 1635–1641

Spring 1635
Van Dyck is back in London. A jetty is built in the River Thames so that the king can visit his studio at Blackfriars. The king visits the artist in June and July.

14 August 1636
Van Dyck asks Franciscus Junius, the earl of Arundel's librarian, for a motto for his engraved portrait of Sir Kenelm Digby. In the same letter he praises Junius' *De pictura veterum*.

February 1637
The duke of Newcastle, writing from Welbeck Abbey, declares how much he enjoys Van Dyck's company and conversation and signs himself "passionately your humble servant."

23 February 1637
Receives payment of £1200 from Charles I for "Certaine pictures by him delivered for our use."

Late 1638
In a memorandum to the king, Van Dyck lists twenty-five paintings for which he has not been paid and states that he has not received his pension for five years. The king annotated the memorandum, reducing the price of fourteen paintings. On 14 December 1638 he is paid £1603 and on 25 February 1639 receives a second payment of £305.

1639
Marries Mary Ruthven, a lady-in-waiting to the queen.

26 June 1639
Queen Henrietta Maria writes to Bernini requesting a sculpted bust of herself like the one he carved of her husband. She promises to send portraits of herself by Van Dyck from which the likeness can be taken.

Early 1640
In a letter to Ralph Verney, the countess of Sussex writes that Van Dyck wants to leave London.

30 May 1640
Death of Rubens in Antwerp.

13 September 1640
Arundel obtains a passport for Van Dyck and his wife to travel to the Continent.

23 September 1640
Cardinal-Infante Ferdinand writes to Philip IV from Brussels, mentioning that Van Dyck is expected to attend the festivities organized by the Guild of Saint Luke on the saint's feastday (18 October) in Antwerp.

10 November 1640
Cardinal-Infante Ferdinand writes from Brussels to King Philip IV informing him that Van Dyck does not wish to complete the paintings for the Torre de la Parada left unfinished at Rubens' death. He is, however, willing to undertake a new commission for the king.

December 1640 (?)
Van Dyck is in Paris trying to secure the commission for the decoration of the Grande Galerie in the Louvre. (In the event, the commission was given to Poussin who returned to Paris to carry it out.)

19 March 1641
Charles I leaves London and moves his court to York. Henrietta Maria has returned to France and is at the court of her brother Louis XIII in Paris.

12 May 1641
Marriage of Princess Mary and Prince Willem II of Orange in London. Van Dyck paints the wedding portrait (Rijksmuseum, Amsterdam).

13 August 1641
In a letter written from Richmond to Count Johan Wolfert van Brederode in The Hague, the countess of Roxburghe says that Van Dyck has been ill for a long time but is now recovered and will be traveling to Holland in 10 or 12 days' time and will bring the promised painting with him.

16 November 1641
Van Dyck is in Paris but is so ill that his portrait of "Monseigneur le Cardinal" (Richelieu) cannot be made and he asks for a passport to allow him to return to England.

1 December 1641
Birth of his daughter Justiniana.

4 December 1641
Makes a will.

9 December 1641
Van Dyck dies at Blackfriars. He is buried on 11 December in the choir of Saint Paul's Cathedral, London. His tomb and his remains are destroyed in the Great Fire of London in 1666.

(*) This chronology is based on that in Vey 1962, 59–69 (with additions from Washington 1990–1991, 75–77).

The Life of Anthony van Dyck

(From G. P. Bellori, *Le Vite de' Pittori, scultori et architetti moderni*, Rome, 1672)*

LE VITE
D E'
PITTORI·SCVLTORI
ET ARCHITETTI
MODERNI,
SCRITTE
DA GIO·PIETRO BELLORI
PARTE PRIMA.
ALL'ILLVSTRISS. ET ECCELLENTISS. SIGNORE
GIO: BATTISTA
COLBERT
CAVALIERE MARCHESE DI SEIGNELAY
Miniftro, Segretario di Stato, Commendatore,e Gran Tefo-
riere de gli Ordini di S.M.Chriftianiffima, Direttore Gene-
rale delle Finanze, Sopraintendente, & Ordinatore Gene-
rale delle Fabbriche , Arti,e Manifatture di Francia..

IN ROMA, Per il Succefs. al Mafcardi , MDCLXXII.
Con licenza de'Superiori.

(*) This translation is from the first edition (Rome 1672, 253-264). It has been made by Tom Henry in collaboration with the present writer. Charles Hope and Elizabeth McGrath made many improvements in substance and style and I am also grateful to Sally Brown and Michael Helston for their help. For a modern Italian edition of the text see *Le Vite de' Pittori, Scultori et Architetti Moderni, Giovan Pietro Bellori*, ed. Evelina Borea, Turin 1976, 271–284. The notes that follow are indebted to those in Borea's edition. They are intended to identify particular paintings where those identifications are more or less secure. In the cases where there is more than one version of a painting, I have only indicated the one I consider to be the prime version. I have also elucidated classical references and corrected a few inconsistencies.

Peter Paul Rubens was renowned throughout Flanders when there appeared in his school in Antwerp a young man possessed of such noble generosity of manners and so fine a talent for painting that he gave every indication that he would bring it distinction and add splendor to the dignity and excellence to which the master had raised his profession. This was Anthony van Dyck, born in the same city in the year 1599. His father was a trader in fabrics, of which those made in Flanders surpass all others in fineness and workmanship; his mother occupied herself with embroidery, and painted with her needle, creating landscapes and figures. With this background, Anthony at a tender age set himself to study drawing; and his mother, who was by this time unable to train him further, understood that nature wished to make him outstanding in art. She persuaded his father to place him with Rubens,[1] who, liking the good manners of the young man and his grace in drawing, considered himself very fortunate to have found so apt a pupil, who knew how to translate his compositions into drawings from which they could be engraved. Amongst these is the Battle of the Amazons, which was drawn by Anthony at that time.[2] Rubens gained no less profit from Van Dyck in painting, since, being unable to fulfill the great number of his commissions, he employed Anthony as a copyist and set him to work directly on his own canvases, to sketch out and even execute his designs in paint, activities which brought him very great benefit.

Anthony made the cartoons and the painted pictures for the tapestries of the stories of Decius[3] and other cartoons, which, because of his great talent, he carried out quite easily. It is said that in this way Rubens' business prospered, and he came to earn a good hundred florins a day from his pupil's labors, while Anthony profited still more from his master, who was a veritable treasury of artistic skills. But it occurred to Rubens that his disciple was well on the way to usurping his fame as an artist, and that in a brief space of time his reputation would be placed in doubt. And so, being very astute, he took his opportunity from the fact that Anthony had painted several portraits, and, praising them enthusiastically, proposed him in his place to anyone who came to ask for such pictures, in order to take him away from history painting. For the very same reason Titian—even more harshly—dismissed Tintoretto from his house[4]; and many other artists who have followed a similar course have in the end been unable to repress brilliant and highly motivated students. Anthony therefore removed himself from the school of Rubens, and it is said that he then made in the Church of Saint Dominic the picture of Christ Carrying the Cross, having fallen on his knees, with the Maries and the soldiers who lead him to Calvary.[5] This work is still in his early Rubensian style. But, thinking it was time to set off for Italy,[6] he left his native country and made his first stop in Venice, where he gave himself over completely to the painting of Titian and Paolo Veronese, sources from which his master had also drunk. He copied and drew the best history paintings, but he took the greatest pleasure in heads and portraits, of which he made a great number of drawings and canvases, and in this way he dipped his brush in the fine colors of the Venetians. And, because he had spent all his money while staying in that city to study, he moved to Genoa, where the beautiful style that he had acquired through this copying was much appreciated, so that he earned enough profit from it to meet all his desires and needs. Thereafter, even when traveling in other parts of Italy, he always found a refuge in Genoa, as if it were his native city; he was loved and held in high regard by everyone there. Yet Anthony's mind was then set on Rome, and he moved there. He was maintained at the Papal Court by Cardinal Bentivoglio, who was well disposed to the Flemish, having lived in Flanders and written a history of enduring fame.[7] Anthony

17

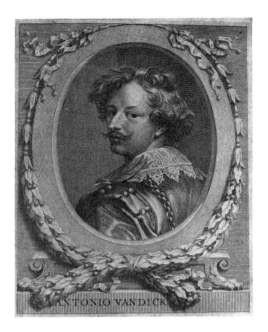

ANTONIO VANDICK

portrayed the cardinal seated, with a letter in his hands, turning as if he had just read it, and he captured on the canvas the features and the gentle spirit of that distinguished man. This portrait is to be found today in Florence, in the palace of the grand duke.[8] For the same cardinal he painted on a canvas of four palmi the Crucified Christ with upturned head, breathing His last.[9] At that time an Englishman, Sir Robert Shirley, had come to Rome. He was acting as ambassador to Christendom for Abbas, king of Persia, and had been sent by him in the first place to Pope Gregory XV to gain support for his campaign against his enemy the Turk.

Anthony painted this gentleman and his wife in Persian dress, enhancing the beauty of these portraits with the charm of their exotic costumes.[10] He was still a young man, his beard scarcely grown, but his youthfulness was accompanied by a grave modesty of mind and nobility of aspect, for all his small stature. His manners were more those of an aristocrat than a common man, and he was conspicuous for the richness of his dress and the distinction of his appearance, having been accustomed to consort with noblemen while a pupil of Rubens; and being naturally elegant and eager to make a name for himself, he would wear fine fabrics, hats with feathers and bands, and chains of gold across his chest, and he maintained a retinue of servants. Thus, imitating the splendor of Zeuxis,[11] he attracted the attention of all who saw him. This conduct, which should have recommended him to the Flemish painters who lived in Rome, in fact stirred up against him the greatest resentment and hatred. For they were accustomed at that time to live cheerfully together, and it was their practice, when one of them was newly arrived in Rome, to take him to supper at an inn and give him a nickname by which he was afterwards known.[12] Anthony refused to participate in these bacchanals, and they, taking his reserved manner for contempt, condemned him as ambitious, criticizing both his pride and his art. And indeed he had come to Rome not to study, but with the intention of working and of displaying his talent for a beautiful and pleasing facility in painting; but the others, disparaging his abilities and saying that he did not know how to draw and could scarcely paint a head, reduced him to such a state that he left Rome in despair and returned to Genoa.

He remained in that city and enjoyed great financial success, making portraits of almost all the nobility and senators. He painted the gentlemen of the Raggi family[13] and the Marchese Giulio Brignole, a celebrated poet, on horseback; he also portrayed his wife the Marchesa, serving nature by preserving her beauty for all time.[14] He depicted the most serene Doge Pallavicino in the costume of an ambassador to the pope,[15] and Giovanni Paolo Balbi on horseback, a most beautiful portrait, the face of which has—on account of his treacherous conspiracy—been painted out and replaced by that of Signor Francesco Maria of the same family.[16] In the collection of the same gentleman there is also Anthony's portrait of an old man in armor with a general's baton in his right hand, his left resting on the pommel of his sword; and this is said to be the Marchese Spinola, a very famous soldier, showing himself as good-natured and alive in paint as he was in reality.[17] In Rome can be seen the portrait of a young man of the Imperiale family, bought by the most serene queen of Sweden with the entire collection of Giovanni Vincenzo Imperiale. It was painted at that time by Anthony, and gives as vivid an impression of life as if it were by the hand of Titian.[18] In addition to these portraits, Anthony painted other figures, including the Crucified Christ at Monte Rosso, a town on the Riviera, with Saint Francis, the Blessed Savior and a portrait of the patron at prayer.[19]

At this time Anthony decided to move to Sicily, where he painted the portrait of the then viceroy, Prince Filiberto of Savoy.[20] But the plague suddenly struck and the prince died, to be succeeded by Cardinal Doria. Anthony, after this grievous setback in Palermo, left as soon as possible, as though in flight and returned to Genoa, taking with him the canvas of a picture for the Oratory of the Company of the Rosary. In this he painted the Virgin in a glory of angels holding rosaries, and below Saint Dominic with the Five Holy Virgins of Palermo, amongst whom are Saints Catherine and Rosalie; a putto nearby puts his hand to his nose to ward off the stench of a skull on the ground, indicating the plague from which the city was delivered by the intercession of these saints.[21] Having completed the picture and sent it to Palermo, Anthony continued to make portraits and accumulated a good

sum of money. He then returned to Antwerp, his native town, after an absence of several years, to the acclaim and satisfaction of his waiting family. There too he occupied himself with portraits, but he also produced quite a number of altarpieces and other compositions for commissions throughout Flanders and elsewhere, enhancing his reputation.

I will mention some of these, since several of his compositions can be seen in prints.[22] Among the first works that he exhibited in Antwerp was the Marriage of the Blessed Joseph of the Premonstratensian Order in the Church of Saint Michael, in which the saint is kneeling before the Virgin, who offers him her right hand supported by an angel.[23] For the nuns of the Beguinage he painted the Lamentation, with the dead Savior in the lap of His mother, the Magdalen kneeling to kiss the wound of His hand, and Saint John. The face of the Magdalen is a portrait of Anthony's sister, a nun, to whom he made a gift of the picture.[24] He painted another Lamentation for the Church of Saint Francis, which is among his most highly regarded works. It represented Christ stretched out on a shroud with His head in the lap of His mother, who opens her arms and casts her mournful eyes heavenwards; behind is Saint John, who takes one of Christ's arms and shows the wound of His hand, while two angels weep at his feet. These three figures all remain in shadow, while the light is confined to the naked body of Christ, which stands out with great force.[25] To the same sister, Susanna, Van Dyck himself dedicated the engraving after another altarpiece in the Church of Saint Augustine, which is also excellent for the vividness of its color and its composition. He depicted the saint in ecstasy, supported by two angels; on one side he showed Saint Monica, on the other a saint of the order. And, as if Augustine had been transported to heaven and divinity had been revealed to him, a supporting angel points to Christ on high, whose arms are open wide, while celestial cupids at His feet display various symbols. One of them holds the sceptre with the eye of Providence, another the olive branch of Peace, and another holds up the serpent biting its tail, the hieroglyph of Eternity. Yet another grasps the sword of flaming fire, and his companion contemplates the Sun of Justice and other sublime mysteries. Above Christ's right hand there is an equilateral triangle, symbol of the Holy Trinity, with the name of God written in Hebrew.[26]

For the Dominican nuns he made a painting of Christ crucified, with Saint Dominic on one side and Saint Catherine of Siena on the other.[27] He painted another Crucified Christ in Ghent, with the Magdalen, who stands embracing the Cross, and Saint John; behind, a soldier on horseback orders one of the executioners to offer the sponge on the reed to the Savior, who is adored and mourned by the angels.[28] In Mechelen, in the Church of Saint Francis, are three other pictures by his hand: Christ on the Cross above the high altar, and on two other altars Saint Bonaventura celebrating mass and the Miracle of Saint Anthony of Padua, when the ass knelt before the sacramental Host.[29]

Turning to portraits, for which Van Dyck gained the highest reputation, while living in Brussels, he painted almost all the princes and great men who happened to be in Flanders at that time, for he had deservedly acquired the greatest name that any portraitist had merited since Titian. And in truth, besides capturing a likeness, he gave the heads a certain nobility and conferred grace on their actions—the very qualities for which Apelles was so widely acclaimed after painting Alexander and Antigonus.[30] He portrayed the Infanta full-length,[31] and Maria de' Medici, the Queen Mother, seated,[32] with her son the duke of Orleans,[33] when they were sheltering in Flanders. Also by his hand are the portraits of the Cardinal-Infante,[34] of Prince Tomaso of Savoy fully armed and on horseback,[35] and of many other important people. In the principal room of the Palace of Justice in the same city he painted life-size the magistrates seated in their college, in their customary way, judging the cases in progress. This is reputed to be one of his best works, well composed and executed.[36] For the prince of Orange he illustrated a story from the Pastor Fido,[37] and that prince also bought a sacred work by his hand, the Virgin and the Child Jesus in front of several little dancing angels. Various other pictures and portraits can be seen in Antwerp in the house of Canon Van Hamme and, notably, that of Diego Uveerdt, in which are preserved the portraits of King Charles I and the

queen of England which he made after he had moved to that court, as we will now recount.[38]

His output and his fame were such that it was almost as if he had filled Flanders with his name, and he decided to move to London, having been called to the service of King Charles. Rubens had already been honorably entertained at the court of this prince, a most generous devotee of every noble discipline and such a friend and promoter of rare talents that he attracted them from far and wide and rewarded them with great liberality. Thus, when Rubens left, Van Dyck succeeded him in royal favor, and at once began to accumulate the rewards and resources he needed to maintain his ostentatious style and splendid way of life. However, he spent his new riches liberally, since his house was frequented by the highest nobility, following the lead of the king, who used to visit him and took pleasure in watching him paint and spending time with him. In magnificence he rivaled Parrhasius,[39] keeping servants, carriages, horses, musicians, singers, and clowns, who entertained all the dignitaries, knights, and ladies who visited his house every day to have their portraits painted. Moreover, he had lavish dishes prepared for them at his table, at the cost of thirty scudi a day. This may seem incredible to anyone accustomed to our Italian frugality, but not to those familiar with foreign countries, nor if one takes into account the number of persons he fed; for, besides those already mentioned, he employed men and women who served as models for the portraits of the lords and ladies, since, having rendered the likeness of the face, he would then complete the remainder from these live models. It pleased the king to be painted several times by Anthony, and when the Cavaliere Bernini was to sculpt his portrait in marble he had no difficulty in providing three different views of Charles on one canvas: full face, profile and half-profile.[40] Van Dyck painted half-length portraits of the king and queen holding between them a branch of myrtle,[41] and another with their children.[42] He also portrayed the king on horseback, in imitation of Titian's painting of Charles V, accompanied by one of his gentlemen who carries his helmet.[43]

He painted General Goring engaged in negotiations, and the earl of Newport, grand master of the artillery, giving orders to his officers, with two armed figures in the background.[44] And because the earl of Arundel, a nobleman particularly interested in the fine arts of design, had introduced Van Dyck into the king's favor and had been instrumental in bringing him to England, he portrayed him life-size with his wife; these figures seem real rather than painted.[45] The portrait of the duchess of Buckingham and her daughters is also by his hand; and as an indication of her devotion to her husband he represented her holding a small painted portrait of the duke.[46] He depicted the duchess of Southampton as the goddess Fortuna, sitting on the globe of the world,[47] and Sir [Kenelm] Digby with his wife, each seated in a chair, with their children beside them.[48] This gentleman was held in high esteem amongst the leading subjects of the kingdom because of his admirable qualities and learning, and Van Dyck, with whom he had a mutual sympathy of mind and spirit, entrusted his every turn of fate to him. He painted him in many guises, in armor, and in the dress of a philosopher with the device of a broken [armillary] sphere and the motto from Horace: SI FRACTUS ILLABATUR ORBIS INTREPIDUM FERIENT RUINAE.[49] This portrait can be seen engraved in a book published by Anthony and printed in Antwerp, which includes a hundred portraits of illustrious men, and in which there are representations of princes, men of letters, painters and sculptors; the best of these are etched by his own hand. He included his own portrait, which has served as the model for the one at the beginning of this Life.[50]

Digby also had the notion of having his wife painted on a large canvas as Prudence, seated wearing a white dress with a colored veil and a jeweled girdle. She extends one hand towards two white doves, while her other arm is encircled by the snake.

Under her feet is a [stone] cube to which are bound, like slaves, Deceit with two faces, Anger with a furious countenance, scrawny Envy with her snake-like hair, and Profane Love, blindfolded, his wings clipped, his bow broken, arrows scattered and torch extinguished, together with other life-size naked figures. Above is a glory of singing and music-making angels, three of whom hold the palm and wreath

above the head of Prudence as a mark of her victory and triumph over the vices, and the motto, taken from Juvenal, NULLUM NUMEN ABEST SI SIT PRUDENTIA.[51] Van Dyck was so pleased with this invention that he painted another version on a small scale, although not of the whole composition, and both were taken to France during the English Revolution.[52] While this gentleman was living in Rome during the pontificate of Urban VIII, as resident of the queen of England, he acquainted me with Van Dyck's career after he went to the court in London.[53] For the same patron Anthony painted Christ taken down from the cross, with Joseph and Nicodemus who anoint Him before placing Him in the tomb; also present are the Magdalen and the Virgin, who is shown fainting. In addition, there were other devotional pictures: Saint John the Baptist in the desert, the Magdalen enraptured by the harmony of the angels, a half-length Judith with the head of Holofernes, and a Christ expiring on the cross, which was given by the same gentleman to the princess of Guemene in Paris. He also painted the portrait of a dark woman in the guise of the armed Pallas, with a plume on her helmet and a most beautiful and vivacious expression.[54] For the earl of Northumberland he painted the Crucified Christ with five angels who collect the blood from His wounds in golden cups, and beneath the cross he placed the Virgin, Saint John, and the Magdalen. For King Charles, besides the portraits and other pictures, he painted the Dance of the Muses with Apollo on Parnassus, the other Apollo who flays Marsyas, the Bacchanals, and another Dance of Cupids who play while Venus and Adonis sleep. Amongst the other noble talents of that court was the painter and musician Nicholas Lanier, whom he portrayed as David playing the harp before Saul.[55] He made the portrait of the duchess of Richmond, daughter of the duke of Buckingham; and the unique beauty of this portrait makes us doubt whether art or nature is the more admirable, since he depicted her as Venus. She is accompanied by her son, the duke of Hamilton, shown naked in the guise of Cupid with a quiver and bow.[56] He painted the countess of Portland and the duchess of Aubigny as nymphs.[57] He also portrayed a lady as Venus with an Ethiopian; she admires herself in a mirror and makes fun of her black companion, as she draws a comparison with her whiteness. For the queen he painted the Virgin with the Child and Saint Joseph turning towards some angels dancing on the ground, while others make music in the sky; this has a beautiful landscape.[58] In imitation of Tintoretto he painted the Crucifixion with the executioners raising the cross, a work filled with many figures. Also beautiful is the picture of the Virgin between two music-making angels; she holds the Child who places the sole of His foot on the globe of the world. Nor can we omit the twelve half-length apostles, beginning with Christ holding the cross, in the fine picture collection of Monsignor Carel Bosch, bishop of Ghent, which can be seen published in the form of engravings,[59] or the bound Samson breaking his bonds, given by Signor Van Woonsel to Archduke Leopold, governor of the Low Countries.[60] This nobleman has surpassed all his contemporaries in his collection of antiquities, medals, and pictures, as can be seen from the book of engravings of his paintings.[61] The king, as well as most generously rewarding Van Dyck, honored him greatly by creating him Knight of the Order of the Bath. But Anthony, who had been afflicted by ill health for several years, was now eager to retire from the continuous activity of painting portraits and other pictures.

Instead, he hoped to dedicate himself to a more tranquil type of work, far removed from the business of court, which would bring him both honor and profit, and thus leave a record and memorial of his talents for posterity. To this end he negotiated with the king, through the good offices of Digby, to make designs for hangings and tapestries for the great saloon of the Royal Court of Whitehall in London. The individual compositions and the general theme were related to the election of the king, the institution of the Order of the Garter by Edward the Third, the procession of knights in their robes and the civil and military ceremonies, and other royal functions. The king liked this proposal, because he already owned both the very rich set of tapestries by Raphael of the Acts of the Apostles and the original cartoons; and these new ones would have been twice the number and larger in scale. Yet the king's intention was not realized, for Van Dyck had reached the point where he did not hesitate to ask three hundred thousand scudi for the cartoons and

paintings needed for the tapestries. This price seemed excessive to King Charles, but the problem would have been resolved if the death of Van Dyck had not intervened.[62]

Anthony still had the ambition to paint the Grand Gallery of the Louvre in the Royal Palace; and, having gone over to Flanders with his wife, on his way back he made a detour for this purpose to Paris, only to find that Nicolas Poussin had just arrived. Having remained there for two months to no purpose, Anthony returned to England, and shortly afterwards he died in London, piously rendering his spirit to God as a good Catholic, in the year 1641. He was buried in Saint Paul's, to the sadness of the king and court and the universal grief of lovers of painting. For all the riches he had acquired, Anthony van Dyck left little property, having spent everything on living magnificently, more like a prince than a painter. Regarding his method of painting, he was in the habit of working without a break, and when he made portraits he would begin them in the morning to gain time, and, without interrupting his work, would keep his sitters with him over lunch.[63] Even though they might be dignitaries or great ladies, they came there willingly as though for pleasure, attracted by the variety of the entertainments. After his meal he would return to the picture, or else do two in a day, adding the final retouching later. This was his usual practice for portraits; if he was making history paintings, he estimated how much work he could carry out in a day and did no more. He made use of reflections and cast shadows, and, having planned in advance the location of the highlights, these would emerge in due time with grace and force. In this respect he followed his master Rubens, observing the same rules and maxims of painting, except that Van Dyck's flesh tones were more delicate and closer to the colors of Titian. Yet he was not so fertile in his inventions, nor did he have Rubens' talent and facility in large and crowded compositions, the harmony of his colors being more appropriate to a small room.

He won the greatest praise for his portraits, in which he was unrivaled, and sometimes as marvelous as Titian himself. In history painting, however, he did not show himself so accomplished and steady in design, nor were his basic conceptions altogether satisfactory, so that in this and other respects he lacked the qualities needed for devising elaborate compositions. In addition to all that has been said of the habits of this artist, he was good, honest, noble, and generous; and despite his small stature, he was well proportioned, graceful, and handsome, with the typical pale skin and fair hair of his native climate.

1. Van Dyck's first master was not Rubens but Hendrik van Balen, whose apprentice he became in 1609. See Chronology.
2. The drawing made from *The Battle of the Amazons* in preparation for Lucas Vorsterman's engraving after the painting seems to be the very large sheet made up of eight pieces of paper which is at Christ Church, Oxford (Byam Shaw 1976, no. 1377). There are traces of indentation with a stylus. In my view, it is not by Van Dyck, nor by Rubens (as Jaffé, quoted in Byam Shaw 1976, has suggested) but a work which should be attributed to Rubens' studio. For a discussion of drawings made for engravings, see below, under cat. 42.
3. These are the cartoons for tapestries depicting the story of the Roman consul Decius Mus made from Rubens' *modelli*. They are in the collection of the prince of Liechtenstein at Vaduz. In the

catalogue of the exhibition "Liechtenstein: The Princely Collections" (Metropolitan Museum of Art, New York, 1985–1986, 338–355), Reinhold Baumstark has argued for an attribution to Rubens and his workshop rather than to Van Dyck. Certainly there are passages which suggest that Rubens went over them but equally there are areas, such as the heads of the soldiers in *Decius Mus Relating His Dream*, which are very close in style to the young Van Dyck. Not only does Bellori identify them as by Van Dyck but they are described as his work as early as 1661. My own view is that they are studio works, but that Van Dyck was the principal assistant, as in the case of the Jesuit church commission, and that his stylistic mannerisms can be detected in a number of significant passages.

4. Titian's treatment of Tintoretto is described by C. Ridolfi, *Le Maraviglie dell'arte ovvero le vite degli illustri pittori veneti e dello stato* (Venice, 1648), II, 5.
5. The painting is still in Saint Paul's Church, Antwerp. See discussion on p. 48ff.
6. Surprisingly, in view of the fact that his principal informant about Van Dyck's life was an Englishman, Kenelm Digby, Bellori did not know about Van Dyck's first visit to England in 1620–1621. See Chronology.
7. Guido Bentivoglio (1579–1644) was papal nuncio to Flanders, based at the court in Brussels, from 1607 until 1615. His first account of Flanders was the *Relatione delle Provincie Unite di Fiandra, fatta dal Card. Bentivoglio in tempo della sua nunziatura appresso i serenissimi arciduche Alberto e Anna Isabella infanta di Spagna, sua moglie*, Rome, 1629.

8. This portrait—which was painted in Rome in 1622 or 1623—is still in Florence at the Palazzo Pitti, Galleria Palatina (Glück 1931, 180).

9. The Roman *palmo* was about 22.2 cm, so this picture was about 90 cm. Van Dyck painted this subject on a number of occasions. It has been suggested that the version in Genoa, Palazzo Reale (Glück 1931, 133) is the one to which Bellori refers, though this is larger (123 x 92 cm).

10. The portraits of Sir Robert and Lady Shirley are at Petworth House, Sussex (The National Trust). They were painted in Rome between 22 July and 29 August 1622 (Glück 1931, 210, 211; London 1982–1983, nos. 4, 5; Washington 1990–1991, cat. nos. 28, 29).

11. Zeuxis was a Greek painter praised by Pliny (Pliny, *Natural History*, Book XXXV, line 61ff.).

12. For the association of Dutch and Flemish painters in Rome, see G. J. Hoogewerff, *De Bentvueghels,* The Hague, 1952.

13. A three-quarter length portrait of a man in armor in the National Gallery of Art, Washington (inv. no. 686; Glück 1931, 161), bears the Raggi coat of arms and is inscribed: MDV/ RAPHAEL RACIUS.I./ REIP. TRIREMIUM/ PRAEFECTUS and has been identified as an early sixteenth-century ancestor of the Raggi family painted by Van Dyck from an earlier portrait. No other portraits of the Raggi family have been convincingly identified.

14. The portraits of Marchese Giulio Brignole-Sale on Horseback and his wife Paola Adorno are still in the Palazzo Rosso, Genoa (Glück 1931, 200, 201) and there is another portrait of Paola in the Frick Collection, New York (Glück 1931, 193).

15. This portrait is now in the J. Paul Getty Museum, Malibu (Washington 1990–1991, no. 25).

16. This portrait is now in the Fondazione Magnani Rocca, Parma.

17. This portrait of Spinola is preserved in a number of studio versions, one of which is in the National Gallery of Scotland (inv. no. 87; Larsen 1980, nos. 430, 431).

18. This picture has not been identified. Van Dyck painted two known portraits of Giovanni Vincenzo Imperiale, a full-length in Brussels (Musées Royaux des Beaux-Arts, inv. no. 3463; Glück 1931, 207) and a half-length in Washington (National Gallery of Art, inv. no. 685; Glück 1931, 206). The Washington painting is inscribed with the date 1625 and the Brussels painting with the date 1626. Queen Christina acquired the Imperiale collection in 1667. See the exhibition catalogue, *Christina, Queen of Sweden,* Stockholm, 1966, 478.

19. This *Crucifixion* has been identified with the picture in the Church of San Michele di Pagana near Rapallo (Glück 1931, 143) that can be dated 1624; see C. Marcenaro, "Precisazioni sulla pala vandyckiana di S. Michele a Rapallo," *Bulletin de l'Institut Historique Belge de Rome* 1937, 209–213. Charles Hope has suggested that the Beato Salvadore—here translated as Blessed Savior—may refer to a locally revered Beato rather than Christ. The right-hand figure is normally said to be Saint Bernard, but could conceivably be a local Beato. There is a *Crucifixion* by Van Dyck (or a follower) in the Church of the Capuchin fathers at Monte Rosso in the area of the Riviera known as the Cinque Terre and it would seem that Bellori has confused the two pictures.

20. This portrait is in the Dulwich Picture Gallery, London (inv. no. 173; Glück 1931, 171; Washington 1990–1991, no. 38). For Van Dyck's stay in Sicily, see Chronology.

21. *The Madonna of the Rosary,* Palermo, Oratorio del Rosario (Glück 1931, 155). See discussion under cat. 45.

22. Bellori presumably had prints in front of him as he wrote. For prints after Van Dyck, see Hollstein 1949, VI, 87–129.

23. *The Mystic Marriage of the Blessed Hermann Joseph,* 1630. Kunsthistoriches Museum, Vienna (inv. no. 488; Glück 1931, 243).

24. Antwerp, Koninklijk Museum voor Schone Kunsten (inv. no. 403; Glück 1931, 223).

25. Antwerp, Koninklijk Museum voor Schone Kunsten (inv. no. 404; Glück 1931, 367; Washington 1990–1991, no. 79). See cat. 80.

26. *Saint Augustine in Ecstasy,* 1628 (Washington 1990–1991, cat. no. 46).

27. Antwerp, Koninklijk Museum voor Schone Kunsten (inv. no. 401; Glück 1931, 236). This picture was painted in 1629 and remained in the Dominican church until its suppression in 1785.

28. Church of Saint Michael, Ghent (Glück 1931, 247). This altarpiece was commissioned by the Confraternity of the Holy Cross and paid for in 1630.

29. *The Crucifixion.* Saint Rombaut's, Mechelen (Glück 1931, 240).

30. For Apelles and his portraits of Antigonus and Alexander the Great, see Pliny, *Natural History,* XXXV, 79–97.

31. Turin, Galleria Sabauda (Glück 1931, 299).

32. Bordeaux, Musée des Beaux-Arts. 1631. For another version, see Glück 1931, 316.

33. Chantilly, Musée Condé. 1631 or 1632 (Glück 1931, 429).

34. *Cardinal-Infante Ferdinand of Austria* (1609–1641), 1634 or 1635. Madrid, Museo del Prado (inv. no. 1480; Glück 1931, 423).

35. Turin, Galleria Sabauda. 1634 (Glück 1931, 421; Washington 1990, cat. no. 71).

36. Van Dyck's life-size group portraits of the échevins of Brussels hung in the town hall but were destroyed in the French bombardment of the city in 1695. Our principal visual record of the project is an oil sketch in the Ecole nationale supérieure des Beaux-Arts, Paris. See catalogue of the exhibition *Le Siècle de Rubens dans les collections publiques françaises,* Paris, Grand Palais, 1977–1978, no. 44.

37. There are several versions of this composition, of which the best are those in the collection of Graf von Schönborn at Pommersfelden and in the Galleria Sabauda, Turin. They are discussed in Washington 1990–1991, cat. no. 60.

38. Oliver Millar has kindly informed me that he considers these to be the originals from which Pieter de Jode made his engraved half-length portraits of the king and queen. See under Glück 1931, 370, and Washington 1990–1991, cat. no. 77.

39. For Parrhasius, see Pliny, *Natural History,* Book XXXV, lines 67–73.

40. *Charles I in Three Positions.* Royal Collection (Millar 1963, no. 146; Glück 1931, no. 389; Washington 1990–1991, cat. no. 75).

41. *Charles I and Henrietta Maria.* 1632. Statni Zamek, Kroměríz, Czechoslovakia (Washington 1990–1991, cat. no. 62; the studio version at Euston Hall is illustrated in Glück 1931, 374).

42. *Charles I and Queen Henrietta Maria with Their Two Eldest Children, Charles, Prince of Wales and Mary, Princess Royal.* 1632. Royal Collection (Millar 1963, no. 150; Glück 1931, 371; London 1982–1983, cat. no. 9).

43. *Charles I on Horseback with Monsieur de Saint Antoine.* 1633. Royal Collection (Millar 1963, no. 143; Glück 1931, 372; London 1982–1983, cat. no. 11). Cat. 67 and 68 are preparatory drawings for this portrait.

44. Bellori appears to refer here to the double portrait of *Mountjoy Blount, Earl of Newport, and Lord George Goring* which is at Petworth House, Sussex (Larsen 1980, no. 861). The present whereabouts of a second double portrait of the two men is unknown (Glück 1931, 435).

45. This may refer to the so-called "Madagascar Portrait" of Arundel and his wife (Glück 1931, 472), of which the best version is at Arundel Castle (London 1982–1983, cat. no. 59) or to a lost *Family Portrait,* which is discussed under cat. 81.

46. *Lady Buckingham with Her Children.* Private collection, Paris (Glück 1931, 402).

47. *Rachel de Ruvigny, Countess of Southampton as Fortuna.* There are versions of this portrait in the Fitzwilliam Museum, Cambridge, and in the National Gallery of Victoria, Melbourne (Larsen 1980, nos. 950, 951).

48. *Sir Kenelm Digby and His Family.* Welbeck Abbey, collection of Lady Anne Bentinck (Glück 1931, 398; see discussion in Millar 1963, 106).

49. "If the heavenly vault should crack and crumble, the ruins will fall on a fearless head" (Horace, *Odes,* III, 3, 7-8; *intrepidum* should be *impavidum*). The portrait of Digby: Glück 1931, 449. Collection of Sir Felix Cassel (1931). For a second version—with a different motto, see Larsen 1980, no. 848.

50. See below, The Drawings for *The Iconography.*

51. "Where there is Prudence no heavenly power is absent" (Juvenal, *Satires,* X, 365). The modern reading, however, changes the meaning: Nullum numen habes, si sit prudentia ...

52. *Venetia Stanley, Lady Digby, as Prudence.* The small version would appear to be the painting in the National Portrait Gallery, London (London 1982–1983, no. 9; Washington 1990–1991, no. 64). There are large-scale versions in the Royal Collection (Millar 1963, no. 179) and the Palazzo Reale, Turin.

53. Digby, a lifelong Catholic, was an ardent royalist and went into exile in Paris. He acted as Henrietta Maria's treasurer and was in Rome in 1645 and again in 1647 raising money for the royalist cause. It was on one of these visits that Digby met Bellori and provided him with information for his life of Van Dyck. See Brown 1982, 144ff.

54. Millar (in London 1982–1983, no. 42) has rejected the identification of this painting with *Portrait of a Girl as Erminia, Attended by Cupid* in the collection of the duke of Marlborough at Blenheim Palace, which had been tentatively proposed by Glück (1931, 408).

55. The only extant portrait of Lanier by Van Dyck is in the Kunsthistorisches Museum, Vienna (inv. no. 501; Glück 1931, 349; Washington 1990–1991, no. 48). It does not show him as David playing the harp: this may be fanciful or this *portrait historié* may have been lost.

56. *Lady Mary Villiers with Lord Arran.* North Carolina Museum of Art, Raleigh, inv. no. 52.17.1 (Washington 1990–1991, no. 78).

57. A double portrait of two women in the Hermitage, Leningrad, has been tentatively identified as *Katherine Howard, Lady d'Aubigny, and Frances Stuart, Countess of Portland,* but they are not dressed "in abito di Ninfe" (Glück 1931, 499).

58. Probably the *Holy Family with Angels* in the Hermitage, Leningrad (Glück 1931, 261).

59. In his early years in Antwerp, Van Dyck painted a number of series of the Apostles. One series was engraved by Cornelis van Caukercken. It is impossible to know which paintings belonged to the bishop of Ghent's set. (See M. Roland, "Van Dyck's Early Workshop, the 'Apostle' series and the 'Drunken Silenus'," *The Art Bulletin* 66, 1984, 211–223, and discussion in Washington 1990–1991, cat. nos. 19, 20.)

60. Kunsthistorisches Museum, Vienna, inv. no. 512 (Glück 1931, 262).

61. The book of engravings is David Teniers' *Theatrum Pictorium* (1660).

62. The only visual record of this project is an oil sketch in the collection of the duke of Rutland, Belvoir Castle (Washington 1990–1991, cat. no. 102).

63. This account of Van Dyck's working practice, presumably based on information given to Bellori by Digby, is at variance with Jabach's, quoted on pp. 34–35.

Van Dyck as a Draughtsman

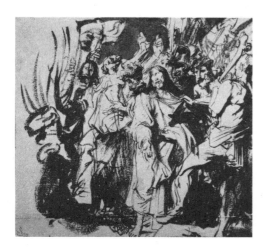

Fig. 1. Anthony van Dyck, *The Taking of Christ*. Pen and brown wash, 218 x 230 mm. Graphische Sammlung Albertina, Vienna (Vey 83)

The immaculate portraits and powerful religious paintings of Anthony van Dyck may seem to have been made almost effortlessly, so sure is the artist's touch and so accomplished his technique. However, in the preparatory drawings, especially those of his early years, we can observe the artist at work and come to appreciate the intense creative effort which lies behind his paintings.

From his first years in Antwerp we possess several remarkable series of drawings for major paintings. For *The Taking of Christ*, for example, there are seven compositional drawings, four sketches for groups of figures within the composition, and a black chalk study for a particular figure.[1] They are the products of constant, restless, and radical experimentation. The compositional format, the direction in which the action moves, the participants in the scenes, and the lighting are all changed and changed again as Van Dyck strives for a solution which satisfies him. Horst Vey, who studied these early drawings so thoroughly, found this a puzzling phenomenon. He could not decide whether it was the consequence of "extraordinary conscientiousness or indecision," whether the drawings are the products of a "weak imagination," or "an abundant fantasy which the artist found difficult to control."[2] Julius Held has interpreted them in the context of Van Dyck's relationship with Rubens, which he considers to have been "charged both with admiration and envy":

> He [Van Dyck] surely wanted to please and to impress his teacher and to show himself worthy of his praise and protection. At the same time, if only unconsciously, there may have been resentment and a wish to rival and possibly outdo him. The paintings Van Dyck did in these years and for which he made these numerous studies are mostly scenes of drama and excitement, precisely the kind of subject for which Rubens had an unsurpassed gift. They disappeared almost completely from Van Dyck's oeuvre after he had found the subjects appropriate to his talent, the lyrical and slightly sentimental religious themes, and above all portraiture, a field Rubens shunned as much as possible.
>
> For some years the young Van Dyck evidently made an intense effort to prove himself another Rubens. Straining against the very nature of his talent, he worked with tremendous concentration and under great tensions; I believe that the multiple studies and sketches for his early paintings remain as mute witnesses of a pertinacious and somehow pathetic struggle toward his goal.[3]

Held also believes that some of the graphic mannerisms of these early drawings—the heavy inking, the bold outlines made with the brush and the powerful contrasts of light and dark—can be understood in this context as "the graphic equivalent of the rather coarse brushwork of many of Van Dyck's early paintings—and like it may be a sign of overcompensation."[4] However, thought-provoking though this account of an artist misdirecting his talent is, it remains only one possible interpretation of the relationship between Rubens and the young Van Dyck. Having learned the basic rules of his craft in the studio of Hendrik van Balen, Van Dyck moved into the circle of Rubens in his mid-teens. For a prodigiously talented young painter in Antwerp this was not in any way surprising. Rubens had returned from an eight-year stay in Italy in 1608, the year before Van Dyck entered Van Balen's studio, and the years of Van Dyck's apprenticeship were the years in which Rubens was establishing his reputation as the city's greatest history painter with a series of breathtakingly bold, highly colored altarpieces. It must have been intensely thrilling for the young apprentice when he first stepped inside the Church of Saint Walburga to see *The Elevation of the Cross* and when he first saw the *Deposition* triptych in the cathedral and *The Adoration of the Magi* in the town hall. Another moment of

1. This series is discussed on pp. 128–130. Six drawings from the series are in the exhibition.
2. Vey 1962, 20.
3. Held 1964, 568.
4. Ibid.

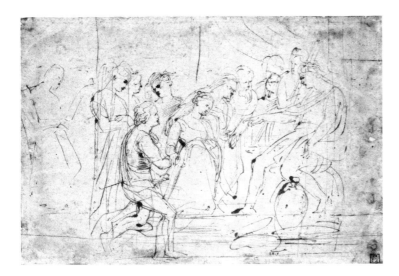 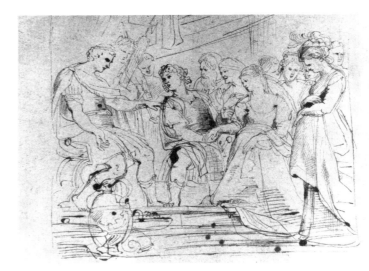

Fig. 2. Peter Paul Rubens, *The Continence of Scipio.* Pen and brown ink, 236 x 343 mm. Staatliche Museen Preussischer Kulturbesitz, Berlin, Kupferstichkabinett

Fig. 3. Peter Paul Rubens, *The Continence of Scipio.* Pen and brown ink, 255 x 354 mm. Musée Bonnat, Bayonne

Fig. 4. Peter Paul Rubens, *The Martyrdom of Saint Stephen.* Pen and brown ink, 342 x 323 mm. Museum Boymans-van Beuningen, Rotterdam

Fig. 5. Anthony van Dyck, *The Martyrdom of Saint Catherine.* Pen and brown ink, 180 x 211 mm. Herzog Anton Ulrich-Museum, Braunschweig [cat. 19]

tremendous excitement must have been his first sight of Rubens' *Samson and Delilah* [cat. 9, fig. 2] hanging in the "great saloon" of Nicholas Rockox's house in the Keizerstraat. These paintings announced a new style, dramatic and realistic, which must have made the Romanist tradition in which Van Dyck was being trained seem tired and jejune.

At the age of sixteen or so Van Dyck immersed himself completely in the intellectual and creative world of Rubens. Compelling evidence of this can be found in the so-called Antwerp sketchbook [cat. 1], in which Van Dyck copied extensively from Rubens' Pocket-Book. It was an attempt to absorb Rubens' interests by a kind of artistic osmosis. Yet as the brilliant young man matured—and we can be in no doubt that he matured early—he came to realize that Rubens' interests were not necessarily his own. Rubens' antiquarianism, his interest in architecture, his love of classical literature—in sum, his humanist preoccupations—were not shared by Van Dyck. It is this growing sense of a difference of interests and temperament rather than a feeling of rivalry that characterizes the relationship between the two painters in the years 1617–1621. For Rubens, with his immensely busy and demanding professional practice in Antwerp, the arrival of a young man who was, as Bellori remarks, so adept at interpreting his intentions, was a godsend.[5] Van Dyck, however, while anxious to learn and dazzled by the brilliance of the older man, was conscious of belonging to a different generation, whose attitudes were conditioned not by the political and religious turbulence of the last quarter of the sixteenth century but by the relative stability of the first two decades of the seventeenth.

After his initial total immersion in Rubens' world, Van Dyck consciously began to construct his own artistic personality, not in a spirit of competition or even of emulation, but rather one of independence. In doing so, he relied on the example of Rubens (few of his early religious compositions do not have their starting point in one of Rubens' designs), but he also drew heavily on the example of his other great artistic mentor, Titian. Up until his visit to London in 1620, Van Dyck had had the opportunity to see relatively few original paintings by Titian and his Venetian contemporaries.[6] He would, however, have seen copies—some by Rubens himself—which attempted to convey the Venetian painter's broken brushwork and rich, saturated color and he strove to incorporate these aspects of Titian's art into his own. In the years 1617–1621, basing himself on his study of Rubens and Titian, Van Dyck was struggling to develop an independent, intensely emotional religious art.

It is against this background that the early series of drawings should be considered. They are the fruits of Van Dyck's restless, developing creativity; he explored, for example, a multitude of possibilities for rendering scenes from the Passion in the most emotionally affecting manner. Held writes of the sentimentality of Van Dyck's religious paintings, using the term pejoratively, but for Van Dyck a

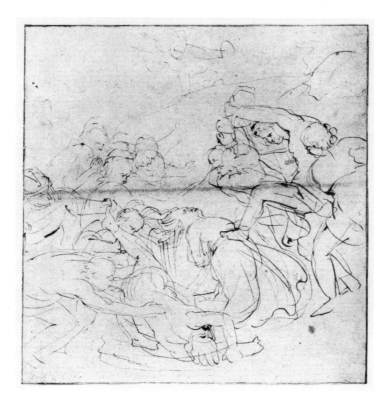

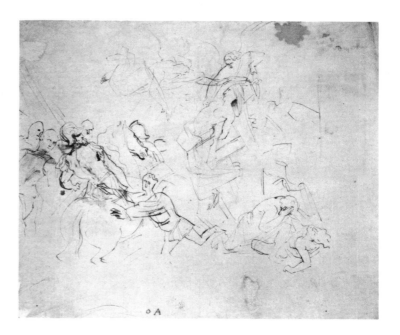

5. Bellori 1672, 254. See above, p. 17.
6. In all the twenty-one Antwerp inventories listed by Denucé (1932) before 1640, there are only three mentions of Titian: a Magdalen by Titian, a Leda after Titian, and "een Marienbeeldt," a picture of the Virgin, by Titian. In the inventory of Rubens' collection drawn up after his death, there were nine paintings and two drawings by Titian and no fewer than thirty copies after Titian (Muller 1989, cat. 1).
7. Muller 1989, 133ff.
8. For the most recent summary of this complex question, see Held 1986, 13–14. In my view the Chatsworth drawing (inv. no. 964) is more likely to be by Rubens than Van Dyck and the better British Museum drawing (Hind, no. 118) is probably by Pontius rather than by Rubens himself. The other two drawings, one in the British Museum (Hind, no. 122) and another formerly in the Northwick Collection (known to me only in a photograph), are generally agreed to be copies.
9. The best discussion of the differences between the graphic styles of Van Dyck and Rubens is in Held 1986, 12–14. My account owes much to Held's.
10. Held 1986, 13.

religious painting which did not move the viewer to tears through his identification with Christ's sufferings would not have been a success. *The Carrying of the Cross* [p. 49, fig. 2] and *The Crowning with Thorns* [p. 118, figs. 1, 2] both aim to evoke as powerful an emotional response as the Crucifixions and Lamentations of his second Antwerp period. These early paintings are powerful and dramatic works which are quite distinct, both in religious feeling and technique, from Rubens' interpretations of the same subjects. The paint is scumbled thinly across the canvas with an almost dry brush. The figures are vigorous in their actions but appear insubstantial, lacking that solidity and three-dimensionality which characterize Rubens' figures at this period. It is this sensation of almost febrile intensity that Van Dyck was refining in his drawings. We know that Rubens, while no doubt recognizing these differences, was an admirer of these early paintings because replicas of them hung in his house, commissioned from Van Dyck or perhaps presented to him by his young assistant.[7]

In many respects Van Dyck aped Rubens' graphic mannerisms in these early years. For example, Rubens' shorthand manner of drawing a face with a circle and a few lines and dots was adopted by Van Dyck, as well as by other assistants and pupils. Both Van Dyck's pen line and his shading and modeling with black and white chalks are based on Rubens' example. Indeed, there is no type of drawing made by Van Dyck which is not paralleled in Rubens' work. Even Van Dyck's practice, in the early series of drawings for religious paintings, of trying out the composition in reverse can be found, for example, in Rubens' two drawings of about 1617–1618 of *The Continence of Scipio* [figs. 2, 3]. It is not therefore surprising that there are still a number of drawings whose attribution is disputed between the two artists: the most notorious example is the group of four drawings showing the same cattle, variously described as by Rubens, Van Dyck, Paulus Pontius, and as copies.[8] However, there are differences between drawings by Van Dyck and Rubens at this time which can assist us in attributing problematic sheets.[9] They are differences both of technique and function [figs. 4–9]. Van Dyck's compositional drawings are made in pen using a very dark ink made from gallnuts rather than the lighter and more traditional bistre (made of soot) favored by Rubens.[10] They always

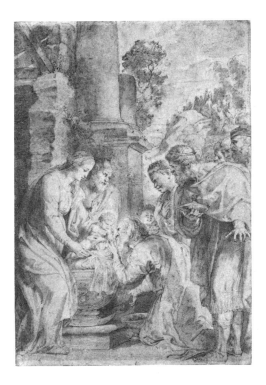

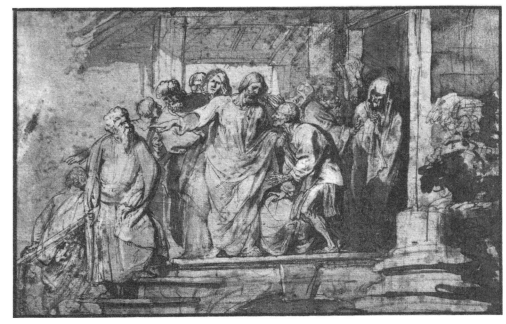

Fig. 6. Peter Paul Rubens, *The Adoration of the Magi*. Pen and brown ink and brown wash, 295 x 190 mm. The Pierpont Morgan Library, New York

Fig. 7. Anthony van Dyck, *The Healing of the Paralytic*. Pen and brown ink and brown wash, 183 x 289 mm. Graphische Sammlung Albertina, Vienna (Vey 36)

Fig. 8. Peter Paul Rubens, *Daniel in the Lion's Den*. Black and white chalk, 507 x 203 mm. The Pierpont Morgan Library, New York

Fig. 9. Anthony van Dyck, *A Kneeling Man, Seen from Behind*. Black and red chalk, with white chalk highlights, 465 x 270 mm. Museum Boymans-van Beuningen, Rotterdam (Vey 75)

give the impression of haste, with little concern for the correct proportions of the figures—displaying the lengthening of the body which is such a striking feature of the paintings—or the details of the hands and feet. Rubens' drawings were made more slowly and with far greater attention to detail. Van Dyck relishes the decorative effect of the pen line on the page. Whereas Rubens' forms are given three-dimensionality by curving and twisting lines, Van Dyck uses washes for this purpose. He prefers to draw in two dimensions and add the third, depth, by creating shadows with dark washes. One particular graphic mannerism, the use of small rows of dots to model form, is often used by Van Dyck but only very rarely by Rubens. Van Dyck uses a figure canon which tends to be thin, elongated, and slightly mannered: Rubens' forms tend to be full, sturdy, and naturalistic.

These differences can be clearly seen in the two artists' figure studies in black chalk. Van Dyck's line is longer and flatter than Rubens', which has richer and softer curves. Both artists worked in pen and chalks, but while Rubens used chalk and pen equally for various types of drawing, Van Dyck made his compositional drawings in pen and his studies for individual figures and portraits in black chalk. The culmination of a series of compositional drawings by Rubens would be a *modello*, an oil sketch painted on a prepared panel, which would be shown to the patron and then handed to the studio assistants to help them in their task of working up the composition on a large scale [fig. 10]. Van Dyck was very familiar with this procedure: he was himself one of the assistants involved in transforming oil sketches into large-scale paintings for both the Decius Mus tapestries and the Jesuit church ceilings. He himself was to use oil sketches later in his career, but in his early years his *modelli* were drawings, which were squared up for transfer onto the large canvas. He would divide the canvas into a grid by stretching strings across it and transferring the design square by square onto it. Perhaps because he had few or no assistants at this stage in his career, he found the preparation of an oil sketch an unnecessary step in the development of the painting.

Despite the freedom with which he handled the pen in this early group of compositional drawings, with their numerous corrections, constant reworking of details, and scribbles and ink splashes, Van Dyck could also work with refinement and precision. Bellori, whose life of the artist is based on conversations in Rome with Van Dyck's friend Kenelm Digby, informs us that he "knew how to translate

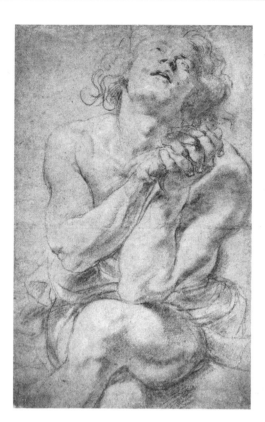 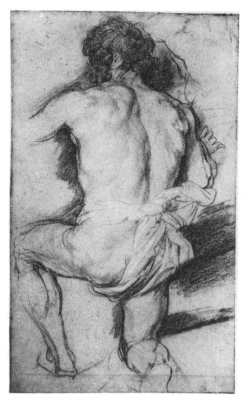

his [Rubens'] compositions into drawings from which they could be engraved. Amongst these is the Battle of the Amazons which was drawn by Anthony at that time."[11] It is largely on the basis of this statement that a group of precise and accomplished drawings in the Louvre, all related to engravings made after works by Rubens in the years around 1620, have been attributed to Van Dyck [see cat. 42]. Van Dyck's experience of collaborating with Rubens in the production of prints may also have affected certain aspects of his procedure as a draughtsman in his early years. His practice of making finished *modelli* squared up for transfer and his habit of reversing his compositions (which, although encountered in Rubens' drawings, is far more frequent in Van Dyck's) are both techniques associated with reproductive printmaking.

No drawings can be dated to Van Dyck's first visit to England in 1620–1621. There are no known preparatory drawings for any of the three paintings—a portrait of the earl of Arundel,[12] a portrait of Sir George Villiers, the marquess of Buckingham, and Lady Katherine Manners as Venus and Adonis,[13] and *The Continence of Scipio*[14]—known to have been made in England. Nor are there more than a handful of drawings from Van Dyck's years in Italy. The most important single sheet is the compositional sketch for the *Madonna of the Rosary*, the great altarpiece he painted for the Confraternity of the Rosary at Palermo [cat. 45]. It is a bold pen drawing showing Van Dyck's first idea for the altarpiece which may well have been made in Palermo and shown to his patrons. He has compressed the three principal groups—the saints, the Virgin and Child, and the angels—within the confines of the sheet, showing alternative poses and representing the angels only in the most summary way. The two female saints, Rosalie and Catherine, are the most fully worked-up figures. Needless to say, the composition was radically changed before the altarpiece was completed. Many drawings for other religious and mythological paintings and for portraits made during Van Dyck's years in Italy must have been lost.

We do, however, possess an invaluable document from these years, Van Dyck's Italian sketchbook, which is today in the British Museum.[15] Unfortunately, it could not be included in this exhibition because of its fragility. The sketchbook, boldly

11. Bellori 1672, 254. See above, p. 17.
12. Malibu, J. Paul Getty Museum. Canvas, 113 x 80 cm. London 1982–1983, no. 2.
13. London, Harari & Johns Ltd. Canvas, 223.5 x 160 cm. Jaffé 1990; Washington 1990–1991, no. 17.
14. Oxford, Christ Church. Canvas, 183 x 232.5 cm. London 1982–1983, no. 3.
15. Adriani 1940 is a facsimile edition of the Italian sketchbook. I am preparing a new facsimile edition of the sketchbook.

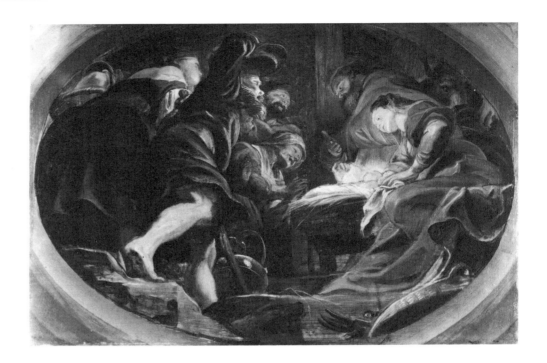

Fig. 10. Peter Paul Rubens, *The Nativity*. Panel, 32 x 47.5 cm. Gemäldegalerie der Akademie der Bildenden Künste, Vienna

Fig. 11. Anthony van Dyck, *Sir Robert Shirley*. Italian Sketchbook, fol. 62. The British Museum, London

Fig. 12. Anthony van Dyck, *Lady Shirley*. Italian Sketchbook, fol. 60v. The British Museum, London

Fig. 13. Anthony van Dyck, *Sofonisba Anguissola*. Italian Sketchbook, fol. 110. The British Museum, London

Fig. 14. Anthony van Dyck, *Roman Women at Prayer*. Italian Sketchbook, fol. 112. The British Museum, London

Fig. 15. Anthony van Dyck, *"una striga in palermo."* Italian Sketchbook, fol. 58v. The British Museum, London

signed "Antonio van Dyck" on its second page, was used during his first three years in Italy, when he was traveling in the peninsula and in Sicily: from February 1622, when he left Genoa (having spent his first Italian winter there) to travel to Rome, until September 1624, when he left Sicily to return to Genoa. In its 122 pages there are only four drawings which are preparatory to paintings: three studies for the portraits of Sir Robert and Lady Shirley which Van Dyck painted in Rome in the summer of 1622 [figs. 11, 12], and the fascinating drawing of the painter Sofonisba Anguissola which he made in Palermo on 11 July 1624, recording their conversation about portrait painting on the same page [fig. 13]. It is not a working sketchbook—there are no studies for any of the Genoese portraits or for his religious commissions —but a record of things seen. There are some scenes from the life—Venetian courtesans, Roman women at prayer [fig. 14], "una striga [witch] in Palermo" [fig. 15]; there are drawings after two antique works of art—a statue of Diogenes and the fresco known as *The Aldobrandini Marriage* (which Rubens admired and may have commended to Van Dyck); there is a solitary drawing after Leonardo, two after Raphael (but none after Michelangelo, whom Rubens copied so enthusiastically during his years in Italy), and a handful of drawings after Italian contemporaries, Guercino, Annibale Carracci, Orazio Gentileschi; but the vast majority are copies after paintings and drawings (noted by Van Dyck as "pensieri") by Venetian artists and by Titian in particular [figs. 16, 17].

In the Italian sketchbook we can observe the reactions of Van Dyck in his early twenties to what he saw in Italy—and the most striking single feature is his selectiveness. Van Dyck matured precociously early: already in Antwerp he was developing a new type of religious painting which to a significant degree was independent of the example of Rubens. At the age of twenty-two he was largely formed as an artist. He knew exactly what he was looking for in Italy, and this was, in the first instance, the work of Titian. Such an attitude is in marked contrast to Rubens whose stay in Italy was a crucial formative experience and who was responsive to the wide range of visual experiences available to him there—antique, Renaissance, and post-Renaissance art. At the back of the sketchbook is a page on which Van Dyck records the places where he saw "le cose de Titian." (There are no such lists for any other painter.) In Rome these include the Palazzi Ludovisi, Aldobrandini, Borghese, and Farnese. He notes that he also saw Titians in Ancona, Reggio, Parma, Milan, and Venice. In Venice, as in Rome, he lists particular locations: the home of Daniel Nys, the Church of the Frari, the Palazzo Grimani, the

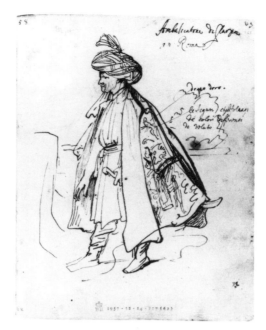 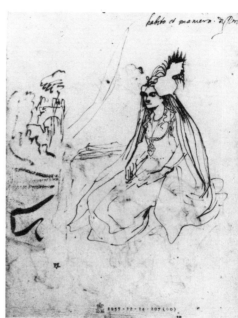

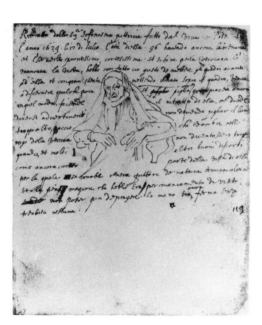 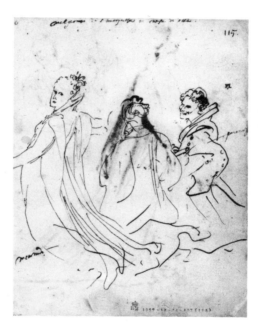 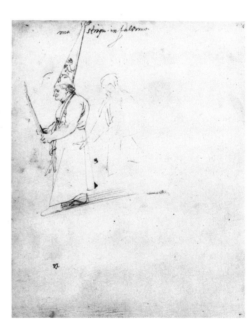

Villa Malcontenta ("al Palazzo delli foscari in strada di padua"), and so on.

The copies in the sketchbook are very freely drawn, lacking the detailed observation of many of Rubens' drawings after classical and Renaissance art. They served as *aide-mémoire* and records of the ways in which Italian painters had solved particular problems of composition, modeling, or color. One example is the drawing which Van Dyck made in Venice after Titian's early masterpiece, *Saint Peter with Alexander VI and Jacopo Pesaro in Adoration*, today in the museum at Antwerp [fig. 18]. He sketched the composition very loosely—there is a tangle of pen strokes in the area of the saint's chest and right arm—and gave Saint Peter a baroque animation absent from the original. He made color notes for the robes of the three figures. The frieze beneath Saint Peter's feet, which he reduced to a few scribbled lines, was of no real interest to him. The drawings are grouped together by subject matter: the Virgin and Child, the Passion, horse studies, figure studies after Titian and Veronese, drawings from life, drapery studies, and portraits. Van Dyck was to refer to them constantly during the rest of his career. We may reasonably assume that he kept the Italian sketchbook with him throughout his life, since it was

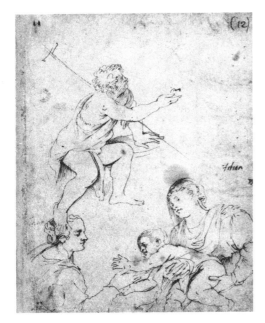

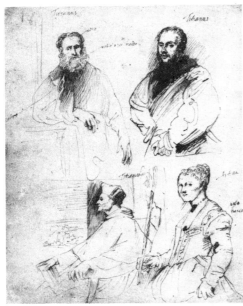

Fig. 16. Anthony van Dyck, *Copies after Titian*. Italian Sketchbook, fol. 12. The British Museum, London

Fig. 17. Anthony van Dyck, *Copies after Titian*. Italian Sketchbook, fol. 104*v*. The British Museum, London

Fig. 18. Anthony van Dyck, *Copy after Titian*. Italian Sketchbook, fol. 19. The British Museum, London

Fig. 19. Anthony van Dyck, *Copies after Titian and Giorgione*. Italian Sketchbook, fol. 20*v*/21. The British Museum, London

Fig. 20. Anthony van Dyck, *The Mocking of Christ*. Canvas, 101 x 78 cm. Barber Institute of Fine Arts, Birmingham

acquired, like so many of his paintings and drawings, in England by Sir Peter Lely shortly after his death.

There are five consecutive pages in the sketchbook devoted to the closely related subjects of the Ecce Homo, the Mocking of Christ, and the Carrying of the Cross. On one double-page spread Van Dyck brings together sketches of the *Mocking of Christ* by Giorgione, Annibale Carracci, and no fewer than five different compositions by Titian [fig. 19]. When in about 1625 he came to paint his own *Mocking*, now in the Barber Institute in Birmingham [fig. 20], he incorporated elements from two of these sketches after Titian, the pose of Christ from one, and the mocking figure from the other. In this painting Van Dyck also closely follows Titian's distribution of light and shade. When in 1634 the Abbé Scaglia asked Van Dyck to portray him adoring the Virgin and Child, Van Dyck turned to the page in the sketchbook where twelve years earlier he had recorded a now lost composition by Titian showing an elderly man kneeling before Mary and the Infant Jesus [figs. 21, 22].

There are some aspects of Van Dyck's interests in Italian painting which are not represented in the Italian sketchbook. From a study of his paintings we may assume, for example, that he looked carefully at the work of Correggio in Parma and was impressed by the early work of Guido Reni. However, the sketchbook does reveal his principal preoccupations during the Italian years. In the exhibition, the copies after Titian made by Van Dyck in Italy are represented by a signed sheet drawn with the same free penwork as those in the sketchbook [cat. 46].

On his return to Antwerp in 1627, Van Dyck established a flourishing practice as a history painter and portraitist. Many of his drawings from this period are related to those paintings and continue his established procedure of laying out the composition in pen and wash and making studies of individual figures in black chalk with white chalk highlights. Both these types of drawing are represented in the exhibition by outstanding examples: *The Crucifixion* [cat. 49], in which Christ's pose has been radically altered and the composition subsequently squared up for transfer, and a study for the body of Christ in *The Lamentation* [cat. 80], one of the most delicate of all his black chalk studies, drawn on gray-blue paper.

Since his Italian years, as can clearly be seen from the *Portrait of an Italian Noble-*

16. The standard work on the *Iconography* is Mauquoy-Hendrickx 1956 (a new edition is in preparation.) The series is discussed below, see The Drawings for *The Iconography*.
17. The status of these sketches, the largest group of which are in the collection of the duke of Buccleuch at Boughton House, is disputed. See below, The Drawings for *The Iconography*.
18. Bellori 1672, 262.
19. London, Royal Collection. Canvas, 199.4 x 191.8 cm. London 1982–1983, no. 58; Washington 1990–1991, no. 85.

man [cat. 48], Van Dyck had been making black chalk drawings on colored paper for portraits. This particular drawing is for pose and costume—and there are many of those—but there are also others, such as *Anna van Thielen and Her Daughter, Anna Maria* [cat. 52], which concentrate on the features, as if the heads in the painted portraits are to be based closely upon them. In England, as we shall see, Van Dyck's usual practice appears to have been to sketch the head directly from life onto the canvas during the sitting and then make chalk drawings for the costume and pose which he passed to his assistants so that they could paint, or at least prepare, the background and the draperies. This procedure was a direct consequence of the demands of a busy portrait practice. In Antwerp, however, and in Antwerp and Brussels in 1634 and 1635, he seems, at least on some occasions, to have made detailed drawings of the sitter and used them for the painted portrait.

It was also during his second period in Antwerp that Van Dyck began to make black chalk drawings for *The Iconography*, the series of etched and engraved portraits of eminent contemporaries which was to be published in a single volume after his death.[16] Many of these were done from life, and their principal purpose was to capture the appearance of the head and the fleeting expression of the face. The costume is often drawn very summarily; the chosen "attribute"—a book, papers, a sculpture, etc.—on which the sitter rests one of his hands, and the background, were added later in the grisaille oil sketches prepared to guide the engraver.[17]

From Van Dyck's English period only two types of drawing survive—those made in connection with portraits and landscapes. There are no preparatory drawings for the history paintings which, Bellori tells us, were painted by Van Dyck in England,[18] or even for the two surviving examples, the *Cupid and Psyche*[19] and the

33

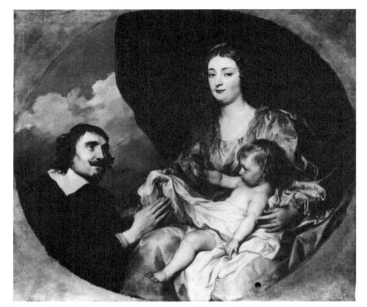

Andromeda.[20] Van Dyck's attitude toward drawing was described by the English miniaturist Edward Norgate, who knew him well:

> the excellent Vandike, at our being in Italie was neat, exact, and curious in all his drawings, but since his cominge here, in all his later drawings was ever juditious, never exact. My meaning is the long time spent in curious designe he reserved to better purpose, to be spent in curious painting, which in drawing hee esteemed as lost, for when all is done, it is but a drawing, which conduces to make profitable things, but is none itself.[21]

The truth of Norgate's account is borne out by the numerous drawings for the British portraits which can be described as "ever juditious, never exact." In the memorandum book of the painter Ozias Humphrey is a transcription of a late seventeenth-century compilation of contemporary and near-contemporary remarks about Van Dyck's painting procedure while he was in England.[22] According to Richard Gibson, who had sat to him, "Vandyke would take a littel piece of blue paper upon a board before him & look upon the Life & draw his figures & postures all in Suden lines, as angles with black Chalk & heighten with white chalk." Many of these "little pieces of blue paper ... all in Suden lines" survive [cat. 82]. The only precise drawings, apart from those made for *The Iconography*, are the studies of the horses and dogs which were to appear in the portraits [cats. 68, 71].

Everhard Jabach, who had sat to Van Dyck on three occasions, described how Van Dyck worked to De Piles:

> The renowned Mr. Jabach, well-known to all art lovers, who was a friend of Van Dyck, and who had him paint his portrait three times, told me that one day when he spoke to the painter about the short time it took him to paint portraits, Van Dyck replied that at the beginning he worked long and hard on his paintings to gain his reputation and in order to learn how to paint them quickly during a period when he was working in order to have enough food to eat. This is, he told me, how Van Dyck usually worked. The painter made appointments with his sitters and never worked more than an hour at a time on each portrait, either when sketching it out or when finishing it. When his clock indicated that the time was up, he rose, thanked the sitter kindly, indicating that that was enough for one day and arranged another appointment. After which his servant

Fig. 21. Anthony van Dyck, *Copy after Titian.* Italian Sketchbook, fol. 46. The British Museum, London

Fig. 22. Anthony van Dyck, *The Abbé Scaglia Adoring the Virgin and Child.* Canvas, 106.7 x 120 cm. National Gallery, London

Fig. 23. Anthony van Dyck, *A Group of Trees.* Brush with brown wash and green watercolor, 195 x 236 mm. The British Museum, London (Vey 303)

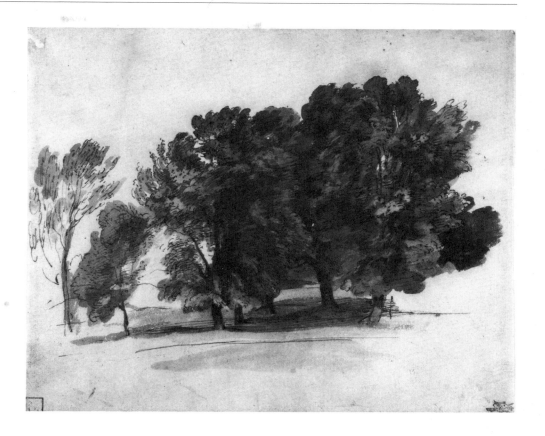

came to clean his brush and bring him another palette whilst he [Van Dyck] welcomed the next sitter, with whom he had made an appointment. In this way he worked on several portraits in the same day with extraordinary speed.

Having lightly sketched out a portrait, he arranged the sitter in a pose that he had thought out beforehand. Then with his grey paper and black and white chalks, he drew the figure and clothes with a great flourish and exquisite taste for about a quarter of an hour. He then gave these drawings to his skillful assistants for them to paint the sitter in the clothes which had been sent at the special request of Van Dyck. His pupils, having done all they could from the life with the drapery, he [Van Dyck] passed his brush lightly and quickly over what they had done and with his talent gave it the art and truth that we admire in his work.

As far as the hands are concerned, he had in his studio people in his employ of both sexes who served as models.[23]

Van Dyck, as De Piles suggests, created a sort of pattern book of hands which he could then use in many of his portraits. He created a similar pattern book of plants and landscape motifs which were observed from nature and then used as and when they were required. Even a view of the Ypres Tower at Rye unexpectedly appears in one of the portraits of Jabach [cat. 74, fig. 1].

There is, however, a small group of landscapes, some drawn in pen and wash and others in watercolor, which are neither preparatory to a known painting or print nor finished drawings made for sale. These few sheets, three of the most beautiful of which are in the exhibition [cats. 89–91], give the lie to Norgate's account of the relentlessly pragmatic and commercial Van Dyck. They seem to have been made from nature in response to the beauty of the hilly English countryside [fig. 23]. It is tempting to imagine that in the midst of his frantically busy life, surrounded by the bustle and intrigue of the court, constantly summoned to attend the royal family, confronted by a new sitter every hour, and with a large team of assistants to instruct and supervise, the creation of these delicate watercolors provided Van Dyck with rare moments of relaxation and solace.

20. Los Angeles, County Museum. Canvas, 215.3 x 132.1 cm. Recently acquired by the museum, this important English period painting was discussed at length for the first time in Brown 1990.

21. Edward Norgate, *Miniatura; or, The Art of Limning* (Oxford, 1919), 83. Norgate may have met Van Dyck during his first stay in England in 1620–1621; he certainly knew him in Italy. When Van Dyck came to England in 1632 he lodged with Norgate (see Chronology).

22. M. Kirby Talley, *Portrait Painting in England: Studies in the Technical Literature before 1700* (London, 1981), 306ff. Humphrey's Memorandum Book is dated 1777–1795.

23. R. de Piles, *Cours de Peinture par Principes* (Paris, 1708), 291–293. Sarah Perry kindly assisted me with the translation.

35

NOTES ON THE CATALOGUE

COLOR PLATES Where possible, the drawings have been illustrated in their actual size.

SEQUENCE The drawings have been arranged in chronological order, as far as is possible.

MEASUREMENTS Almost all the drawings have been remeasured for this catalogue. Height precedes width. Measurements of drawings are given in millimeters and paintings in centimeters.

LITERATURE The literature section is selective. I have not included general works.

WASHINGTON 1990–1991 As the European editions of this catalogue are to appear as a companion volume to the catalogue of the exhibition "Anthony van Dyck," held at the National Gallery of Art, Washington, in 1990–1991, cross-references to numbers in that catalogue have been given throughout.

CATALOGUES OF PAINTINGS BY VAN DYCK AND RUBENS I have used as the standard catalogues of paintings by Van Dyck and Rubens the volumes in the *Klassiker der Kunst* series by Glück (1931) and Oldenbourg (1921) respectively. In the case of paintings not included in those volumes, I have given the appropriate reference.

SERIES OF DRAWINGS In the cases of series of drawings for particular projects, I have thought it useful to provide short introductions to establish the sequence of work, in addition to the individual catalogue entries. I have endeavored to make these introductions clear, readable, and (relatively) free of footnotes. Detailed arguments and references are given in the catalogue entries for individual drawings.

VEY The Vey number given in the description of individual drawings refers to his catalogue raisonné of Van Dyck's drawings published in 1962 (Vey 1962).

ANTWERP
1615–1621

1
The Antwerp Sketchbook

c. 1615–1617

Pen with brown ink, brown wash. The sketchbook is made up of 87 original leaves and 8 additional leaves and inserted fragments. The size of the original pages is 206/210 x 160 mm.

Watermark: a small unidentified watermark can be seen in the fold of a number of sheets.

Devonshire Collection, Chatsworth

PROVENANCE P. H. Lankrink (1628–1692) (L.2090, stamped on fol. 35v); S. W. Reynolds (1773–1835); Hon. George Agar Ellis (1797–1833), later 1st Lord Dover (by 1830); by descent to his grandson, 4th Viscount Clifden (1863–1895); his sale, Christie's, London, 6 May 1893, lot 36 (with the Italian sketchbook, which today is in the British Museum); purchased by Deprez for £120.15s.0d.; Deprez was presumably acting for Fairfax Murray, by whom both sketchbooks were sold in the following year, 1894, to Herbert F. Cook; collection of the duke of Devonshire, Chatsworth, by 1900. (In Cust 1900 it is said to be at Chatsworth, along with the Italian sketchbook, and it must have reached Chatsworth between 1896 and 1900.)

LITERATURE Cust 1900, 29 (as by Daniel van den Dyck); Cust 1902, 1–2 (as by Daniel van den Dyck); Jaffé 1959, 317–321; Antwerp 1960, 26 (as not by Van Dyck); Vey 1962, 30 (as not by Van Dyck); Jaffé 1966; Müller Hofstede 1989, 125–131 (as not by Van Dyck).

1. British Museum, Department of Prints and Drawings, inv. no. 1957.12.14.207. Published in facsimile in 1940 (2d ed., 1965): see Adriani 1940. I am preparing a new facsimile edition of the Italian sketchbook.
2. White 1960, 513.
3. In the introduction to the catalogue of Nottingham 1960, strongly supporting Jaffé's attribution, he wrote that "the drawings in the Sketchbook reveal something of Van Dyck's personality: facile, excitable, unstable, over-brilliant."
4. Held 1986, under no. 4.
5. On a visit to Chatsworth with me in 1987.
6. In a lecture delivered at the Institute of Fine Arts, New York University, in 1987. I am very grateful to Dr. Balis for letting me read the text of this unpublished lecture.
7. For Jaffé's detailed arguments, see Jaffé 1966. For those of Balis, see the lecture referred to in note 6.
8. Vey 1962, 30.
9. The monogram is on the base of the pitcher from which one of Silenus' followers drinks. Glück 1931, 67. Washington 1990–1991, no. 12.
10. In his Autobiography (Jessop 1887, 199), North notes that in going through Lely's collection after his death, "I got a stamp, P.L., and with a little painting ink, I stamped every individual paper ..."
11. Quoted in Jaffé 1966, I, 54.
12. Lugt 1949, no. 1013 (as Rubens' Italian period); Held 1980, I, 323, 647 (as a copy after Rubens). He notes that the Turin painting is a late work.

In 1894 this sketchbook and the Italian sketchbook,[1] which was transferred from Chatsworth to the British Museum in 1957, were purchased by Herbert Cook. On the flyleaf of the Italian sketchbook, he wrote: "Acquired at Lord Dover's sale [1893] by Mr. Fairfax Murray from whom I obtained these two books. Only vol i is genuine, vol ii consisting of sketches by Daniel van den Dyck, a later and inferior artist. Vol 2 was passed upon Lord Dover [and perhaps an earlier possessor] as a genuine thing and the Christian name deliberately torn out [i.e., Daniel] to minimise the risk of detection." The attribution of this sketchbook to Daniel van den Dyck (1614–1663), an Antwerp painter who was a pupil of Pieter Verhaecht, settled in Italy, and principally active in Venice and Mantua, was presumably suggested by the last page of the book, which contains an inserted sheet of alphabetical exercises that is torn at the bottom; a signature—..l vanden Dyck—can, however, be made out. Cust supported the attribution to Daniel van den Dyck.

In 1959 Michael Jaffé announced the discovery of a second Van Dyck sketchbook at Chatsworth in an article in the *Burlington Magazine*. In the following year in the catalogue of the exhibition "Antoon van Dyck: Tekeningen en olieverfschetsen," held at Antwerp and Rotterdam, Roger-A. d'Hulst and Horst Vey rejected the attribution, and in 1962, in his catalogue raisonné of Van Dyck drawings, Vey repeated this rejection. In 1966 Jaffé published the sketchbook in facsimile with a detailed discussion of its provenance, style, and contents. In recent years the attribution to Van Dyck has increasingly gained acceptance. Van Dyck's authorship has been upheld by Christopher White,[2] Oliver Millar,[3] Julius Held,[4] Egbert Haverkamp-Begemann,[5] and Arnout Balis,[6] while Justus Müller Hofstede has denied it.

The first six pages of the sketchbook contain recipes for painting materials and medicines in Flemish; there are then thirty pages of sketches, largely copies of figures from Italian and German engravings. They are grouped by subject, for example, the Lamentation, judicial punishments, Silenus and Bacchus, Jupiter, satyrs, Hercules. These subject groups have one-word Latin titles. Then follow four pages of simple arithmetic, the conversion of Flemish currency into sterling; then twenty more pages of copies grouped by subject—Hercules, scenes of rape and abduction, female nudes, copies after paintings or after copies of paintings by Titian, again with subject titles in Latin; then five pages of physiognomic comparisons in which the features of women are compared to those of horses and those of men to bulls; finally, there are fifteen pages concerned with illustrated works on architecture, including extensive quotations in Latin from Sebastiano Serlio's *De Architectura libri quinque* (Venice, 1569). Pages 40 onwards of the sketchbook can be closely connected with the De Ganay and Johnson manuscripts which preserve parts of Rubens' lost Pocket-Book. The degree to which the sketchbook follows Rubens' Pocket-Book is not entirely clear. Jaffé considers that many of the copies were made independently by Van Dyck, whereas Balis considers that the entire sketchbook is effectively a copy after Rubens' original.[7]

In addition to arguments of connoisseurship—whether or not the drawings can be related to Van Dyck's early style as a draughtsman—there are at least three telling arguments in favor of an attribution to Van Dyck. In the first place, as we have seen, the sketchbook contains substantial passages from Rubens' lost Pocket-Book. Rubens would presumably only have granted the privilege of such access to the Pocket-Book to a close pupil or associate. Secondly, the sketchbook contains a number of copies after Titian, the artist whom Van Dyck admired above all others. (None of the paintings by Titian copied in the sketchbook are known to have been in Antwerp at that time and the artist—if he remained in Antwerp—must have worked from drawn or painted copies.) Thirdly, it contains on folio 17 verso a remarkable drawing of a man being dragged to execution which is clearly related to a drawing on folios 19 verso and 20 recto of the Italian sketchbook. These are the

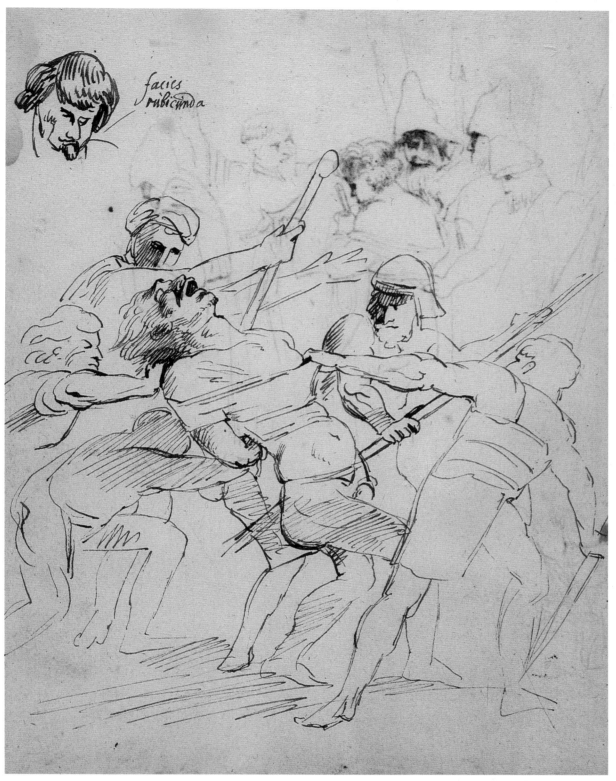

facies
rubicunda

17v

39

Satira

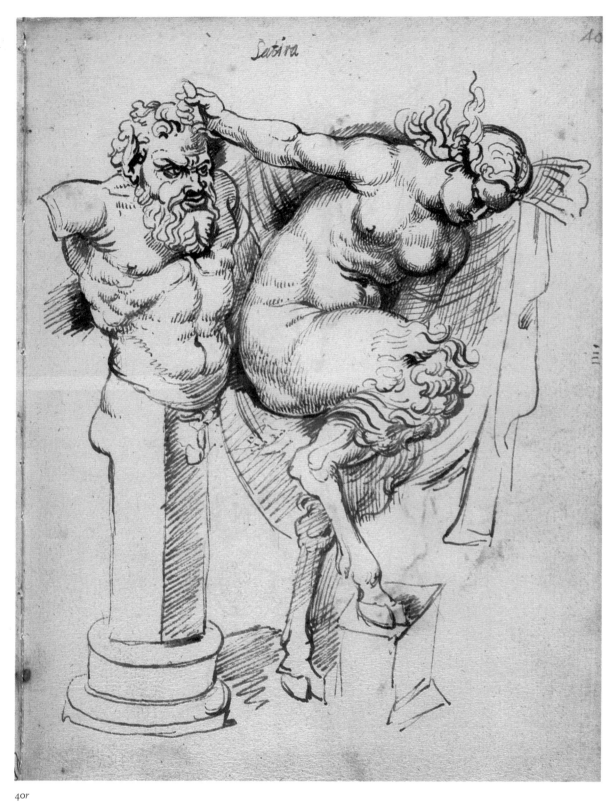

40r

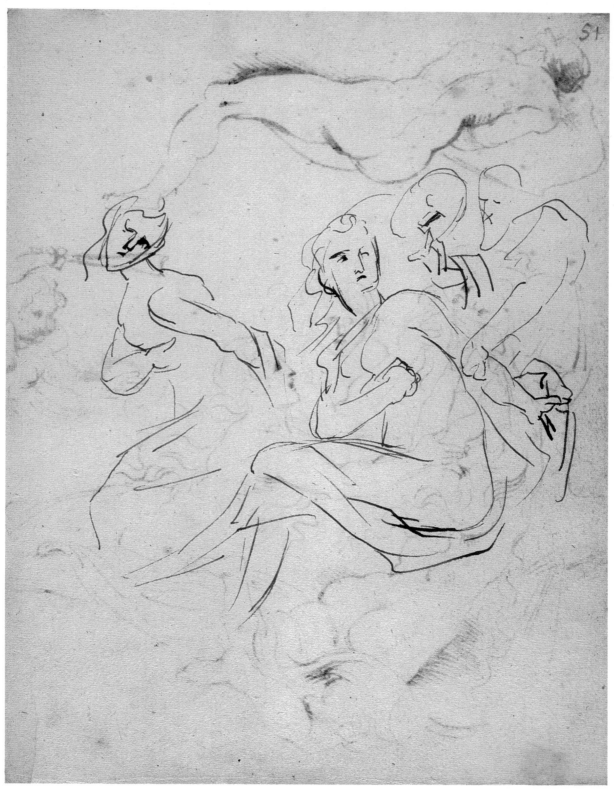

53r

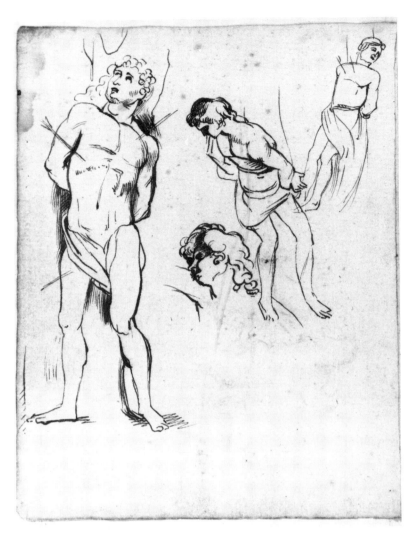

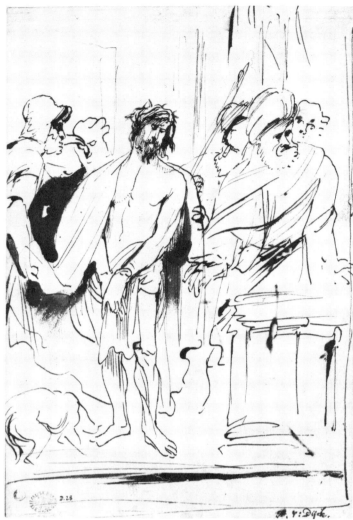

Antwerp Sketchbook, fol. 19v

Fig. 1. Anthony van Dyck, *Ecce Homo*. Pen and brown ink and brown wash, 238 x 160 mm. Musée des Beaux-Arts et d'Archéologie, Besançon (Vey 89)

13. The painting was included, with its companion piece, which is said to show Dejanira being tempted by a fury, in the exhibition *Rubens e Genova*, Palazzo Ducale, Genova, 1977–1978, no. 4. In the catalogue Giuliano Frabetti (following Max Rooses and Antonio Morassi) incorrectly dates them to about 1606.
14. Jaffé 1966, I, 65; II, 235.
15. Burchard and d'Hulst 1956, no. 140.
16. Magurn 1955, 61.

only known records of this powerful composition—do they point to a common, painted prototype or is the latter a reworking six or seven years later, in Italy, of an idea first recorded in the Antwerp sketchbook?

In rejecting the attribution of the sketchbook to Van Dyck, Vey wrote: "The drawing style is not that of Van Dyck; documentary evidence of any substance for the attribution does not exist; in view of its content and lack of resonance in Van Dyck's early work, it is unlikely to be by him. However, the book remains a rare, captivating document for the development of a master from among the followers of Rubens and Van Dyck in the early seventeenth century."[8] It is worth considering these points in turn. It is true to say that the drawing style is in places cruder than in any other drawing or group of drawings that we know by Van Dyck. If folio 19 verso is compared, for example, with the recto of a drawing in Besançon [fig. 1], the viewer cannot help but be struck by the clumsiness and lack of anatomical exactitude in the sketchbook drawing. While the Besançon drawing is rough, almost scribbled, it presupposes a firm grasp of anatomy. If we compare the double-page spread in the sketchbook showing the *Carrying of the Cross* (folios 11 verso and 12 recto) with any of the drawings for his painting of this subject in the Dominican church in Antwerp [cats. 2–4], there can be no doubt that the former are far cruder. The Dominican church commission probably dates from 1617–1618, and so these drawings can only date from a year or two after the sketchbook. On the other hand, there are marked graphic mannerisms, particularly in the abbreviation of faces, which can be paralleled in later, firmly attributed drawings: compare, for example, folio 53 recto, showing *Susannah and the Elders*, with the study for *The Adoration of the Shepherds* on the verso of cat. 22. Comparison with the Italian sketchbook, which was principally used by Van Dyck during the first years (1621–1624) of his stay in

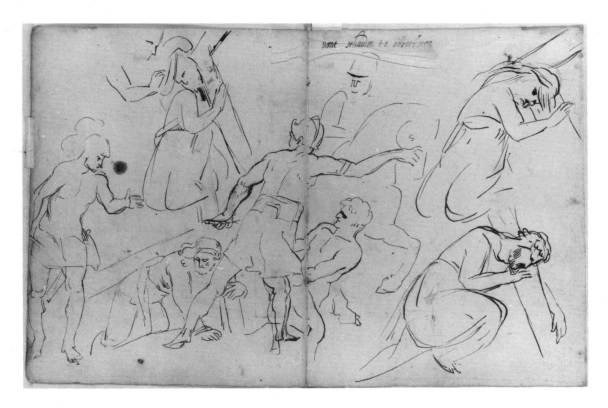

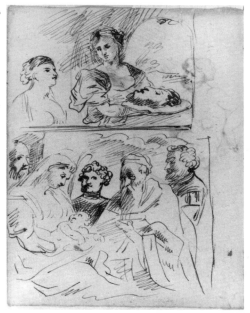

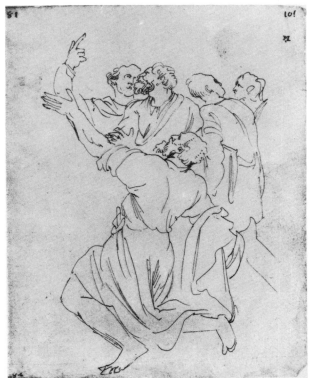

Antwerp Sketchbook, fol. 11v/12

Antwerp Sketchbook, fol. 63v

Fig. 2. Anthony van Dyck, Italian Sketchbook,
fol. 97. The British Museum, London

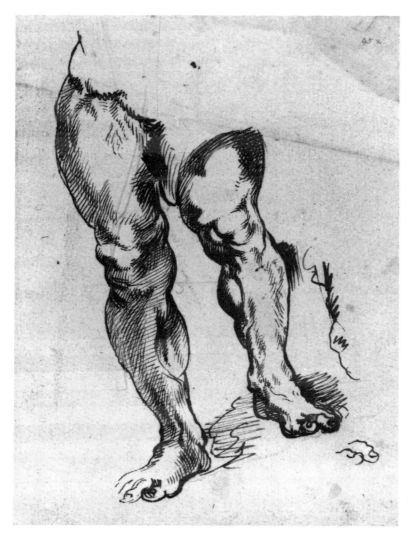

Antwerp Sketchbook, fol. 46r

Fig. 3. Peter Paul Rubens, *Hercules in the Garden of the Hesperides*. Canvas, 246 x 168.5 cm. Galleria Sabauda, Turin

Italy, is equally tantalizing. If, for example, we compare the groups of apostles on folio 22 recto of the Antwerp sketchbook and folio 97 recto of the Italian sketchbook [fig. 2], the absolute assurance of the latter can only point up the crudeness of the former.

Vey's second point, that there is no firm documentary evidence for the authorship of the book, is effectively true. There is on folio 2 recto a small monogram which Jaffé reads as AVD. It is not used by Van Dyck anywhere else and is quite different from the monogram he used on the *Drunken Silenus* in Dresden[9] in about 1620 and the bold "Antonio van Dyck" signature on the second page of the Italian sketchbook both in its calligraphy and position on the page. Nor does the provenance substantially support the attribution. The book's history is certainly closely connected with that of the Italian sketchbook, as Jaffé has shown, but the Antwerp sketchbook does not bear the stamp of Sir Peter Lely, which is on every page of the Italian sketchbook. Since we know that Lely's executor, the Hon. Roger North, was very conscientious in stamping every paper in Lely's collection,[10] it is unlikely that the Antwerp sketchbook was owned by Lely. It cannot, therefore, be traced, as Jaffé attempts to do, back to Van Dyck via Lely. The Antwerp sketchbook does, however, bear the stamp of Prosper Henry Lankrink, as does the Italian sketchbook, but between Lankrink's death in 1692 and an entry in the Hon. George Agar Ellis' diary for 1830 in which he notes having shown "my Van Dyck Sketch Books" to William Young Ottley,[11] there is no mention of it.

Thirdly, Vey claims that the content of the Antwerp sketchbook is not what we would expect from our knowledge of the young Van Dyck, and this is a powerful argument. The sketchbook contains many drawings after the antique and many pages of notes on architecture, which are illustrated by drawings of architraves and

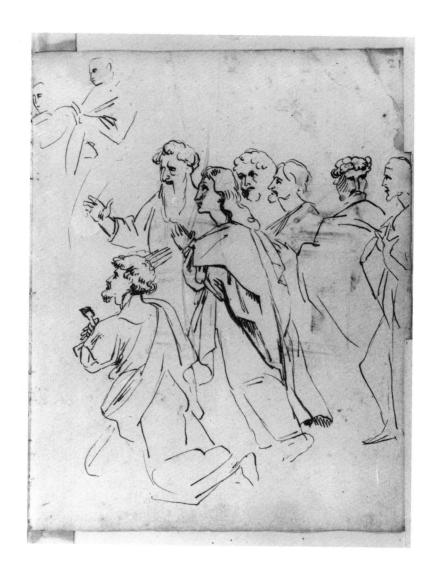

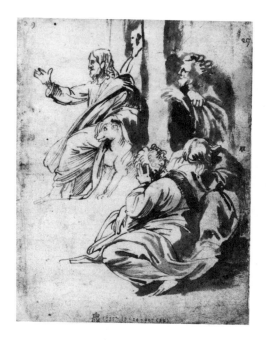

Fig. 4. Anthony van Dyck, Italian Sketchbook, fol. 29. The British Museum, London

Antwerp Sketchbook, fol. 22r

columns. There are also pages of medical recipes. It is true to say that Van Dyck does not evince any real interest in these matters later in his career. Indeed, it is a striking aspect of his Italian sketchbook that there are very few drawings after antique sculpture and none of architecture. It also contains many pages of notes in Latin, a language with which Van Dyck did not show great familiarity in his later years. It is, therefore, true to say that it is difficult to reconcile the artistic personality of the mature Van Dyck with that of the artist of the Antwerp sketchbook.

None of these arguments is, however, irrefutable if we think of the Antwerp sketchbook as a very early work and a copy made by Van Dyck of Rubens' Pocket-Book, which the older man had lent to the young artist. There can be no doubt that the young Van Dyck was fascinated by Rubens, and it should not be surprising that he conscientiously studied Rubens' Pocket-Book, whether or not it reflected his own artistic and intellectual interests. Yet, if it is a copy made by the young Van Dyck of the Pocket-Book we would not expect to find the three (or four) different scripts contained within it, none of which are particularly similar to inscriptions on the early drawings or in the Italian sketchbook.

There remains, however, one serious obstacle to the attribution of the Antwerp sketchbook to Van Dyck. On folios 46 recto and 47 recto are two drawings of Hercules. The pose is that of Rubens' *Hercules in the Garden of the Hesperides* [fig. 3]. The details of the pose are exactly the same, and there can be no doubt that this is the source of the drawing in the sketchbook. There is an oil sketch in Paris for this composition, but its attribution to Rubens is disputed.[12] However, there is a painting which is certainly by Rubens in the Galleria Sabauda in Turin which, judging by the loose handling of the figure and the treatment of the landscape, must date from the last decade of Rubens' career.[13] Jaffé dates the sketch, which he

45

considers to be authentic, to about 1618.[14] Burchard and d'Hulst, however, had dated it late in Rubens' career.[15] In my view the Sabauda painting must date from the 1630s, and, if the Paris sketch is by Rubens, it too should be dated at that time. Therefore, if the drawing in the sketchbook is a copy of Rubens' painting or oil sketch, they establish a *terminus post quem* of the early 1630s, which would rule out Van Dyck as the artist of the sketchbook. The only possible explanations are that these pages, which are tipped in, do not belong to the sketchbook in its original form (although in style they are perfectly consistent with it), or that Van Dyck was copying an earlier composition by Rubens, which Rubens later reworked in the Turin painting.

Having considered the question of the authorship of the Antwerp sketchbook over many years and having studied the book on numerous visits to Chatsworth, I continue to find it puzzling. If it is by Van Dyck, it must be a very early work of about 1615–1617, significantly earlier than our knowledge of the first contact between Rubens and Van Dyck, which is in a letter of 28 April 1618 when Rubens told Carleton of "the best of my pupils."[16] Rubens must have lent his Pocket-Book to the young man who transcribed it painstakingly. The sketchbook would then represent Van Dyck's total immersion in the intellectual and artistic world of Rubens, which he was later to reject. It is a striking feature of the Italian sketchbook that Van Dyck constantly made use of it in subsequent years: the Antwerp sketchbook was not used in this way nor are the interests revealed in it to be found later in his career. The question of the sketchbook's attribution is, in the last resort, one of connoisseurship, and it seems to reveal too many of the graphic mannerisms of the mature Van Dyck *in ovo* to be by any other artist: compare, for example, folio 29 recto of the Italian sketchbook [fig. 4] and folio 22 recto of the Antwerp sketchbook, particularly the profile of Christ and Saint John.

The Antwerp sketchbook has never been previously included in an exhibition of Van Dyck's drawings, and the generous agreement of the Chatsworth trustees to allow its inclusion here presents an opportunity to examine the work alongside drawings which are indisputably by him.

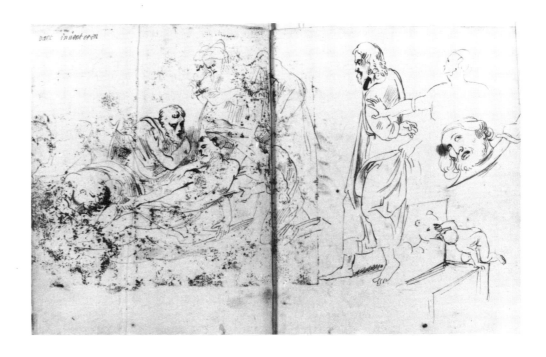

Antwerp Sketchbook, fol. 10*v*/11

Antwerp Sketchbook, fol. 18*r*, 21*v*, 22*v* ; 23*r*, 28*v*, 32*r* ; 32*v*, 36*r*, 52*r*

46

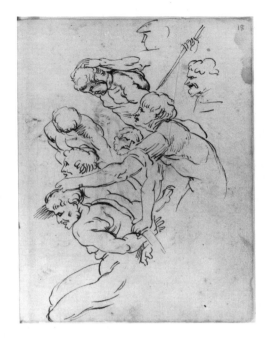

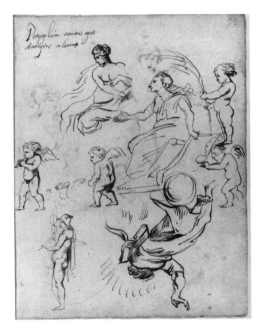

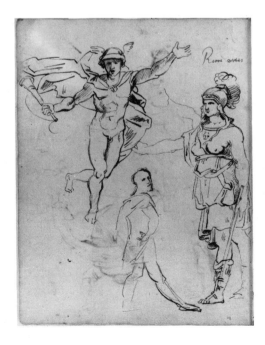

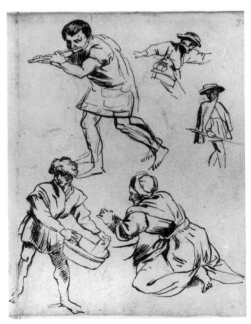

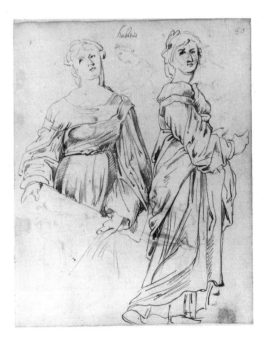

The Drawings for *The Carrying of the Cross*

c. 1617–1618

During the second decade of the seventeenth century the Dominicans of Antwerp, taking their lead from other religious orders in the city, notably the Jesuits and Augustinians, commissioned a series of paintings for their church, now Saint Paul's. The series of fifteen paintings illustrating the Mysteries of the Rosary can be seen hanging in their original setting in a painting of 1636 by Pieter Neefs the Elder which is in the Rijksmuseum [fig. 1]. The paintings are still in place in the church. From a document in the church archives, the names of the artists involved in this ambitious undertaking are known. They include all the leading painters in the city: among them Rubens, Jordaens, Frans Francken the Younger, David Teniers the Elder, Cornelis de Vos, and Hendrik van Balen. Although only in his late teens, Van Dyck was also among this distinguished group. This document does not, however, tell us the date of the commission. However, the frame of Rubens' painting in the series The Flagellation bears the date 1617, and, although the frame is not contemporary, it seems likely that it preserves an original inscription, and so it is reasonable to assume that this is the date of Rubens' painting and the rest of the series. Van Dyck, however, did not enter the Guild of Saint Luke in Antwerp as a master until 11 February 1618. It would certainly be unusual for an artist to receive such an important commission before becoming a master, but it is not clear how strictly guild regulations were enforced: Van Dyck had been active as an independent painter since at least 1616. In his life of the artist, Bellori mentions *The Carrying of the Cross* [fig. 2], Van Dyck's painting in this series,[1] as amongst his earliest works. It seems reasonable, therefore, to assume that he was working on it during 1617 and 1618. There are no fewer than ten preparatory drawings for this commission (Vey 7–14 and 79 verso), of which four are included in this exhibition. Of these drawings, nine show Van Dyck working out the composition, and the other is a study in black chalk for the figure reaching back to pull Christ along by his robe, which was made from a model posed in the studio. If we bear in mind that some drawings may be lost, this gives an idea of the painstaking care with which the young Van Dyck prepared himself for this important commission.[2]

Van Dyck's starting point, as so often in his early paintings, was a composition by Rubens. Rubens' oil sketch of *The Carrying of the Cross* in the Akademie, Vienna [fig. 3], has been dated by Held to about 1614–1616,[3] and Van Dyck's first drawing, the sheet in Providence [cat. 2], shows many elements of this composition. (It is worth noting that there are drawings of *The Carrying of the Cross* in the Antwerp sketchbook on folios 11 verso and 12 recto, which may reflect Rubens' interest in the subject a few years earlier.) Indeed, Vey suggested that the commission may have originally gone to Rubens and that, having made the Akademie sketch (and a second, formerly in Warsaw, which Held does not consider to be by Rubens[4]), he turned the project over to Van Dyck. There is no evidence for this and there are a number of arguments against. It is evident from the disposition of the paintings in the church that the procession to Calvary must go from left to right, as in Van Dyck's painting, whereas Rubens' sketch shows it going from right to left. Rubens included Saint Veronica holding the *sudarium*. She is omitted by Van Dyck, for whom the central drama is the glance exchanged between Christ and his mother: this is appropriate for a cycle of paintings of the Mysteries of the Rosary, for this is one of the Seven Sorrows of the Virgin. Finally, Van Dyck makes many other substantial changes to Rubens' composition. Rubens adopts a low viewpoint and stresses Christ ascending Calvary, as he was to do in his altarpiece *The Carrying of the Cross*, which was installed on the high altar of the church in the Benedictine abbey at Afflighem in 1637 and is now in the museum in Brussels.[5] He stresses this sense of climbing the mountain by showing at the bottom of the composition the figures of the thieves and the soldiers accompanying them in half and three-quarter length. The whole composition has an irresistible, diagonal, upward movement.

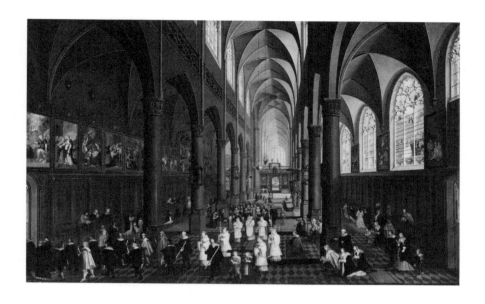

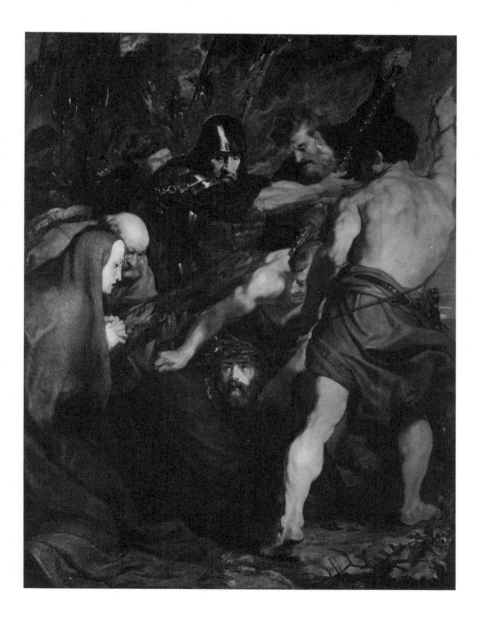

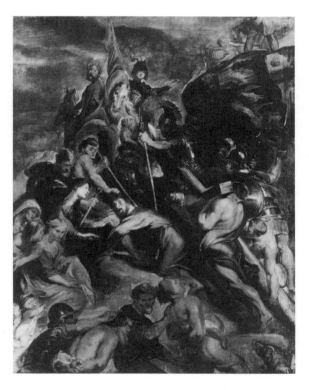

Fig. 1. Pieter Neefs the Elder, *Interior of the Dominican Church at Antwerp*, 1636. Panel, 68 x 105.5 cm. Rijksmuseum, Amsterdam

Fig. 2. Anthony van Dyck, *The Carrying of the Cross*. Panel, 211 x 161.5 cm. Saint Paul's Church, Antwerp

Fig. 3. Peter Paul Rubens, *The Carrying of the Cross*. Panel, 64 x 49.5 cm. Gemäldegalerie der Akademie der Bildenden Künste, Vienna

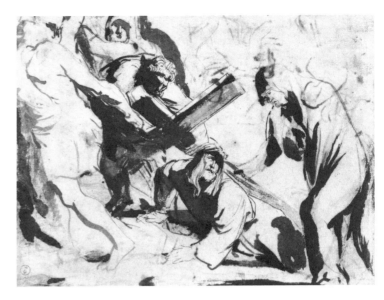

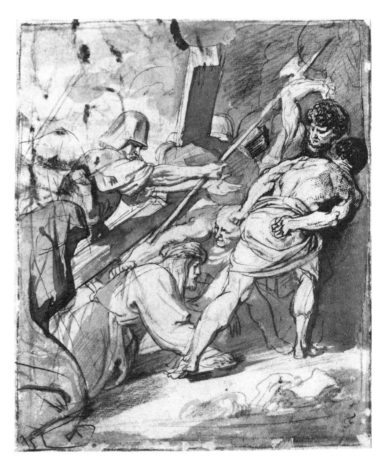

1. Glück 1931, 11. For an extended discussion of the commission, see Van Gelder 1961.
2. Bellori 1672, 254.
3. Held 1980, no. 344.
4. Held 1980, I, 473.
5. Canvas, 560 x 350 cm. Musées Royaux des Beaux-Arts de Belgique, Brussels. Oldenbourg 1921, 419.
6. For this drawing, see Teréz Gerszi in the catalogue of the recent exhibition of drawings from the Biblioteca Reale, *Da Leonardo a Rembrandt*, ed. G. C. Sciolla (Turin, 1990), no. 140.
7. In the exhibition catalogue, Princeton 1979, 38–39.
8. Held 1980, no. 345.
9. B. XIV. 28.

From the Providence drawing through to the finished painting, Van Dyck's composition is quite different. The viewer is on the same level as the sacred figures, the scale of the figures is larger, and they have been reduced in number. The emphasis is on the harrowing encounter between the fallen Christ and his mother. In his first drawing [cat. 2] Van Dyck takes from Rubens' composition the key elements he requires for his own: the pose of Christ, the figure of the Roman soldier with his plumed helmet, and the figure, seen from behind, with a heavily muscled naked back pulling along the first of the thieves. He introduces the standing figure of the heavily veiled Virgin on the left. The second drawing is a pen sketch on the reverse of a sheet in Berlin, which is unfortunately in a poor state of preservation [fig. 4]. The recto shows a study for *The Taking of Christ* [see p. 128, fig. 1]. This sketch shows the figure of the Virgin moved to the right and Christ looking back at

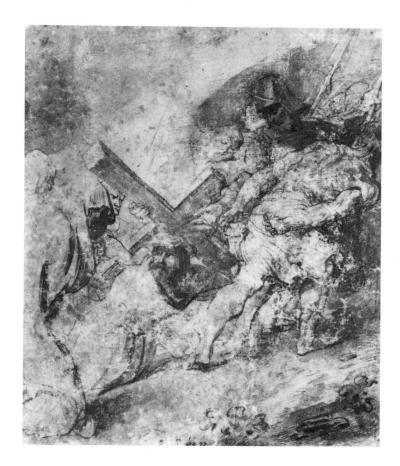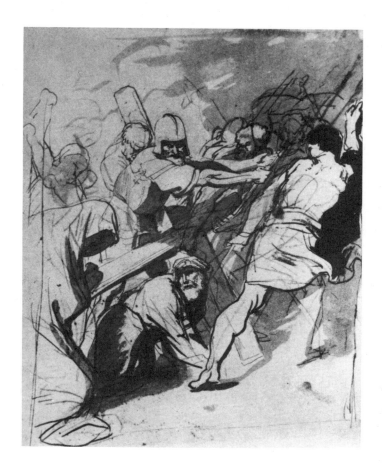

Fig. 4. Anthony van Dyck, *The Carrying of the Cross*. Pen and brown ink over black chalk, 170 x 222 mm. Staatliche Museen Preussischer Kulturbesitz, Berlin, Kupferstichkabinett (Vey 79*v*)

Fig. 5. Anthony van Dyck, *The Carrying of the Cross*. Pen and brown ink over black chalk, with brown wash, 155 x 202 mm. Biblioteca Reale, Turin (Vey 8)

Fig. 6. Anthony van Dyck, *The Carrying of the Cross*. Point of brush over black chalk, 155 x 202 mm. Biblioteca Reale, Turin (Vey 8*v*)

Fig. 7. Anthony van Dyck, *The Carrying of the Cross*. Pen and brown ink over black chalk, with brown and gray wash, 197 x 156 mm. Devonshire Collection, Chatsworth (Vey 10)

Fig. 8. Anthony van Dyck, *The Carrying of the Cross*. Black chalk, gone over with pen with brown ink and with brown wash, 223 x 186 mm. Collection V. de S., Vorden (Vey 11)

Fig. 9. Anthony van Dyck, *The Carrying of the Cross*. Pen and brown ink over black chalk, with brown wash, 225 x 184 mm. Formerly Kunsthalle, Bremen (Vey 12)

her over his left shoulder. This is the composition further elaborated in the next drawing, the recto of a sheet in the Biblioteca Reale, Turin [figs. 5, 6].[6] It is on the verso of that sheet that Van Dyck first reversed the direction of the composition, in a sketch in black chalk and pen which does little more than outline the principal figures: here the Virgin is still on the right-hand side. The next in the sequence is the drawing in Lille [cat. 3] in which the composition is for the most part in its final form, with the Virgin on the left and the two half-naked figures pulling Christ along in their eventual positions. This drawing, however, gives the composition a horizontal format, whereas it must have always been evident from its place in the series that the composition should be vertical. A new vertical format is adopted, the poses and relative positions of the remaining figures resolved, and the disposition of light and shade refined in three further drawings at Chatsworth [fig. 7; on the verso is a study for *The Brazen Serpent*, see p. 79, fig. 1], Vorden [fig. 8], and Bremen [fig. 9; lost during World War II]. Finally, there is the squared-up drawing in Antwerp [cat. 4] which was the *modello* for the painting. Following Rubens' usual procedure, Van Dyck then posed models in the studio for individual figures: one of them, for the man who reaches back to grasp Christ's robe to pull him along, has survived and is included in the exhibition [cat. 5].

In their stimulating discussion of this group of drawings, Feigenbaum and Martin[7] question Van Dyck's direct dependence on a Rubens prototype, considering that the sketch in the Vienna Akademie should be dated later than the engraving by Pontius of 1632 after Rubens' oil sketch at Berkeley.[8] This caused them to suggest that Agostino Veneziano's engraving after Raphael's *Carrying of the Cross*[9] was in Van Dyck's mind when he began this project and that he was also indebted to Dürer's woodcuts of the subject. In my view, Held's dating of the Akademie sketch is correct and the sketch is the starting point for Van Dyck's composition. It is not necessary, therefore, to speculate about other possible sources.

51

2
The Carrying of the Cross

c. 1617–1618

Black chalk gone over with pen and brown ink and brown and gray washes, 203 x 170 mm. A later (eighteenth-century?) hand has added a number of strokes in the sky on the right in blue chalk. There are further, light green-yellow retouchings on the robe of Mary and the loincloth of the figure behind the Roman officer. Elsewhere, there are retouchings in black chalk. There is a repaired damage in the center of the left-hand edge. There is a line in brown ink around the edge of the sheet. Bottom right corner, an inscription in a later hand: *A. v: Dijk.*

The original white paper has been stuck down on a stiffer gray-blue paper, which makes it impossible to see the verso or any watermark. The lengthy French inscription which lists early owners of the drawing is not, as Vey notes, on the verso but on the back of the old mount. The drawing has been remounted, and the old mount is now in the drawing's dossier.

Watermark: not visible (laid down)

Museum of Art, Rhode Island School of Design, Providence, Rhode Island (inv. no. 31.359)

Vey 7
Exhibited in New York

PROVENANCE C. A. Coypel (1694–1752), Paris; Mariette, *Abécédario*, II, 181); "Vente Silvestre, 1811" (?)[1]; "Vente Van Os, 1861, 140 [guilders?]"[2]; Schneider sale (Paris, Drouot, 6–7 April 1876, lot 66); Etienne Martin, Baron de Beurnonville (1779–1878); Paris, Drouot, 16–19 February 1885, lot 150, 700 francs); A. Marmontel (1816–1898) (Paris, Drouot, 28–29 March 1898, lot 22, 600 francs); "Vente Mme D"[3]; P. Dubaut (b. 1886), Paris; Martin Birnbaum, New York; Mrs. G. Radeke (1855–1931). Acquired by the museum 3 November 1931.

EXHIBITIONS Paris 1879, no. 308; Hartford 1948, no. 108; Antwerp 1960, no. 6; Princeton 1979, no. 1; Providence 1983, no. 78.

LITERATURE Engraving by the duc A. C. P. de Caylus in Recueil 1729, no. 99; Guiffrey 1882, 153; Antal 1923, 70, no. 1; Burchard 1932, 10; Delacre 1934, 95–97, pl. 49; Delen 1943B, 130, n. 1 (questions the attribution to Van Dyck); *Rhode Island Museum Notes* (October 1946), 2, pl. 2; Vey 1958, 11ff.; Van Gelder 1961, 3–11, pl. 1; Vey 1962, no. 7.

1. This sale is noted in the French inscription on the reverse of the old mount. There is no 1811 Silvestre sale listed in Lugt, *Répertoire*.
2. This sale is noted in the French inscription on the reverse of the old mount. There is no 1861 Van Os sale listed in Lugt, *Répertoire*.
3. This sale is noted in the French inscription on the reverse of the old mount.

The attribution of the drawing was doubted by Delen (who resolved his doubts) and by Delacre. This was perhaps because it has been gone over rather clumsily by a later hand in black chalk and wash and blue chalk has been added in the top right corner. However, a careful study of, for example, the head of the helmeted Roman soldier, the head of Christ, or that of Simon of Cyrene (who supports the cross), makes its autograph quality clear. In the center of the sheet between the figures of Simon of Cyrene and the Roman officer are lightly sketched figures in the background which Van Dyck may have intended to develop. One has been sketched over to become part of Simon's robe.

As is usual in these early compositional drawings, Van Dyck sketched out the initial idea in black chalk and then went over it in pen and wash, adding considerable detail (using short pen strokes) in the principal figures, notably here in the figure of the Roman officer, and suggesting volume and the disposition of shadow by adding dark washes.

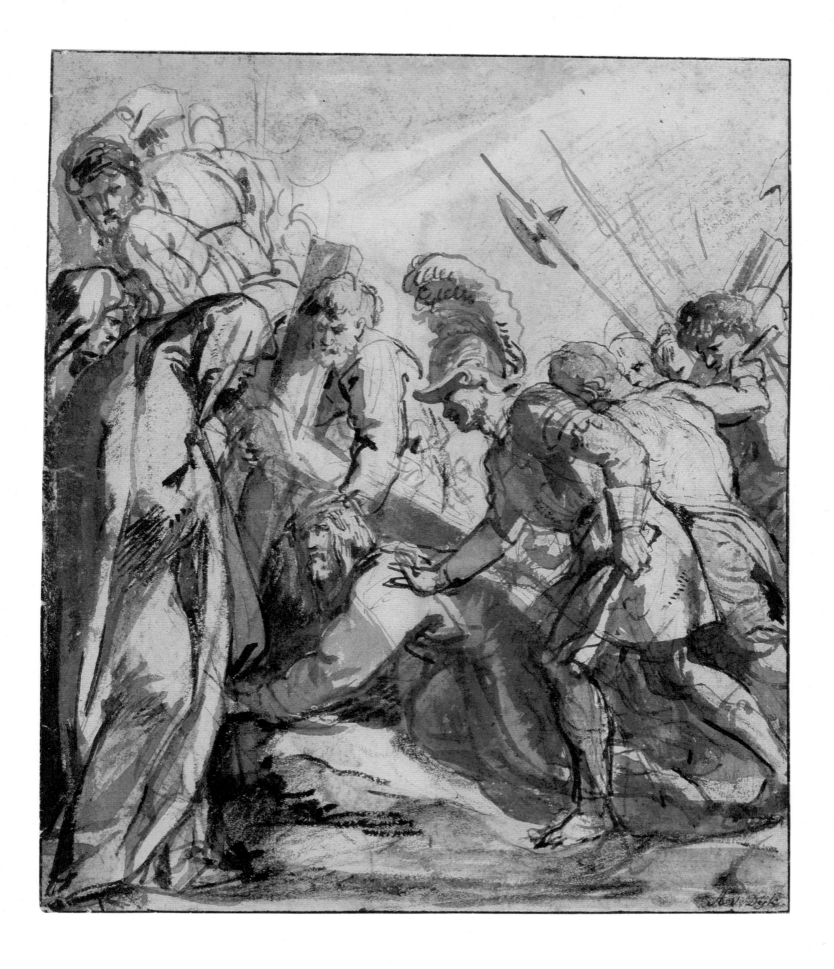

3
The Carrying of the Cross

c. 1617–1618

Black chalk with pen and brown ink and brown wash, 159 x 205 mm. There is some white bodycolor in the robe of the Virgin. Trimmed slightly on all four sides.

Watermark: not visible (laid down)

Musée des Beaux-Arts, Lille (Wicar Collection) (inv. no. 960)

Vey 9

PROVENANCE J. Thane (1748–1818), London (L.1544, lower left); Sir Thomas Lawrence (1769–1830), London (L.2445, lower left); R. P. Roupell (1798–1886), London (L.2234, verso, top right); A. W. Thibaudeau (c. 1840–c. 1892), Paris and London; Musée des Beaux-Arts, Lille (L.1682c, verso, lower left).

EXHIBITIONS Antwerp 1949, no. 80; Antwerp 1960, no. 8; Berlin 1964, no. 60; Princeton 1979, no. 2.

LITERATURE H. Pluchart, *Musée Wicar. Notice des Dessins*, Lille, 1889, 216, no. 960; Delen 1931, pl. 1; Delacre 1934, 99, pl. 51; Delen 1943B, no. 97; Delen 1949, no. 22; Vey 1958, 11ff.; Van Gelder 1961, 3–18, pl. 8; Vey 1962, no. 9.

On the verso of the drawing in Turin [p. 51, fig. 6], Van Dyck made a bold and very summary brush sketch which reversed the direction of the composition. Christ is now moved from left to right and no longer needs to turn his head around to see his mother, who remains in the right foreground. It is this change of direction, dictated by the position the painting was to occupy in the series, that is further worked out in this drawing from Lille. Van Dyck did this in a horizontal format, knowing that he would have to adapt it in subsequent drawings to the vertical format of the series of paintings. The procession is from left to right, with Christ's head placed in the center of the sheet; but Van Dyck reverted to Mary's position on the left, so that in turning towards her Christ is shown full face and the pathos of his glance is emphasized. Van Dyck has repeated the hooded figure of Mary on the right side of the sheet: this is not an alternative position but rather a reworking of the figure. A completely new figure is the half-naked man who leans powerfully to the right, a figure further articulated in the drawings in Chatsworth and Vorden [p. 51, figs. 7, 8]. A second new figure is the helmeted soldier stretching out above Christ with a spear in his hand: his head is drawn in two positions. His pose is taken, as Van Gelder observed, from a drawing in Berlin for *The Taking of Christ* [fig. 1]. The Lille sheet is an astonishingly immediate and vigorous drawing which, showing as it does the young draughtsman radically revising his entire conception of the subject, is very revealing of Van Dyck's intense and restless creative personality.

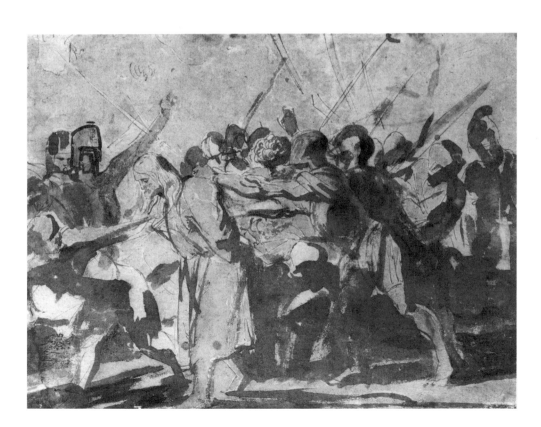

Fig. 1. Anthony van Dyck, *The Taking of Christ*. Pen and brown ink and point of brush over black chalk, with brown wash, 170 x 222 mm. Staatliche Museen Preussischer Kulturbesitz, Berlin, Kupferstichkabinett (Vey 79)

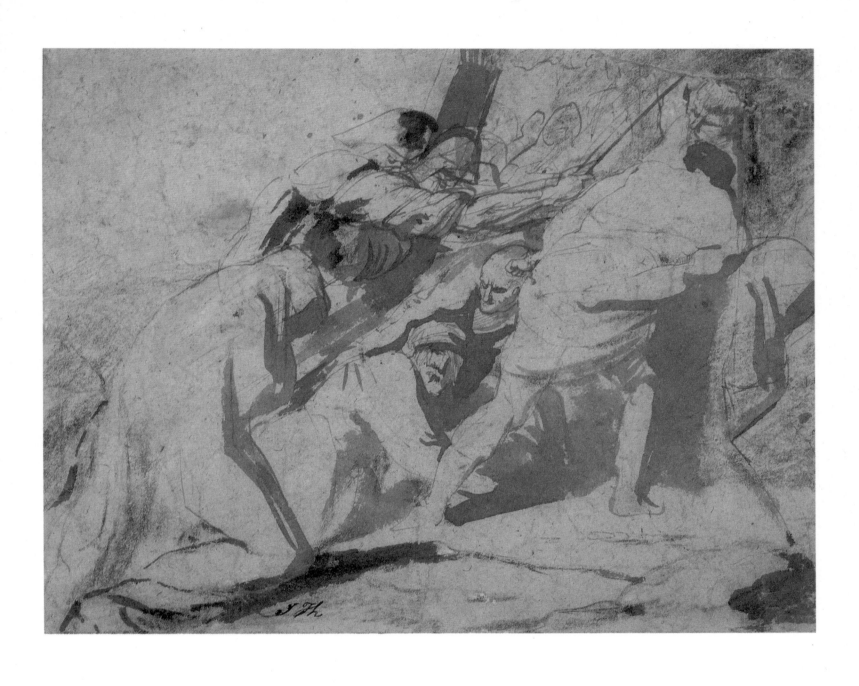

4
The Carrying of the Cross

c. 1617–1618

Black chalk with pen and brown ink and gray and brown washes, 210 x 170 mm. Some white bodycolor. Squared up with black chalk. Lower left-hand corner, an old inscription, in pen: *Vandyck*. At the bottom edge, inscribed, in pen, twice: *90.*

Watermark: none

Stedelijk Prentenkabinet, Antwerp (inv. no. 375)

Vey 13

PROVENANCE Private collection, Brussels; Stedelijk Prentenkabinet, Antwerp (L.2045a, verso, center).

EXHIBITIONS Antwerp 1936, no. 71; Antwerp 1949, no. 79; Paris 1954, no. 109; Antwerp 1956, no. 605; Antwerp 1960, no. 10; Bologna 1965, no. 63; Antwerp 1971, no. 17; Washington 1976–1978, no. 31; Princeton 1979, no. 4; Ottawa 1980, no. 17.

LITERATURE Delen 1930, 58, pl. 39; Delen 1931, 193–199, pl. 3; Glück 1931, 11; Delacre 1934, 105, pl. 56 (as a copy after the painting); Delen 1938, no. 375, pl. 70; Delen 1941, no. 5; Delen 1943B, no. 100; Vey 1958, 11ff.; Van Gelder 1961, 3–18, pl. 11; Vey 1962, no. 13.

1. Balis 1986, II, nos. 4–7. The four hunting scenes for the duke of Bavaria, the future elector Maximilian I, were, as we know from a letter written by Rubens to Sir Dudley Carleton, ready before 28 April 1618. For the similarity to Van Dyck's figure, note, for example, the bearded man in the center on the left-hand side of *The Boar Hunt* (Marseilles, Musée des Beaux-Arts) who drives his spear into the mouth of the boar, and the rider on the left of the *Hippopotamus and Crocodile Hunt* (Munich, Alte Pinakothek) who raises his spear in order to drive it into the open mouth of the hippopotamus.

This drawing is the *modello* for the painting in the Dominican church. It has been squared up in black chalk for transfer to the panel, and the composition was used with little variation in the final painting. After the Lille drawing [cat. 3], Van Dyck changed the composition from a horizontal to a vertical format in a drawing at Chatsworth [p. 51, fig. 7] and added details in pen—the muscular back of one and the head of the other—to the two figures leading Christ. (On the verso of that sheet is a study for *The Brazen Serpent*, see p. 79, fig. 1.) He refined the composition further in drawings in Vorden and formerly in Bremen [p. 51, figs. 8, 9], turning Christ's head to meet his mother's glance and repositioning the helmeted soldier. In the Antwerp drawing he completed the composition, introducing a new figure, Simon of Cyrene, beside the Virgin, and a bearded man to the right of the helmeted soldier who raises his staff to strike Christ's head. In his pose, the violence of his action, and the expression of grim determination on his face, this figure recalls those of hunters in hunting scenes which were being painted in Rubens' studio at about this time [fig. 1].[1]

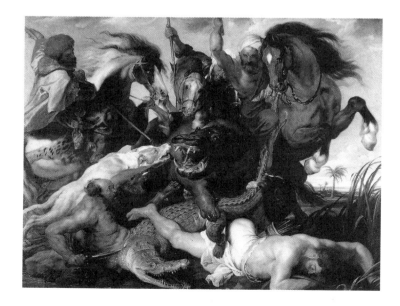

Fig. 1. Peter Paul Rubens, *Hippopotamus and Crocodile Hunt*. Canvas, 248 x 321 cm. Alte Pinakothek, Munich

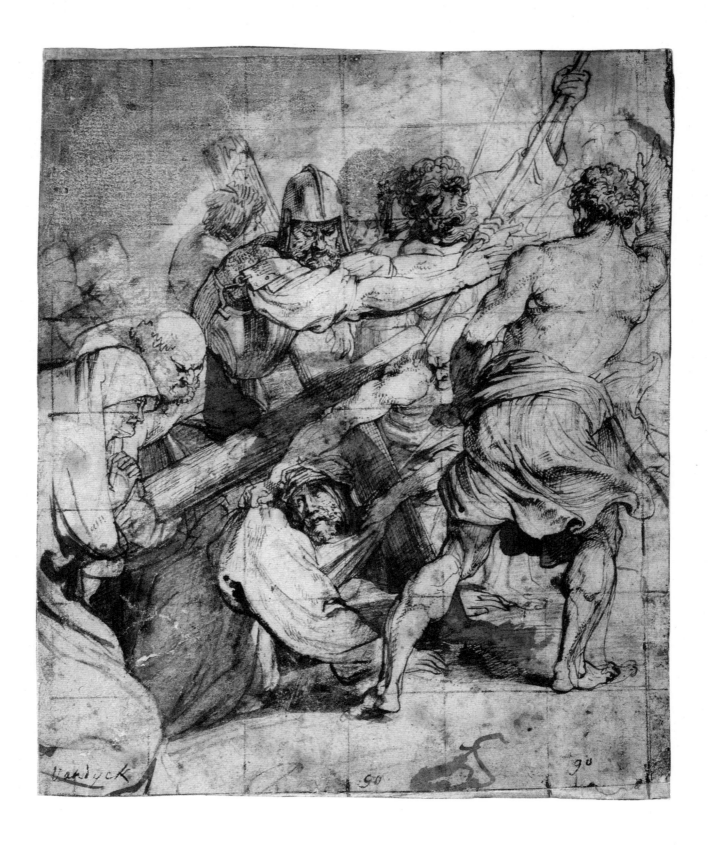

5
A Man Reaching Forward with an Outstretched Arm: with Four Studies of the Arm and Hand

c. 1617–1618

Black chalk with highlights in white chalk on buff paper, 270 x 428 mm. Trimmed slightly on the left- and right-hand edges and along the bottom. Lower right-hand corner, an old inscription, in pen: *Van Dyck*.

Verso, on the backing sheet, lower center, in pen: *W.44/ GG.10./ Y22./ Z.* (in Richardson's hand).

Watermark: not visible (laid down on the Richardson mount)

Courtauld Institute Galleries, London (Witt Collection, inv. no. 1664)

Vey 14
Exhibited in New York

PROVENANCE P. H. Lankrink (1628–1692), London (L.2090, lower center); Jonathan Richardson the Elder (1665–1745), London (L.2183, lower right corner); Leeder (his sale, Christie's, London, 27 July 1923, lot 39); Sir Robert Witt (1872–1952), London (L.2228b, lower left corner, on the backing sheet).

EXHIBITIONS London 1927, no. 589 (Memorial Volume, pl. 123); London 1938, no. 622; Rotterdam 1948–1949, no. 77; Brussels 1949, no. 123; Paris 1949, no. 123; Antwerp 1949, no. 81; London 1953, no. 273; London 1953 (Witt), no. 84; London 1953–1954, no. 487; London 1958, no. 32; Antwerp 1960, no. 11; Manchester 1962, no. 38; London 1977–1978, no. 62; Princeton 1979, no. 5; Ottawa 1980, no. 18; London 1983, no. 41.

LITERATURE Vasari Society (2d series), XII, no. 11; Glück 1931, 11; Burchard 1932, 10; Delen 1931, pl. 4; Delacre 1934, 97; Delen 1943B, no. 98; Van Puyvelde 1950, 47 (as Rubens); *Hand-List of the Drawings in the Witt Collection* (London, 1956), 126; Vey 1958, 11ff.; Van Gelder 1961, 3–18; Vey 1962, no. 14.

This is a study from a model posed in the studio for a figure pulling Christ along in the center of the composition. In the *modello* [cat. 4] this man is bald and his face is almost a caricature of evil. In the painting the figure has hair on his head and his expression is one of strenuous physical effort. This suggests that this drawing was made after the *modello* and was then used for the painting, a practice which Van Dyck adopted from Rubens. The main study shows a man bending, his left arm resting on his thigh and his right arm extended. In the painting the right hand is clutching Christ's robe at the back of his neck: in the drawing this hand holds a rope which was presumably attached to a fixing in the studio that enabled the model to maintain this pose. On the right of the sheet there is a light study of the left hand and on the left are three further studies of the right hand in slightly differing positions.

Parker[1] suggested that Watteau made use of this drawing for his own drawing of the satyr for his *Nymph and Satyr* (or *Jupiter and Antiope*) [fig. 1] in the Louvre.[2] Watteau was undoubtedly interested in the work of Van Dyck and may well have been influenced by his *Jupiter and Antiope* [fig. 2] in his own composition, but similarity with the drawing is not so close that a direct dependence can be assumed.

1. K.T. Parker, *The Drawings of Antoine Watteau* (London, 1931), 43.
2. M. M. Grasselli and P. Rosenberg, *Watteau 1684–1721* [exh. cat. National Gallery of Art, Washington; Galeries Nationales du Grand Palais, Paris; Schloss Charlottenburg, Berlin, 1984–1985], no. 36 (Watteau's preparatory drawings for the figure of the satyr are figs. 7 and 8).

Fig. 1. Antoine Watteau, *Study of a Kneeling Man*. Red and black chalk with white chalk highlights, 244 x 298 mm. Musée du Louvre, Paris, Département des Arts graphiques

Fig. 2. Anthony van Dyck, *Jupiter and Antiope*. Canvas, 151 x 206 cm. Museum voor Schone Kunsten, Ghent

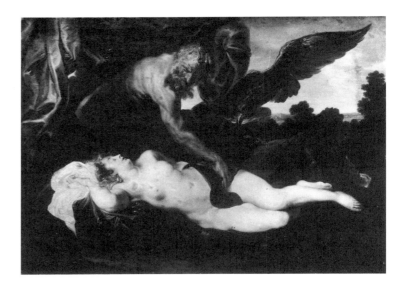

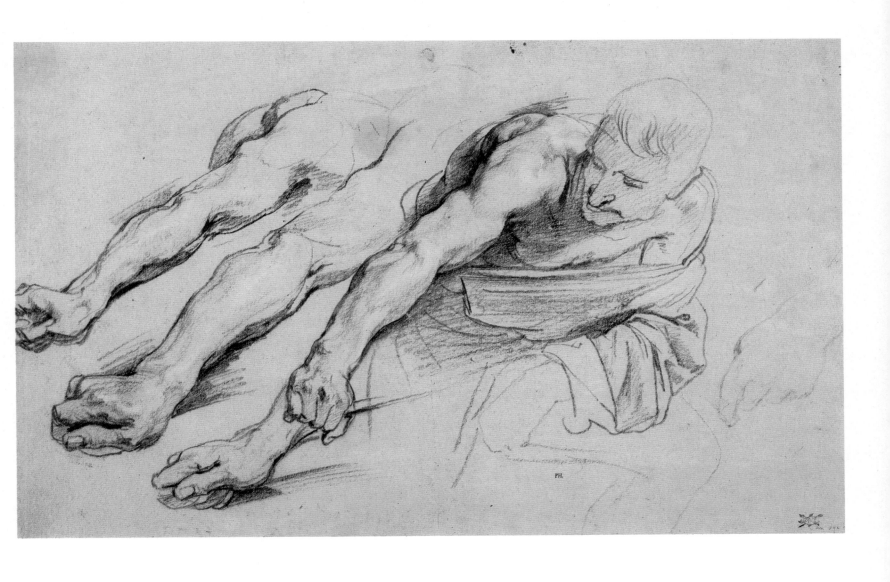

59

6
The Entombment

c. 1617–1618

Pen and brown ink and dark brown wash, 254 x 218 mm. There are traces of black chalk beneath Christ's winding-sheet. There is white bodycolor in the face of the figure supporting the Virgin, the headdress of the Virgin, the chest of the Virgin, in the lower half of the body of the man on the left supporting Christ's feet, and in the area of shadow beneath the body of Christ. There is also a stroke of white bodycolor running from just above the Virgin's right hand to Christ's winding-cloth. The figure of the man who stands in the center supporting the body of Christ is touched with red chalk, as is the face of Saint John who supports the Virgin. The headdress of the Virgin is touched with green chalk, as is part of her sleeve. There are two vertical and six horizontal folds in the sheet. There is a border in brown wash on the top and right sides and partially on the bottom edge. This suggests that the sheet has been slightly trimmed along the bottom edge. Lower right-hand corner: L.959.

Verso: Study in pen and brown ink, brown wash, and black chalk of a figure of an elderly bearded man kneeling, presumably to lift the body of Christ. Above him, in pen, a study for the group of the Virgin, Saint John, and a third figure. This group is cut off at the top and right edges, which suggests that the sheet has been trimmed. On the left-hand side are traces of a very light drawing in black chalk; a standing figure and a head, turned to the left, can be made out. Inscription, in pen, at bottom edge: *No 29.*

Watermark: none

J. P. Getty Museum, Malibu (inv. no. 85. GG. 97)

Vey 4

PROVENANCE N. A. Flinck (1646–1723), Rotterdam (L.959, lower right corner); purchased by William, 2d duke of Devonshire, and by descent to the present duke (Chatsworth inv. no. 856); Christie's, London, 3 July 1984, lot 57; art market, New York; purchased by the Getty Museum in 1985.

A small group of drawings record that Van Dyck was working on the subject of the Entombment, probably in the years 1617–1618. Two sheets, this one and a second in Haarlem [cat. 7], contain drawings on both sides by Van Dyck. A third drawing, which shows the same composition on both sides [figs. 1, 2], is thought by Vey to record a lost drawing by Van Dyck: it certainly shows a related composition and is too weak to be by the artist himself. No painting of this subject by Van Dyck from this period of his career is known, but in view of his usual working practice at this time, it is likely that a painting was planned and abandoned or that it was painted and has subsequently been lost.

The Malibu and Haarlem drawings have interesting physical similarities. Both have touches of colored chalk in faces and figures. It is possible that these were added later, but in view of the similarity of treatment and the different provenances of the two drawings, it is equally possible that they are by Van Dyck himself. Secondly, both drawings have been folded into squares. Again, the similarity of this procedure and the different provenances of the drawings suggest that this was done at an early date, possibly in Van Dyck's studio. Folding may have been used to square up the paper for transfer to the painting, rather than the usual squaring with black chalk, as in cat. 4.

It is difficult to establish the priority of the Malibu or Haarlem drawing. The verso of the Malibu drawing has been cut, which makes it likely that Van Dyck began on the verso and then made the pen drawing on the recto, added the wash, drew a border, and cut the sheet around it. The recto of the Malibu drawing is certainly the most "finished" of all four, and seems to have been squared up by folding. The tomb, however, is missing, unless it is meant to be suggested by the vertical strokes of wash beneath Christ's body, and Christ's body itself is posed rather clumsily. It may possibly have been dissatisfaction with these aspects of the composition that caused Van Dyck to begin a new sheet. He may have begun on the verso of the Haarlem sheet, with the group of the Virgin now moved to the left and a man holding the body of Christ. After making a number of other, smaller sketches on this side of the paper, he then turned it over and drew the new composition, with the tomb shown prominently on the right, the Virgin in the center, and a man on the left, who may be Nicodemus, bracing himself to support the weight of Christ's body by advancing his right leg. Van Dyck has begun to indicate the decoration of the robe of the figure on the far left, which may suggest that he felt that he had completed the main features of the composition and was thinking about the detail.

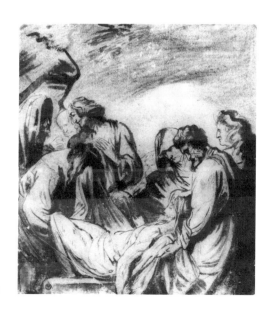

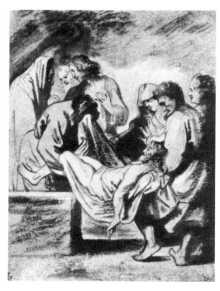

Fig. 1. After Anthony van Dyck (?), *The Entombment.* Point of brush, with gray wash, with some red and in places gone over in pen, 192 x 162 mm. Ecole nationale supérieure des Beaux-Arts, Paris (Vey 5r)

Fig. 2. After Anthony van Dyck (?), *The Entombment.* Point of brush, with gray wash, with some red and in places gone over in pen, 192 x 162 mm. Ecole nationale supérieure des Beaux-Arts, Paris (Vey 5v)

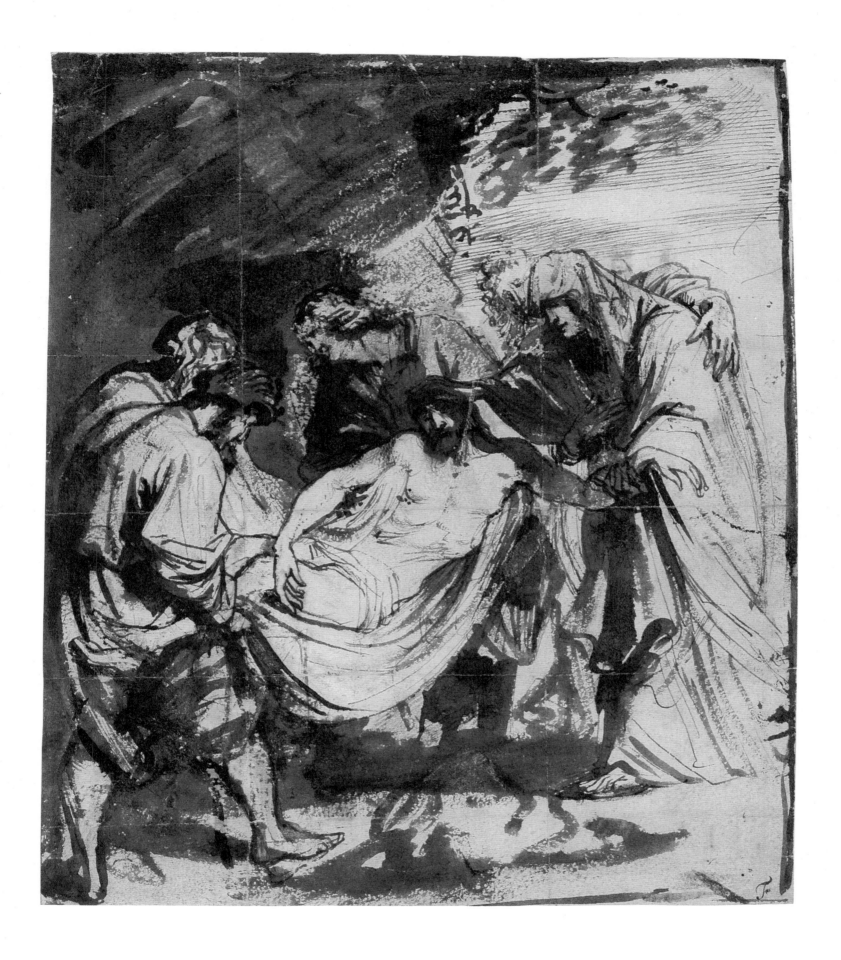

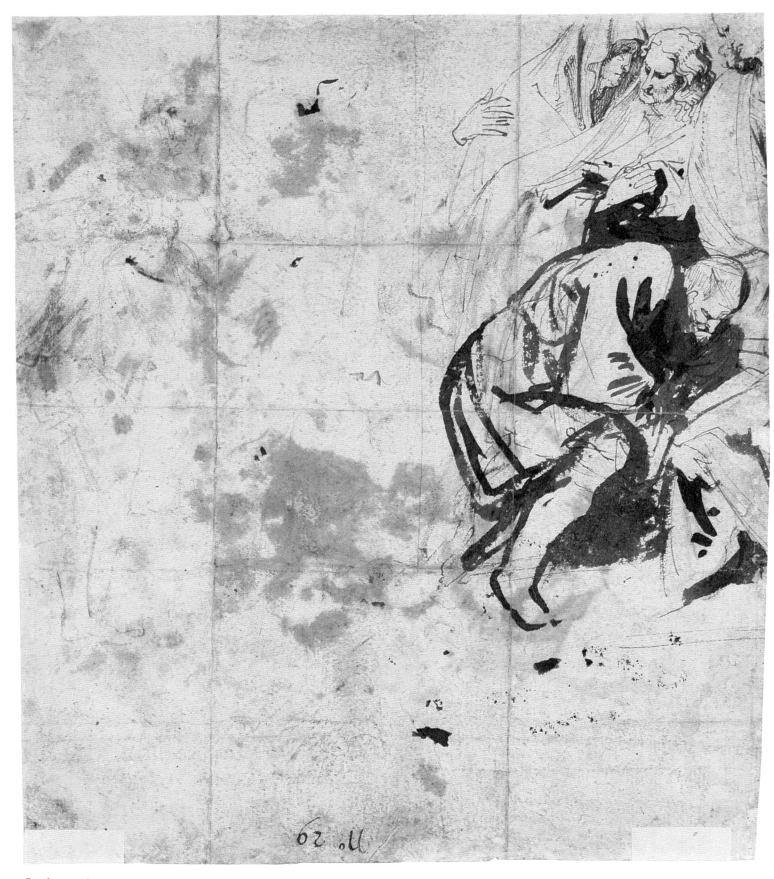

Cat. 6 verso

EXHIBITIONS London 1938, no. 585; Rotterdam
1948–1949, no. 88; Brussels 1949, no. 110; Paris
1949, no. 117; London 1953, no. 290; London
1953–1954, no. 488; Nottingham 1960, no. 38;
Washington 1962–1963, no. 78; London 1969,
no. 78; Tokyo 1975, no. 74; Jerusalem 1977,
no. 30; Princeton 1979, no. 6; Ottawa 1980, no. 19.

LITERATURE Vasari Society (1st series), VI,
no. 19; Leporini 1928, 242, pl. 118; Vey 1958,
36–38; Van Gelder 1961, 5, 7; Vey 1962, no. 4;
Goldner 1988, no. 86.

1. Ottawa 1980, 65, under no. 19. He also related
the Malibu and Haarlem drawings to an oil sketch
in a private collection, which was included in the
Ottawa exhibition (no. 20). This panel is in poor
condition and its status problematic.
2. Ottawa 1980, 64, no. 19.
3. This painting is no. 129 in Jaffé 1989. He dates it
about 1610. The painting is damaged but the
attribution seems correct.

He also applied wash to this drawing, drew a border, cut the sheet around it and, possibly, folded it for squaring.

The third drawing [figs. 1, 2], which is in the Ecole des Beaux-Arts in Paris, shows the composition of the Haarlem drawing (but not the body of Christ) reversed, with the tomb on the left and a bearded Nicodemus on the right. The status of this drawing is problematic. Although Vey considered it to be a copy of a lost drawing by Van Dyck, and it is certainly Van Dyckian in style, McNairn pointed out (and I agree) that it does not fit particularly well with the Malibu and Haarlem drawings and may well be an imitation by an artist familiar with Van Dyck's work.[1] (The cloth grasped in the mouth of the man holding Christ's feet is a distinctly Rubensian element: it can be seen, for example, in the central panel of the *Deposition* triptych in Antwerp Cathedral.)

McNairn discussed the possibility that the germ for this composition was a copy Van Dyck made after Titian's *Entombment* [fig. 3].[2] This drawing [fig. 4], now in the British Museum, made with red, black, and white chalks and brown and yellow-green washes, was, he considered, not made after Titian's original but after a copy made of it by Rubens [fig. 5].[3] There are certainly significant similarities between Van Dyck's drawings and Titian's composition, for example, the group of the Virgin, Saint John, and a third figure on the verso of the Malibu sheet, and the figure of the bearded man in the bottom right-hand corner of the verso of the Haarlem sheet. Although Van Dyck may well have been aware of Titian's composition, the British Museum drawing cannot be dated with any certainty to this period and, indeed, its attribution to Van Dyck seems to me an open question. Titian's painting was in Mantua when Van Dyck was in Italy and he may have copied it there. Later, he would have known it in England, for it was among the paintings Charles I bought with the Mantua collection in 1627–1628.

Fig. 3. Titian, *The Entombment*. Canvas, 148 x 212 cm. Musée du Louvre, Paris

Fig. 4. Anthony van Dyck, *The Entombment* (after Titian). Black and red chalk, gone over in pen with brown ink, with some white chalk highlights, with brown and yellow-green wash, 271 x 338 mm. The British Museum, London (Vey 146)

Fig. 5. Attributed to Rubens, *The Entombment* (after Titian). Panel, 73.5 x 104 cm. Collection of Sir Jan Rankin, Bt., London

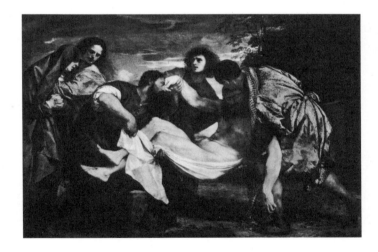

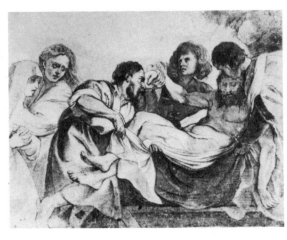

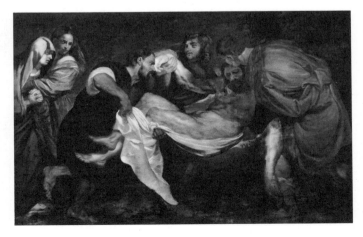

7
The Entombment

c. 1617–1618

Black chalk, pen and brown ink and brown wash, with blue and red chalk, 220 x 186 mm. The Virgin's robe is touched with blue chalk, and there are touches of red chalk in the robe of the man who holds Christ's feet.[1] There are two vertical and four horizontal folds.

Verso: Four studies, in pen and wash, for *The Entombment*. The principal one, in the center of the sheet, shows the body of Christ supported by a man (Saint John?), while the Virgin reaches over him and holds his right arm. In the bottom right-hand corner is a study for the man supporting Christ's feet on the recto (though he is shown bearded here and clean shaven on the recto). At the lower left, at 90 degrees, is a brush study for a standing figure facing left, and on the right edge, at the center, is part of the figure of a standing man, possibly a study for one or other of the two men on the left side of the recto.

Watermark: none

Teylers Museum, Haarlem (inv. no. 1597, 0*15)

Vey 6

PROVENANCE Oudenaarden/Van Noorde sale, The Hague, 1–2 November 1796, A 8: "Een Graflegging, zeer konstig met de Pen en een weinig gecouleurd, door A. van Dyk" (f252 Hendricks)[2]; Teylers Museum, Haarlem (L.2392, verso, top right corner).

EXHIBITIONS Antwerp 1949, no. 83; Antwerp 1960, no. 5; London 1970, no. 20.

LITERATURE Rooses 1903, no. 138 (as "nach-italienisch"); Scholten 1904, 96, no. 15; Buisman 1924A, no. 10, ill. (recto); Buisman 1924B, no. 10, ill.; Delen 1943A, no. 3, ill. (recto); Delen 1949, no. 26 (recto); Vey 1958, 36ff.; Vey 1962, no. 6; Ottawa 1980, 64, 67 (discussed under nos. 19 and 20).

COPY There is a copy of the verso in the British Museum (Hind 1923, no. 9).

1. In London 1970 Van Regteren Altena and Ward-Jackson stated that the pen lines go over the colored areas which must therefore be original. Although I too consider these areas to be original, I find it difficult to be sure that the pen lines go over them.
2. In the sale of Jhr. J. Goll van Fr., 1 July 1833, no. P2 was a "Graflegging van Van Dyck" (6 guilders to Engelberts).
3. In London 1970.

The composition was first outlined in black chalk and then gone over in pen and wash. As in cat. 6, there are areas of color made with blue and red chalks. Vey thought these were added later, but, as is suggested in the previous catalogue entry, they may be by Van Dyck himself. Van Dyck cut the drawing on all four sides when he had completed the drawing on the recto. Like cat. 6 this sheet has been folded into squares, which may have been done by Van Dyck with a view to transferring the design onto a panel or canvas.

The evolution of this composition and its close relationship with the sheet in Malibu is discussed in the previous catalogue entry. Vey dated this sheet (and cat. 6) to Van Dyck's earliest years in Antwerp and stressed the influence of Rubens, not long back from Italy, and the early Jordaens as well as the Venetian influence of Bassano and Palma Vecchio. Van Regteren Altena and Ward-Jackson suggested that the germ for the Haarlem drawing was a sketch after Rubens in the Antwerp sketchbook [fig. 1], although Van Dyck "transformed the idea and handled it in a new way."[3] I agree with Vey that this is an early project and should be dated about 1617–1618, when Rubens' influence on the young Van Dyck was paramount. There is, however, no obvious Rubens prototype, and the composition should be considered a reworking of Titian's *Entombment*—see the discussion in the previous catalogue entry—under the powerful influence of Rubens.

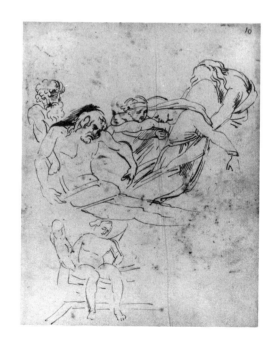

Fig. 1. Anthony van Dyck, Antwerp Sketchbook, fol. 10r. Devonshire Collection, Chatsworth

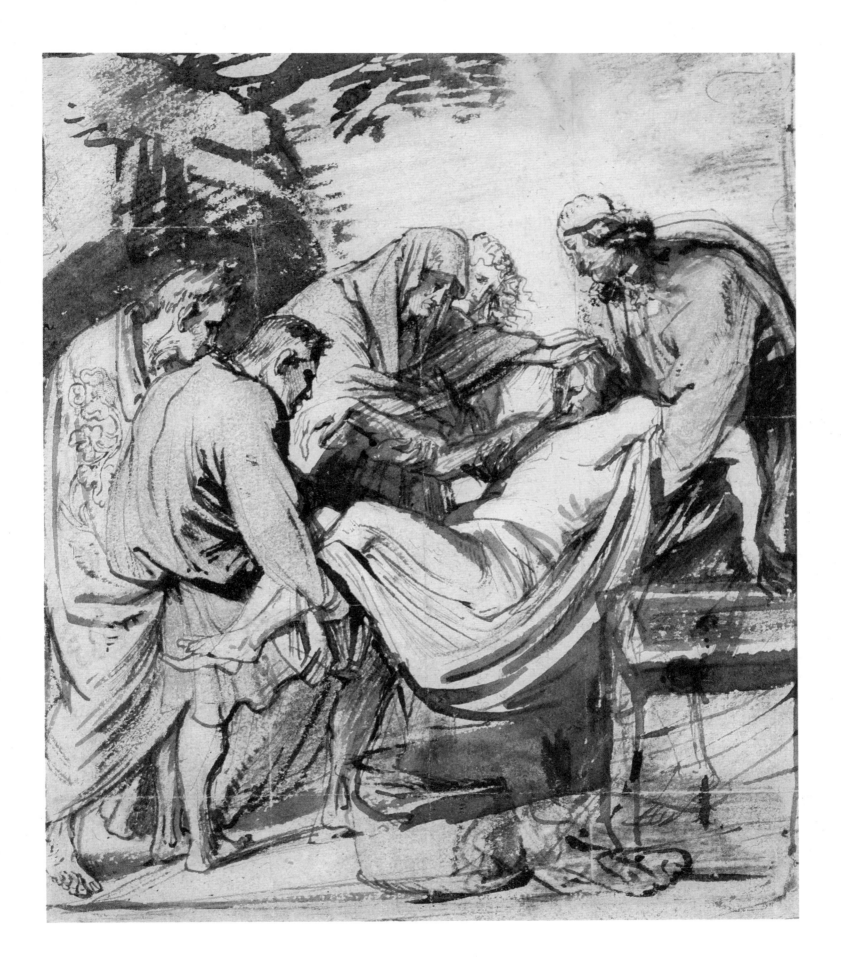

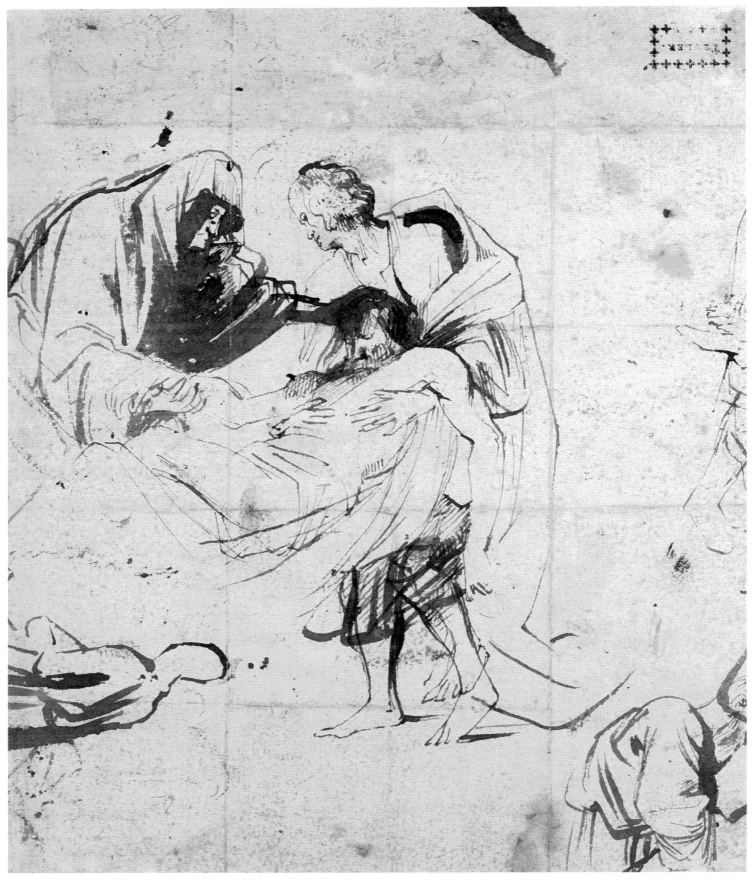

Cat. 7 verso

An Old Bearded Man Holding a Bundle beneath His Arm

c. 1618

Black, red, and white chalk, 380 x 220 mm.[1]

Verso: Drawings in pen of unidentified scenes. There are four principal drawings or groups of drawings. On the right, a group of men are standing gazing intently to the right; one raises his arms in astonishment or exaltation. The figure farthest to the left raises his left hand in front of his face as if in thought. (This figure seems to be reworked to the left of center towards the top of the sheet. Here his hand is lower and he is seen to be an elderly bearded man.) The two figures furthest to the right are bent over a tomb, chest or bed. The figures could be apostles and the subject Pentecost, the Death of the Virgin, or the Assumption of the Virgin. In the center of the sheet, partially obscured by some watercolor lines, is a figure of an old bearded man, apparently wearing a toga, sitting with his left foot on a step above his right. There is a second, standing figure to his right. They would appear to be apostles, perhaps Saint Peter and Saint Paul. Finally, on the far left, a bearded man, possibly in Roman armor, stretches both hands forward. His action is watched closely by a number of other men standing beside him. There are a number of other heads above this scene and an architectural decoration at the top edge of the sheet.

Watermark: none

Private collection, U.S.A.

Vey 35
Exhibited in Fort Worth

PROVENANCE Collection of Lt.-Col. J. C. Dundas, Fochtertyre, Stirling; his sale, Sotheby's, London, 6 March 1946, lot 134; collection of Dr. and Mrs. Francis Springell, Portinscale, Cumberland; their sale, Sotheby's, London, 30 June 1986, lot 58; with William Acquavella, New York, 1990.

EXHIBITIONS London 1953, no. 275; London 1953–1954, no. 483; London 1959, no. 37; Antwerp 1960, no. 17; Edinburgh 1965, no. 32.

LITERATURE Vey 1962, no. 35.

1. Vey states that the ear, neck, and shoulder have been retouched in red chalk by a later hand and that the head is abraded. In my view, the drawing is entirely by Van Dyck—it is an outstanding example of his working in Rubens' trois crayons manner—and the condition is very good, except for a few small marks caused by staining. A closely comparable drawing—a study from a studio model using black, white, and red chalks—is the Kneeling Man Seen from Behind (Vey 75) in Rotterdam. It is a study for The Crowning with Thorns and is also entirely from Van Dyck's own hand.

This is a study for the paralytic in The Healing of the Paralytic. It shows a model posed in the studio and was presumably made after Van Dyck had established the composition in a now lost compositional drawing or modello. There are two painted versions of this composition, one in the Royal Collection in London [fig. 1][2] and the second in the Bayerische Staatsgemäldesammlungen, presently at Schleissheim [fig. 2].[3] The differences between the two are relatively minor, but the painting in London has generally been taken to be the prime version and that at Schleissheim a replica from Van Dyck's studio. In the Schleissheim version the paralytic is bearded, as he is in the drawing, but in the London painting he is clean shaven. In both paintings he appears younger than here, and the bundle he carries is a blanket. The paintings show Van Dyck at his most Rubensian, giving the figures a solidity and three-dimensionality which is not present in, for example, the Samson and Delilah [see cat. 9, fig. 1], which was painted perhaps a year later. There is, however, no direct Rubens prototype, and Van Dyck used the basic compositional scheme of Titian's Tribute Money (Genoa, Palazzo Bianco). At this point in his career Van Dyck was assisting Rubens with the Decius Mus series, and the apostle on the right is based on the figure of a centurion on the right-hand side of the second scene in the Decius Mus series, The Interpretation of the Sacrifice [fig. 3]. The strong similarities with the Decius Mus series, not just in this particular detail but in overall style, enables us to date the painting to about 1618. That Van Dyck was under the powerful influence of Rubens at this moment is the key to the study of the verso of this sheet.

None of the scenes on the verso, which are biblical and historical, can be identified with certainty, but all are very Rubensian and can be related to paintings Rubens was working on at about this time. The group on the right has strong echoes of both The Assumption of the Virgin in Düsseldorf and Pentecost in Munich, while the sketch on the far left recalls the first two scenes of the Decius Mus series. They are not literal copies, and whether Van Dyck was working from drawings by Rubens or

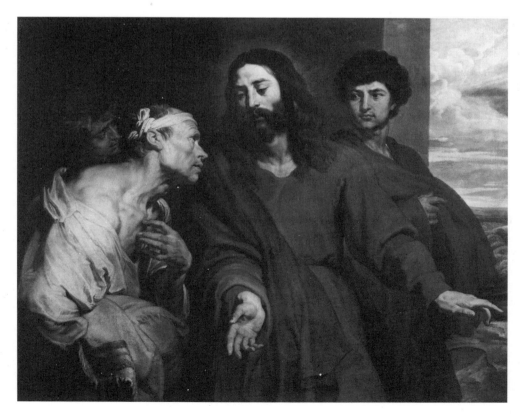

Fig. 1. Anthony van Dyck, The Healing of the Paralytic. Canvas, 121 x 149 cm. Collection of Her Majesty Queen Elizabeth II

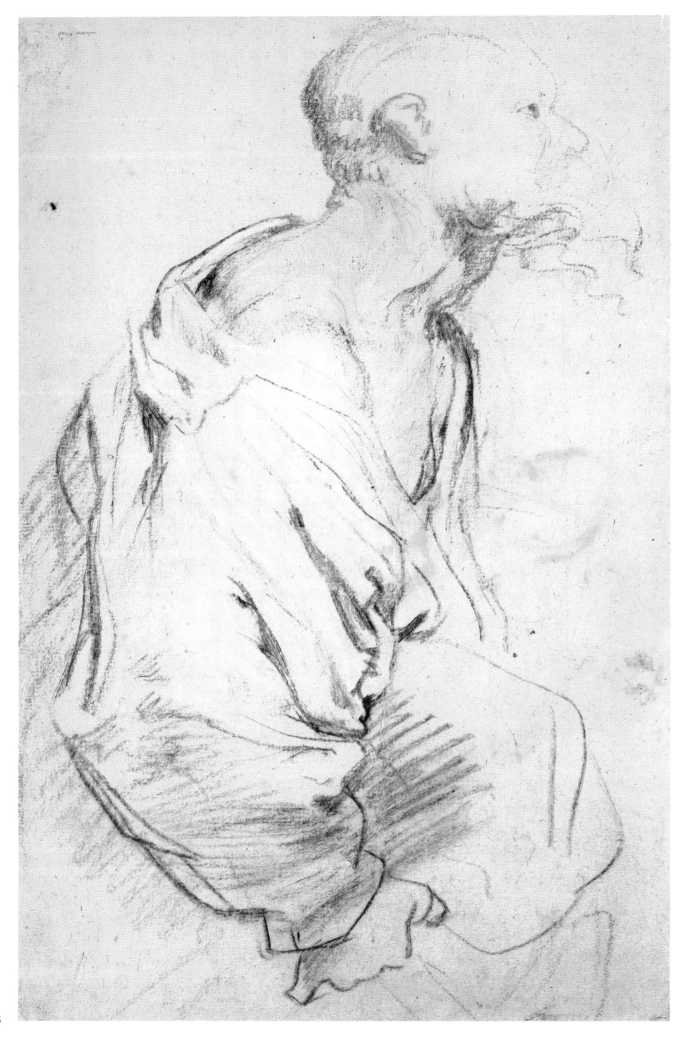

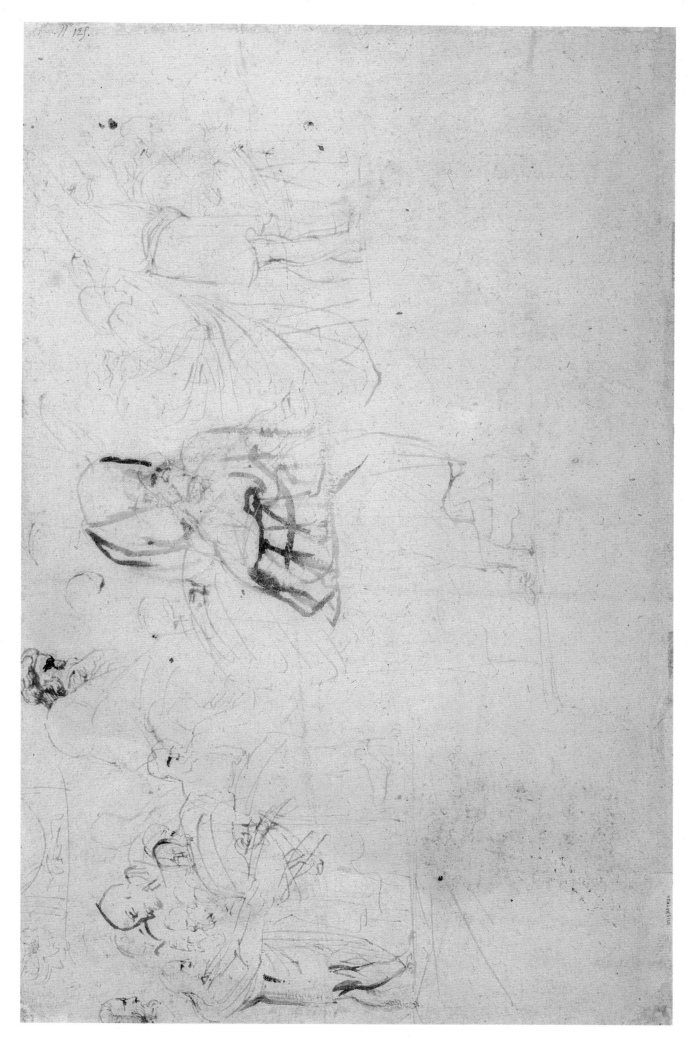

2. Millar 1963, no. 174, pl. 86. It is interesting to note that when first recorded (Martin Robyns sale, Brussels, 22 May 1758, lot 1) it was attributed to Rubens, but it was already catalogued as Van Dyck at its next appearance (Chevalier de Verhulst sale, Brussels, 16 August 1779, lot 77). Millar notes copies at Schleissheim (in my view, by Van Dyck and his studio), the Musée du Chanoine Puissant, Mons, and in the Mme Laurens collection, Sable-sur-Sarthe. A grisaille copy attributed to Van Diepenbeeck was with Leonard Koetser, London, in 1975.
3. Inv. no. 559.
4. Elizabeth McGrath has pointed out that this figure is based on an antique sculpture (now thought to be a Roman copy after a Hellenistic original) known as *The African Fisherman* (Louvre, Paris; see F. Haskell and N. Penny, *Taste and the Antique*, London, 1981, 303–305, no. 76). In the seventeenth century the figure was thought to be the Dying Seneca and was drawn in Rome by Rubens. (The drawing is in the Biblioteca Ambrosiana, Milan; see Held 1982, 96 and fig. VIII.6.)

whether, as is more likely, these are free variations on compositions by Rubens is unclear. What is clear, however, is Van Dyck's strong absorption of Rubens' ideas at this moment in his career. The use of *trois crayons* is itself a further example of Rubens' profound influence on the young Van Dyck: it is a technique particularly associated with Rubens, although his most frequent use of it was in the 1630s.

Vey has noted three compositional drawings by Van Dyck for *The Healing of the Paralytic* [figs. 4–6], but none accords closely with the paintings, and we must imagine that the compositional drawing for the final design has been lost. Of those that do survive, the closest to the final composition is a drawing in Rotterdam [fig. 4] which shows Christ in the center, three-quarter length, turning to his left towards a paralytic who, bending down, looks up at him. In the second drawing [fig. 5], Christ is shown in profile, looking towards the left: the paralytic is quite differently posed, straining beneath a heavy bundle carried on his shoulders. Finally, there is a drawing [fig. 6] showing a crowded group of full-length figures in the center of which stands Christ, turning to his left towards a paralytic who has placed his bundle on the ground and, resting his right hand on it to support himself, looks up at him.[4] The setting, on shallow steps above an arch, is taken from Rubens' *Visitation* on the left wing of the *Descent from the Cross* triptych.

Fig. 2. Anthony van Dyck (and studio), *The Healing of the Paralytic*. Canvas, 130 x 159 cm. Bayerische Staatsgemäldesammlungen, Schleissheim

Fig. 3. Peter Paul Rubens, *The Interpretation of the Sacrifice* (from the Decius Mus series). Canvas, 293.5 x 413.5 cm. Collection of the Prince of Liechtenstein, Vaduz

Fig. 4. Anthony van Dyck, *The Healing of the Paralytic*. Pen and brown ink and point of brush, with brown wash, 120 x 162 mm. Museum Boymans-van Beuningen, Rotterdam (Vey 33)

Fig. 5. Anthony van Dyck, *The Healing of the Paralytic*. Pen and gray ink, with gray wash, 117 x 174 mm. Fondation Custodia (Coll. F. Lugt), Institut Néerlandais, Paris (Vey 34)

Fig. 6. Anthony van Dyck, *The Healing of the Paralytic*. Pen and brown ink, with brown wash, over black chalk, 183 x 289 mm. Graphische Sammlung Albertina, Vienna (Vey 36)

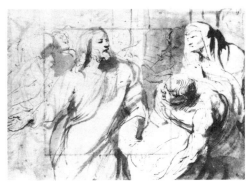

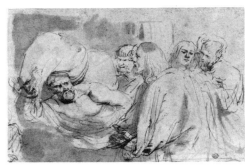

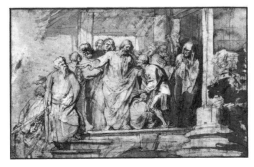

9
Samson and Delilah

c. 1618–1619

Pen and brown ink and brown wash,[1] on toned brown paper, 152 x 228 mm. There are horizontal lines in black chalk in the bottom quarter of the sheet. Squared in black chalk. There is a border around the drawing in pen. The drawing has deteriorated in the shadowed area of the face and chest of the man cutting Samson's hair. There are white spots in Delilah's right elbow and in the skirt of the man cutting Samson's hair. (These may be the original color of the paper.) Beneath the elbow of the man cutting Samson's hair is an eye and a nose (at right angles to the composition). In the lower right-hand corner there is an old inscription, in pen: *Ant Vandijk.*

Watermark: not visible (laid down)

Staatliche Museen Preussischer Kulturbesitz, Berlin, Kupferstichkabinett (KdZ 5396)

Vey 3

PROVENANCE Collection of J. D. Lempereur (1701–1779), Paris (L.1740, far right corner) (the catalogue of his sale, which took place in Paris between 24 May and 28 June 1773 does not identify this drawing, but lots 307 and 308 were pen studies by Van Dyck); collection of Mundler (19th century); A. von Beckerath (Berlin, 1834–1915).

EXHIBITIONS Antwerp 1960, no. 4; Brussels 1965, no. 315; Princeton 1979, no. 9; Ottawa 1980, no. 15.

LITERATURE Lippmann 1910, II, no. 252; Bock and Rosenberg, 124, no. 5396; Lugt 1931, 44; Glück 1931, pl. 13; Delacre 1934, 196; Vey 1958, 43ff.; Vey 1962, no. 3.

1. The shadows appear to be created with wash but could have been made with close pen lines.

This is the *modello*, the final, squared-up drawing, for the painting which is in the Dulwich Picture Gallery [fig. 1]. The starting point for Van Dyck's treatment of this subject was Rubens' great painting which was made shortly after his return from Italy in 1608 for Nicholas Rockox, burgomaster of Antwerp, and which today is in the National Gallery, London [fig. 2].

A drawing by Van Dyck, which was formerly in Bremen [fig. 3], is based on that painting but already rearranges the figures of Delilah, who is placed in the center of the composition facing the spectator, and the man cutting Samson's hair, who kneels on the left in a pose reminiscent of the man supporting Christ's feet in *The Entombment* on the verso of cat. 6. As in Rubens' painting, the old woman is on the left and the door crowded with waiting Philistines is on the far right. In the present drawing Van Dyck reversed the composition, moving Delilah to the right, which made it resemble the engraving by Jacob Matham after Rubens' painting of about 1613.

When Van Dyck transferred the drawing onto the canvas, he made a number of important changes. He added a fifth figure, an old woman who is a procuress, a type familiar from earlier northern representations of this subject and used by Rubens; he moved Delilah's hand to the left away from her mouth; he covered the corner of the bed, with its superb lion's-paw foot, with a rich brocade; he placed a decorated urn prominently against the area of sky above Samson's head; and he introduced a column and, to the left of it, a group of soldiers in place of the balustrade seen in the foreground on the left of the drawing. This is a striking example of the way in which Van Dyck reworked his compositions on the canvas, even after having prepared them carefully in a series of drawings.

Van Dyck, as can be seen very clearly in this drawing, indicated shading not just with pen lines drawn close together but with small dots. This is obvious in the face and upper body of the man cutting Samson's hair and in the right side of Delilah's face. This is a technique rarely used by Rubens. Van Dyck presumably added the border in brown ink himself as a way of delimiting the composition with the finished painting in mind, as, for example, in cats. 6 and 7.

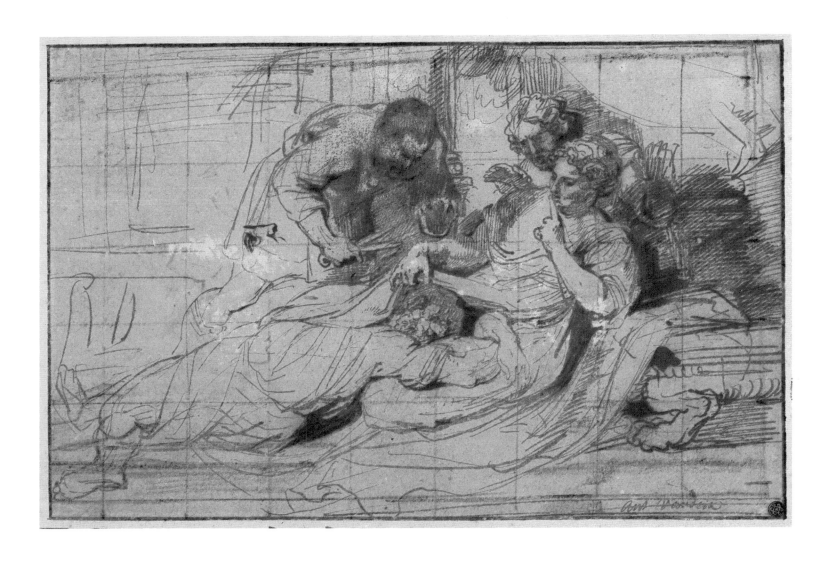

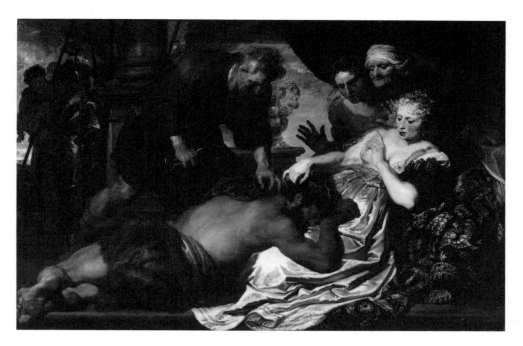

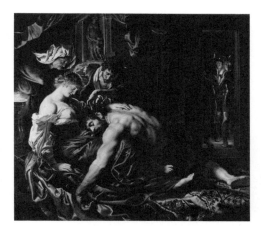

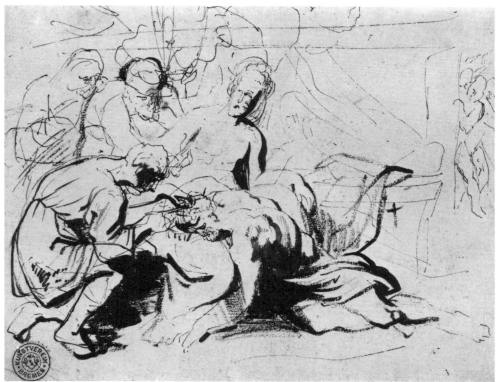

Fig. 1. Anthony van Dyck, *Samson and Delilah*.
Canvas, 149 x 229.5 cm. Dulwich Picture Gallery,
London

Fig. 2. Peter Paul Rubens, *Samson and Delilah*.
Panel, 185 x 205 cm. National Gallery, London

Fig. 3. Anthony van Dyck, *Samson and Delilah*.
Pen and point of brush, with brown wash,
158 x 203 mm. Formerly Kunsthalle, Bremen
(Vey 2)

73

A Seated Man Leaning Backwards

c. 1618–1621

Black chalk, with white chalk highlights across the shoulders, 235 x 274 mm. Elsewhere, especially in the top left-hand corner, white chalk is used to white out black chalk lines.

Verso, top left, inscribed in pen: *64*; lower left, in graphite: *vDyck* and *207*.

Watermark: none

Museum Boymans-van Beuningen, Rotterdam (inv. no. Van Dyck 11)

Vey 16

PROVENANCE Gerard Leembruggen (1801–1865), Hillegom; his sale, Amsterdam, 5 March 1866, lot 207; Museum Boymans, Rotterdam (L.1857, lower right).

EXHIBITIONS Antwerp 1949, no. 88; Paris 1952, no. 71; Antwerp 1960, no. 13; Prague 1969, no. 16; Princeton 1979, no. 16.

LITERATURE Boymans 1869, no. 127; Boymans 1927, no. 552; Burchard 1932, 10; Glück, notes to plates 24–26; Delacre 1934, 144, 148, pl. 80; Van Puyvelde 1940, 38–41, ill.; Vey 1956A, 48–49, pl. 12; Vey 1958, 61ff.; Vey 1962, no. 16; Müller Hofstede 1973, 154; Ottawa 1980, 13, pl. 10.

Fig. 1. Anthony van Dyck, *Saint Martin Dividing His Cloak*. Panel, 170 x 160 cm. Church of Saint Martin, Zaventem

Fig. 2. Anthony van Dyck, *Saint Martin Dividing His Cloak*. Canvas, 284.5 x 238.5 cm. Collection of Her Majesty Queen Elizabeth II

This is a study made from a model posed in the studio for the figure of the beggar receiving half of the cloak in *Saint Martin Dividing His Cloak*. There are two paintings by Van Dyck of this composition. One is an altarpiece painted on oak for the parish church of Saint Martin at Zaventem [fig. 1], near Brussels, where it still hangs, and the second is a larger painting, on canvas, in the Royal Collection in London [fig. 2]. The exact circumstances and date of the Zaventem commission are unknown, although it has been suggested that it was commissioned for the church by Ferdinand van Boisschot, lord of Zaventem, whose portrait Van Dyck also painted. It certainly belongs to Van Dyck's first Antwerp period and should probably be dated about 1618–1621. It is possible that the second version, on canvas, was painted by Van Dyck for Rubens. There was a Saint Martin by Van Dyck in the inventory of Rubens' collection,[1] and he also owned variants of two other early works *The Taking of Christ* [p. 128, fig. 2] and *The Crowning with Thorns* [p. 118, fig. 2], which are both today in the Prado, Madrid.[2]

As noted by Vey, there is an oil sketch by Rubens [fig. 3] which is the starting point for Van Dyck's composition.[3] The format is horizontal with Saint Martin on the left-hand side of the composition while his two companions on horseback occupy the right-hand side. Held has noted that "except for the reversal of the design and the elimination of the youthful horseman at the right, Van Dyck's painting follows the basic plan of Rubens' sketch. In view of these similarities, it seems to me likely that the donor(s) of the Zaventem picture had first approached Rubens, who responded by making the present sketch."[4] Held dates the Rubens sketch to about 1612–1613 and notes that delays of several years were not uncommon in such commissions. The original circumstances of the commission must remain hypothetical unless any documents come to light, but, although it is true that Van Dyck must have begun by working from Rubens' sketch, the

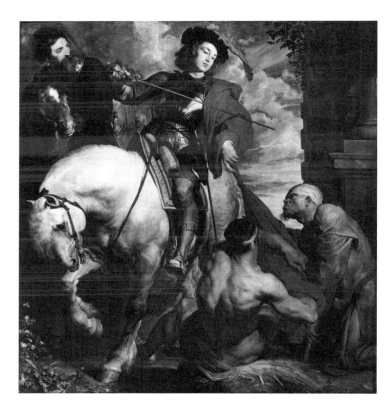

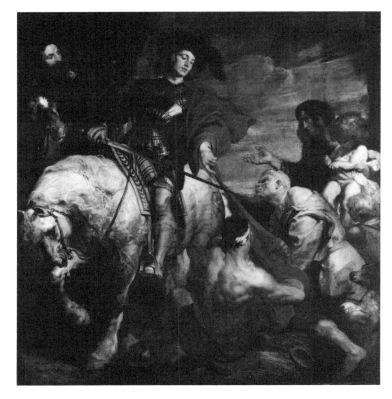

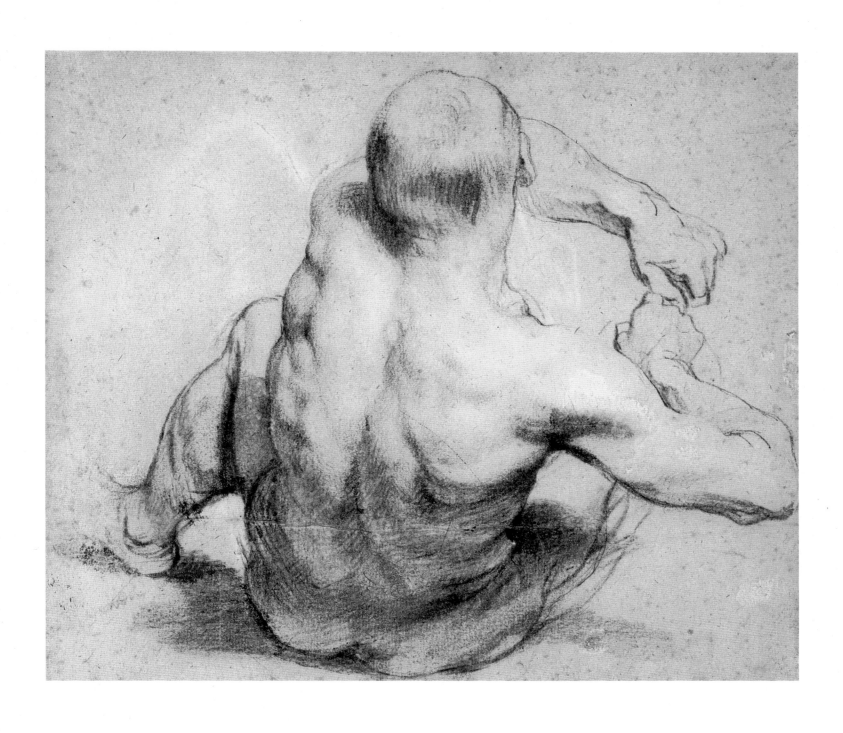

1. Muller 1989, Catalogue I, 135, no. 234.
2. Ibid., 134–135, nos. 232 and 235.
3. Vlieghe 1972–1973, no. 172; Held 1980, no. 418. This sketch was sold at Sotheby's, London, 2 July 1986, lot 139. Oliver Millar (Millar 1963, 104) and Ann-Marie Logan do not consider the sketch to be by Rubens. I agree with Held and Jaffé (1989, no. 168) that it is an autograph work.
4. Held 1980, 575.
5. Adriani 1940, fol. 24v, 25, 25v, 26, 41v, 42, 54v, and 55.
6. In Princeton 1979, 75.

composition was developed and refined through a number of studies. It has been pointed out that the figure of Saint Martin is very close to that of one of Pharaoh's horsemen in Domenico delle Grecche's woodcut after Titian's *Crossing of the Red Sea*, of which Van Dyck made a number of drawings in his Italian sketchbook [fig. 4].[5] No compositional drawings for the *Saint Martin* are known: Vey considered that the existence of Rubens' sketch made the lack of drawings easier to understand and suggested that fewer might have been made than for other early projects. However, as Martin and Feigenbaum noted,[6] the fact that the composition is substantially different as well as what we know of Van Dyck's working practice at this period makes it more likely that he did make such drawings (in pen and wash) which have subsequently been lost. What does survive from this project are three drawings in black chalk: the present drawing for the beggar whom Saint Martin clothes, a second, at Chatsworth, for the kneeling beggar on the right, which is cat. 11 here; and a third, also at Chatsworth, for the horse's head [fig. 5].

Van Dyck's model for this drawing must have supported himself with a rope or a sling attached to the ceiling or wall of the studio. The beggar is similarly posed in Rubens' oil sketch but the pose is reversed and the beggar moved to a more prominent position in the composition. The drawing is very similar to the black chalk drawings made from studio models by Rubens himself, and it must have been in Rubens' studio that Van Dyck learned the technique and gained the assurance necessary to make such a study with absolute fluency and lack of hesitation.

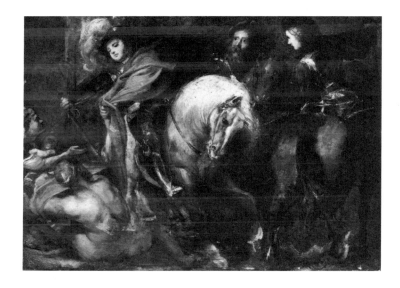

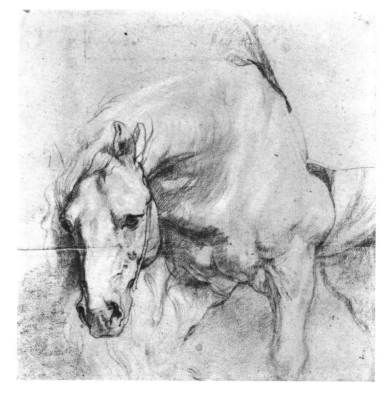

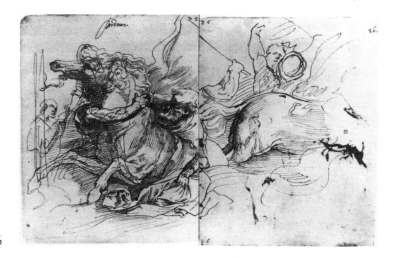

Fig. 3. Peter Paul Rubens, *Saint Martin Dividing His Cloak*. Panel, 36 x 48.5 cm. Present whereabouts unknown (sold at Sotheby's, London, 2 July 1986, lot 139)

Fig. 4. Anthony van Dyck, Italian Sketchbook, fol. 25v/26. The British Museum, London

Fig. 5. Anthony van Dyck, *Head and Front Quarters of a Horse*. Black chalk, with white chalk highlights, 341 x 319 mm. Devonshire Collection, Chatsworth (Vey 18)

11
A Kneeling Man

c. 1618–1621

Black chalk, with some highlights in white chalk, 342 x 285 mm. (On the right-hand side, a rectangular strip has been cut or torn off and the lower right-hand section, which contains the man's feet, has been reattached. It has also been torn along the lower right-hand edge.)

Verso: The sheet has been pasted down onto another sheet of paper. There are two drawings on the verso that can be seen through the paper to which the original sheet is attached. They appear to be studies of men in profile (Vey saw two striding men, bent forward); one, a standing man, can be seen if the sheet is turned through 90 degrees.

Watermark: none

Devonshire Collection, Chatsworth (inv. no. 678B)

Vey 17

PROVENANCE Unknown.

EXHIBITIONS London 1927, no. 583 (Memorial Volume, pl. 121); London 1949, no. 30; Antwerp 1960, no. 14; Manchester 1961, no. 72; Brussels 1965, no. 321; Princeton 1979, no. 17.

LITERATURE Glück 1931, 24–26; Delacre 1934, 145, pl. 81; Van Puyvelde 1940, 38–41; Vey 1958, 61ff.; Vey 1962, no. 17.

1. J. Shearman, *Raphael's Cartoons in the Collection of Her Majesty the Queen and the Tapestries for the Sistine Chapel* (London, 1972), 145–147.

Like the previous drawing, this is a study from a model posed in the studio for a figure in *Saint Martin Dividing His Cloak*. It is for the kneeling beggar on the right-hand side of the composition. The model is shown in a tattered tunic that exposes his left shoulder, as in the painting. As there, he wears a bandage on his head. His right arm, concealed in the painting by Saint Martin's cloak, is not shown, and his left hand, which in the Zaventem version of the painting [cat. 10, fig. 1] is seen grasping his stick (but is covered by the cloak in the London picture), is only summarily indicated. This figure has no equivalent in the oil sketch by Rubens on which Van Dyck's composition is based [see above, cat. 10]. Rather it is taken from *The Healing of the Lame Man* [fig. 1], one of the series of tapestry cartoons by Raphael. By 1620 the cartoons (on loan from the Royal Collection to the Victoria and Albert Museum, London) were probably in Italy and about to move to London,[1] but Van Dyck would have been very familiar with these famous designs in the form of the tapestries as well as in prints and drawn and painted copies.

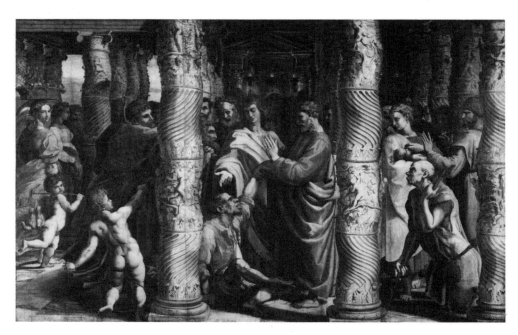

Fig. 1. Raphael, *The Healing of the Lame Man*. Tapestry cartoon. Collection of Her Majesty Queen Elizabeth II, on loan to the Victoria and Albert Museum, London

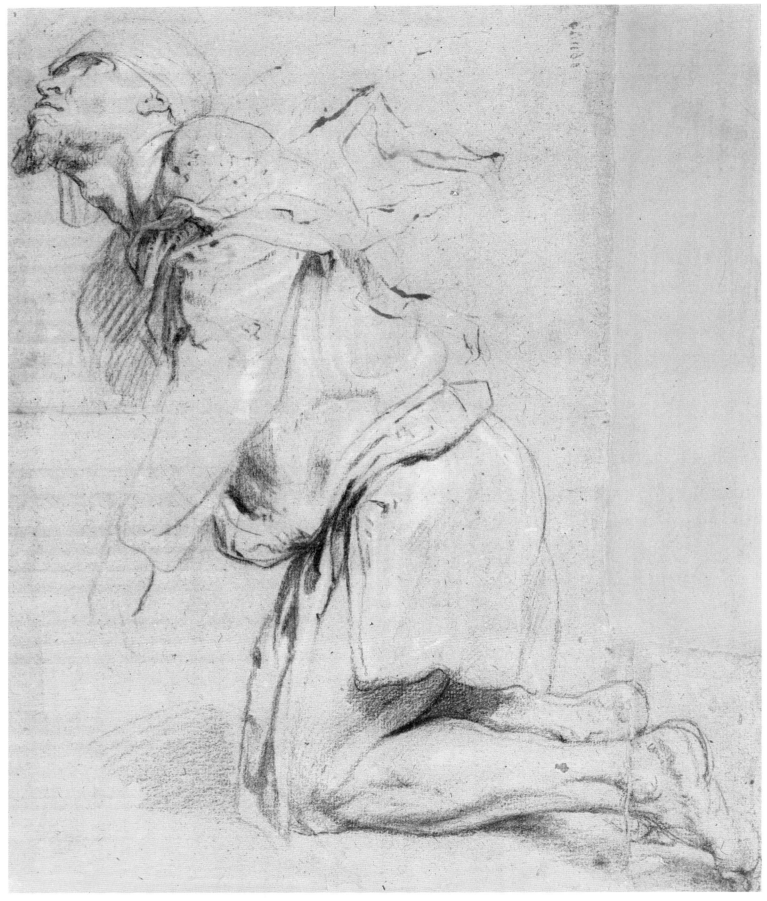

Cat. 11

The Drawings for *The Brazen Serpent*

Van Dyck's painting of *The Brazen Serpent*, which is in the Prado in Madrid [fig. 1], dates from the last years of his first Antwerp period, that is, about 1618–1621. There are no fewer than seven sheets of compositional studies for this painting, of which four are included in this exhibition. In addition, there are two studies in black chalk for individual figures in the composition. Nothing is known of the circumstances of the commission, but it is clear that the young Van Dyck took immense care with this composition.

Of all these compositional drawings, only the Chatsworth sheet [cat. 15], which has been squared up in black chalk, is close enough to the painting to be considered the drawing from which Van Dyck worked, but the composition is in reverse. The drawing in the Courtauld Institute [cat. 14] must have been made shortly before; although it too shows the composition in reverse, the disposition of the principal figures has been established.

Van Dyck's starting point, as has long been recognized, was Rubens' treatment of the subject in the painting of about 1609–1610 in the Courtauld Institute Galleries [fig. 2]. (In turn, Rubens' composition is based on Michelangelo's *Worship of the Brazen Serpent*, which occupies a corner spandrel in the Sistine Chapel.) Van Dyck retains Rubens' basic structure, with Moses divided from the Israelites by the serpent, but changes the format, with the strong central vertical of the cross upon which the serpent is displayed, into a horizontal composition, in which the cross is moved towards the left side of the painting and the principal visual emphasis is on the group of Israelites.

The precise sequence of the drawings is difficult to establish, but that proposed by Vey is largely convincing. The New York drawings [recto and verso of cat. 12] were not known to Vey but must show an early phase in Van Dyck's thinking about the group of Israelites, since none of the principal figures among the group as finally painted by Van Dyck can be found on either side of this sheet; and indeed, there

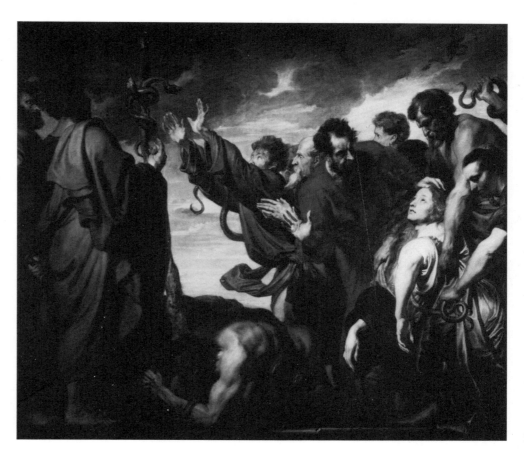

Fig. 1. Anthony van Dyck, *The Brazen Serpent*.
Canvas, 205 x 235 cm. Museo del Prado, Madrid

are other figures in quite different poses in their places. The Rotterdam drawing [cat. 13] contains studies of Moses and the Israelites, notably the man stretching out his hands towards the serpent. The first of two drawings formerly in Bremen shows on the recto [fig. 3] a detailed study for a woman and her child on the ground being urged to look up at the serpent, a group which was later to be abandoned altogether. On the verso [fig. 4], is the first idea for the kneeling woman being supported and her head held up to look at the serpent. The Courtauld drawing [cat. 14] shows many of the principal elements in place but in reverse, while the second Bremen drawing [fig. 5] and the sheet in Bayonne [fig. 6] show the artist further refining the details of the group of Israelites. These are very different types of drawing, which are fascinating to compare. The Bremen drawing [fig. 5] shows Van Dyck at his most economical. He is concerned with the figure of the woman being held up to face the serpent. Her nude figure is carefully drawn in pen, with the shadows around her indicated in wash. All of the other figures are shown summarily, and Moses is conjured up with half a dozen pen lines. By contrast, the Bayonne drawing is the study of the whole group: the woman is the focus of attention, but Van Dyck's principal interest is in the disposition of light and shade, and he studies it with boldly applied wash over the hastily sketched pen lines. There is then a fragmentary pen drawing on the verso of a sheet at Chatsworth for *The Carrying of the Cross* (Vey 10). It shows a group of Israelites with the woman being supported to look at the Brazen Serpent and the man with arms outstretched with in addition a bearded man reaching down towards the left. The Serpent is drawn with a bold circular flourish of the pen. Next comes the squared-up but reversed Chatsworth drawing [cat. 15], which is the closest to the final composition but cannot be considered a *modello* in the sense of the Antwerp *modello* for *The Carrying of the Cross* [cat. 4] or the one in Hamburg for *The Taking of Christ* [cat. 34].

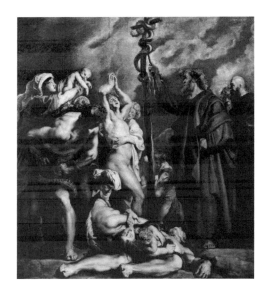

Fig. 2. Peter Paul Rubens, *The Brazen Serpent*. Panel, 159 x 144 cm. Courtauld Institute Galleries (Princes Gate Collection), London

Fig. 3. Anthony van Dyck, *Studies for The Brazen Serpent*. Pen and brown ink and point of brush, with brown wash, 188 x 245 mm. Formerly Kunsthalle, Bremen (Vey 43r)

Fig. 4. Anthony van Dyck, *Studies for The Brazen Serpent*. Pen and brown ink, 188 x 245 mm. Formerly Kunsthalle, Bremen (Vey 43v)

Fig. 5. Anthony van Dyck, *The Brazen Serpent*. Pen and point of brush, with brown wash, 184 x 243 mm. Formerly Kunsthalle, Bremen (Vey 45)

Fig. 6. Anthony van Dyck, *Study for The Brazen Serpent*. Pen and brown ink and point of brush, over black chalk, with brown wash, 193 x 227 mm. Musée Bonnat, Bayonne (Vey 46)

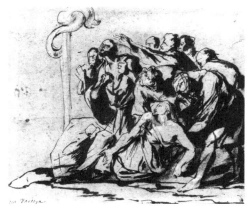

12
Studies for *The Brazen Serpent*

c. 1618–1621

Pen and brown ink, 241 x 202 mm. There is an inscription, top right, in Van Dyck's own hand: *pagendo/ pagato per p[r]imo* (there is a damage in the area of the second letter of the final word and it is not at all clear that it is an *r*). A line has been drawn in pen (by Van Dyck?) around the edge of the sheet. There are small stains caused by red ink in the center of the sheet.

Verso: Further studies for the group of Israelites in *The Brazen Serpent*. The two central figures in this group are drawn again at the top of the sheet, which has subsequently been cut at the top and right-hand edges.

Watermark: none

Collection of Mr. and Mrs. Eugene Victor Thaw, New York

[Not in Vey]

PROVENANCE With Galerie De Bayser, Paris, 1984; with Bob P. Haboldt & Co., New York, 1989.

LITERATURE Bob P. Haboldt & Co., *Old Master Drawings and Paintings: The First Five Years* (New York, 1989), 19; Haverkamp-Begemann 1990.

1. Egbert Haverkamp-Begemann kindly made the manuscript of his article for *Master Drawings* available to me before publication (op. cit.).

This important double-sided sheet of studies for *The Brazen Serpent* has only recently come to light.[1] As has been discussed above, the sequence of drawings for this commission is very difficult to establish, although it seems likely that the Chatsworth drawing [cat. 15] should be placed at the end. This sheet, which contains studies on both sides for the group of Israelites, must represent a relatively early phase in Van Dyck's thinking about the picture, for these figures are shown quite differently in the Chatsworth drawing and in the painting. In the final composition, the principal figures in the group of Israelites are the woman on the right whose head is being held up to face the serpent, the man who stretches out his arms to the serpent, and the man on the ground beneath him who is trying to free himself from a snake. None of these key figures is present in either of these drawings, and indeed there are other figures in quite different poses in their places: a half-naked, muscular man who reaches over the prostrate figure of a woman on the far right; a woman who lifts her child towards the serpent; a bald man, naked to the waist, who lifts both arms; and a dead man, face down, in the left foreground. None of these figures was incorporated into the painting in anything like this form. In addition, the figure of Moses, standing some way back and facing the viewer, is posed quite differently from the way he was to be shown in the painting. These remarks apply equally to the verso, which shows the Israelites posed quite differently from the painting or indeed from any of the other drawings.

The inscription is puzzling [fig. 1]. It appears to be in Italian (rather than Latin), but it is difficult to know what its meaning is or whether it relates in any way to the subject matter of the drawing. Haverkamp-Begemann comments: "Why Van Dyck wrote these words, and why so carefully in spite of their partial incomprehensibility remains a mystery unless one supposes that he tried his pen and that in their partial lack of meaning these words resemble doodles." He may, of course, simply have been practicing his Italian shortly before his departure for Genoa. Haverkamp-Begemann remarks that they are similar to the words written on one of the Bremen drawings for *The Brazen Serpent* [p. 80, fig. 4]. Towards the left at the top in that drawing are the words: *ave maria/ gratia plena*. At the lower left are: *a sangonio (?)/ Lenora Lenora Lenora*. These words, however, are readily comprehensible: a prayer, a place, and a woman's name. In my view, the words on the Thaw drawing did, like those on the Bremen sheet, have a private significance (rather than merely being doodles), but are not related to the subject of *The Brazen Serpent*.

Fig. 1. Detail of the inscription on the recto of cat. 12

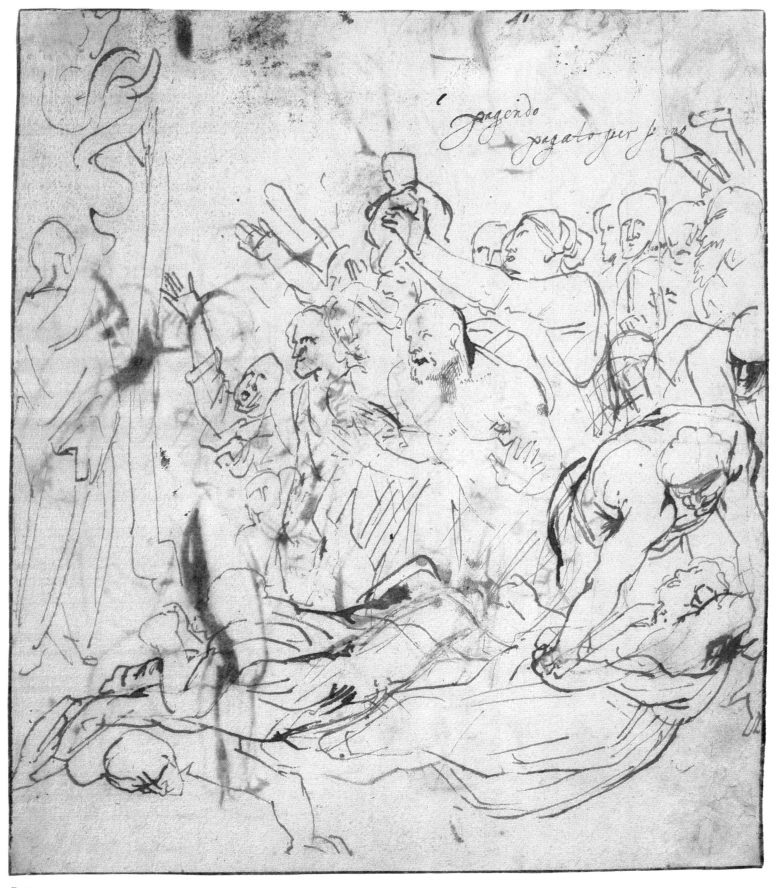

Recto

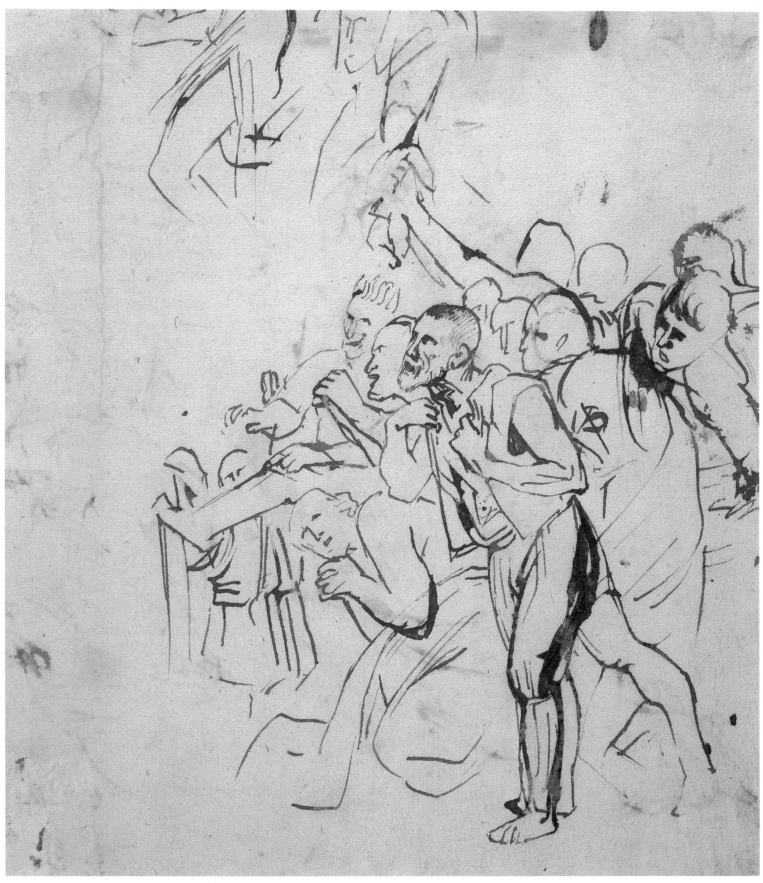

Verso

13
Studies for *The Brazen Serpent*

c. 1618–1621

Pen and brown ink and brown wash, over black chalk, 209 x 262 mm. Lower left, inscribed in pen in a later hand: *Ant Vandick*. Upper right, some graphite scribbles by a later hand. Water staining at the top, left, and right edges. Some damage at the top on the right.

Verso: *The Conversion of Saint Paul*. Pen, with light gray wash. Water and damp staining. There are spots of blue watercolor on the bottom edge on the left and right applied, probably accidentally, by a later hand.

Watermark: none

Museum Boymans-van Beuningen, Rotterdam (inv. no. Van Dyck 7)

Vey 42

PROVENANCE F. J. O. Boymans (1767–1847), Utrecht; Museum Boymans, Rotterdam (L.1857, verso, top right, twice).

EXHIBITIONS Antwerp 1949, no. 73; Antwerp 1960, no. 23; Prague 1969, no. 77.

LITERATURE Boymans 1852, no. 1852–261–268 (as School of Van Dyck); Boymans 1869, no. 1869–128–135 (as School of Van Dyck); Burchard 1932, 10; Delacre 1934, 30, pl. 11; Vey 1956A, 45–46, pl. 10; Vey 1958, 152ff.; White 1960, 513, pl. 21; Vey 1962, no. 42; Held 1964, 566.

1. Held 1986, no. 4. Ann-Marie Logan prefers, however, to retain the attribution of these drawings to Van Dyck.
2. Egbert Haverkamp-Begemann (1990, 302, n. 4) also considers the verso to be by Van Dyck.

In the center of this sheet Van Dyck tried out two poses for the figure of Moses. He then moved across the paper to the right and placed Moses in a figure group, raising his right arm towards the serpent. In the background he added one figure lifting up another—the first idea for the woman held up to see the serpent, which was to become such an important feature of the design. This entire group is rendered in a very schematic manner. On the left, turned through 90 degrees, is a far more worked-up group of Israelites reaching out towards the serpent. All three figures of Moses were begun in black chalk and gone over in pen, and there are also traces of black chalk at several places in the group of Israelites. At two places on the sheet are meaningless marks—to the right of the head of the horned Moses in the center and on his left at about waist height. These were presumably made by Van Dyck trying out his pen. The group of Israelites as shown here is very close to the final painted version, though in reverse. Of the three versions of the figure of Moses, only the last, on the far right of the sheet, is related to the final pose. It is interesting to note that Moses is shown with horns in the central pose but not in Rubens' painting. He is shown horned in Van Dyck's painting in the Prado.

The verso contains a very free pen drawing, with gray wash, of *The Conversion of Saint Paul*. As Vey noted, it appears at first sight to be a copy of the painting of 1567 by Pieter Bruegel the Elder in Vienna [fig. 1], but there are substantial differences between the two, and the drawing is presumably a copy after a later variant of Bruegel's painting. Vey mentioned, for example, a free copy of the Bruegel composition attributed to Joos de Momper in a private collection in Stockholm. He considered the drawing on the verso of cat. 13 to be by a later hand: he thought it too crude for Van Dyck. He compared it with drawings after Bruegel or Bruegelesque prototypes in Lille (Vey 143) and Chatsworth [fig. 2]. Following Held,[1] I consider both these drawings to be by Rubens rather than Van Dyck, and so do not accept the comparison as relevant. Nor would it be relevant to compare the drawing with the page of the Italian sketchbook showing a peasant scene copied after a Flemish prototype [fig. 3]. If, however, the highly schematic representation of the figures is compared with some on the recto (notably those behind the figure stretching out his hands) or on, for example, the verso of cat. 14, it will be found to be very similar in its graphic mannerisms. I agree, therefore, with Held that the verso is a free copy by Van Dyck himself after a Bruegelesque original.[2]

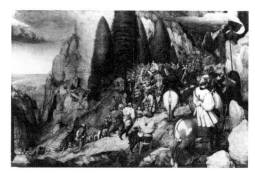

Fig. 1. Pieter Bruegel the Elder, *The Conversion of Saint Paul*, 1567. Panel, 108 x 156 cm. Kunsthistorisches Museum, Vienna

Fig. 2. Peter Paul Rubens, *Studies of Peasants*. Pen and brown ink, 247 x 198 mm. Devonshire Collection, Chatsworth (Vey 144, as Van Dyck)

Fig. 3. Anthony van Dyck, Italian Sketchbook, fol. 67v. The British Museum, London

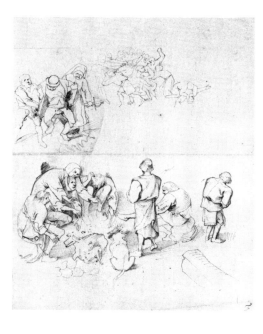

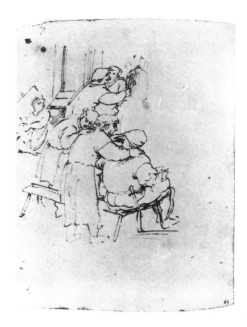

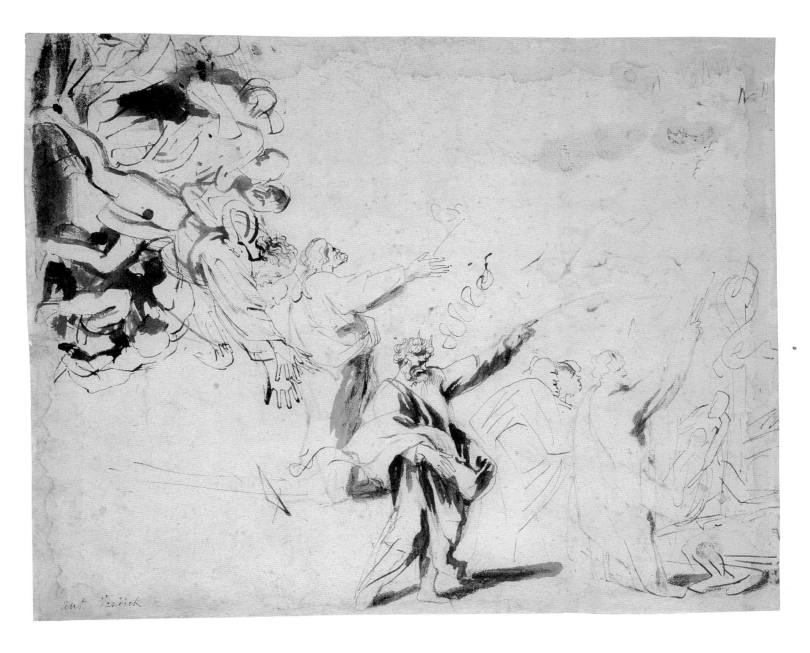

14
Studies for *The Brazen Serpent*

c. 1618–1621

Pen and brown ink, with brown and gray wash, 146 x 205 mm. Trimmed at the left and right edges and at the bottom. At the top the sheet has been cut into a shallow oval shape.

Verso: There are three separate drawings on this complex (and rather confusing) sheet. In the first place, Van Dyck has traced a number of figures through from the recto. He then turned the sheet through 90 degrees and drew a study for *The Mystic Marriage of Saint Catherine* and, finally, turned the paper again and, in the top left-hand corner, made a sketch of a crab.

Watermark: a cross surmounted by two half-circles (not in Briquet)

Courtauld Institute Galleries, London (Witt Collection, inv. no. 2365)

Vey 44
Exhibited in New York

PROVENANCE Jonathan Richardson the Elder (1665–1745), London (L.2183, lower right); Thomas Hudson (1701–1779), London (according to a note by Roupell on the mount); J. Barnard (d. 1784), London (according to London 1835A, no. 3); Sir Thomas Lawrence (1769–1830), London, no. 78 in his MS inventory in the Royal Academy of Arts (London 1835A and 1835B, no. 3) (L.2445, lower left); R. P. Roupell (1798–1886), London (L.2234, verso, lower right); Sir Robert Witt (1872–1952), London (L.2228b, verso, lower left).

EXHIBITIONS Antwerp 1930, no. 401; London 1938, no. 576; London 1943; Rotterdam 1948–1949, no. 80; Paris 1949, no. 119; London 1953B, no. 85; London 1958, no. 24; Antwerp 1960, no. 24; London 1977–1978, no. 63; Ottawa 1980, no. 21; London 1983, no. 42.

LITERATURE Oppé 1931, 70; Burchard 1932, 10; De Bruyn 1930, 31–32; Glück 1931, 73; Delacre 1934, 32, 124; *Hand-list of the Drawings in the Witt Collection, London*, 1956, 126; Vey 1958, 152ff.; Vey 1962, no. 44.

1. Vey noted that there are Renaissance bronzes of crabs but in my view this is more likely to be a doodle.

By the time Van Dyck made this drawing, the final composition of *The Brazen Serpent* had been largely established, with Moses on one side of the serpent and the Israelites on the other, although he was to reverse this arrangement in the painting. For the first time in this drawing we can see the dramatic and immensely effective figure of a young woman in the center of the group of Israelites whose head is being held up to look at the serpent. On the verso, Van Dyck has traced through part of the figure group: here we see his first idea for the final painted solution, in which the same basic elements were used but in reverse. On the same sheet is a drawing for *The Mystic Marriage of Saint Catherine* [p. 91, fig. 1]. The Virgin and Child and Saint Catherine are disposed more or less as they are in the painting and so, interestingly, is the palm-carrying saint behind the Christ Child. Between the Virgin and Saint Catherine is a marvelously lively head of a saint, which can be seen in other drawings in this series but was omitted from the painting. This commission and the series of drawings Van Dyck made for it are discussed under cats. 16–18. Finally, there is a doodle, in the form of a crab.[1]

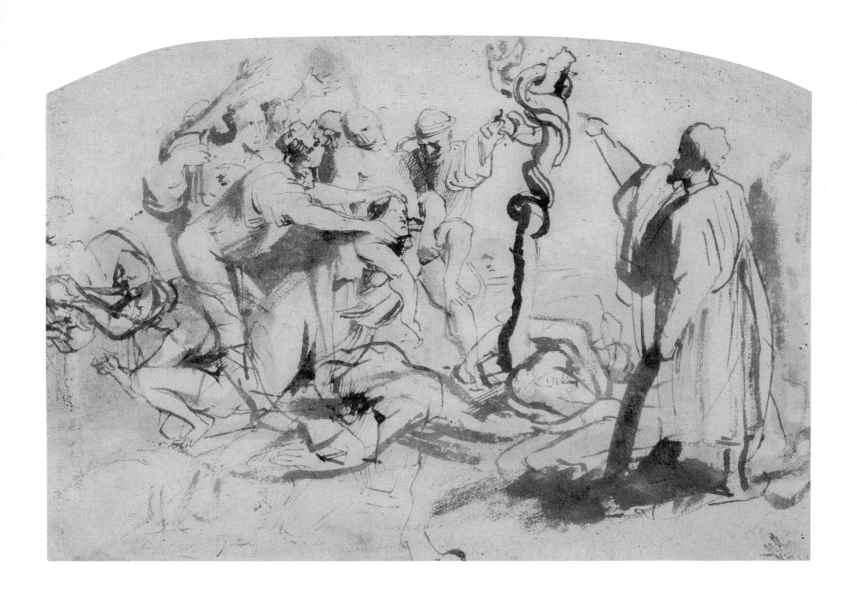

Cat. 14 verso

15
The Brazen Serpent

c. 1618–1621

Pen and brown ink and brown and gray wash,
121 x 192 mm. Lightly squared up in black chalk.
Some staining. The sheet has been trimmed along
the top edge, the left and right edges, and (very
slightly) the bottom edge.

Verso: Three of the heads on the recto have been
traced through in pen. The whole sheet is squared
up in pen.

Watermark: none

Devonshire Collection, Chatsworth (inv. no. 1010)

Vey 47

PROVENANCE Unknown.

EXHIBITIONS Nottingham 1960, no. 60; Antwerp
1960, no. 25; Ottawa 1980, no. 22.

LITERATURE Russell 1926, 8, pl. 14; Glück 1931,
73; Delacre 1934, 29, pl. 10; Vey 1958, 152ff.; Vey
1962, no. 47.

This drawing, from the series of seven for *The Brazen Serpent*, is closest to the
painting in the Prado. All the principal elements of the composition are present here
but in reverse. The drawing is lightly squared in black chalk on the recto and,
unusually, is squared in pen on the verso. Three of the heads on the recto have been
traced through onto the verso. It was Burchard's belief (as recorded by Vey) that
Van Dyck used it from the back as the *modello* for the painting. That would have
been a curious and unusual procedure, but it is certainly a possibility. It is also
possible that the squaring on the verso was done for the drawing to be copied in
reverse onto another sheet of paper. That sheet, now lost, would have been the
modello.

If this sheet is compared with the *modello* for *The Carrying of the Cross* [cat. 4] or
the *modello* for *The Taking of Christ* [cat. 34], it can be seen to be far less precise in
detail: for example, the figure of Aaron is merely suggested with a few pen lines.
However, as has already been observed, Van Dyck continued to rethink his compo-
sitions on the canvas despite having prepared himself with so many drawings, and
this drawing may have been sufficient as a *modello* to establish the general disposi-
tion of the figures and of light and dark.

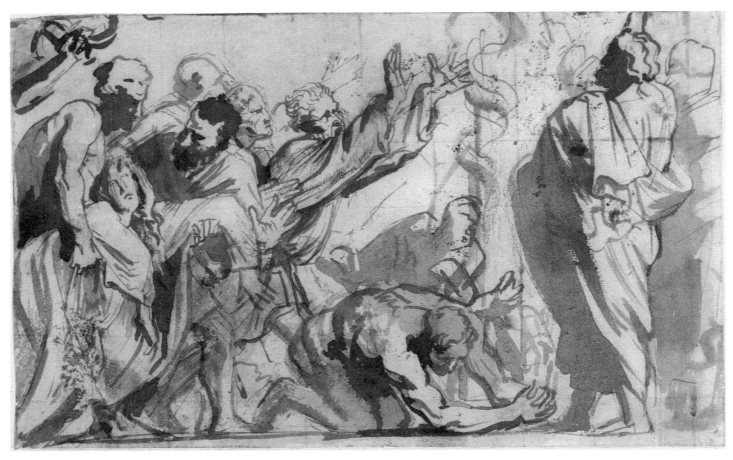

Cat. 15 recto

Verso (detail)

The Drawings for *The Mystic Marriage of Saint Catherine*

1. Wethey 1969, I, no. 67, as Workshop of Titian, about 1520.
2. Canvas, 110 x 137 cm. Inv. no. 742. Ibid., no. 72, as about 1520. Van Dyck sketched it (after a copy in Antwerp) on fol. 63*v* of the Antwerp sketchbook. The sketch contains an additional head of Saint Joseph against the curtain on the left.
3. The drawing was in the Rump collection, Copenhagen, and was lot 167 at Amsler and Ruthhardt, Berlin, in May 1908.
4. Müller Hofstede 1973, 156.

The Mystic Marriage of Saint Catherine, which is today in the Prado in Madrid [fig. 1], was painted in about 1618–1621. It has the same light tonalities and scumbled technique as *Samson and Delilah* [cat. 9, fig. 1]. The recent cleaning of both paintings has made these similarities even more striking. *The Mystic Marriage of Saint Catherine* is strongly Venetian in its composition: in the three-quarter length format of the figures and the profile of Saint Catherine, it recalls Titian's *Madonna and Child with Saints John the Baptist, Mary Magdalen, Paul, and Jerome* in Dresden [fig. 2],[1] and in the pose of the Madonna and Child, is similar to the same artist's *Madonna and Child with Saints Stephen, Jerome, and Maurice* in the Louvre[2] which Van Dyck had drawn in his Antwerp sketchbook [fig. 3].

There are six compositional drawings for this painting, of which four are included in this exhibition. The first idea seems to have been a drawing in Berlin [cat. 16], which shows the composition reversed, with the Virgin and Child on the right. The composition seen in that drawing may well be based on an Italian, more particularly a Venetian, prototype. The next drawing, still strongly Venetian in conception, is presumably the boldly washed and extensively altered sheet formerly in Bremen [fig. 4]. Then may well have come the sketch on the verso of the drawing for *The Brazen Serpent* in the Courtauld Institute Galleries [cat. 14] which shows the Virgin and Child and Saint Catherine but omits the subsidiary figures on the right, and after that a drawing showing the Virgin and Child in the center of the composition in the Institut Néerlandais [fig. 5]. This was presumably judged unsatisfactory because the central drama—the presentation of the ring—was confined to the right-hand side of the sheet. Then came two large drawings in which the composition, having been largely established, is refined. The Pierpont Morgan sheet [cat. 17] is freely drawn in pen, with a few splashes of wash, while the Woodner drawing [cat. 18] is far more precise, with delicate washes added in the shadows. There are a number of important differences between these two drawings and the final painting. In the painting Saint Joseph has been replaced by a column, and the group of four men standing behind Saint Catherine in the Woodner drawing has been reduced to two. Very much closer to the final, painted composition is the drawing [fig. 6] that Vey considered the *modello* for the painting, although it is not squared

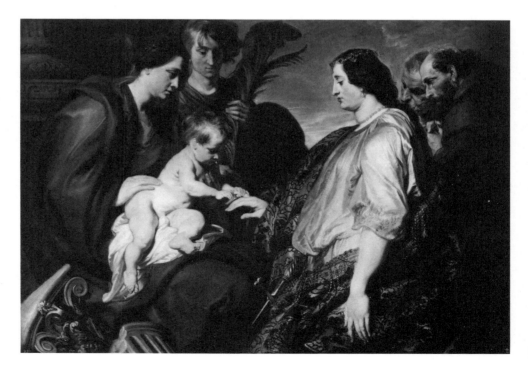

Fig. 1. Anthony van Dyck, *The Mystic Marriage of Saint Catherine*. Canvas, 121 x 173 cm. Museo del Prado, Madrid

up. This drawing was last recorded on the Berlin art market in 1908 and is unknown in the original both to Vey and the present writer.[3] Van Dyck has adjusted Christ's pose, removed Saint Joseph, and reduced the group behind Saint Catherine to the two monks seen in the painting. The central figure, seen in the background between the Virgin and Child and Saint Catherine, and prominent in the two previous drawings, is shown in shadow prior to his being omitted altogether from the composition in the painting. It is possible that there was a further drawing, now lost, which served as the *modello* and was carried out with the care of the *modelli* for *The Carrying of the Cross* [cat. 4] and *The Taking of Christ* [cat. 34].

In addition to these compositional drawings, Van Dyck posed a model in the studio for the figure of the Virgin and made a delicate drawing in black chalk [fig. 7], on the reverse of which he made black chalk studies of babies drawn from the life, and seen sleeping and suckling. A sheet containing two further pen studies for the Christ Child was erroneously considered by Vey to be a copy but reinstated by Müller Hofstede.[4]

Fig. 2. Titian (and studio), *Madonna and Child with Saints John the Baptist, Mary Magdalen, Paul, and Jerome.* Panel, 138 x 191 cm. Gemäldegalerie, Dresden

Fig. 3. Anthony van Dyck, Antwerp Sketchbook, fol. 63*v.* Devonshire Collection, Chatsworth

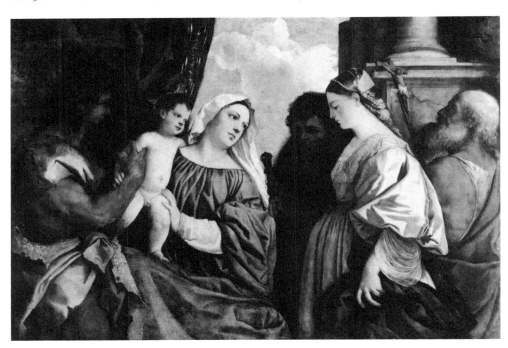

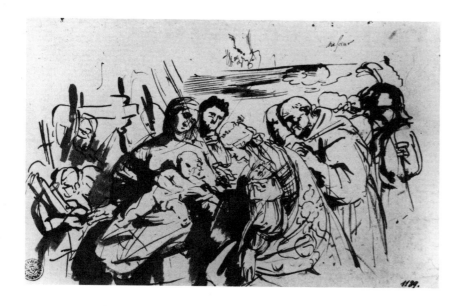

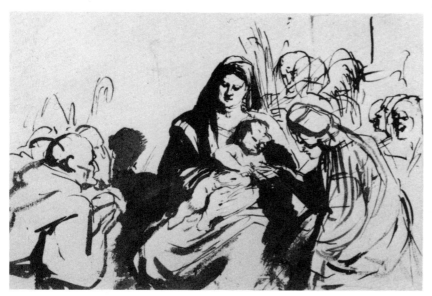

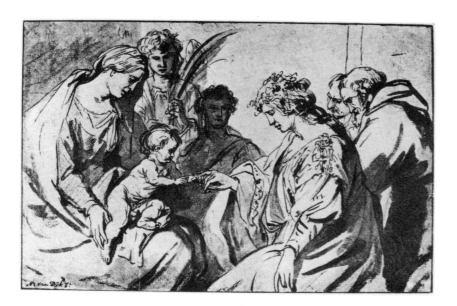

Fig. 4. Anthony van Dyck, *The Mystic Marriage of Saint Catherine*. Pen and brown ink, with brown wash, 191 x 289 mm. Formerly Kunsthalle, Bremen (Vey 53)

Fig. 5. Anthony van Dyck, *The Mystic Marriage of Saint Catherine*. Pen and brown ink, with brown wash, 183 x 262 mm. Fondation Custodia (Coll. F. Lugt), Institut Néerlandais, Paris (Vey 52)

Fig. 6. Anthony van Dyck, *The Mystic Marriage of Saint Catherine*. Pen and brown wash, 132 x 195 mm. Berlin art market in 1908. Present whereabouts unknown (Vey 56)

Fig. 7. Anthony van Dyck, *A Young Woman Seated* (study for the Virgin in *The Mystic Marriage of Saint Catherine*). Black chalk, 410 x 285 mm. The British Museum, London (Vey 57)

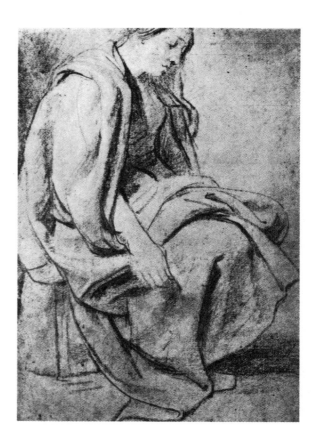

16
The Mystic Marriage of Saint Catherine

c. 1618–1621

Pen and brown ink and brown wash, 183 x 260 mm. A border has been drawn by a later hand in pen.

Verso: a Baptism scene (*The Baptism of the Eunuch?*) in pen. Lower right, in pen: 23; top right, in graphite: *A. v. Dyck* and *Hausmann 134/K.d.Z. 1338*; center left: L.1606.

Watermark: none

Staatliche Museen Preussischer Kulturbesitz, Berlin, Kupferstichkabinett (KdZ 1338)

Vey 59

PROVENANCE B. Hausmann (1784–1874), Hanover (L.377, lower right); Kupferstichkabinett, Berlin (L.1606, verso, center left).

LITERATURE Bock and Rosenberg, 124, no. 1338 (verso: The Baptism of Christ); Delacre 1934, 129 (verso: The Baptism of Christ); Vey 1958, 83ff.; Vey 1962, no. 59.

1. Princeton 1979, 85.
2. Gemäldegalerie, Berlin-Dahlem. 1978 cat., no. 677.
3. Alte Pinakothek, Munich. 1983 cat., no. 10735.
4. Held 1964, 565.

This sheet is related to a group of drawings preparatory to the painting of *The Mystic Marriage of Saint Catherine* in the Prado [p. 91, fig. 1]. The sequence of these drawings is discussed above. As is noted there, this particular sheet is difficult to incorporate into the sequence. It does contain all the essential elements of the composition: the Virgin and Saint Catherine both seen half-length, in profile; the palm-bearing figure beside the Virgin; and the hooded monk behind Saint Catherine. The composition is, unlike all the other preparatory drawings, in reverse. Van Dyck's predilection for trying out his early religious compositions in reverse has already been noted in, for example, his drawings for *The Brazen Serpent*. It is worth pointing out that in this drawing he sketched the figure of Saint Catherine a second time, to the right of the Virgin, that is, on the right-hand side of the composition, in the position she was to assume in the painting. In this slight sketch of Saint Catherine, we may be seeing the genesis of the eventual disposition of the figures in the painting. Vey did not think that this drawing could be considered preparatory to the painting; rather, he thought that it is "perhaps a paraphrase of an Italian painting laced with individual motives from his own studies." Martin and Feigenbaum, however, stressed the similarities to the final composition and thought that it "has surely to be accorded a place in the early stages of Van Dyck's preparations for the Madrid painting."[1] I would agree with this. They also noted that in this drawing, as in all of the other preparatory drawings, the light falls from the right whereas in the finished painting it comes from the left.

On the verso is a hasty pen sketch of a scene of baptism. Bock and Rosenberg identified it as the Baptism of Christ. The presence of horsemen and a rearing horse (on the right of the figure being baptized), and the long robe of the man performing the baptism suggested to Vey the Baptism of the Eunuch. He compared it with paintings of the subject by Pieter Lastman in Berlin (1608)[2] and Munich (1620).[3] Held, on the other hand, preferred to identify the subject as the baptism of Cornelius (Acts of the Apostles, chapter 10).[4] This drawing, which shows Van Dyck's graphic style at its most abbreviated, is perhaps a record, of the most schematic kind, of a painting seen by Van Dyck or of an idea which went through his mind but was never developed further.

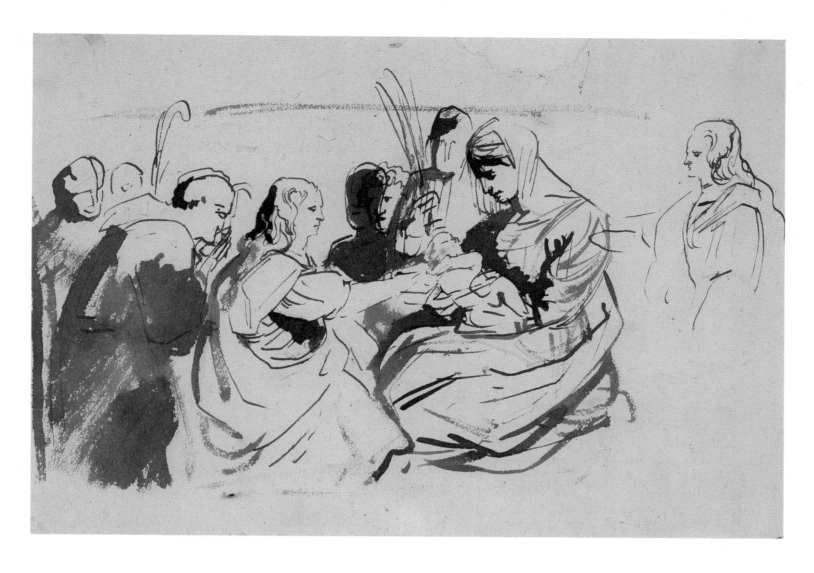

Verso

17
The Mystic Marriage of Saint Catherine

c. 1618–1621

Pen and brown ink, brown wash, 158 x 235 mm. In the lower left-hand corner is an inscription in black chalk and brown ink written when the sheet was the other way up, in Flemish, in Van Dyck's own hand. It has been rendered illegible by the trimming of the paper on the left and bottom edges. Lower right, an inscription in graphite by a later hand: *Vandick.*

Verso: A male torso, lying down and seen from the back. Pen and brown ink. An inscription, in Roupell's hand, lower left, in graphite: *357 Lawrence/ Woodburn 18/ Bot by me at Morants 1862.* Numbered, lower right: *10.*

Inscribed on the mount, in Roupell's hand, in graphite: *A. van Dyck/ "Marriage of St. Catherine."/ no 6 In the Lawrence Gallery exhib. 1835./ Norblin Coll. Morants.* In another hand: *(Bought by Mr. Roupell at Morant's Sale).*

Watermark: none

The Pierpont Morgan Library, New York (inv. no. I, 245a)

Vey 54

PROVENANCE Jean-Pierre Norblin de la Gourdaine (1745–1830), Paris; Sir Thomas Lawrence (1769–1830), London (L.2445, bottom left, very faint) (no. 6 in London 1835A); Samuel Woodburn; Lawrence-Woodburn sale, Christie's, London, 4–8 June 1860, lot 357 (to Morant for £1.10s.0d); George J. Morant, London; his sale, Foster, London (*A Catalogue of an Important Collection of Works of Art by a Well Known Amateur*), 9–16 April 1862, no. 226 (to Roupell); Robert Prioleau Roupell (1798–1886), London; his sale, Christie's, London, 12–14 July 1887, lot 1198 (to Riggall for £0.12s.0d); Dr. Edward Riggall, London; his sale, Sotheby's, London, 6–8 June 1901, lot 544 (to Fairfax Murray for £14.0s.0d); Charles Fairfax Murray (1849–1919), London; J. Pierpont Morgan.

EXHIBITIONS London 1835, 8, no. 6; Antwerp 1960, no. 28; Paris 1979–1980, no. 29.

LITERATURE Lugt 1949, under no. 605; Vey 1958, 83–84; Vey 1962, no. 54; Held 1964, 567; Stampfle 1991, no. 268.

This is one of the six compositional drawings for *The Mystic Marriage of Saint Catherine* in the Prado. The sequence in which they were made is discussed above. This drawing, with its hasty, vigorous pen strokes and splashes of wash, shows the disposition of the principal figures as they were to appear in the painting. The composition was to be refined by Van Dyck in two further extant drawings [cat. 18 and Vey 56]. The principal changes are that the central male figure was to be omitted, as was Saint Joseph (on the far left) and the figure on the extreme right.

Vey suggested that the male torso seen from above, which is drawn in pen on the verso, was made after an antique sculpture. It certainly calls to mind, for example, the Torso Belvedere in the Vatican, which had been drawn in situ by Marten van Heemskerck, Goltzius, Rubens, and other northern artists. This drawing would have been made by Van Dyck after a cast or, more probably, after a drawing or an engraving. In its emphasis on the bulging muscles of the torso it recalls Rubens' drawings after the antique and may be a copy after one of them, although the handling is certainly more schematic than Rubens'. The pose and the musculature are similar to those of the figure of the sleeping Samson in *Samson and Delilah* [cat. 9] which Van Dyck may have been working on at this time.

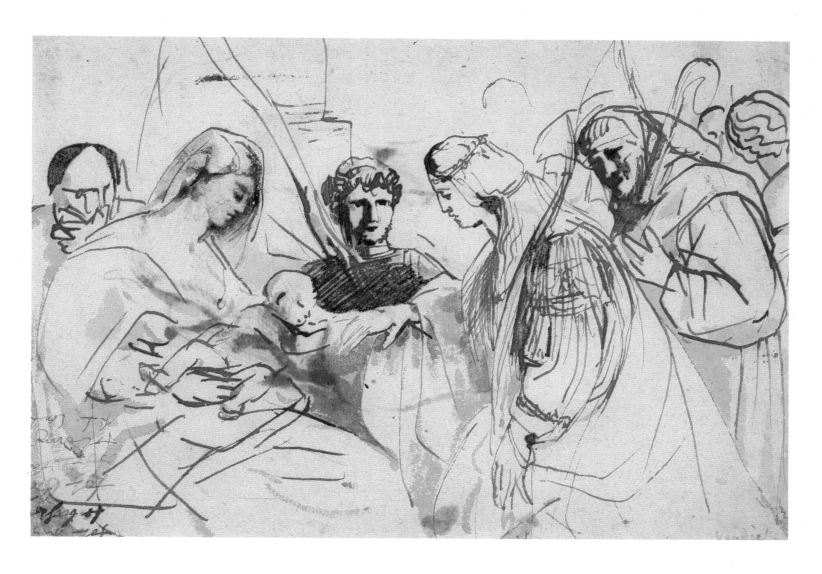

Verso

18
The Mystic Marriage of Saint Catherine

c. 1618–1621

Pen and brown ink and point of brush over black chalk, with brown and gray washes, 182 x 279 mm. In the center there is a horizontal tear and there are four vertical folds. In the middle towards the bottom is a monogram in a seventeenth-century hand: *NL*.

Verso: a number of inscriptions in pen in Italian (?) and French: *Come [?], pour La somme de deux Ce[nt?] Soixante douze Mille/ pistolles pour Laquelle Somme* and *Dieu donne*.

Watermark: none

The Woodner Family Collection, New York

Vey 55

PROVENANCE N. A. Flinck (1646–1723), Rotterdam (L.959, lower right); bought by the 2d duke of Devonshire and by descent to the present duke, Chatsworth (inv. no. 989); Chatsworth Drawings sale, Christie's, London, 6 July 1987, lot 12.

EXHIBITIONS London 1938, no. 582; Rotterdam 1948–1949, no. 81; Paris 1949, no. 120; Genoa 1955, no. 105; Nottingham 1957, no. 33; Nottingham 1960, no. 44; Antwerp 1960, no. 29; Washington 1969–1970, no. 81; London 1973A, no. 81; Tokyo 1975, no. 76; Princeton 1979, no. 20; Richmond 1979–1980, no. 82; London 1987.

LITERATURE Vasari Society (1st series), III, 1907, no. 16; Pauli 1908, no. 84; Oppé 1930, pl. 72; Glück 1931, no. 60; Delacre 1934, 125; Vey 1958, 83ff.; Vey 1962, no. 55; Müller Hofstede 1973, 156 (under no. 3).

1. Lugt I, no. 605.
2. Hollstein 1949, VI, 120, no. 467.

This drawing, as has been discussed above, is a development of cat. 17. Instead of sketching with slashing pen strokes and splashes of wash, here Van Dyck began by outlining the principal features of the composition in black chalk and then going over that drawing in pen, finally washing the principal areas of shadow. He has taken special care with the heads, drawing them all in considerable detail, even those of the subsidiary figures on the far right. A particular *tour de force* is the head of Joseph on the far left, which is drawn not in pen but in brown wash with the point of the brush. There is a copy of this drawing in the Louvre[1] and a print after it by Mariette.[2]

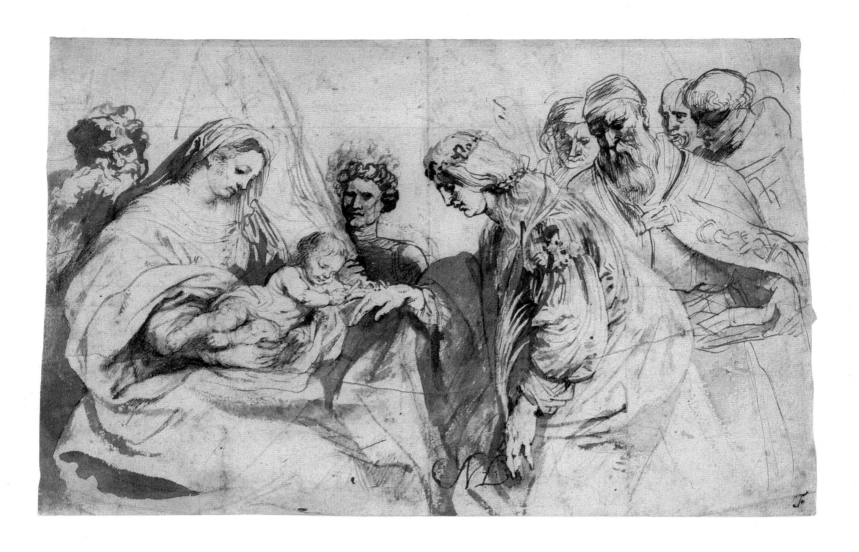

19
The Martyrdom of Saint Catherine

c. 1618–1621

Pen and brown ink on buff paper, 180 x 212 mm.
Cut at the left edge. Several stains and small
damages. In the center of the bottom edge, in a
later hand, are the letters: *O A*. In the top
right-hand corner, in red chalk: *v Dyck*.

Verso: The sheet has been pasted down, but there
appear to be pen sketches on the reverse.

Watermark: none

Herzog Anton Ulrich-Museum, Braunschweig
(inv. no. Z.119)

Vey 60
Exhibited in Fort Worth

PROVENANCE In the collection of Herzog Carl I
von Braunschweig (1713–1780) by 1754 and
probably in the ducal collection some time earlier.[1]

EXHIBITION Antwerp 1960, no. 30a (not in
catalogue).

LITERATURE Vey 1958, 78ff.; Vey 1962, no. 60.

1. My thanks to Christian von Heusinger for his
assistance in tracing (as far as is possible) the
history of this drawing.
2. The dating of these two paintings has been
much discussed. The discussion is summarized in
H. Braham, *Rubens: Paintings, Drawings and Prints
in the Princes Gate Collection* [exh. cat. Courtauld
Institute Galleries, London, 1988–1989], no. 30. The
dating of about 1610–1612 is now widely accepted
(Held 1980, under nos. 421 and 422).
3. B. XV, 444, no. 27.

This animated and very schematic sketch is one of two which show this subject
from the artist's first Antwerp period. (The other one is cat. 20.) No painting by Van
Dyck of this subject survives, but he was presumably planning one. The treatment
of the subject is highly dramatic: Van Dyck represents the moment at which angels
descended from heaven to destroy the wheel on which Saint Catherine was being
martyred and to crown her and present her with a palm of martyrdom. In Van
Dyck's drawings, the burst of light in which they descend causes horses to rear and
men to cover their eyes and flee in terror. His treatment of the subject is very similar
to that of Rubens in a pair of paintings showing *The Defeat of Sennacherib* [fig. 1] and
The Conversion of Saint Paul [fig. 2], painted about 1610–1612.[2] The figure of the rider
falling backwards from his horse in Van Dyck's drawings is very close (in reverse)
to that of Sennacherib, and in *The Conversion of Saint Paul* God appears in a burst of
light which causes Paul to be thrown from his horse while his terrified attendants
raise their arms to protect their eyes.

Van Dyck also seems to have been aware of Giulio Romano's treatment of this
subject, which he would have known in a print by Diana Ghisi[3] or in a reversed
print published by Hieronymus Cock in 1562. Saint Catherine is shown in the same
position in Ghisi's print, as is the group of falling men in the lower right- hand
corner, whereas the running man in the center left moves towards the right and has
his back to the viewer in Ghisi's print.

Fig. 1. Peter Paul Rubens, *The Defeat of Sennacherib.*
Panel, 97.7 x 122.7 cm. Alte Pinakothek, Munich

Fig. 2. Peter Paul Rubens, *The Conversion of Saint
Paul.* Panel, 95.2 x 120.7 cm. Courtauld Institute
Galleries (Princes Gate Collection), London

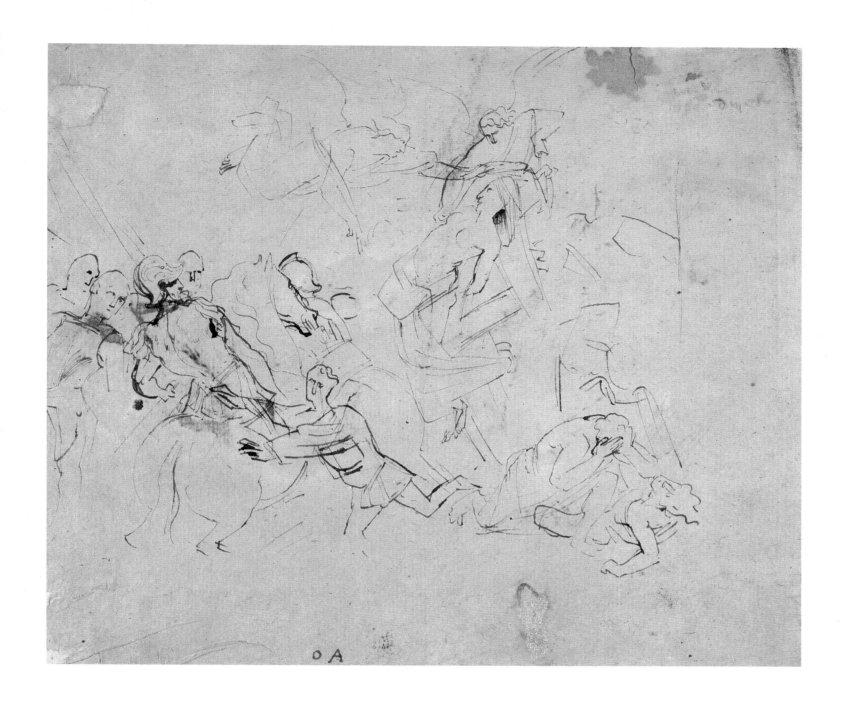

O A

20
The Martyrdom of Saint Catherine

c. 1618–1621

Pen and brown ink, brown wash over black chalk, 285 x 210 mm. In several places (probably applied by a later hand) are touches of ocher, lilac, and red watercolor, and some toning with blue pastel. Lower left, in a later hand: *A : V : Dijk ft.*

Watermark: not visible (laid down)

Ecole nationale supérieure des Beaux-Arts, Paris (inv. no. 34582)

Vey 61
Exhibited in Fort Worth

PROVENANCE Schneider collection, Paris (Drouot sale, 6–7 April 1876); A. Armand (1805–1888), Paris; collection of P. Valton, Paris, by whom presented in 1908 to the Ecole des Beaux-Arts (L.829, lower right).

EXHIBITIONS Paris 1879, no. 318; Paris 1947, no. 49; Antwerp 1960, no. 30; Paris 1984, no. 177.

LITERATURE Guiffrey 1882, 29, 32; Cust, 239, no. 37A; Lavallée 1917, 229–230; Muchall-Viebrook 1926, no. 37; Van Gelder 1942, no. 3; Vey 1958, 78ff.; Vey 1962, no. 61.

1. Leblanc 2, 523, s.v., no. 8; Hollstein 1949, VI, 118, no. 392.
2. The size is given as 11 ¼ x 8 ¼ in. London 1835A, no. 20. This—or another copy—was sold at Christie's, London, 23 November 1971, no. 117 (282 x 214 mm. Ex-Bouverie collection).
3. Cust 1900, 239, no. 37B.

This is a development of the ideas contained in cat. 19. In that sheet Van Dyck put down, with hasty pen strokes, his first ideas for *The Martyrdom of Saint Catherine*, based on his study of Rubens and Giulio Romano. In this sheet he refined those ideas. He changed the composition from a horizontal to a vertical format, which had the effect of emphasizing the burst of light from the heavens. (This radical change of format makes it unlikely that this was a commission for a particular altarpiece.) He then moved Saint Catherine from right to left, which enabled the light to illuminate the naked body of the saint and to blind and terrify the horsemen. He established the outlines of the composition in black chalk, went over it in pen adding detail, particularly in the faces, and finally applied the rich brown washes.

The two drawings for this project [cats. 19 and 20] could scarcely be more different in technique. They present a fascinating comparison of two drawing styles practiced by the young Van Dyck. The first is truly a sketch, little more than a notation of the positions of the principal figures. It was done very quickly with the forms indicated in the simplest and most schematic terms. The second is a very careful drawing, involving the three distinct stages and techniques described above. In this drawing Van Dyck is giving the composition depth and disposing the light and dark, which is such a key element of his conception of the scene.

A print was made after this drawing by Willem van der Leeuw (1603–c. 1665?) with an attribution to Rubens.[1] There is a copy of the drawing in the Zurcher collection, Lucerne (Drouot sale, Paris, 28 November 1927, no. 1). Sir Thomas Lawrence owned a drawing of this subject from the De Vos collection in Amsterdam. He described it as being "in free pen, bistre, and colour: of the finest quality."[2] Cust mentions another drawing of the subject in the Hermitage, but it can no longer be traced.[3]

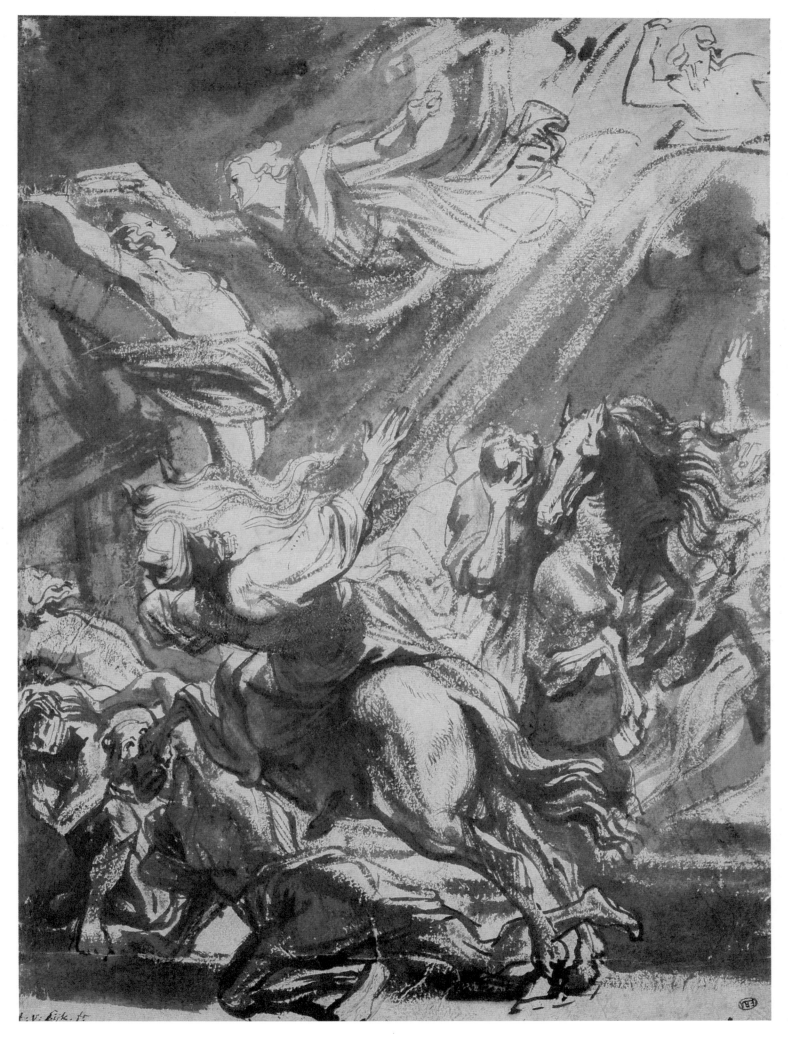

A. V. Dick. f.

103

21
The Martyrdom of Saint Lawrence

c. 1618–1621

Pen and brown ink, with brown and gray washes, 241 x 170 mm. Inscribed, lower right, in pen: 3.

Verso, lower edge, in graphite: *Anthony van/ Dyck* and in the bottom left-hand corner, erased numbers, beneath which is *£8—8*.

On the old mount, in Roupell's hand, in black ink: *RPR/ Van Dyck/ Martyrdom of Saint Lawrence/ from the Norblen Collection (Paris)/ One of the 50 drawings selected for/ Exhibition by Messrs. Woodburn in the/ Lawrence Gallery in July 1835.*

Watermark: illegible fragment

The Pierpont Morgan Library, New York (acc. no. III, 177)

Vey 71

PROVENANCE Possibly Samuel van Huls, former burgomaster of The Hague; his sale, The Hague, Swart, 14 May 1736, Album M, 17, lot 549 ("Saint Laurent & 2 autres"); Jean-Pierre Norblin de la Gourdaine (1745–1830), Paris; Sir Thomas Lawrence (1769–1830), London (London 1835A, no. 43); Samuel Woodburn; Lawrence-Woodburn sale, Christie's, London, 12 June 1860, lot 1208 (to Roupell for £2.15s.0d.); Robert Prioleau Roupell; his sale, Christie's, London, 12–14 July 1887, lot 1182; and his sale, Frankfurt-am-Main, F. A. C. Prestel, 6 December 1888, 13, lot 47 ("Eine der 50 von Woodburn gewählten Zeichnungen, die 1835 in der Lawrence Gallery ausgestellt wurden"); Edward Habich (1818–1901), Kassel (L.862, lower right); his sale, Stuttgart, H. G. Gutekunst, 27–29 April 1899, lot 246 (bought in for DM 140); Charles Fairfax Murray, London; J. Pierpont Morgan.

EXHIBITIONS London 1835B, no. 43; Antwerp 1960, no. 35; Stockholm 1970, no. 62; Paris 1979–1980, no. 28.

LITERATURE Guiffrey 1882, 251, no. 197; Eisenmann 1890, p. 33; *25 Handzeichnungen alter Meister aus der Sammlung Habich* (Kassel), no. 7; Morgan 1912, no. 177, repr.; Vey 1962, no. 71; Stampfle 1991, no. 267.

1. Vertue I, 132.
2. Vlieghe 1972–1973, II, no. 126; Munich 1983, no. 338. (In 1981 the Graphische Sammlung, Munich, acquired a pen drawing by Rubens for the *Martyrdom of Saint Lawrence*. See K. Renger, "Rubens' 'Laurentiusmarter'. Eine unbekannte Entwurfszeichnung," *Essays in Northern European Art presented to Egbert Haverkamp-Begemann*, Doornspijk, 1983, 205–208).
3. Commissioned by Canon Sebastian Briquet for the high altar of the Capuchin church in Cambrai and delivered in 1616. The *modello* is in Munich (1983, no. 59), and the commission is discussed in Held 1980, no. 366.
4. Oldenbourg 1921, 165.
5. Wethey 1969, I, no. 114 (painted 1548–1557).
6. Ibid., no. 115 (painted by Titian and his workshop in 1564–1567).
7. Ibid. The engraving is dated 1541 and dedicated to Philip II. It is illustrated by Wethey as plate 180.
8. Hollstein 1949, VI, 113, no. 168.

This is the only known drawing of this subject by Van Dyck. He outlined the figures with hasty pen strokes and went over, and in several places changed, the principal ones with his brush. This can be seen clearly, for example, in Saint Lawrence's left foot. He then reworked some of the heads in pen, giving detail to faces and hair, and finally he applied the washes. Van Dyck may have been planning a painting of Saint Lawrence in the years around 1618–1621. No painting is known, but George Vertue mentions in his Notebooks "at Lord Radnors Sale ... the martyrdom of Saint Laurence by Vandyke 65 guin."[1] Van Dyck's starting point for the composition was Rubens' painting now in Munich [fig. 1],[2] which is usually dated about 1615. Van Dyck adopted the principal features of Rubens' composition, with Lawrence in the center of the foreground being manhandled onto the griddle by men on either side of him. Van Dyck removed the muscular figure putting faggots on the fire in the lower left and added the elderly man in the lower right. He retained the old man who points up at the statue of Jupiter in Rubens' painting, although Van Dyck only indicates with the faintest of brushstrokes that he is intending to include the building and so give point to the gesture. He takes the figure on the left (though not the contorted position of his left leg) from another painting by Rubens, *The Entombment of Christ*, today in the Church of Saint-Géry, Cambrai,[3] which is from the same period. (This is an intriguing borrowing, as Lawrence's body seems lifeless, although he should be alive, and the griddle, whose fire is not being stoked as in Rubens' painting, resembles an open tomb. The substitution of an old man on the right for Rubens' vigorous young man also calls *The Entombment* to mind.)

The principal difference between Rubens' and Van Dyck's treatment of the subject is in the figure of the saint himself. Rubens' Saint Lawrence is shown from the side: he is forced from a standing position back onto the griddle. His back is lowered onto it while his feet are still on the ground. Van Dyck's Saint Lawrence is distinctly ungainly. He is shown frontally, his right arm hangs down as if lifeless, and his legs are splayed clumsily. He is closer in pose to Rubens' figure of Saint John the Evangelist, who was also martyred on a griddle, on the left wing of *The Adoration of the Magi* triptych in Saint John's, Mechelen, which was painted in 1617–1619.[4] This figure, rather than Rubens' Saint Lawrence, may well have been Van Dyck's inspiration. Rubens' source for his *Martyrdom of Saint Lawrence* was Titian: he could have seen the painting in the Gesuiti in Venice[5] and the version of a decade later in the Escorial.[6] Van Dyck would have known the Escorial painting in the form of a print by Cornelis Cort,[7] and he may also have looked at this when he was drawing the body of Saint Lawrence.

The drawing was engraved, in reverse with variations by Anton van der Does (1609–1680).[8]

Fig. 1. Peter Paul Rubens, *The Martyrdom of Saint Lawrence*. Canvas, 244 x 174 cm. Alte Pinakothek, Munich

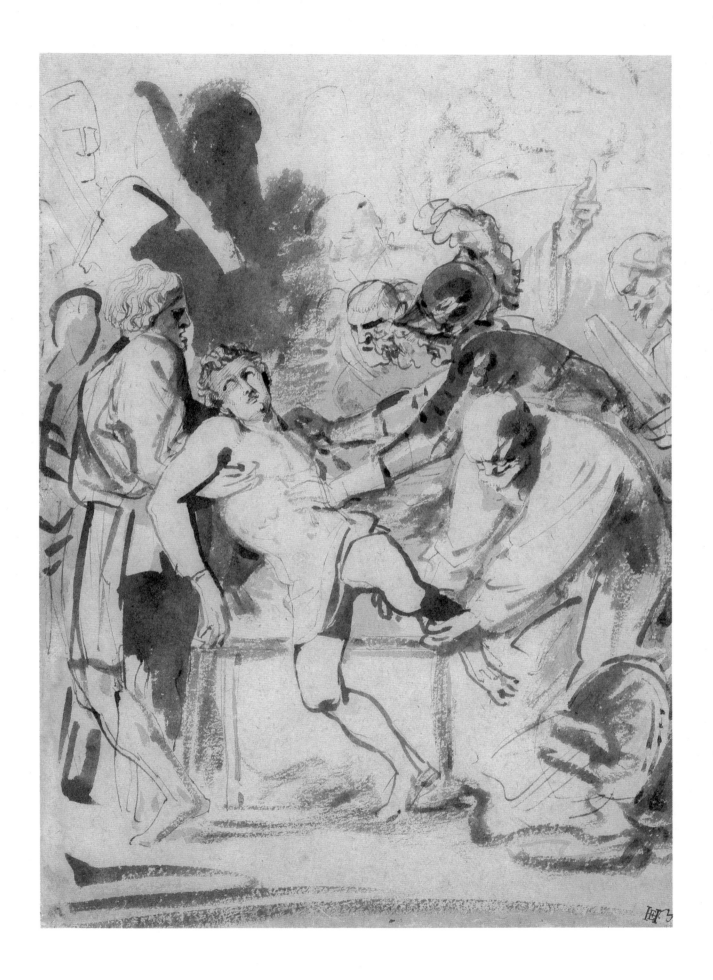

22
The Penitent Magdalen

c. 1618–1621

Pen and brown ink, and brown wash, 184 x
230 mm. Cut on left and right edges. At the top
on the right, in Van Dyck's hand, is the name:
Sofinisba.

Verso: study for *The Adoration of the Shepherds*. Pen
and brown ink. In the center is a large ink blot. On
the right, at the top, is an inscription in pen:
oo.9–56.

Watermark: none

British Museum, London, Department of Prints
and Drawings (inv. no. oo.9–56).

Vey 92

PROVENANCE J. Richardson the Younger
(1694–1771), London (L.2170, lower right);
W. Young Ottley (1771–1836), London; R. Payne
Knight (1750–1824), London (L.1577, top right), by
whom bequeathed to the British Museum.

LITERATURE Hind 1923, no. 12; Vey 1962, no. 92.

1. Van Dyck painted at least six pictures of Saint
Jerome during his first Antwerp period. This
group is discussed in Ottawa 1980, under no. 74,
and Washington 1990–1991, nos. 2 and 8.
2. Hamburg, Kunsthalle. Canvas, 228 x 198 cm.
Glück 1931, 257.
3. Church of Our Lady, Dendermonde. Canvas,
244 x 172 cm. Glück 1931, 255. Washington
1990–1991, no. 61.

In the center of the sheet is the kneeling Magdalen. Above, Van Dyck has drawn her
head for a second time. To the left is a dog who scratches himself with his back leg.
Just to the left of the Magdalen is a man (or a boy) inclining his head and holding
his hat on his chest: this is a study for one of the shepherds in *The Adoration of the
Shepherds* [see cat. 23], for which there is a compositional sketch on the verso.

The study of the Magdalen is not related to any known painting by Van Dyck.
Vey notes the similarity of the pose to that in the various paintings of Saint Jerome
from the first Antwerp period [fig. 1].[1] He suggests that Van Dyck may possibly
have been planning a penitent Magdalen as a companion piece. Vey observes the
similarity of the pose of the scratching dog to antique sculpture and to south
German and Paduan bronzes, but it seems to me just as possible that, despite its
firm line and plasticity, it was drawn from life. The inscription on the recto is
fascinating: it could refer to a woman known to Van Dyck, the classical heroine
Sophonisba or even to the painter Sofonisba Anguissola, whom Van Dyck was to
meet in Palermo in 1624 and whose portrait he drew in his Italian sketchbook
[see Introduction, fig. 13] with, on the same page, a detailed account of their
conversation about painting.

On the verso is a compositional drawing for *The Adoration of the Shepherds*. The
Virgin and Child, with five men in adoration (one cut in half by the trimming of the
page on the right), are shown very schematically on the right-hand side of the sheet.
To the left the central group of the Virgin and two shepherds, one raising his hat,
the other gesturing towards the Child, is drawn a second time. Van Dyck did paint
this subject during his first Antwerp period: there are paintings in Potsdam [cat. 23,
fig. 3] and London [cat. 23, fig. 4]. Both, however, are very early pictures and show
compositions quite different from this one. From the existence of this drawing, we
must presume that towards the end of his first Antwerp period Van Dyck was
planning another painting of this subject, to which he was to return again after his
stay in Italy, in paintings now in Hamburg[2] and Dendermonde.[3]

Fig. 1. Anthony van Dyck, *Saint Jerome*.
Canvas, 192 x 215 cm. Gemäldegalerie, Dresden

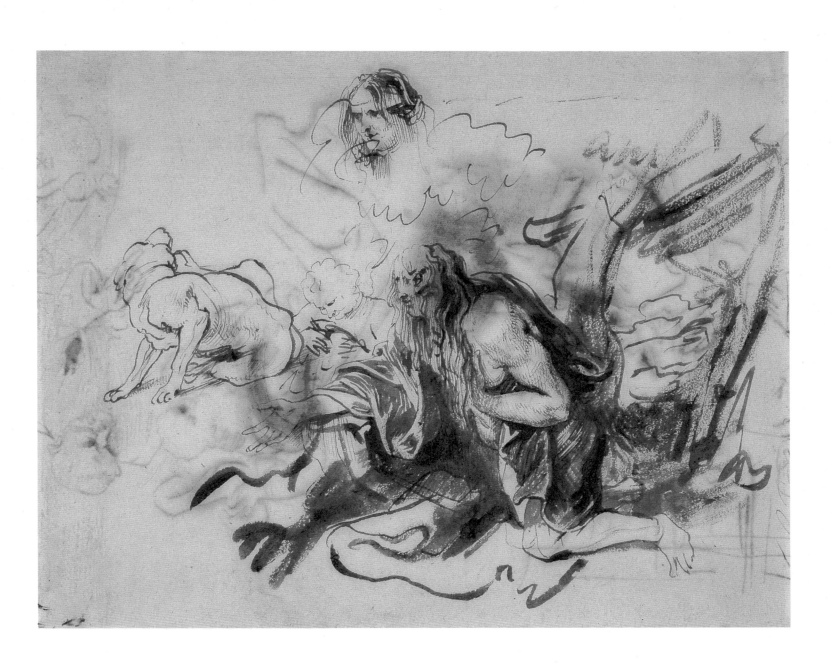

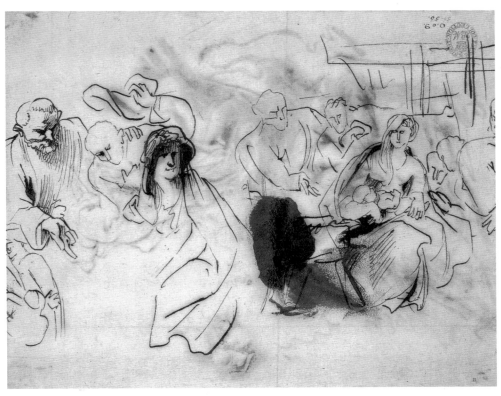

23
The Adoration of the Shepherds

c. 1618–1621

Pen and brown ink, brown wash (this seems to have been applied on top of black chalk which is visible in a few places but elsewhere has been rubbed away), 229 x 192 mm. There is cream bodycolor on the cloth covering the child which Mary lifts. Some damage in lower left-hand corner. Lower right, an inscription in pen in a later hand: *Van Dyk*.

Watermark: not visible

Graphische Sammlung Albertina, Vienna (inv. no. 8624)

Vey 30

PROVENANCE Unknown; Albertina (L.174, lower right).

EXHIBITION Antwerp 1960, no. 16.

LITERATURE Schönbrunner-Meder VIII, no. 907; Benesch 1938, 30; Vey 1962, no. 30.

Towards the end of his first Antwerp period Van Dyck was preparing a painting (or more than one painting) of *The Adoration of the Shepherds.* In addition to the verso of cat. 22, there is another compositional drawing in pen and delicate washes in which the subject is treated in a horizontal format (Vey 28),[1] and there are three sheets containing sketches for individual figures. One, in Berlin [fig. 1], shows a shepherd offering gifts while another shepherd stands behind him. The second [fig. 2], formerly in Bremen, is catalogued by Vey as a copy, but, judging from photographs, I believe (following Held[2]) it to be by Van Dyck himself. It shows two groups of shepherds adoring the Child, one lifting his hat in a gesture that recalls the composition on the verso of cat. 22 and a study for the Virgin and Child. The third, a study for a shepherd, is cat. 24. There is also the present drawing, which is in an upright format, and has little in common with Vey 28. Three of these drawings [cat. 22 verso and figs. 1 and 2] appear to be related to the composition which is recorded in a developed form in the drawing in a private collection in America (Vey 28). The shepherd raising his hat recurs, though in a different position, as does the kneeling shepherd who has a basket, in both the Berlin and Bremen drawings. The Albertina drawing, however, stands alone and cannot be related to this group. It appears either that Van Dyck decided to change the format from horizontal to

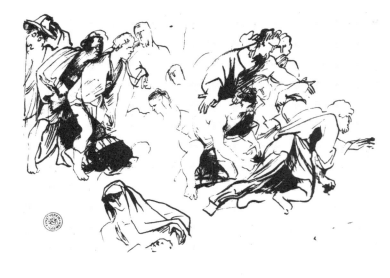

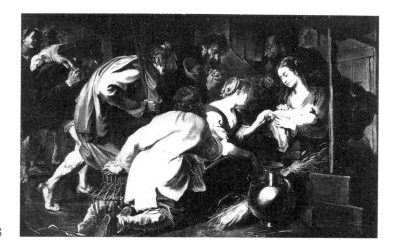

Fig. 1. Anthony van Dyck, *The Adoration of the Shepherds.* Black chalk, gone over in places in pen, 201 x 266 mm. Staatliche Museen zu Berlin, Kupferstichkabinett (Vey 29)

Fig. 2. Anthony van Dyck, *The Adoration of the Shepherds.* Pen, 206 x 319 mm. Formerly Kunsthalle, Bremen (Vey 27)

Fig. 3. Anthony van Dyck, *The Adoration of the Shepherds.* Canvas, 155 x 232 cm. Sanssouci, Potsdam, Bildergalerie

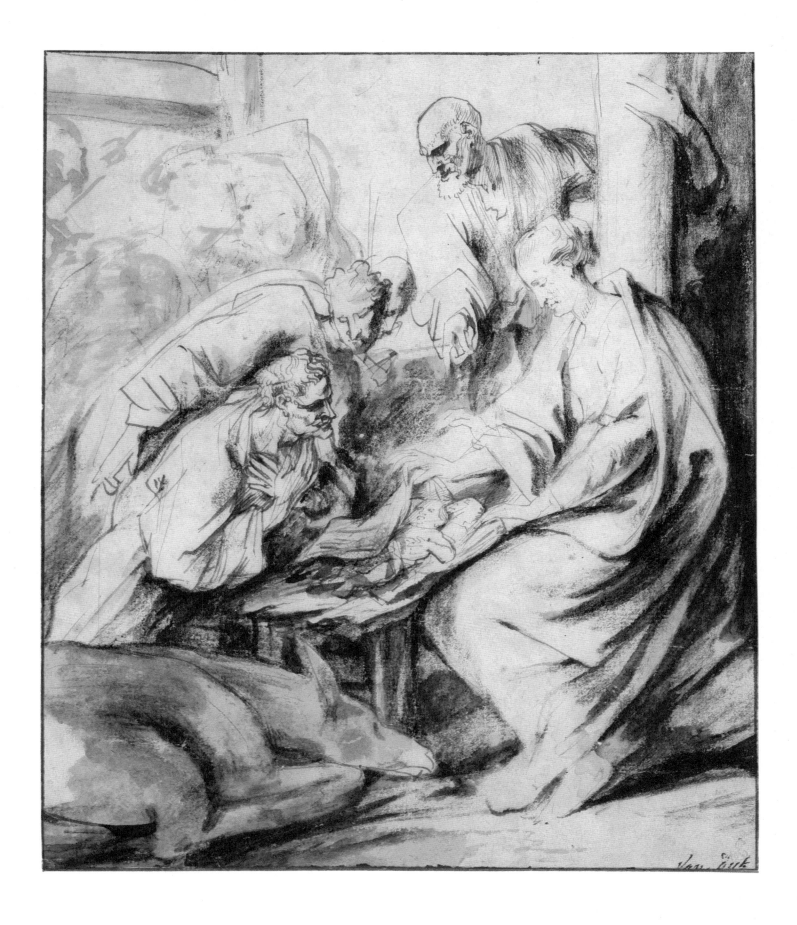

1. Although this drawing probably records a composition by Van Dyck, Held (1964, 566) considered it to be a copy. I have not seen the drawing in the original but, judging from photographs, consider it likely that he is correct.
2. Held 1964, 566.
3. *Flemish Paintings and Drawings at 56 Princes Gate London* (London, 1955), no. 43.
4. Oldenbourg 1921, 166 (top). As part of his duties in Rubens' studio, Van Dyck may have made a drawing after this painting for the engraving of 1620 by Lucas Vorsterman (Vey 164). It is one of the group of drawings for engravings after paintings by Rubens in the Cabinet des Dessins in the Louvre. For a discussion of this group, see under cat. 42.
5. Rouen, Musée des Beaux-Arts. Canvas, 338 x 228 cm. Jaffé 1989, no. 532.
6. Oldenbourg 1921, 198.

vertical and entirely recast it or that this was a different project, which, with its upright format, could have been for an altarpiece.

Van Dyck painted this subject twice at the very outset of his career, that is, in about 1617, in pictures now in Potsdam [fig. 3] and London [fig. 4][3] that show the same composition with small changes. They are imbued with the influence of Rubens, as are the drawings, all of which were made a few years later. Rubens' paintings in Marseilles [fig. 5],[4] Rouen,[5] and Munich [fig. 6],[6] all painted in the period 1617–1619, were the direct inspiration for Van Dyck's drawings and contain individual figures and motifs which can be found there. The horizontal format of the composition recorded in the drawing in an American private collection, the general disposition of the figures, and even the prominence of the ox are to be found in the Marseilles canvas (which was the *predella* of an altarpiece in the Church of Saint John at Mechelen), while the vertical format of the Rouen painting, the placing of the figures, and the pose of the Virgin reappear in the Albertina drawing. Finally, the shepherds who eagerly press forward in Rubens' great altarpiece in Munich are the models for those in this drawing. Van Dyck knew all these works well, and his own drawings are variations on them: he took those elements that he required and refashioned them. This constant, searching analysis of Rubens' work was part of the process of learning to be an independent artist.

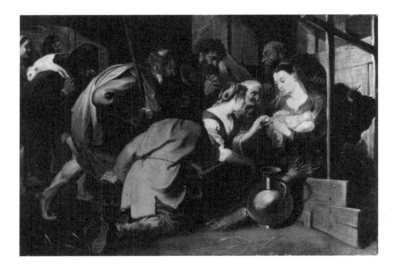

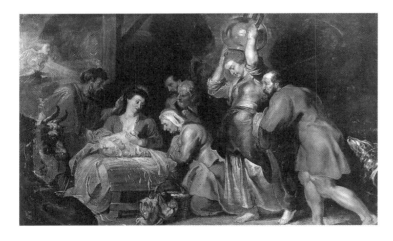

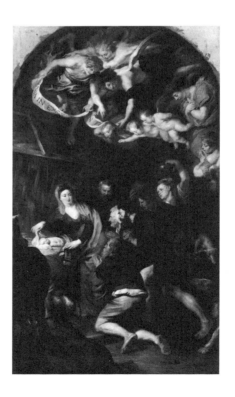

Fig. 4. Anthony van Dyck, *The Adoration of the Shepherds*. Canvas, 111 x 161 cm. Courtauld Institute Galleries (Princes Gate Collection), London

Fig. 5. Peter Paul Rubens, *The Adoration of the Shepherds*. Canvas, 65 x 100 cm. Musée des Beaux-Arts, Marseilles

Fig. 6. Peter Paul Rubens, *The Adoration of the Shepherds*. Canvas, 475 x 270 cm. Bayerische Staatsgemäldesammlungen, Munich

24
A Young Man Leaning on a Staff

c. 1618–1621

Pen and brown ink, brown wash, 186 x 116 mm. On the ground, beneath and between the young man's feet, in the staff and to the left are strokes of black chalk.

Verso: the middle and lower back and left arm of a naked man. Pen with brown ink, with black chalk shading in lower back and buttocks. Also a number of splashes and blots of ink.

Watermark: none

Museum Boymans-van Beuningen, Rotterdam (inv. no. Van Dyck 6)

Vey 51

PROVENANCE Collection of F. J. O. Boymans (1767–1847), Utrecht; Museum Boymans (L.1857, lower right).

EXHIBITION Antwerp 1930, no. 404.

LITERATURE Boymans 1852, no. 258; Boymans 1869, no. 122; Vey 1956A, 52–53, pl. 16; Vey 1962, no. 51.

1. Oldenbourg 1921, 133.
2. It is also possible, as Julius Held suggested to me, that Van Dyck was himself planning a painting of Cimon and Ephigenia.

This bold study of a young man holding a staff was drawn with the point of a brush and later details were added in pen and black chalk. It appears to be a study for a shepherd in one of the compositions of *The Adoration of the Shepherds* which Van Dyck was working on towards the end of his first Antwerp period. It was, however, not used by him in any of the compositional drawings he made of this subject. (These sheets are discussed above, in the entry for cat. 23.) Certainly a shepherd with a staff is a conventional feature of treatments of the subject of *The Adoration of the Shepherds*: one, a far older man, can be found in the early Potsdam and London Adorations by Van Dyck [cat. 23, figs. 3, 4]. Vey points out the similarity of the pose in this drawing to the figure of the shepherd Cimon in the painting by Rubens in Vienna of Cimon and Ephigenia [fig. 1], which dates from about 1617.[1] This may be an accidental resemblance, but if not, it would demonstrate Van Dyck's use of figures by Rubens in different contexts.[2]

The verso, which shows a naked male torso, was thought by Vey to be the work of a different hand. It is, however, similar in technique to the verso of cat. 17 and in my view is by Van Dyck himself. As with that drawing, it seems to be after a cast or (more probably) an engraving of an antique sculpture, an interest which is evident in the Antwerp sketchbook but which had been largely abandoned by the time Van Dyck reached Italy and had the opportunity to study such sculptures in the original.

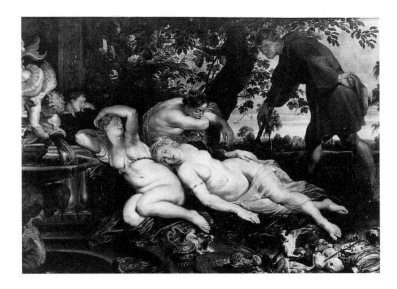

Fig. 1. Peter Paul Rubens, *Cimon and Ephigenia.* Canvas, 208 x 282 cm. Kunsthistorisches Museum, Vienna

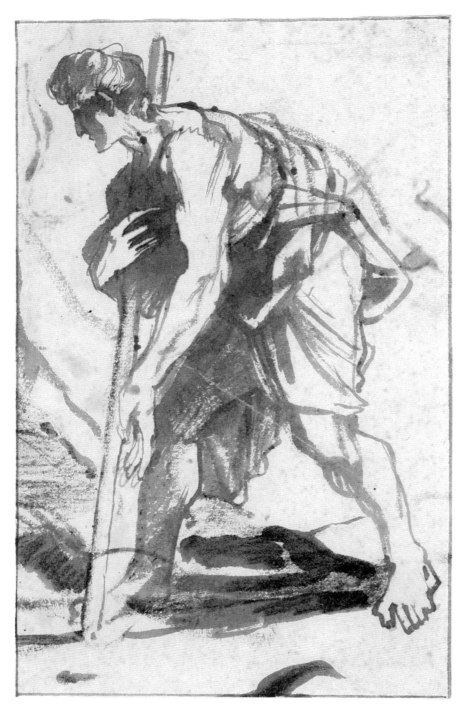

Cat. 24 recto

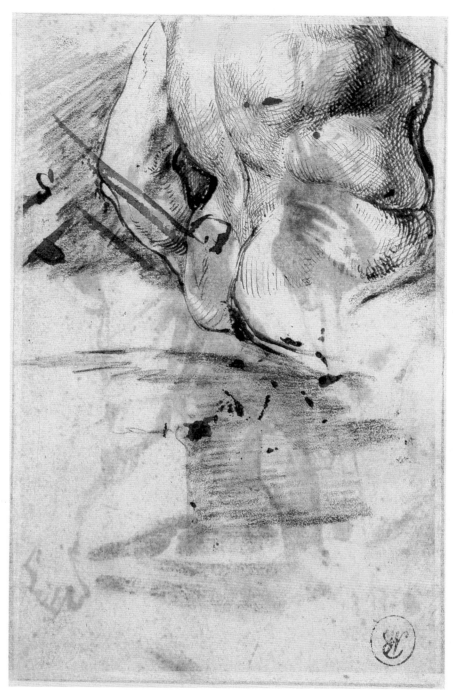

Verso

25
The Expulsion from Paradise

c. 1618–1621

Pen and brown ink, brown wash, 171 x 222 mm.

Verso: four studies for the figures of Adam and Eve in *The Expulsion from Paradise*.

Watermark: none

Stedelijk Prentenkabinet, Antwerp
(inv. no. 122, A.XXI.2)

Vey 1

PROVENANCE Collection of C. van Cauwenberghs (1863–1945), Antwerp.

EXHIBITIONS Antwerp 1927, no. 35; Antwerp 1936, no. 69; Antwerp 1949, no. 72; Antwerp 1960, no. 1; Antwerp 1971, no. 16; Paris 1974, no. 22; Washington 1976–1978, no. 14; Princeton 1979, no. 22; Ottawa 1980, no. 46.

LITERATURE Delen 1938, no. 374, pl. 69; Delen 1943A, no. 1a; Vey 1962, no. 1; Held 1964, 566.

1. Held 1964, 566.
2. In Princeton 1979, no. 22.
3. J. R. Martin, *The Ceiling Paintings for the Jesuit Church in Antwerp*, Corpus Rubenianum Ludwig Burchard, Part 1 (London, 1968), no. 40 (I), 187–189.

This marvelously vigorous drawing shows Adam and Eve being driven from the Garden of Eden by an angel who holds a sword in his raised right arm. Between the angel and Adam and Eve is the Tree of the Knowledge of Good and Evil, around the branches of which the serpent is coiled. The verso is equally vigorous and shows no fewer than four different studies of the figures of Adam and Eve. Vey described these drawings as copies by a later hand after the figures of Adam and Eve on the recto. Following Held,[1] I consider that they are certainly by Van Dyck himself and show the artist's first thoughts for the composition. Martin and Feigenbaum[2] have proposed a convincing sequence of work. The project began with the fleeing pair on the far right of the verso, which is marked off by a vertical line at the left-hand side of the composition. Adam and Eve are shown fleeing, both looking over their shoulders in terror at the angel, who cannot be seen. In the lower left-hand corner is a new pose for Adam, bending slightly and looking over his shoulder. Above this figure are Adam and Eve again; here Adam's body has been straightened and turned slightly towards the viewer; Eve is indicated by a few very sketchy pen lines. Finally, in the center of the sheet, in a very schematic manner, Adam is shown half-turned towards the angel and with his left hand raised. This solution evidently satisfied Van Dyck, for he then turned the paper over and used this pose in the compositional drawing on the recto. Adam's pose, from the blind terror of the first sketch on the verso, now contains an element of defiance. Van Dyck's compositional drawing was first outlined in pen which he then went over with his brush in order to emphasize particular details, make small changes (in, for example, the branches of the tree), and indicate dark areas.

The expulsion of Adam and Eve from Paradise was one of the subjects planned for the ceilings of the Jesuit church in Antwerp but never carried out.[3] Van Dyck was Rubens' principal assistant on this project and would have been familiar with Rubens' oil sketch of *The Expulsion from Paradise*, which is now in the Národní Galerie, Prague [fig. 1]. Rubens' treatment of the subject was based on a long established northern tradition that included woodcuts by Hans Holbein and Tobias

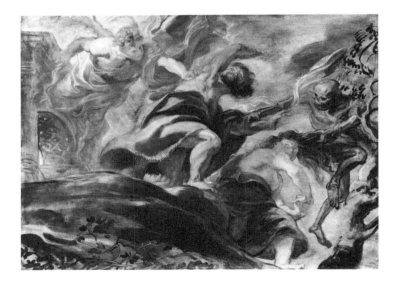

Fig. 1. Peter Paul Rubens, *The Expulsion from Paradise*. Panel, 49.5 x 64.5 cm. Národní Galerie, Prague

Fig. 2. Attributed to Jan Boeckhorst, *The Expulsion from Paradise*. Oil on paper, 19.1 x 17.2 cm. National Gallery of Canada, Ottawa

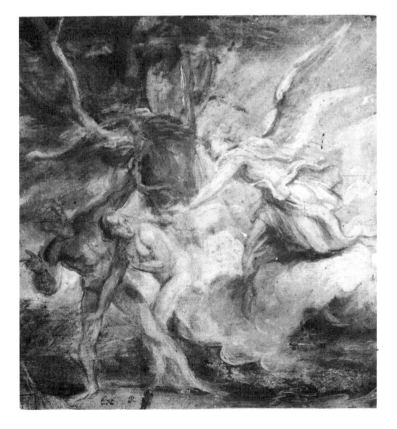

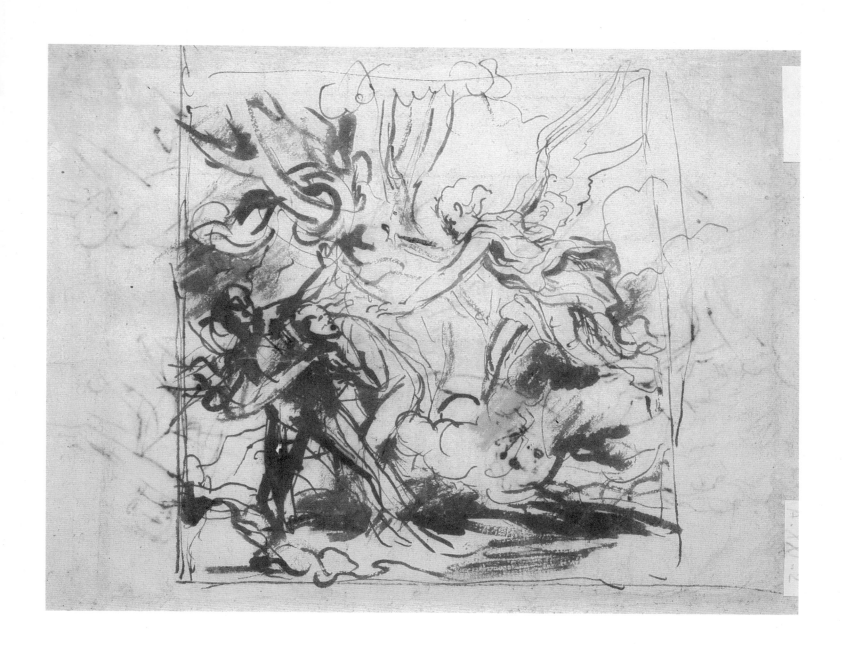

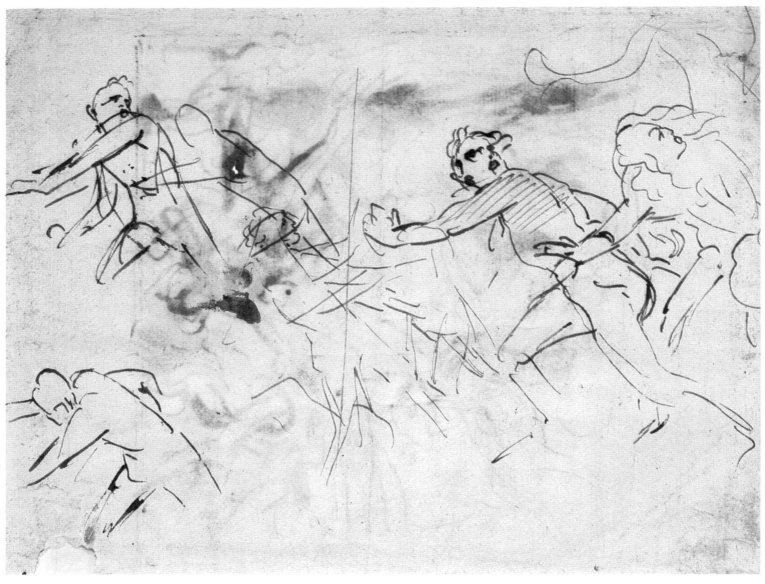

Verso

4. As noted by Martin, ibid.
5. Provenance: collection of Jonathan Richardson the Elder (L.2184); Thomas Hudson (1701–1779), London (L.2432); Sir Joshua Reynolds (1723–1792), London (L.2364); J. B. S. Morritt, Rokeby Park, Yorkshire, and by descent; private collection, London; Exhibition of Drawings, Baskett and Day, London, 1973, no. 7; purchased by the National Gallery of Canada from Baskett and Day, London, 1975.
6. It was exhibited as Van Dyck in Princeton 1979, no. 23; Ottawa 1980, no. 47; and Vancouver 1988–1989, no. 39. It was discussed as Van Dyck by B. Nicolson, "Current and Forthcoming Exhibitions," *Burlington Magazine*, 116, 1974, 52–53; Carlos van Hasselt in Paris 1974, 35 (under no. 22); J. D. Stewart, [Review of Princeton 1979], *Burlington Magazine*, 121, 1979, 466–468; Washington 1990–1991, no. 90 (catalogue entry by J. Held). However, in Larsen 1980, it is rejected (no. A68).
7. In Vancouver 1988–1989, no. 39, J. Douglas Stewart suggests that *The Expulsion* is a late, English period work by Van Dyck and may have been intended as a pair to the *Cupid and Psyche* (London, Royal Collection) as part of the decorations of the Queen's House at Greenwich. There is no documentary evidence for this idea (which is iconographically unlikely), while stylistically the drawings (and so the sketch, if it is by Van Dyck) must be from the first Antwerp period.
8. In Antwerp 1990, 126–127.
9. *Apollo and Marsyas*. Ibid., no. 29. The *Apollo and Python* (Ibid., no. 28) is presumably from the same cycle of scenes from the life of Apollo.
10. Lahrkamp 1982, nos. 102, 102a.
11. Denucé 1932, 271.
12. A.-M. Logan, "Jan Boeckhorst als Zeichner," in Antwerp 1990, 118–132, fig. 85.
13. H. Vlieghe, "Jan Boeckhorst als Mitarbeiter," ibid., 75–86, and I. van Tichelen and H. Vlieghe, "Jan Boeckhorst als Maler von Vorlagen für Bildteppiche," ibid., 109–117.
14. Ibid., 140.

Stimmer. Burchard[4] noted that a number of ideas in this composition were taken from *The Expulsion* in Stimmer's *Neue Künstliche Figuren Biblischer Historien* (Basle, 1576), from which Rubens made a number of copies. Although Van Dyck must have been aware of Rubens' composition, he treated the subject in a quite different way. Instead of placing the scene at the gate of the Garden of Eden, he shows it taking place inside the garden, with the Tree of Knowledge in the background. The viewpoint and poses are quite different and the figure of Death is omitted. Van Dyck's Adam and Eve are naked while Rubens' wear animal skins. Van Dyck's treatment is more concentrated and so more dramatic than Rubens', but it lacks the narrative power which is such an important part of Rubens' approach to history painting.

Van Dyck seems to have gone back to Stimmer's book, which he probably knew well, rather than basing his design on Rubens'. This might suggest that Van Dyck's drawing was made before Rubens' oil sketch, and indeed Vey considered that this was probably one of the earliest of all Van Dyck's drawings. I find this difficult to accept if the Antwerp sketchbook shows Van Dyck's earliest drawing style. Rather, this drawing fits stylistically with the many drawings which are roughly datable to the period 1618–1621.

Closely related to this drawing is an oil sketch on paper in the National Gallery of Canada [fig. 2].[5] It has a distinguished provenance and has been widely accepted as an early though untypical work by Van Dyck.[6] As such it is the only oil sketch from his first Antwerp period[7] when the function of the *modello* was (as far as we know) served not by an oil sketch but by a drawing. In addition, this sketch is strikingly different in technique and support from Rubens' oil sketches for the Jesuit church project, with which Van Dyck would have been very familiar. It has recently been suggested by Ann-Marie Logan that this sketch is in fact by Jan Boeckhorst,[8] and I find her arguments, which are largely stylistic, very persuasive. The long-legged Adam is a physical type that is hard to parallel in Van Dyck but can be found, for example, in the figure of Apollo in Boeckhorst's *Apollo and Marsyas* in the collection of Hans Platzer in Zollikon and in the *Apollo and Python* in Ghent [fig. 3].[9] Logan compares the figure of the angel with an angel in one of Boeckhorst's illustrations for the *Breviarium Romanum* of 1655.[10] She also points out that in a codicil to his will dated 20 April 1668 Boeckhorst bequeathed his painting of Adam and Eve to a glass painter, Jacques Horremans, and that in Horremans' inventory (6–7 May 1678) the painting is described as "het Verdryven van Adam en Eva uit Aerts paradys" (The Expulsion of Adam and Eve from the Earthly Paradise).[11] If Boeckhorst is the artist of the Ottawa sketch, the attribution of the Antwerp drawing is also called into question. In my view, there is nothing among the drawings known to be by Boeckhorst[12] that is comparable to the Antwerp drawing, whereas that drawing, in its vigor, its abbreviated faces, and roughly sketched limbs (often without hands or feet), has much in common with other drawings by Van Dyck from the period 1618–1621. The only conclusion must be that Boeckhorst, who was a close friend of Van Dyck, worked the drawing up into an oil sketch and, perhaps, into a painting. It is clearly the case that a number of paintings by Boeckhorst are based on Rubensian models,[13] and it is perfectly feasible that he should have based his *Expulsion* on a drawing by Van Dyck, although there may have been a substantial time lapse, as Boeckhorst is not known to have been in Antwerp before about 1626.[14]

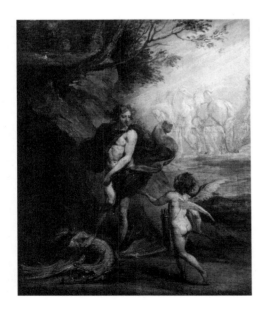

Fig. 3. Jan Boeckhorst, *Apollo and Python*. Canvas, 60 x 50 cm. Museum voor Schone Kunsten, Ghent

The Drawings for *The Crowning with Thorns*

1. Elizabeth McGrath has pointed out that this subject should more properly be described as *The Mocking of Christ*, as the crowning with thorns is only one element in the *Mocking*. I have chosen, however, to retain the traditional title (used by Glück 1931 and Vey 1962) for ease of identification.
2. The format of the Berlin painting was more upright—and so more appropriate for an altarpiece—than that of the Madrid version.
3. Muller 1989, Catalogue I, 135, no. 235 ("Une Coronation de notre Seigneur").
4. Kunsthistorisches Museum (inv. no. 524). Oldenbourg 1921, 191.
5. Van Dyck's free copy (in oil on canvas) is in the National Gallery, London (inv. no. 50). Canvas, 149 x 113.2 cm. It was probably painted about 1618–1621 for Nicholas Rockox, whose portrait appears in the group of figures on the right. Washington 1990–1991, no. 10.
6. The great triptych of *The Raising of the Cross* is now in the Cathedral in Antwerp (Oldenbourg 1921, 36).
7. Glück 1931, 31 (right) and 36 (bottom).
8. This drawing was sold at Christie's, London, 8 July 1975, lot 100. The handling is very clumsy. In my view, it does not necessarily record a lost Van Dyck drawing but may be a later imitation based on cat. 28 (Vey 74).

As with most of Van Dyck's major projects in his first Antwerp period, there is more than one version of *The Crowning with Thorns*.[1] The prime version would seem to be the painting on canvas which was in the Kaiser-Friedrich-Museum, Berlin, and was destroyed during the war [fig. 1].[2] A slightly smaller second version, also on canvas, is in the Prado [fig. 2]. That painting was in Rubens' collection and was bought shortly after his death by Philip IV of Spain.[3] It must have originally been planned as a replica of the Berlin painting, but Van Dyck painted out the figure of a Roman centurion wearing a lion skin on the left (who is taken—loosely—from Rubens' *Saint Ambrose and the Emperor Theodosius* in Vienna,[4] which Van Dyck had copied[5]) and made the figure leaning over Christ more prominent. He also added a snarling dog, which is a direct quotation from Rubens' *Raising of the Cross* for Saint Walburga,[6] and two figures seen through the bars of the window. He altered the heads of the two figures who lean over Christ on left and right, using head studies he had made previously.[7] Vey lists six drawings for *The Crowning with Thorns* as well as another which he considers to be documented in a copy (Vey 76).[8] Four of these drawings are in the exhibition and show Van Dyck evolving and refining his treatment of the subject. As is so often the case with Van Dyck in the first Antwerp period, his subject is based on a Rubens prototype, *The Crowning with Thorns*, painted in 1602 for Santa Croce in Gerusalemme in Rome and now in the Cathedral in Grasse [fig. 3].[9] Van Dyck would not have known the original before he traveled to Rome but a preparatory drawing by Rubens for this painting is in

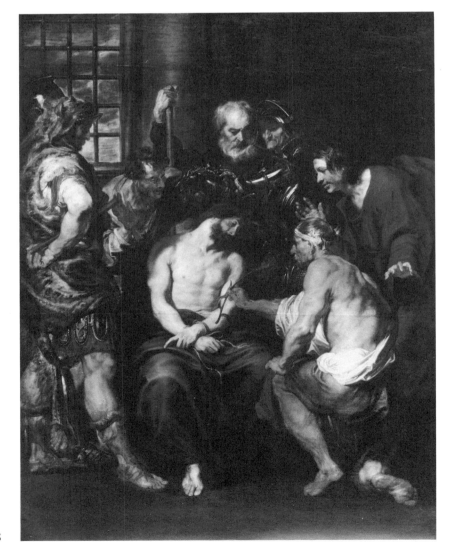

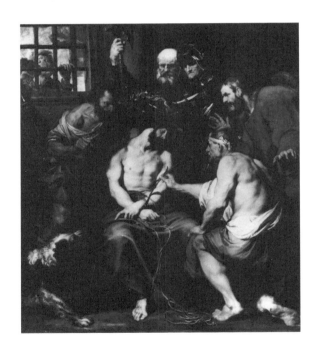

Fig. 1. Anthony van Dyck, *The Crowning with Thorns*. Canvas, 262 x 214 cm. Formerly Kaiser-Friedrich-Museum, Berlin

Fig. 2. Anthony van Dyck, *The Crowning with Thorns*. Canvas, 223 x 196 cm. Museo del Prado, Madrid

9. Oldenbourg 1921, 2 (left).
10. Held 1986, no. 13.
11. Princeton 1979, 62.

Braunschweig [fig. 4][10] and may well have been known to Van Dyck.

The drawing which is closest to the finished paintings is in the Louvre [fig. 5]. It is lightly squared for transfer to the canvas and so should be considered the *modello* for the painting formerly in Berlin. The exact sequence of the others is hard to determine. Both the drawings in London [cat. 26] and in Amsterdam [cat. 27] show compositions which are very different from the final one and must therefore represent relatively early stages in the evolution of the design. Vey considered the London drawing to have come first, whereas Martin and Feigenbaum[11] thought that the Amsterdam drawing preceded it. While it is true to say that the degree of detail and finish in an early drawing by Van Dyck does not establish its exact place in a sequence of drawings, the earliest drawings tend to be sketchier and have bold slashes of dark wash. I have, therefore, reverted to Vey's order, placing the London drawing first, followed by the drawings in Amsterdam [cat. 27], Paris (Musée du Petit Palais) [cat. 28] and the black chalk study for the figure of Christ in the Ashmolean Museum [cat. 29]. In addition, there is a drawing in black, red, and white chalk in Rotterdam for the tormentor who kneels on the right [fig. 6], and finally, the Louvre *modello* [fig. 5].

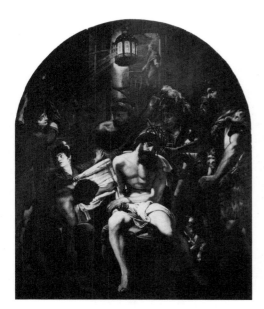

Fig. 3. Peter Paul Rubens, *The Crowning with Thorns*. Panel, 224 x 180 cm. Cathedral, Grasse

Fig. 4. Peter Paul Rubens, *The Crowning with Thorns*. Pen and brown ink, 208 x 289 mm. Herzog Anton Ulrich-Museum, Braunschweig

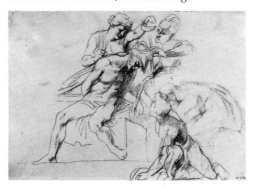

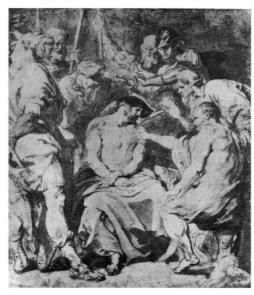

Fig. 5. Anthony van Dyck, *The Crowning with Thorns*. Black chalk, with gray wash and gone over in places with pen and brown wash, squared up with black chalk, 384 x 316 mm. Musée du Louvre, Paris, Département des Arts graphiques (Vey 78)

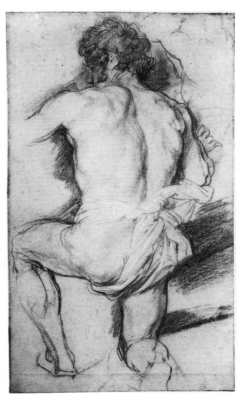

Fig. 6. Anthony van Dyck, *A Kneeling Man, Seen from Behind*. Black and red chalk, with white chalk highlights, 465 x 270 mm. Museum Boymans-van Beuningen, Rotterdam (Vey 75)

26
The Crowning with Thorns

c. 1618–1621

Pen and brown ink, with brown wash, 239 x 208 mm. Lower right, an inscription in pen: *525*.

Watermark: not visible (laid down)

Victoria and Albert Museum, London (inv. no. Dyce 525)

Vey 72

PROVENANCE J. Richardson the Younger (1694–1771), London (L.2170, lower right); Rev. A. Dyce (1798–1869); Victoria and Albert Museum (L.1957, lower right).

EXHIBITIONS Princeton 1979, no. 11; Ottawa 1980, no. 28.

LITERATURE Dyce 1874, 78, no. 525 (attributed to Van Dyck); Rooses 1903, 136; Glück 1931, 48 (it is presumably this drawing that is referred to); Delacre 1934, 48; Vey 1958, 115ff.; Vey 1962, no. 72.

1. Princeton 1979, 64.
2. This painting belongs to the series of Mysteries of the Rosary of which Van Dyck's *Carrying of the Cross* (see discussion on p. 48ff.) was another.

This drawing shows an early stage in the evolution of the design of *The Crowning with Thorns*. Van Dyck took the general disposition of the figures from Rubens' painting of 1602 (which he knew in the form of a copy or preparatory drawings such as that in Braunschweig: see discussion above), but at this stage he greatly simplified the composition, reducing the number of tormentors to four and emphasizing the force with which the crown of thorns is crammed on Christ's head. In doing this he may well, as Vey notes, have had access to Rubens' preparatory drawing in Braunschweig [p. 119, fig. 4], in which Christ's pose, with his head farther to the right than in the painting and his right leg stretched out to the left, is far closer to the pose in this drawing than in Rubens' painting. The pressure with which he is crowned pushes Christ's head and body to the right: he is prevented from falling by the man on the right who braces his body by raising his left knee. This figure recalls the well-known pose of Saint John as he supports the body of Christ in Rubens' *Descent from the Cross* in Antwerp Cathedral [fig. 1]. The figure of Christ's principal tormentor—who crushes the crown of thorns on his head—has been altered. He was at first shown wearing a helmet and his face was lower, closer to Christ's head. The position of his left arm has been changed a number of times.

The kneeling tormentor on the left, whose face is in profile, is, as Vey has pointed out, based on a similar figure in Dürer's *Crowning with Thorns* [fig. 2] in the "Small Woodcut Passion." The baluster on the left, to which the pole on the end of which the brazier hangs is attached, was thought by Martin and Feigenbaum[1] to refer to the iconography of the "low column" of Christ's Flagellation, the event in the Passion which immediately precedes the Crowning with Thorns. This is probably correct: it certainly resembles closely the column to which Christ is bound in Rubens' *Flagellation* in Saint Paul's, Antwerp.[2] It also has the practical function of supporting the brazier. Van Dyck has used wash in a bold and original manner to suggest the fire and smoke in the brazier.

Fig. 1. Peter Paul Rubens, *The Descent from the Cross*. Detail showing the figure of Saint John. Cathedral, Antwerp

Fig. 2. Albrecht Dürer, *The Crowning with Thorns* from the "Small Woodcut Passion," 1511

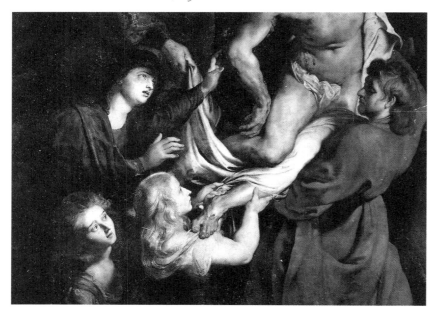

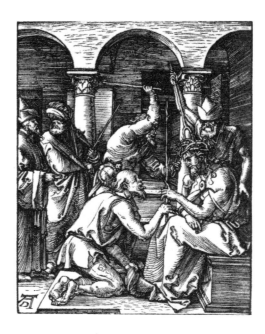

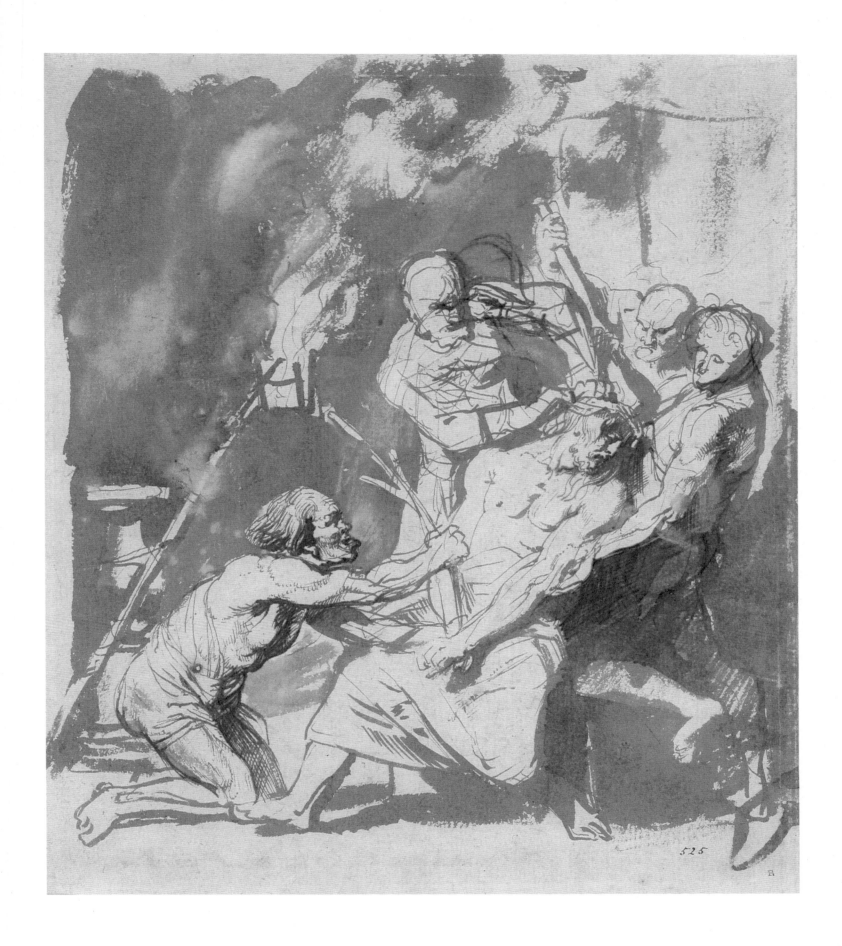

525

27
The Crowning with Thorns

c. 1618–1621

Pen and brown ink over black chalk, with brown wash and touches of white bodycolor, 186 x 176 mm. Lower left, in pen: *V. dyck.*

Verso: lower left, in pen: *300.*

Watermark: none

Amsterdams Historisch Museum (Fodor Collection, no. 52)

Vey 73

PROVENANCE J. Barnard (d. 1784), London (according to London 1835A, no. 16); Sir Thomas Lawrence (1769–1830), London (London 1835A, no. 16) (L.2445, lower left); Six Collection; Six van Hillegom sale, Amsterdam, 7 June et seqq. 1845, lot 268 (purchased by Fodor); C. J. Fodor (d. 1860), Amsterdam; Museum Fodor (L.1036, verso).

EXHIBITIONS Antwerp 1949, no. 78; Recklinghausen 1959, no. 84; Antwerp 1960, no. 36; Amsterdam 1963, no. 11; Princeton 1979, no. 10.

LITERATURE Fodor 1863, 29, no. 52; Cust 1900, 238, no. 6; *Vereeniging tot Bevordering van Beeldende Kunsten* (Amsterdam, 1927), ill.; Delacre 1934, 46, pl. 21; Vey 1958, 115ff.; Vey 1962, no. 73; Schapelhouman 1979, no. 15.

In this study for *The Crowning with Thorns*, Van Dyck has straightened the pose of Christ's body from that in the London drawing [cat. 26] and placed it more centrally in the composition. He has also repositioned the left leg. The group of five figures in the London drawing has been increased to nine including the kneeling tormentor on the left. This figure, which has such an ungainly pose, is taken from a kneeling attendant in *The Interpretation of the Sacrifice* from the Decius Mus series [cat. 8, fig. 3]. He is less prominent than his predecessor (who was taken from Dürer) in the London drawing, and Van Dyck subsequently whited him out with bodycolor. A new figure is the man holding a dish: he is present in a substantially altered form in cat. 28 but is dropped from the final composition.

An entirely new emphasis is on the group of figures on the right. The Roman soldier in armor is taken from Rubens' 1602 altarpiece. This impressive figure has apparently been drawn in a darker ink over the existing figures which on close inspection can be seen to continue beneath him. It was probably after he had drawn this figure and so decided to place greater emphasis on the right-hand side of the composition that Van Dyck whited out the kneeling tormentor on the left and cut the sheet on the left in order to place the body of Christ in the center of the composition.

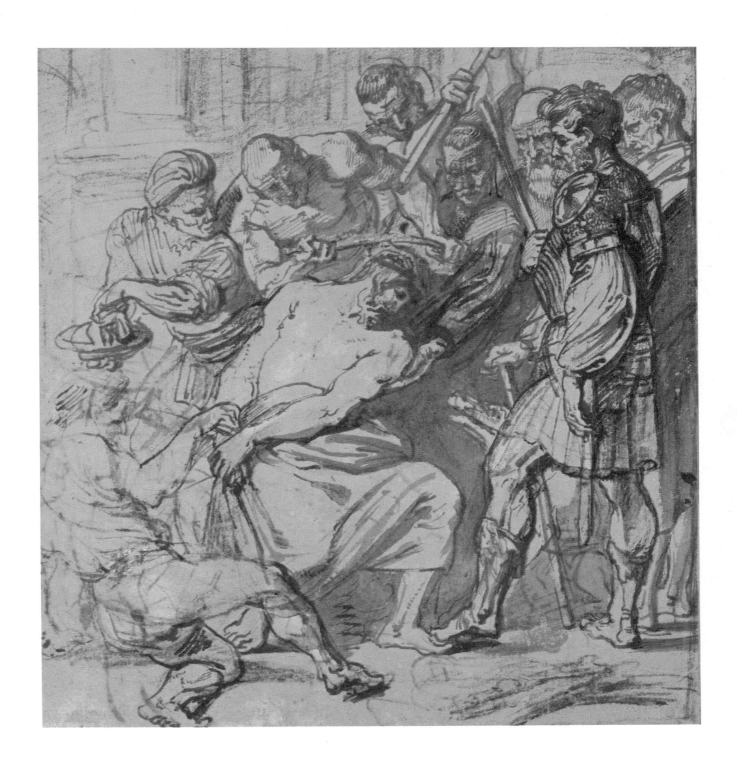

28
The Crowning with Thorns

c. 1618–1621

Black chalk, pen and brown ink, brown and gray washes, 223 x 194 mm. Beneath the figure of Christ is a faded (obliterated?) inscription in black chalk. The letter *d* is visible (part of a signature?). Lower right, in pen: 5.

Musée du Petit Palais, Paris (Dutuit Collection, inv. no. 1033)

Vey 74

PROVENANCE R. Houlditch (d. 1736), London (L.2214, lower right); Thomas Hudson (1701–1779), London (according to London 1835A, no. 27); Sir Thomas Lawrence (1769–1830), London (London 1835A, no. 27) (L.2445, lower left); Baron J. G. Verstolk van Soelen (1776–1845), The Hague; his sale, Amsterdam, 22 March 1847, lot 53; G. Leembruggen (1801–1865), Hillegom; his sale, Amsterdam, 5 March 1866, lot 203; L. Galichon (1829–1893), Paris; his sale, Paris, 10–14 May 1875, lot 46; De Chennevières (1820–1899), Paris (according to Guiffrey 1882, 36); E. and A. Dutuit (1807–1886 and 1812–1902), Rouen (L.709a, lower left).

EXHIBITIONS Paris 1879, no. 314; Zurich 1947, no. 107; Rotterdam 1948–1949, no. 79; Paris 1949, no. 118; Brussels 1949, no. 111; Antwerp 1949, no. 77; Princeton 1979, no. 12; Ottawa 1980, no. 29.

LITERATURE Guiffrey 1882, 36; Menotti 1897, 387; Buschmann 1916, 43; Lugt 1927, no. 27, pl. 13; Glück 1931, 48; Delacre 1934, 49, pl. 23; Vey 1958, 115ff.; Vey 1962, no. 74.

1. Chatsworth inv. no. 987. Delacre 1934, pl. 24; exhibited in Nottingham 1960, no. 42. Vey has kindly informed me that a second copy was in 1964 in the collection of Victor Sordan, New York.

In this, the third in the series of compositional drawings for *The Crowning with Thorns*, Van Dyck has again made radical changes in the composition. The kneeling tormentor on the left, so prominent in the London drawing [cat. 26], and redrawn and subsequently whited out in the Amsterdam drawing [cat. 27], has now gone altogether. The man holding a dish in cat. 27 has been developed into a far more prominent figure, a turbaned man who leans forward to dip his hand into a dish held by a boy. The boy watches the scene with fascinated horror. On the right, the soldier taken from Rubens' painting of 1602 and introduced into cat. 27 at an advanced stage has now been moved in towards the center of the composition. Instead of being an observer he is now an active participant: it is he who places the crown of thorns on Christ's head. His appearance has been radically changed: he is younger, beardless, and wears a helmet. He performs the crowning carefully, almost gingerly: it is truly a coronation. In front of him, towards the right, are two tormentors, the most prominent seen from behind, the other, with a face which is a caricature of boorishness, reaches towards Christ making a mocking gesture and pursing his lips to spit at him. There is a fine study for the kneeling tormentor drawn from a studio model in black chalk with white highlights (and touches of red and yellow) in Rotterdam [p. 119, fig. 6].

In this drawing, for the first time in the series, the architectural setting, which is intended to suggest the palace of Pontius Pilate *(aula Pilati)*, is rendered in some detail. There is no attempt to create a setting in cat. 26; in cat. 27 we can make out some rudimentary architecture sketched in black chalk, including the base of a column. Here the column has become a banded pilaster, and at the left there is a vista into an arcaded courtyard.

Vey notes that there is a copy of this drawing at Chatsworth.[1]

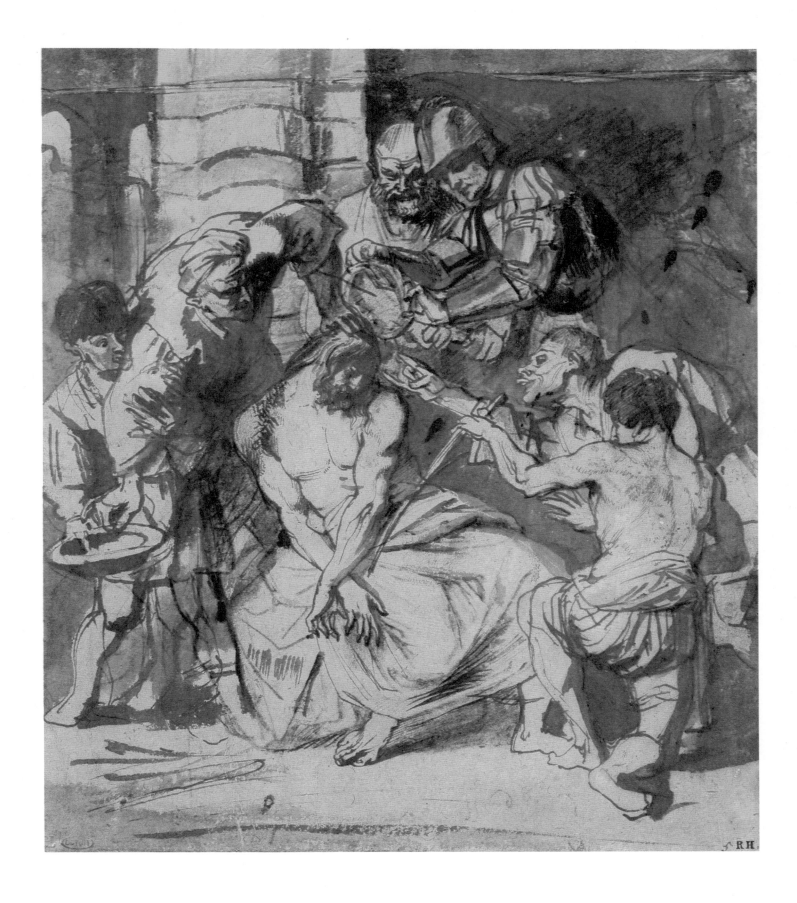

125

29
Studies for *The Crowning with Thorns*

c. 1618–1621

Black chalk, highlighted with white chalk, on white paper (which has been toned light rose-brown), 370 x 270 mm. There are touches of red and black chalk and dark gray and dark brown wash on chin, arms, and hands, probably by a later hand. Some staining and small damages.

Verso: study for *The Crowning with Thorns*. Black chalk. Lower right, an inscription in graphite: *Vandike*. Top right, in pen: *Pp. 13*.

Watermark: none

Ashmolean Museum, Oxford

Vey 77

PROVENANCE P. H. Lankrink (1628–1692), London (L.2090, lower right); J. Richardson the Elder (1665–1745), London (L.2184, lower right); Thomas Hudson (1701–1779), London (L.2432, lower left); Sir Joshua Reynolds (1723–1792), London (L.2364, lower right); Chambers Hall (1786–1855), Southampton and London (L.551, lower right); University Galleries, Oxford (L.2003, lower right).

EXHIBITIONS London 1927, no. 585; London 1938, no. 604; Antwerp 1949, no. 76; Leicester 1952, no. 29; London 1953–1954, no. 484; Antwerp 1960, no. 38; Princeton 1979, no. 15; Ottawa 1980, no. 30.

LITERATURE Colvin 1907, no. 21; Buschmann 1916, 44–45; Glück 1931, 48; Burchard 1932, 10; Delacre 1934, 52, pls. 26 and 27; Parker 1938, no. 129, pl. 26; Delen 1943A, no. 101; Delen 1949, no. 27; Vey 1958, 115ff.; Vey 1962, no. 77.

1. Panel, dimensions unknown. Present whereabouts unknown. Glück 1931, no. 31 (right).
2. Inv. no. 16380.

On the recto of this sheet is a study for the figure of Christ in *The Crowning with Thorns*. Having, after numerous changes and revisions [see cats. 26, 27, and 28], arrived at his final composition in the drawing in the Louvre [p. 119, fig. 5], Van Dyck posed models in the studio in the positions of particular figures. Three of these studies have survived, of which two are on either side of this sheet. The third, for the kneeling tormentor seen from the back on the right, is in Rotterdam [p. 119, fig. 6]. For the drawing on the recto of this sheet Van Dyck posed a model in the position of Christ and indicated the way in which Christ's hair was pulled by a figure standing behind him: only the hand of this figure can be seen in the drawing. On the verso is a study of a hand holding a staff. This is for the figure of the elderly bearded soldier standing above Christ. The model's head is shown in the most schematic manner on the right edge of the sheet. Above the shoulder of the model holding the staff is a faint drawing in black chalk of a bearded man's head seen in profile. This is a study for the head of the man above the kneeling tormentor on the right. He was young and beardless in the Berlin painting, but in the Madrid painting [p. 118, figs. 1, 2] has become older and bearded. The drawing is related to this change; it is clearly for the second version of this figure, for which Van Dyck also made use of a head study in oil on canvas.[1] Vey notes a copy of the recto in the Biblioteca Reale in Turin.[2]

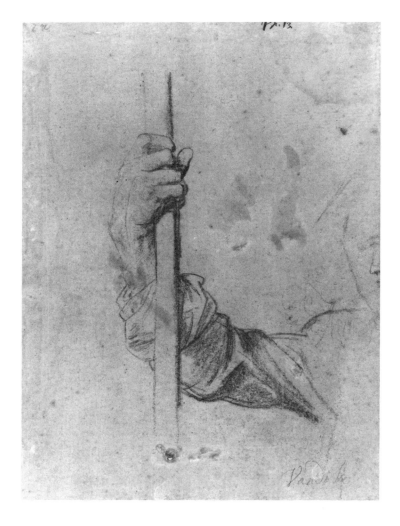

Verso

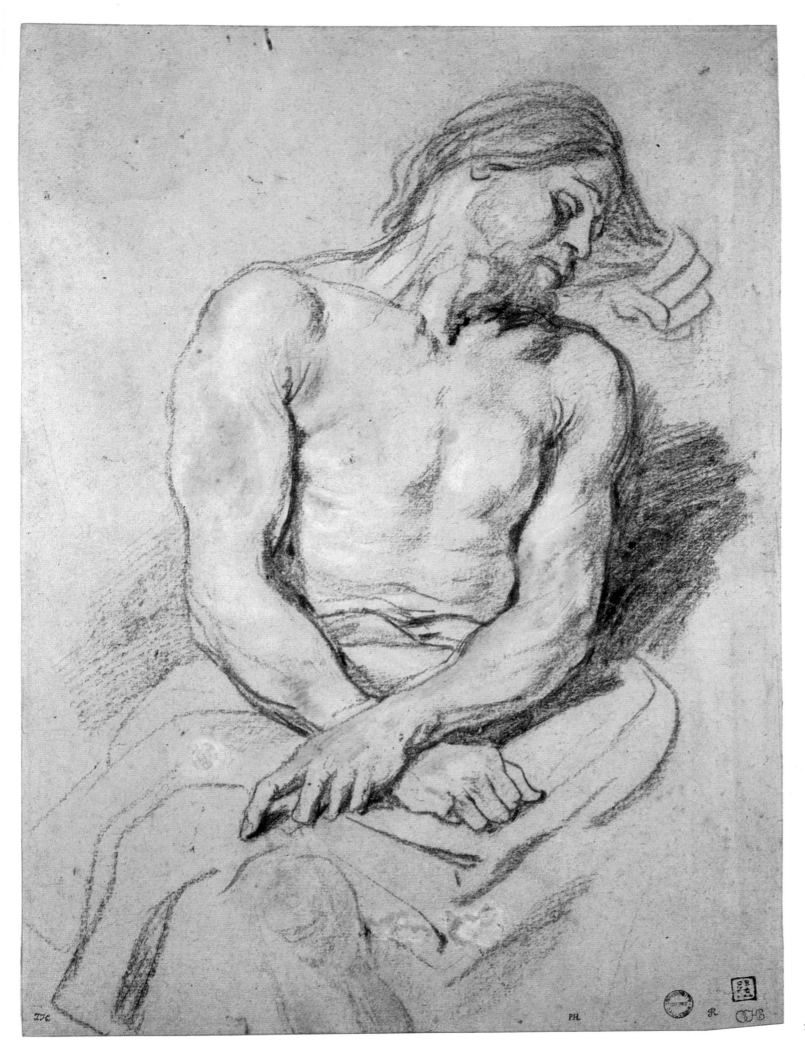

PH.

127

The Drawings for *The Taking of Christ*

1. Muller 1989, Catalogue I, 134, no. 232.

The Taking of Christ was a subject on which Van Dyck worked incessantly over a period of many months towards the end of his first Antwerp period. There are three paintings of this subject. One is a monumental canvas at Corsham Court [fig. 1]. An even larger painting is in the Prado, also on canvas, with a number of significant changes, notably the inclusion of the incident of Peter cutting off the ear of Malchus [fig. 2]. This painting was in Rubens' collection[1] and was purchased from his estate by Philip IV of Spain. Finally, there is another canvas, in the Minneapolis Institute of Arts [fig. 3], which has the character of a sketch, being very freely painted, but would seem to be too large to be one. It has the same composition as the Madrid picture but shows a different version of the Peter and Malchus incident.

There are seven surviving compositional drawings for this project, three sketches for the Peter and Malchus group, one for a group of sleeping apostles (an idea which was not used in any of the paintings), and one black chalk study (for the figure of Malchus) made from a posed model. Six of these drawings have been brought together in this exhibition, and in studying them in the original as a group, we can enter into the workings of Van Dyck's creative intellect in a way that is rarely possible. Here we can see the young Van Dyck at work on a composition, trying out ideas, rejecting some, developing and refining others.

The drawn *modello* in Hamburg [cat. 34], squared up for enlargement, is preparatory to the Minneapolis painting. It was Vey's view that the Corsham Court painting preceded this version and that the Minneapolis picture preceded the Prado version as a *modello* or was painted at the same time as the Prado picture. Stechow, however, reversed this order considering that the Minneapolis painting, which is the most spontaneous in execution and the smallest of the three, was the first and the Corsham Court painting, which entirely omits the Peter and Malchus incident,

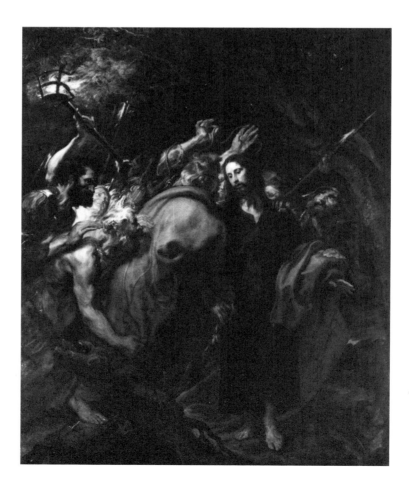

Fig. 1. Anthony van Dyck, *The Taking of Christ*. Canvas, 274 x 222 cm. Corsham Court, Wiltshire (on loan from the City of Bristol Museum and Art Gallery)

Fig. 2. Anthony van Dyck, *The Taking of Christ*. Canvas, 344 x 249 cm. Museo del Prado, Madrid

Fig. 3. Anthony van Dyck, *The Taking of Christ*. Canvas, 142 x 113 cm. Minneapolis Institute of Arts

was the last. As has been noted in the case of *The Crowning with Thorns*, it was not unusual for Van Dyck at this period of his career to make a smaller replica, with significant variations, of a major commission. As a number of these replicas found their way into Rubens' collection, we may reasonably speculate that these were commissioned by Rubens as a record of his brilliant assistant's work or, more probably, they were offered to him by Van Dyck in a spirit of homage. Thus the Corsham painting, the largest of the three and indisputably a finished work, may have been painted for the initial commission (of which we have no record whatsoever) and the Prado version for Rubens. The real puzzle is the function of the Minneapolis painting. Rather than being a third version carried out for a patron or a friend or even a kind of *ricordo*, it is based on the Hamburg *modello* and was probably a large-scale sketch, a means of trying out the effectiveness of the composition before embarking on the larger canvases. The handling is very free and it may well have been carried out hurriedly. It must be stressed, however, that there are no comparable sketches on this scale for any of the other early religious paintings by Van Dyck. Its existence may testify to the importance of this project.

The sequence of these drawings also presents taxing problems. I find the sequence proposed by Vey largely acceptable. The drawing in Berlin [fig. 4], which unfortunately is in poor condition, must come first. On the verso is a study for *The Carrying of the Cross* in Saint Paul's in Antwerp, which can be dated [see above, cats. 2–5] to 1617–1618. In the Berlin drawing, the principal elements of the composition are loosely sketched in pen, and these pen lines were then gone over and in some places obliterated by dark washes. Van Dyck has focused on a moment late in the story. Christ has been arrested and his hands bound behind his back: he is being led away. In the mass of people Judas cannot be identified. The composition, and indeed the choice of a particular moment in the story, was so radically changed in the later composition that we can imagine that this drawing was not in fact directly connected with the commission for the paintings. It may well date from two years or so earlier.

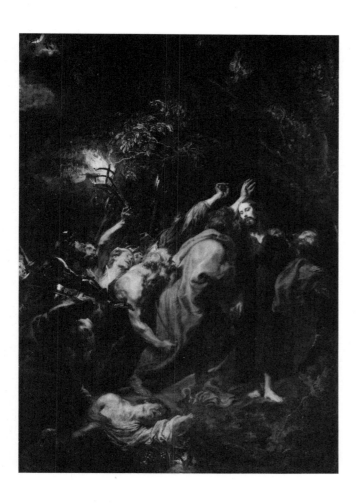

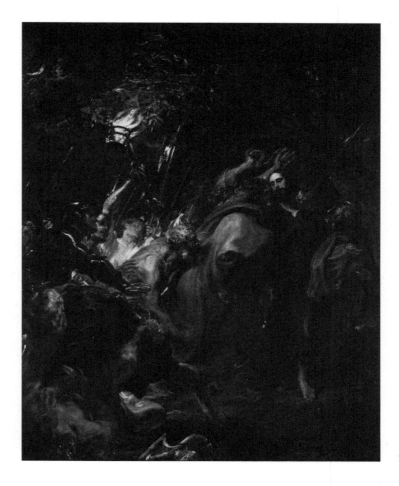

The first of the drawings to be truly preparatory for the paintings is one of the two in this series in Vienna [cat. 30]. The key features of the final composition are already present: Judas' face close to Christ's but not actually kissing him, the noose held high above the crowd and just about to be put around Christ's neck, and the violent Peter and Malchus incident. In the next drawing in Berlin [cat. 31], the group which includes Christ and Judas has been moved to the right. In this sheet the Peter and Malchus incident has been replaced by a group of sleeping apostles, which is reworked twice on the verso. Above the sleeping apostles on the recto, Christ is shown a second time, bound and being led away. A third drawing, also in Berlin, [cat. 32] is an almost startlingly free sketch in pen and wash in which the whole composition is simplified and compressed into an upright format, the two previous drawings having been conceived horizontally. On the verso are a number of individual head studies and a sketch of Peter raising his sword to strike Malchus. The next drawing is the astonishing sheet in Vienna [fig. 5], which moves Judas from right to left and omits both Peter and Malchus and the sleeping apostles. It is an intense study of the central drama of the kiss, with a breathtakingly direct and bold use of wash. It is the antithesis of a *modello*, being confused and full of corrections, meaningless lines, and splashes of ink. Looking at it the viewer has an extraordinary sense of observing the young artist's creative struggles. The two compositional drawings that follow, which are in Paris [cat. 33] and Hamburg [cat. 34], are far more restrained. They are both squared for enlargement and can be considered *modelli*. They present different compositional solutions. In both Christ is placed on the right and Judas leans towards him, clasping his hand. In both the noose is in the air, about to fall around Christ's neck, but many of the subsidiary figures are different. In the Paris drawing there is a tree on the left, beneath which a group of apostles are asleep, whereas in the Hamburg drawing (as in the paintings in Madrid and Minneapolis) a soldier in armor rushes forward with arms outstretched. Beneath him Peter attacks Malchus. However, the Paris *modello* was not used for any of the paintings, as none have the tree and the sleeping apostles, while the Hamburg *modello* was used with one very significant change: the Peter and Malchus group, which clearly gave Van Dyck great difficulty, was recast in the Madrid and Minneapolis canvases and omitted altogether from the Corsham Court painting. Despite such intensive preparation, he substantially reworked his compositions on the canvas.

Fig. 4. Anthony van Dyck, *The Taking of Christ.* Pen and brown ink and point of brush, with brown wash, 170 x 222 mm. Staatliche Museen Preussischer Kulturbesitz, Berlin, Kupferstich-kabinett (Vey 79)

Fig. 5. Anthony van Dyck, *The Taking of Christ.* Pen and brown ink, with brown wash, 218 x 230 mm. Graphische Sammlung Albertina, Vienna (Vey 83)

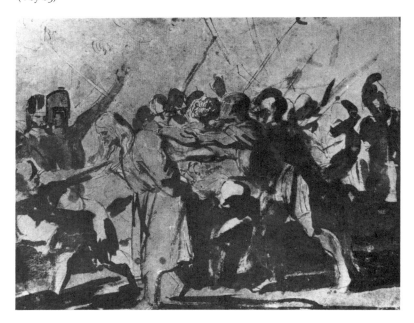

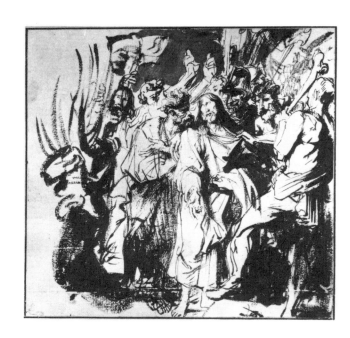

30
The Taking of Christ

c. 1618–1621

Pen and brown ink, brown wash, 211 x 323 mm.
White bodycolor on the faces of Christ and Judas
(applied to make corrections to the brown wash).

Verso: The sheet has been pasted down, but a
number of pen lines can be made out, including a
sketch, a column of figures, and some words and
letters.

Watermark: not visible (laid down)

Graphische Sammlung Albertina, Vienna
(inv. no. 11644)

Vey 80

PROVENANCE Albertina, Vienna (L.174, lower
left).

EXHIBITIONS Antwerp 1930, no. 393; Vienna
1930, no. 190; Rotterdam 1948–1949, no. 83; Paris
1949, no. 122; Antwerp 1960, no. 40; Ottawa 1980,
no. 40.

LITERATURE Guiffrey 1882, 27; Cust 1900, 237,
no. 3 (incorrectly, as engraved by Soutman);
Schönbrunner-Meder 1896, V, no. 513; Rooses
1903, 136; Schaeffer 1909, XV; Muchall-Viebrook
1926, no. 34; De Bruyn 1930, 29ff.; pl. 62, fig. 85;
Glück 1931, 69–71; Delacre 1934, 71, fig. 37; Delen
1943B, no. 104; Delen 1949, no. 25; Vey 1958,
178ff.; Stechow 1960, 7, pl. 8; Vey 1962, no. 80;
Held 1986, 13, fig. 1.

As is discussed above, this is the first of the series of drawings which can be
considered truly preparatory to the paintings of *The Taking of Christ*. In many of the
other compositions from this period of his career Van Dyck based himself on a
Rubens prototype. In this case there was no such prototype, and although at a later
stage he borrowed elements from Marten de Vos and Dürer, he was creating an
entirely original composition, which may explain the unusually large number of
preparatory works. Van Dyck began with a horizontal format. The central drama is
the kiss, and at the moment of the kiss, the noose which loops above the head of
Christ will fall around his neck. The central figures of Christ and Judas have been
drawn in pen in some detail, but the subsidiary figures are merely indicated with
rough pen strokes. There are numerous changes, notably in the figure farthest to the
left, who has been reversed and is now seen from the back holding a torch with
which to illuminate Christ. The violent episode of Peter slashing off Malchus' ear is
already present in the lower right-hand corner. When the composition had been
sketched out in pen, Van Dyck added the deep washes to model the principal
figures and throw the outstretched arm of Malchus into dramatic relief.

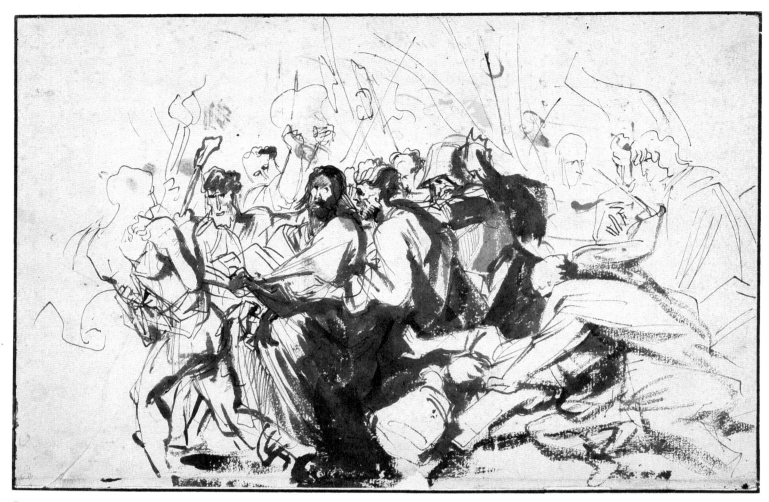

Cat. 30

31
The Taking of Christ

c. 1618–1621

Pen and brown ink, 160 x 245 mm. Cut at the top and on the right.

Verso: studies of sleeping apostles. Point of brush with brown wash. Top left, in pen: *63*; lower left, in pen: *o–4*.

Watermark: none

Staatliche Museen Preussischer Kulturbesitz, Berlin, Kupferstichkabinett (KdZ 5683)

Vey 81

PROVENANCE A. von Beckerath (1834–1915), Berlin (L.2504, lower left).

EXHIBITION Ottawa 1980, no. 41.

LITERATURE Bock and Rosenberg, 124, no. 5683; Glück 1931, 69–71; Delacre 1934, 74; Vey 1958, 178ff.; Stechow 1960, 8; Vey 1962, no. 81.

In this drawing Van Dyck develops the horizontal composition which he first articulated in the Vienna drawing [cat. 30]. He has now turned the body of Christ to face Judas, who grasps his hand. A second figure, on Christ's left, holds his left arm, presumably preparing to restrain him when the noose, poised in the air, falls around his neck. The figures to the left of this central group have been drawn, altered, and then redrawn. Farther to the left is a sketch of Christ, hands bound behind his back, being led away. This is, of course, a later moment in the story and recalls the drawing in Berlin [p. 130, fig. 4], probably made some years earlier, which shows Christ being led from the Garden of Gethsemane. Beneath the bound Christ is a group of sleeping apostles, indicated by a few pen lines. It is this group which is elaborated on the verso in pen and wash.

There are two principal sketches. At the top on the right a sleeping apostle is seen from the back while an older apostle, crouched forward, his face in deep shadow, appears to be stirring. In the foreground, on the left, one apostle sleeps, his head in his hand, while in front of him Peter, having awakened, reaches for his sword. In the top left-hand corner is a sketch of a bald, bearded old man dozing, his right hand at the side of his head. This group was not used in any of the painted versions, although Peter's attack on Malchus was included in both the Minneapolis and Madrid canvases.

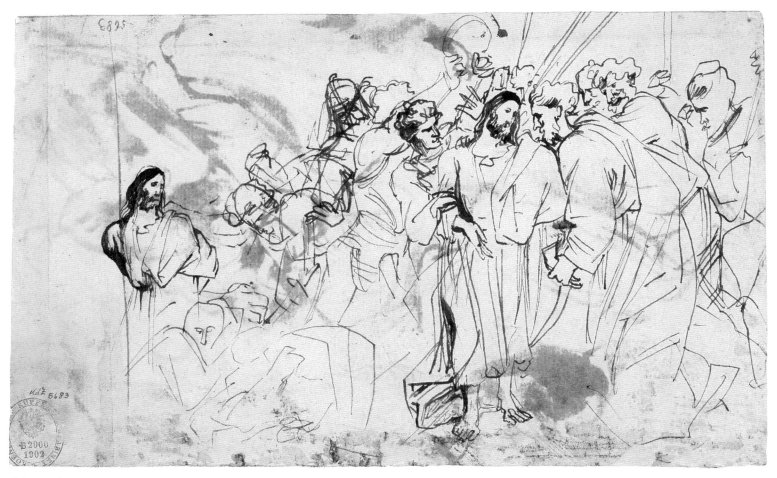

Cat. 31 recto

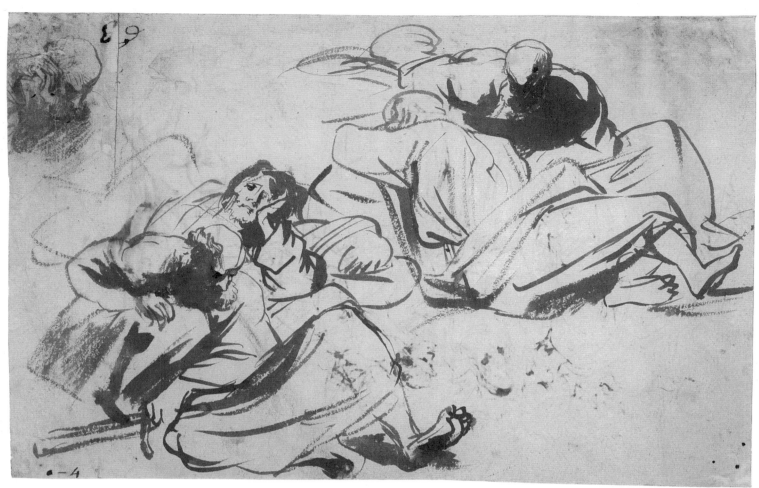

Verso

135

32
The Taking of Christ

c. 1618–1621

Pen and brown ink, brown wash, with some white highlighting, 190 x 187 mm. There is a border, in brown ink.

Verso: At the left edge, where the sheet has been cut, there is a pen sketch of Peter raising his sword against Malchus. Above Peter there is a head study, and to the right are three more head studies: one for Malchus looking up at his attacker, the other two for figures in the crowd surrounding Christ. There are modern inscriptions along the top edge: *A. v. Dyck, K.d.Z. 1340, Hausmann 215* and *inv. no. 4115*.

Watermark: none

Staatliche Museen Preussischer Kulturbesitz, Berlin, Kupferstichkabinett (KdZ 1340)

Vey 82

PROVENANCE B. Hausmann (1784–1874), Hanover (L.378, lower right); Kupferstichkabinett, Berlin (L.1606, center top).

EXHIBITIONS Antwerp 1960, no. 41; Princeton 1979, no. 25.

LITERATURE Bock and Rosenberg, 124, no. 1340; De Bruyn 1930, 29ff.; Glück 1931, 69–71; Delacre 1934, 73; Winkler 1948, 61–62; Vey 1958, 178ff.; Stechow 1960, 8; Vey 1962, no. 82.

The central group of Christ and Judas is virtually unchanged from the previous Berlin drawing [cat. 31], although Christ's gesture with his right hand has been altered. His palm is now turned outward. The most significant single change is the new, upright format, which Van Dyck emphasized by drawing a border around the composition. The left-hand side of the sheet is so confused with numerous alterations in both pen and wash that it is hard to be certain how Van Dyck resolved this area. To the left of the figure who holds up the noose is a soldier whose head is shown in two quite different positions, once in pen and then with the tip of the brush in wash. Beneath this figure is a group which would seem to show Peter bending over Malchus. The bearded old man on the extreme left may be another idea for Peter. The bold use of wash and the white bodycolor on Christ's robe and elsewhere suggests the flickering light thrown on the figures by the torches.

On the verso are a study for the Peter and Malchus group, truncated when the sheet was cut, and four studies for individual heads. On the right, above him and to the left, is a head in the same pose as Christ's, though it appears to show an older man; beside this head, to the left, is a study for the head of a soldier; and finally, above Peter, is the upper part of a head in profile.

136

Verso

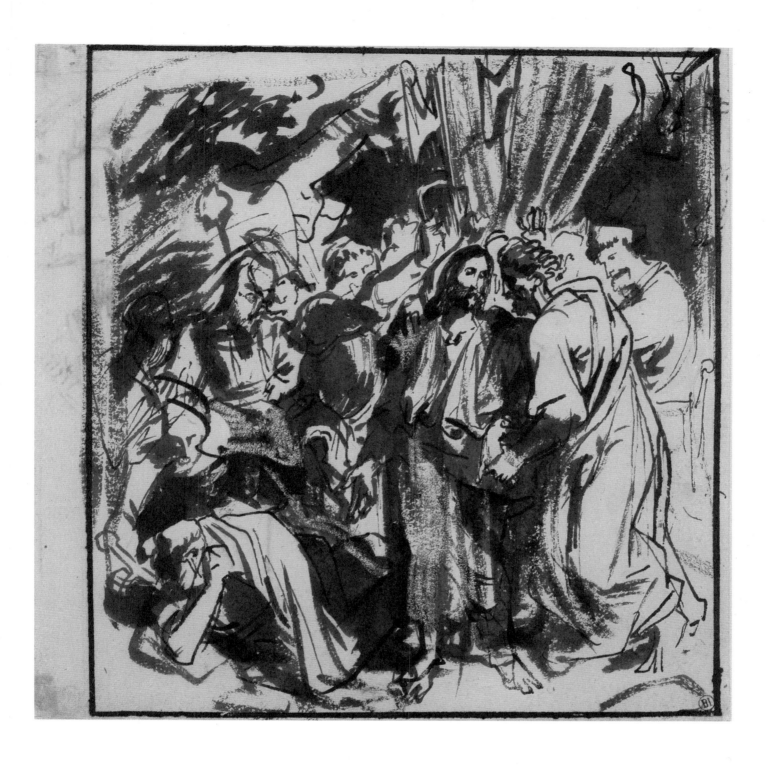

33
The Taking of Christ

c. 1618–1621

Pen and brown ink, brown wash, 241 x 209 mm.
The sheet has been torn in the top right hand
corner and repaired. On the addition the drawing
is continued in grey wash. The whole sheet is
squared up in black chalk.

Watermark: none

Musée du Louvre, Paris, Département des Arts
graphiques (inv. no. 19909)
Vey 84
Exhibited in New York

PROVENANCE Nourri collection, Paris (L.3834);
his sale, 24 February–14 March 1785, no. 908–2;
Charles-Paul de Bourgevin Vialart de Saint-
Morys; seized by the State during the French
Revolution; Musée du Louvre (L.1955, center,
bottom edge; L.2207, bottom right).

EXHIBITIONS Paris 1978, no. 134; Princeton 1979,
no. 26; Ottawa 1980, no. 42; Paris 1987–1988,
no. 44.

LITERATURE Morel d'Arleux 1797–1827, VI,
no. 8851; Guiffrey 1882, 25; Rooses 1903, 134;
Glück 1931, 69–71; Delacre 1934, 78; Lugt 1949, I,
no. 586; Vey 1958, 178ff.; Stechow 1960, 8; Vey
1962, no. 84; Bacou and Calvet 1968, no. 64; Labbé
1987, 361.

1. Hollstein and Puppel, sale catalogue, no. 50,
pl. 11 (Pen with brown ink and wash, 290 x 235
mm). See Delacre 1934, 77, fig. 43.

In an astonishingly bold drawing in pen and wash in Vienna [p. 130, fig. 5], which
unfortunately is too fragile to travel to this exhibition, Van Dyck had made a major
change to the composition of *The Taking of Christ*, moving Judas from Christ's left to
his right. This meant that Christ inclined his head to his right and gestured, palm
outward, with his right hand. The change is retained in this drawing which,
although squared for transfer, was not apparently used for any of the painted
versions of the composition. A number of important elements are, however, added.

The threatening figure on the right of the Vienna sheet, holding a cudgel with a
bulbous end over his shoulder, is abandoned, and the entire composition is moved
to the right. Judas grasps Christ's outstretched hand and lays his left hand on
Christ's shoulder. There is a tree on the far left, from behind which a soldier
emerges with his right forearm stretched out. In the shadow thrown by this tree,
two apostles sleep, one of whom, the older, bald, and bearded man whose right
hand rests against his head, is presumably Peter. His head is closely based on the
drawing in the top left-hand corner of the verso of cat. 31.

It is certainly most unusual for the apostles to be shown sleeping at the very
moment of Christ's arrest. It was while Christ was chiding them for their weakness
in falling asleep as he prayed that Judas approached him. It was presumably this
iconographic inconsistency that caused Van Dyck to remove this group from the
final painting. With that group replaced by a tree, and with the addition of several
more figures, the drawing is most similar to the Corsham Court painting, which, as
has been argued above, I consider to be the first of the three. It may have been used
as a *modello* to establish the general disposition of the figures prior to Van Dyck's
extensive reworking of the composition on the canvas. Vey noted that there was a
copy of this drawing, with the composition slightly extended on either side, on the
Berlin art market in 1920.[1]

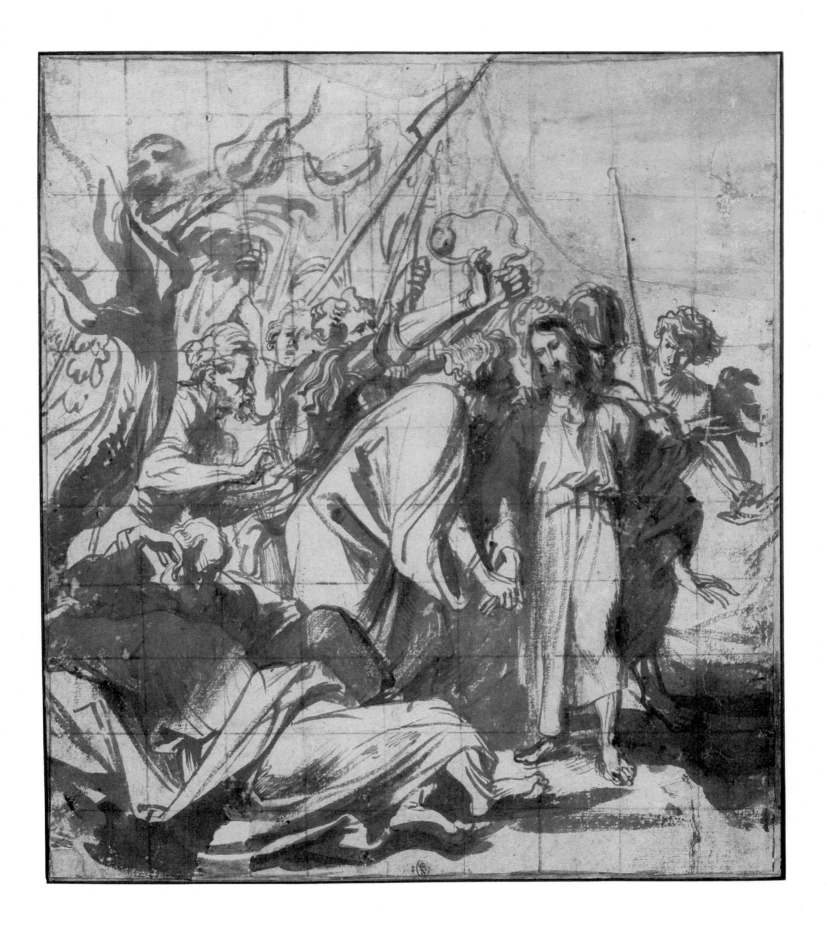

34
The Taking of Christ

c. 1618–1621

Black chalk, gone over in pen and brown ink and some red chalk, 533 x 403 mm. Squared up in red chalk.

Watermark: none

Kunsthalle, Hamburg, Kupferstichkabinett (inv. no. 21882)

Vey 86
Exhibited in New York

PROVENANCE E. G. Harzen (1790–1863), Hamburg (L.1244, verso).

EXHIBITIONS Antwerp 1930, no. 402; Rotterdam 1948–1949, no. 82; Paris 1949, no. 121; Antwerp 1960, no. 44; Princeton 1979, no. 28; Ottawa 1980, no. 44.

LITERATURE Pauli 1912, no. 7; Lugt 1925, 157; Lugt 1931, 46; Burchard 1932, 10; De Bruyn 1930, 29ff.; Delacre 1934, 85 (as workshop); Delen 1943A, no. 8; Delen 1943B, no. 105; Van Puyvelde 1950, 178 (as engraver's copy); Vey 1958, 178; Vey 1962, no. 86; Stubbe 1967, no. 70.

This very large drawing, which is squared up in red chalk for transfer onto canvas, is Van Dyck's *modello* for the painting in Minneapolis. The pen is handled with extreme delicacy and the wash applied very sparingly. The ferocious encounter of Peter and Malchus which is drawn in the bottom left-hand corner is omitted from the Corsham Court painting and is treated differently in the Prado canvas. It has been argued above that the Minneapolis picture is probably a preparatory work; it does not follow the *modello* precisely. The man holding a rope beside Judas is changed from being beardless and wearing a hat to being elderly, bearded, and bald. The position and the features of the soldier on Christ's left are altered, and in the painting the man who holds up the torch is more prominent. Once again, Van Dyck's restless desire to improve his treatment of the subject caused him to continue to make major changes as he worked on the painting at his easel.

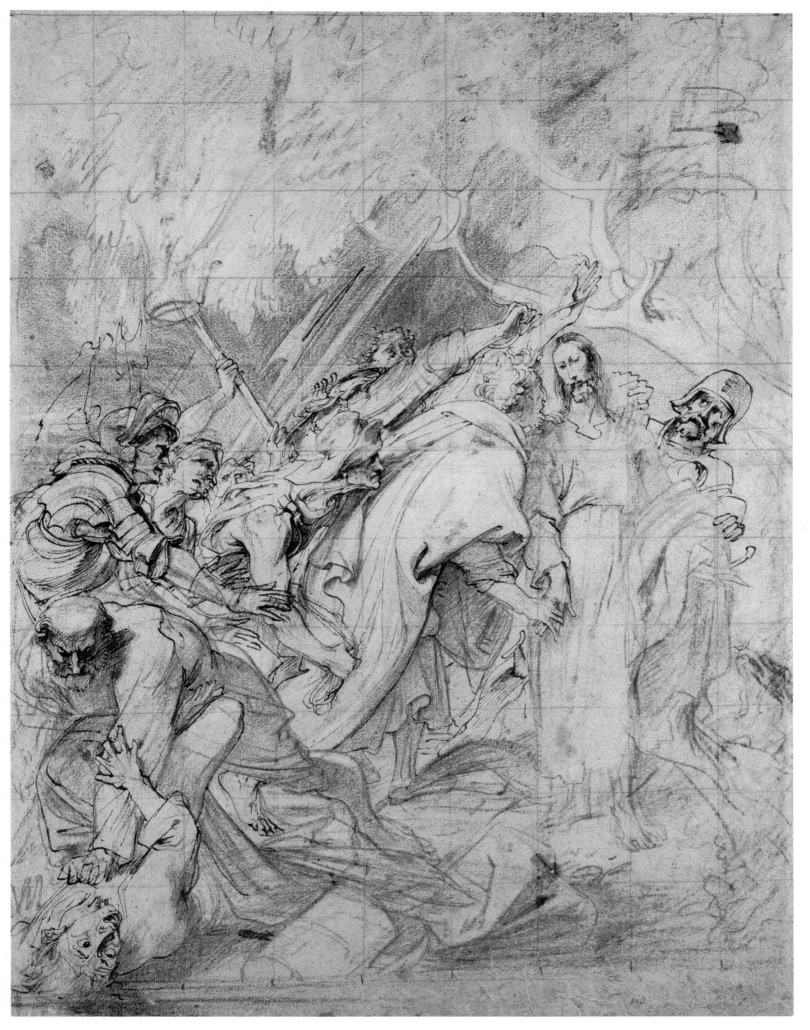

35
Study for Malchus

c. 1618–1621

Black chalk, 245 x 373 mm. Trimmed slightly at all four sides. Lower right, an old inscription in pen: *ant. vandijck.*[1]

Verso: faint black chalk sketches of what appear to be bases of columns. They are cut off at the top edge.

The passe-partout (which has been removed) is from the Mariette and Huquier collections.[2]

Watermark: none

Museum of Art, Rhode Island School of Design, Providence, Rhode Island (inv. no. 20.443)

Vey 87
Exhibited in New York

PROVENANCE P. J. Mariette (1694–1774), Paris; G. Huquier (1695–1772), Paris; his sale, Amsterdam, 14 September 1761, no. 563 (to Hooft, 89 guilders); W. I. Hooft (1782–1863), Amsterdam (L.2631, on the mount); Mrs. Gustav Radeke (1855–1931); gift of Mrs. Radeke, 1920.

EXHIBITIONS Antwerp 1960, no. 45; Princeton 1979, no. 29; Providence 1983, no. 77.

LITERATURE Banks 1931, 63; Burchard 1932, 11; Richmond 1932, 14–15; Delacre 1934, 80, 81, 97; Vey 1958, 178ff.; Vey 1962, no. 87.

1. Vey described this sheet as slightly worn and thought that it might have been lightly retouched by a later hand here and there. However, when I studied the drawing in Providence in August 1990, I saw no sign of significant losses, nor of retouching.
2. An inscription on it reads: "No. 563 du catalogue de la Collection de Mr. Huquier, Septembre 1761 Amsterdam et se trouva autrefois dans la Collection de Mariette. Ecole Hollandaise." In Basan's 1775 catalogue raisonné of Mariette's collection, this drawing cannot be precisely identified but may be included among the groups of Van Dyck drawings listed under nos. 913 or 914 (I, 140).

This is a study from a model posed in the studio for the figure of Malchus in the Madrid version of *The Taking of Christ* [p. 128, fig. 2]. Malchus reaches out in terror as he tries in vain to escape from his attacker, who has raised his sword. The circular object beneath him is a lantern, which he has dropped in his panic. Malchus is posed quite differently in a drawing of the Peter and Malchus group in Rotterdam [fig. 1] and in the Minneapolis painting and its *modello* in Hamburg [cat. 34]. The pose reminded Vey of the *Laocoön*, of which there is a drawing on folio 28 verso of the Antwerp sketchbook [fig. 2].

Fig. 1. Anthony van Dyck, *Peter and Malchus*. Pen and brown ink, with brown wash, 156 x 143 mm. Museum Boymans-van Beuningen, Rotterdam (Vey 85)

Fig. 2. Anthony van Dyck, Antwerp Sketchbook, fol. 28*v*. Devonshire Collection, Chatsworth

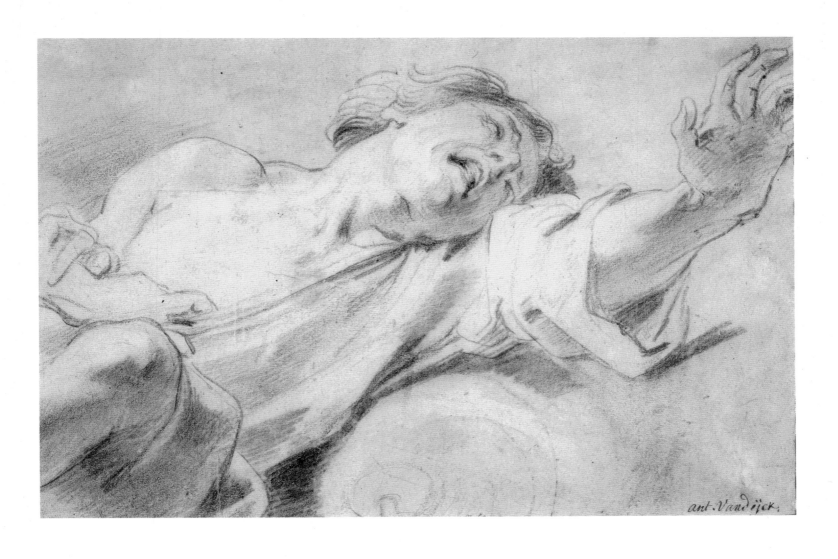

36
Six Saints in Adoration

c. 1618–1621

Pen and brown ink, point of brush, with brown wash and touches of grey wash, 297 x 242 mm. Forty millimeters from the right edge a new piece was added by Van Dyck or the sheet cut and rejoined. A damage in the top right hand corner has been repaired. Trimmed at left edge and along the bottom.

Watermark: none

Private collection, New York

Vey 95

PROVENANCE N. A. Flinck (1646–1723), Rotterdam (L.959, lower left); purchased by William, 2d duke of Devonshire in 1723 and thence by descent to the present duke, Chatsworth (inv. no. 991); Chatsworth drawings sale, Christie's, London, 3 July 1984, lot 56; John R. Gaines Collection sale, Sotheby's, New York, 17 November 1986, lot 13.

EXHIBITIONS Genoa 1955, no. 100; Nottingham 1957, no. 34; Antwerp 1960, no. 49; Manchester 1961, no. 73; Washington 1969–1970, no. 82; London 1973A, no. 82; Jerusalem 1977, no. 31; Ottawa 1980, no. 54.

LITERATURE Vey 1958, 137ff.; Vey 1962, no. 95.

1. Saint Catherine is identified by her attribute of a broken wheel in the related drawing in the British Museum [fig. 1].

There are five drawings showing saints in adoration and saints grouped around the Virgin and Child which belong to the last years of Van Dyck's first Antwerp period (Vey 94–98). All are strongly Venetian in spirit and also echo contemporary altarpieces by Rubens. Three of them, one a double-sided sheet, are included in this exhibition [cats. 36–38].

On the left of this sheet Saint Jerome is shown, kneeling. Standing behind him, in helmet and armor, is Saint George. In the center, in profile and carrying a palm branch, is a female saint who may be Saint Catherine.[1] Behind her, the young man with his chest bared and holding what may be arrows in his left hand is presumably Saint Sebastian. Behind him are two elderly men: the one on the right, drawn over the base of the column, wears a cowl. Vey suggested that they were Dominic and Francis. The object of the devotion of these saints is presumably the Virgin and Child. There is the outline of a face in pen halfway up on the left-hand edge which may have been intended for the Virgin but has been washed over. The composition is closely related to that of a drawing in the British Museum [fig. 1] which shows the same group of saints, full-length and in front of an arched doorway, in the opposite direction. In that drawing, Saint Catherine kneels, holding her attribute of a broken wheel, and Saint George is shown with his head bare, without a beard, and with a banner rather than his more usual lance. In neither form was this group of saints used for a painting by Van Dyck. However, they strongly recall the group of saints in *The Virgin and Child with Saints and Penitents* at Kassel [fig. 2], an altarpiece designed by Rubens and carried out in his workshop in about 1618, probably with the collaboration of Van Dyck. That group includes the two monks and Saint George but not Jerome, Catherine, and Sebastian. This drawing dates from the same period and may have been made in connection with another project in Rubens' studio.

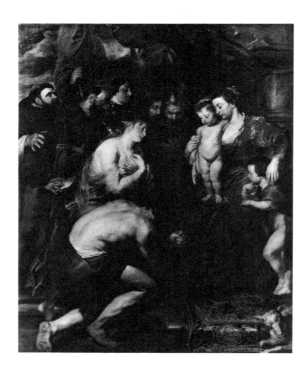

Fig. 1. Anthony van Dyck, *Six Saints in Adoration.* Pen and brown ink and point of brush, with brown wash, 192 x 300 mm. The British Museum, London (Vey 94)

Fig. 2. Peter Paul Rubens, *The Virgin and Child with Saints and Penitents.* Canvas, backed on panel, 257 x 202 cm. Staatliche Kunstsammlungen, Kassel

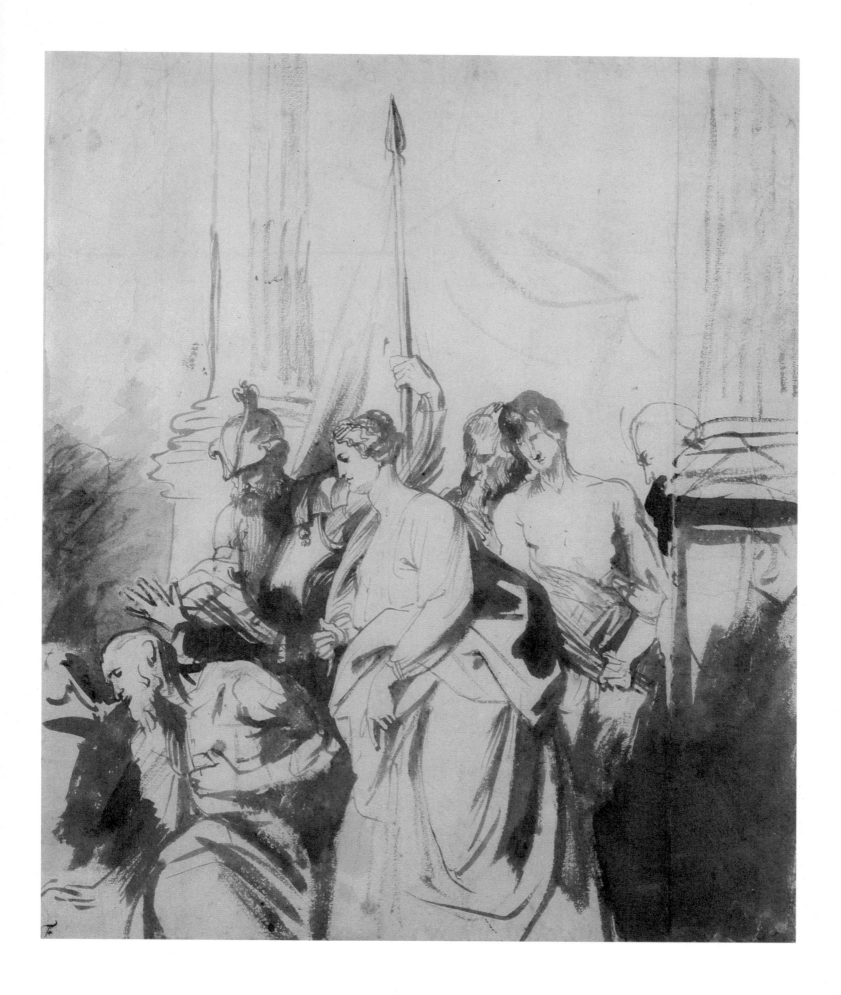

37
The Virgin and Child Adored by Saints

c. 1618–1621

Pen and brown ink, point of brush, with brown wash, over black chalk, 196 x 286 mm. There are traces of white bodycolor, applied to make corrections to the wash. Some damage along the right edge and on the left hand side of the sheet.

Verso: Virgin and Child Adored by Saints. Pen and brown ink, brown wash over black chalk.

Watermark: none

Graphische Sammlung Albertina, Vienna (inv. no. 8637)

Vey 97

PROVENANCE Albertina (L.174, lower left).

EXHIBITION Antwerp 1930, no. 395.

LITERATURE Guiffrey 1882, 110–111; Schönbrunner-Meder 1896, VIII, no. 907; Muchall-Viebrook 1926, no. 35; De Bruyn 1930, 31–32; Glück 1931, 61; Delacre 1934, 132; Vey 1958, 137ff.; Vey 1962, no. 97.

1. Vey considers 96 a double-sided sheet in the Ecole nationale supérieure des Beaux-Arts in Paris (inv. no. 1596), to be a copy, but, following Held, I believe it to be by Van Dyck himself.

On this double-sided sheet Van Dyck was trying out ideas for *"sacre conversazioni"* of a Venetian type. On the recto, the saints are the same as those seen in cat. 36: Jerome (whose lion stands behind Saint George), George, Sebastian, Catherine, and two monks. On the verso are Jerome, a kneeling female saint (perhaps Saint Catherine), and three monks. Van Dyck has tried out alternative positions for the head of the Virgin and of the Child, and the left foot of the monk nearest to her. These two drawings, as well as cat. 38 and three others with related compositions [figs. 1, 2 and cat. 36, fig. 1],[1] appear to be for the same project which, as far as we know, was never carried out. Vey notes the similarities of these compositions to the woodcut by Niccolò Boldrini of *Doge Francesco Donato Adoring the Virgin and Child* [fig. 3], which preserves the composition of a painting by Titian of *Doge Andrea Gritti in Adoration*, destroyed in 1574. Van Dyck made two drawings after this two-sheet woodcut in his Italian sketchbook (folios 15 [fig. 4] and 93v).

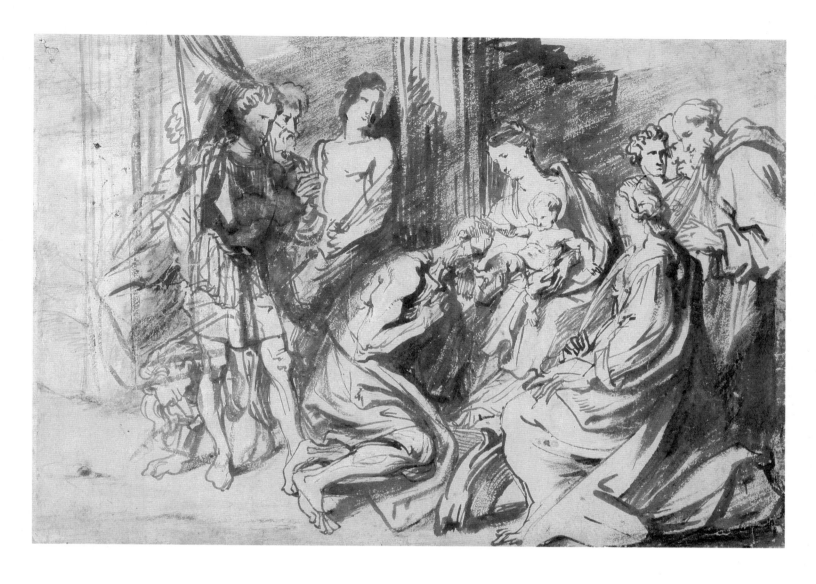

Verso

Fig. 1. Anthony van Dyck, *The Virgin and Child Adored by Saints*. Pen and brown ink and point of brush, with brown wash, 192 x 300 mm. The British Museum, London (Vey 94*v*)

Fig. 2. Anthony van Dyck, *Three Saints in Adoration*. Pen and brown ink and point of brush over black chalk, with brown wash, 282 x 208 mm. Ecole nationale supérieure des Beaux-Arts, Paris (Vey 96)

Fig. 3. Niccolò Boldrini, after Titian, *Doge Francesco Donato Adoring the Virgin and Child*. Woodcut on two sheets, 434 x 388 mm and 434 x 390 mm. The British Museum, London

Fig. 4. Anthony van Dyck, Italian Sketchbook, fol. 15. The British Museum, London

147

38
The Virgin and Child Adored by Saints

c. 1618–1621

Pen and brown ink, point of brush, brown and a little gray wash, 213 x 278 mm. Slightly trimmed on all four sides. Abraded in the area of the Child's feet.

Verso: studies for Peter and Malchus in *The Taking of Christ*. Pen and brown ink, brown wash. There are a number of words written in Van Dyck's hand. They appear to be a mixture of Latin, Italian, and Flemish: *Aso../ Ave Maria g../ per pien di dolcette il Core Cante rag../ soy [?] nog amoor non sey/ piene di bel/ d'amor bel mie la..[ll?]* and a column of figures.

Devonshire Collection, Chatsworth (inv. no. 986)

Vey 98

PROVENANCE N. A. Flinck (1646–1723), Rotterdam (L.959, lower left); purchased by William, 2d duke of Devonshire in 1723 and thence by descent.

EXHIBITIONS Genoa 1955, no. 106; Nottingham 1957, no. 32; Nottingham 1960, no. 41; Antwerp 1960, no. 50; Pittsburgh 1987–1988, no. 89.

LITERATURE Vasari Society, IV, no. 22; Delacre 1934, 136; Vey 1958, 137ff.; Vey 1962, no. 98.

1. Oldenbourg 1921, 129.
2. The inscription has been newly transcribed for this catalogue; the transcription differs slightly from that given by Vey.
3. In Pittsburgh 1987–1988.

Fig. 1. Anthony van Dyck, *The Continence of Scipio.* Canvas, 183 x 232.5 cm. The Governing Body, Christ Church, Oxford

Fig. 2. Anthony van Dyck, *Madonna and Child with Five Saints.* Panel, 112 x 94 cm. North Carolina Museum of Art, Raleigh

Saint Jerome kisses Christ's foot while Saint Sebastian and two monks (probably Dominic and Francis) stand beside him on the left. On the right are Saint Catherine, Saint George, and a third saint. This is the most finished of a group of drawings for a *"sacra conversazione"* of the Venetian type: cats. 36 and 37 (recto and verso) also belong to this group. As has been noted above, Van Dyck was familiar with the woodcut by Niccolò Boldrini [cat. 37, fig. 3] after a Titian *Adoration* of this type. Van Dyck does not ever seem to have painted this subject at this period of his career, but a number of altarpieces from Rubens' studio painted at about this time, notably the *Virgin and Child Adored by Saints and Penitents* in Kassel [cat. 36, fig. 2],[1] employ similar groups of saints, and these drawings may have been connected with a project in Rubens' studio rather than an independent commission by Van Dyck. However, while Van Dyck did not use these studies for a painting as far as we know, there are echoes of individual figures and poses in a number of paintings made shortly afterwards, for example, *The Continence of Scipio* [fig. 1] and the *Madonna and Child with Five Saints* [fig. 2].

On the reverse of this sheet are studies for the Peter and Malchus group in *The Taking of Christ* [see above, cats. 30–35]. In the group on the left (at right angles to the page) the pose of Saint Peter, holding Malchus down with his left hand and about to raise the sword in his right hand, is very similar to that in cat. 31, an early conception of the scene. The second sketch, however, on the right-hand half of the sheet, shows a quite different conception of the scene. Peter's raised sword is about to strike Malchus, whose leg and foot can be seen as he tries in desperation to escape. This is close to the treatment of this group in the Madrid version of the painting. Between these two groups is the study of a leg emerging from drapery and on the right-hand edge is a pen drawing of a foot and leg which was cut off when the paper was trimmed. Both legs, at very different angles, presumably belong to Malchus. The inscriptions on this side of the sheet are intriguing. There is a Latin prayer, a snatch of an Italian song or poem, and, most interestingly, a phrase in both Flemish and Italian.[2] Van Dyck would, of course, have been working hard improving his Italian in the months before his departure for Italy in October 1621. On the basis of the Italian inscription, Jaffé has dated this drawing to Van Dyck's Italian period.[3] In view of the study on the verso for *The Taking of Christ*, all three versions of which were painted in Antwerp in 1618–1621, this is most unlikely, and the drawing should be dated to the years immediately preceding his departure for Italy.

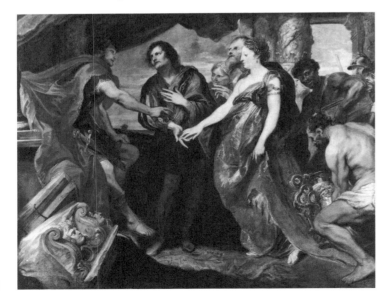

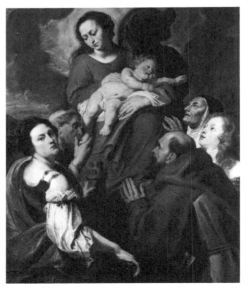

148

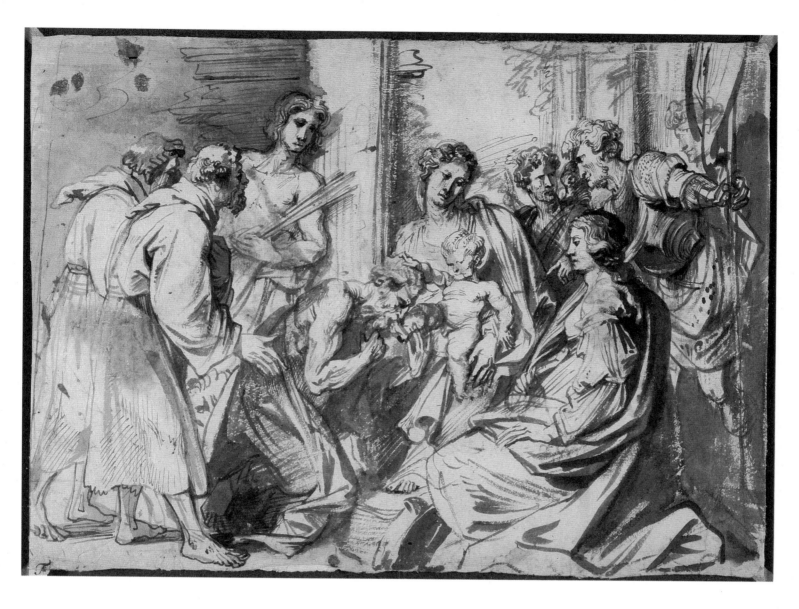

Verso

39
Diana and Actaeon

c. 1618–1621

Pen with brown ink, brown and gray washes, 155 x 223 mm. In a number of places are touches of red chalk over black chalk lines. (Strips of paper have been added later to the sheet at the top and on the right at the bottom: with these additions the sheet's dimensions are 170 x 223 mm.)

Watermark: not visible (laid down)

Musée du Louvre, Paris, Département des Arts graphiques (inv. no. 19.919)

Vey 23
Exhibited in New York

PROVENANCE Charles Paul de Bourgevin Vialart de Saint-Morys; seized by the State during the French Revolution; Musée du Louvre (L.1886, lower left).

EXHIBITIONS Antwerp 1960, no. 15; Paris 1978, no. 138; Ottawa 1980, no. 66.

LITERATURE Morel d'Arleux, VIII, 12.626; Guiffrey 1882, 413; Lugt 1949, I, no. 589, pl. 55; Vey 1962, no. 23; Labbé 1987, 361.

The story of Diana and Actaeon is told by Ovid in the *Metamorphoses* (Book 2, lines 138–252). Actaeon, a hunter, saw Diana and her nymphs bathing and was transformed by the angry goddess into a stag. He was then hunted down and killed by his own hounds. Van Dyck's drawing represents the moment at which Actaeon's metamorphosis is taking place: the artist showed him first with a human face and then drew the stag's head over it. Actaeon's almost apologetic pose is contrasted to the violent gestures with which the nymphs protect their own and Diana's modesty. On the right, a group of three nymphs turn away with gestures of horror, and the two nymphs on either side of Diana gather a cloak around her.

This marvelously spirited drawing, in which the water and the landscape are represented with the boldest and most abbreviated of pen strokes, is one of three sheets on which Van Dyck developed this composition. One, in the Kupferstichkabinett in Berlin, is on the verso of a sheet containing sketches of five male figures [fig. 1]. Two figure groups, one for Diana with the nymph on the left and the second for one of the fleeing nymphs on the right, are drawn in pen. The second sheet is a drawing for the whole composition, very boldly sketched in pen and wash [fig. 2]. Vey considered this drawing to be a copy but both Keith Andrews and Julius Held believed it to be an original and I agree.[1] It would seem most likely that this sheet

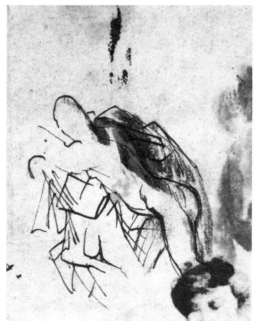
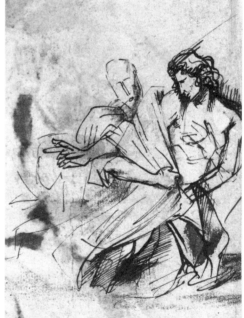

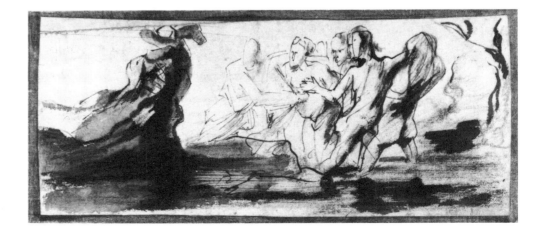

Fig. 1. Anthony van Dyck, *Two Studies for Diana and Actaeon* (detail). Black chalk and pen with brown ink, 209 x 216 mm. Staatliche Museen Preussischer Kulturbesitz, Berlin, Kupferstichkabinett (Vey 21v)

Fig. 2. Anthony van Dyck, *Diana and Actaeon*. Pen and brown ink over black chalk, 95 x 223 mm. Formerly Collection of Dr. and Mrs. F. Springell, Portinscale, Cumberland (Vey 22)

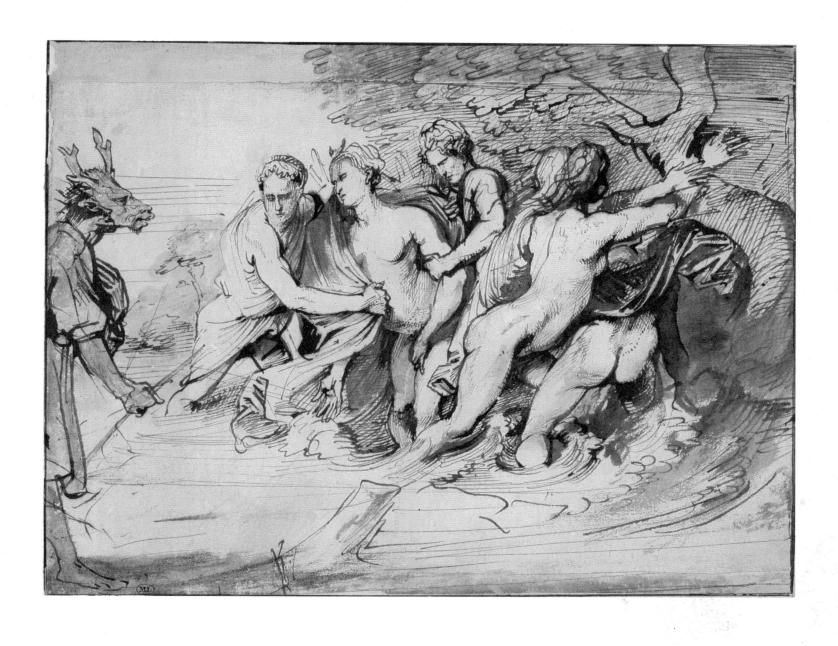

1. Pen and brown ink, brown wash, 95 x 223 mm. Held 1964, 566. This drawing was in the collection of Mr. and Mrs. F. Springell and was included in the exhibition of their collection held in Edinburgh in 1965 as by Van Dyck. The catalogue was written by Keith Andrews (Edinburgh 1965, no. 31). It was sold at Sotheby Mak van Waay, Amsterdam, 3 May 1976, no. 203, ill., but its present whereabouts are unknown.
2. Denucé 1932, 351.
3. Glück 1931, 58.
4. Larsen 1980, no. 204. This painting is known to me only in a photograph.
5. Bock and Rosenberg, no. 124.
6. Lugt 1949, I, 53 under no. 589.
7. Held 1986, no. 8.

contains Van Dyck's first idea and that he subsequently refined the two figure groups in the Berlin sketches and worked up the more detailed Paris drawing. There is no painting of this composition by Van Dyck, but it is worth noting that there was "het Bat van Diana, oock van van Dyck" in the inventory of Johannes Aertsen in Antwerp in 1690.[2] The figure of the most prominent nymph in the right-hand group, who turns her back to Actaeon and raises her hands, was used by Van Dyck in a painting of *Nymphs Surprised by Satyrs* [fig. 3], which was in Berlin but was destroyed during the last war[3] and in a second painting of the same subject [fig. 4], which also contains a third nymph in the pose of Venus Pudica, in a private collection in Brussels.[4]

In the Kupferstichkabinett in Berlin there is a drawing of *The Discovery of Callisto* [fig. 5], which Bock and Rosenberg hesitantly attributed to Van Dyck.[5] Lugt agreed with this attribution, comparing it to the present drawing.[6] In fact, as Julius Held has cogently argued, the Berlin drawing is by Rubens and was probably made in about 1600.[7] In the context of the perennial problem of separating the drawing styles of Rubens and Van Dyck, this particular comparison is very revealing. Though the physical types of the women are similar, Rubens' technique is far more tentative and imprecise. He used very short pen strokes where Van Dyck employed a far longer line. There is nothing in Rubens' drawing to compare with the superbly sinuous back of the fleeing nymph on the right hand side of the present sheet. Rubens worked and reworked the outlines and indicated shadows with short cross-hatched strokes, while Van Dyck boldly employed brown and gray washes to plan the disposition of light and dark. In a number of places—on the buttocks of the nymphs farthest to the right and on the raised arm of the most prominent nymph in this group, for example—are the dotted lines used by Van Dyck to suggest a fold of skin, a technique which Rubens used very rarely.

Fig. 3. Anthony van Dyck, *Nymphs Surprised by Satyrs*. Canvas, 81 x 94 cm. Formerly Kaiser-Friedrich-Museum, Berlin

Fig. 4. Anthony van Dyck, *Nymphs Surprised by Satyrs*. Canvas, 110 x 135 cm. Collection of F. Mogin, Brussels

Fig. 5. Peter Paul Rubens, *The Discovery of Callisto*. Pen and brown ink, 179 x 139 mm. Staatliche Museen Preussischer Kulturbesitz, Berlin, Kupferstichkabinett

40
Venus and Adonis

c. 1618–1621

Pen with brown ink, with brown and gray washes, over black chalk, 259 x 185 mm. Cut on the left.

Watermark: not visible (laid down)

British Museum, London, Department of Prints and Drawings (inv. no. 1910.2.12.210)

Vey 25

PROVENANCE J. Richardson the Younger (1694–1771), London (L.2170, lower right); G. Salting (1835–1909), London.

EXHIBITIONS London 1900, no. 206; London 1912, no. 142.[1]

LITERATURE Waagen 1857, supplement, 118; Cust 1900, 241, no. 59; Hind 1923, no. 23; Vey 1962, no. 25.

1. According to this catalogue the drawing was in the collections of R. Payne Knight (1750–1824) and C. S. Bale (1791–1880). This information was quoted by Vey but appears to be incorrect.
2. The present location is given in Larsen 1988, no. 310. According to Cust 1900, no. 59, the painting was from the Palazzo Pallavicini, Genoa. This has been shown to be incorrect by Jaffé 1990, 701–703.
3. Oldenbourg 1921, no. 29.
4. It is based on the *Bacchus and Ariadne* in the series of Loves of the Gods by Perino which was engraved by Caraglio.
5. Jaffé 1990; Washington 1990–1991, no. 17.
6. Panel, 350 x 250 mm. Muller, Amsterdam, 17 November 1918, lot 7, and Mak, Amsterdam, 26–27 May 1925, lot 29. Horst Vey informs me that a painting in the Crocker Art Museum, Sacramento, attributed to Willeboirts, is related to the drawing.

Venus, who had a foreboding that Adonis would die during the hunt, is shown trying to restrain her headstrong young lover. She strokes him beneath the chin and clasps the wrist of his left arm. (The story of the goddess' love for the mortal Adonis and his death, gored by a wild boar, is told by Ovid in the *Metamorphoses*, Book 10.)

This is a study for a painting said to be in a private collection in Locarno, Switzerland [fig. 1].[2] While the general disposition of the two figures is retained, there are numerous changes of pose and dress. Venus, who is almost entirely naked, reaches her right hand to restrain Adonis' right arm, which carries his spear. His naked legs can be seen beneath his tunic. Adonis bends his young face (which is now beardless) towards the goddess so that their faces are close together. On the left are his two dogs. One of them, anxious to start the hunt, leaps up at his master. The trees on the right are an elaboration of those sketched in the drawing. On the left is a distant landscape of a lake with hills beyond.

Van Dyck's starting point was Rubens' *Venus and Adonis* of about 1610, which is now in Düsseldorf [fig. 2].[3] This heroic image, based on a composition by Perino del Vaga,[4] is a study of two classical nudes. Behind them is the outstretched wing of one of the amorous swans who pull Venus' chariot. Van Dyck's interpretation is far more human, sensual, and playful, both in the painting and the drawing. Van Dyck's figures entirely lack the classicizing monumentality of Rubens'.

It is fascinating that shortly after painting the *Venus and Adonis*, Van Dyck painted the marquess of Buckingham and his wife, Katherine Manners, in the guise of Venus and Adonis when he was in London in 1620–1621 [fig. 3].[5] As might be expected in a *portrait historié*, the poses are more decorous, although the duchess is shown naked to the waist and Buckingham's chest and legs are bare. The setting is very similar to that in the *Venus and Adonis*, and the dog who leaps up on the left is so close that it might be imagined that a drawing for it was among the works that Van Dyck took with him to England.

Vey noted that a copy in oil on panel after the drawing was sold in Amsterdam in 1918 and again in 1925.[6] The drawing was engraved by Lucas Franchois.

Fig. 1. Anthony van Dyck, *Venus and Adonis.* Canvas, 175 x 175 cm. Private collection, Locarno

Fig. 2. Peter Paul Rubens, *Venus and Adonis.* Canvas, 374 x 182 cm. Kunstmuseum, Düsseldorf

Fig. 3. Anthony van Dyck, *Sir George Villiers and Lady Katherine Manners as Venus and Adonis.* Canvas, 223.5 x 160 cm. Harari and Johns Ltd., London

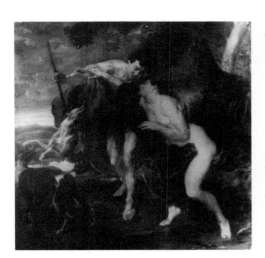

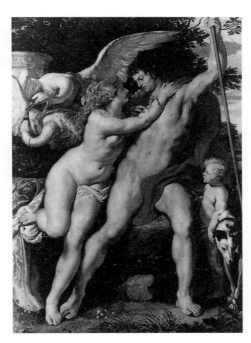

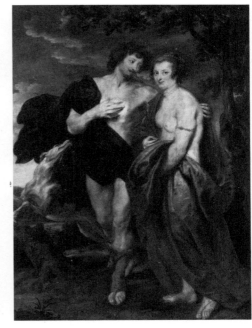

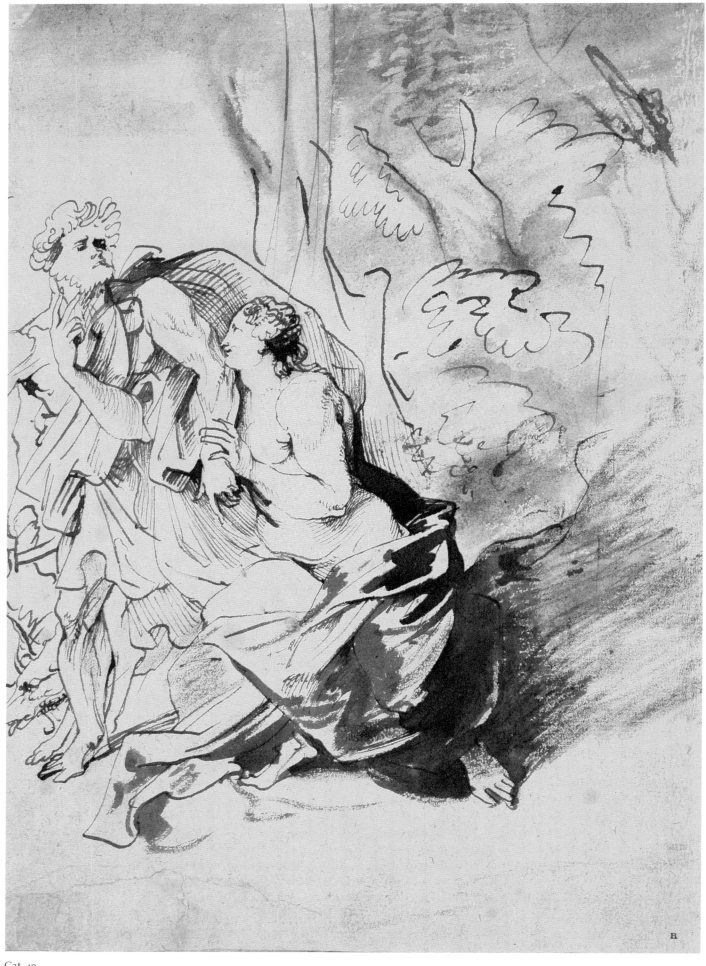

Cat. 40

154

41
The Suicide of Sophonisba

c. 1618–1621

Pen and brown ink, brown and gray washes. Squared up in black chalk, 163 x 253 mm.

Verso: an inscription in pen: *Uit het kabinet van/ Wylen den (?)/ Hr Rutgers in de Kerkstraat te/ Amsterdam gekocht.* And beneath two further inscriptions: *Leiden/ 402.*

Watermark: none

Rijksmuseum, Amsterdam, Rijksprentenkabinet (inv. no. 00.430)

Vey 105
Exhibited in Fort Worth

PROVENANCE According to the inscription on the verso, it was in the collection of A. Rutgers, Amsterdam, but it was not in his sale held in Amsterdam on 1 December 1778.

LITERATURE Vey 1962, no. 105 (as a copy).

1. Fitzwilliam Museum (inv. no. 375). B. Gaehtgens, *Adriaen van der Werff*, Munich, 1987, cat. no. 102.

A woman wearing a diadem and with her breasts bared reaches out towards a circular bowl or dish held out by a man on the left. On the far left is a soldier; beside the woman is an elderly man in armor who also reaches out his hand as if to restrain her and another figure in shadow who may be her servant or maid. In the background are curtains and the base of a column. Vey suggested that the subject was the suicide of Sophonisba which is described in Livy's *Ab Urbe Condita*, book 30, chapter 12. Sophonisba, however, should hold a letter and be surrounded by women. On the inventory card in the Rijksprentenkabinet it is noted that Van Puyvelde identified the subject as Cleopatra, queen of Syria, forced to empty the beaker sent to her by her son. This is unlikely, as the object to which the queen reaches is certainly not a beaker. Sophonisba also drank from a poisoned cup, but the object seems too shallow to be a cup. Another possibility is the story of Artemisia, who drank her husband's ashes mixed with wine in order to become a living mausoleum. Her story is told by Valerius Maximus (*Facta et Dicta Memorabilia*, book 4, chapter 6). However, she is normally shown holding a goblet in which the ashes are being poured while a pitcher of wine with which they are to be mixed, can be seen as, for example, in the painting by Rubens at Sanssouci [fig. 1]. A further possibility is a subject from Boccaccio's *Decameron*, Tancred's servant presenting the heart of Guiscard in a golden cup to Guismond, which was painted by Adriaen van der Werff in a small panel in Cambridge.[1] None of these subjects accords exactly with the scene in Van Dyck's drawing and until this iconographical puzzle is solved, I have thought it best to retain Vey's title.

Although it is squared up, there is no known painting or print of this composition. Vey considered the drawing to be a copy, citing what he considered to be a timid use of the pen and mechanical application of wash. These weaknesses are not apparent to me, and when it is compared to finished drawings like *The Taking of Christ* [cat. 34] or *The Crowning with Thorns* [p. 119, fig. 5], it can be seen to have the same delicate pen work and restrained use of dark washes.

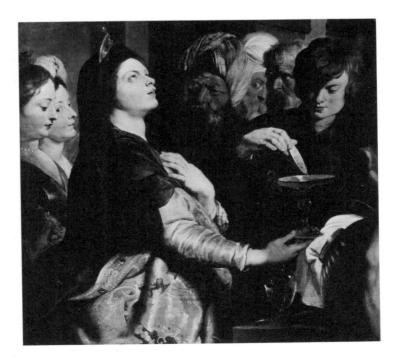

Fig. 1. Peter Paul Rubens, *Artemisia*. Panel, 79 x 105 cm. Sanssouci, Potsdam, Bildergalerie

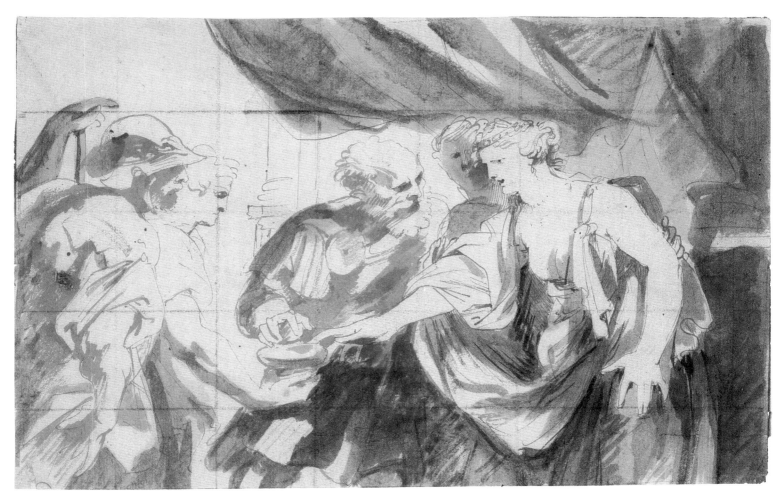

Cat. 41

42
The Torments of Job

c. 1620–1621

Black chalk, with white chalk highlights in the body and clothes of Job and his wife, and some red chalk in the face of Job's wife, 403 x 276 mm.

Verso: On the backing sheet is Jabach's inventory number in pen: *8738*, and several modern annotations.

Watermark: not visible (laid down)

Musée du Louvre, Paris, Département des Arts graphiques (inv. no. 20. 316)

Vey 166
Exhibited in New York

PROVENANCE Everhard Jabach (1618–1695), Paris (L.2961, lower left); sold by him to Louis XIV in 1671; Musée du Louvre (L.1899, lower right; L.2207, lower left).

EXHIBITIONS Paris 1952, no. 1129; Paris 1959, no. 48; Antwerp 1960, no. 21; Cologne 1975, no. 49.

Fig. 1. Anthony van Dyck, *The Stigmatization of Saint Francis*. Black chalk, with some brown wash and highlights in white bodycolor, 518 x 352 mm. Musée du Louvre, Paris, Département des Arts graphiques (Vey 160)

Fig. 2. Anthony van Dyck, *The Return of the Holy Family from Egypt*. Black chalk, with highlights in white bodycolor, in places gone over in pen with brown ink, 415 x 316 cm. Musée du Louvre, Paris, Département des Arts graphiques (Vey 163)

In his life of Van Dyck, Bellori writes that it was one of the artist's tasks when he was in Rubens' studio to make drawings for the engravers: "[Rubens] gli parve gran ventura di haver trovato uno allievo a suo modo, che sapesse tradurre in disegno le sue inventioni, per farle intagliare al bulino: fra queste si vede la battaglia delle Amazzoni disegnata all'hora da Antonio." ([Rubens] considered himself very fortunate to have found so apt a pupil, who knew how to translate his compositions into drawings from which they could be engraved. Among these is *The Battle of the Amazons*, which was drawn by Anthony at that time.[1]) There are in the Louvre a group of black chalk drawings preparatory to engravings after the work of Rubens which were among the 5,542 drawings purchased *en bloc* by King Louis XIV in 1671 from the banker Everhard Jabach, who was a patron of both Rubens and Van Dyck. They were originally catalogued as by Rubens, but Bellori's statement had already attracted the attention of Mariette when he discussed them in the *Abécédario* (V, 70). Unfortunately a drawing for Vorsterman's very large print after *The Battle of the Amazons* (which is dated 1623) is not among them,[2] and so there is no sure basis on which to attribute these drawings to Van Dyck. They have had a variety of attributions: in addition to that to Van Dyck, they have been given to Rubens, himself, to his studio with retouchings by Rubens, and to the individual engravers.[3] Vey, however, following Lugt, did attribute to Van Dyck seven of the drawings from the Jabach collection, *The Stigmatization of Saint Francis* [fig. 1], *Lot's Flight from Sodom* (Vey 161), *The Return of the Holy Family from Egypt* [fig. 2], *The Adoration of the Shepherds* (Vey 164), *The Adoration of the Magi* [fig. 3], and the present drawing for prints by Lucas Vorsterman and *The Miracle of Saint Ignatius* (Vey 162) for a print by Marinus van der Goes. These attributions have not been universally accepted. For example, in an exhibition held in Paris in 1978, *The Miracle of Saint Ignatius*, *The Adoration of the Shepherds*, and *The Return of the Holy Family from Egypt* were said to be by Rubens' studio and retouched by the master himself.[4]

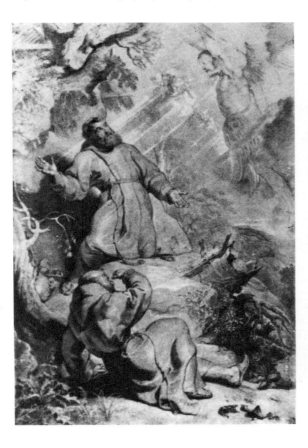

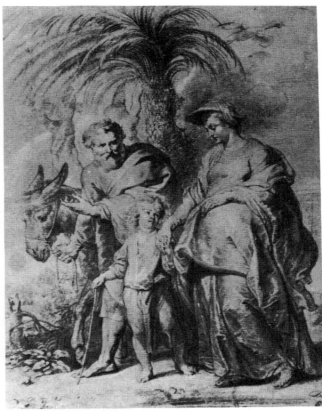

LITERATURE Smith 1829–1842, II, no. 153, 54; Hymans 1893, 26–27, 68, under no. 4; Rooses 1892, 5, 147; Michel 1900, pl. 15; Van den Wijngaert 1940, no. 709; Van den Wijngaert 1945, 179–180; Müller Hofstede 1961, 151, fig. 2; Lugt 1949, 2, no. 1129; Vey 1962, no. 166; Renger 1974–1975, I, 139; Rome 1977, 69, under no. 123; Bacou 1978, no. 186; d'Hulst and Vandenven 1989, 182–183, under no. 55.

1. Bellori 1672, 254. See above, p. 17.
2. A large drawing on eight pieces of paper (pen and brown ink, brush and grey wash, with some white bodycolor, and black chalk, 810 x 1020 mm) at Christ Church, Oxford (inv. no. 1377; Byam Shaw 1976, no. 1377), appears to be the drawing made for Vorsterman's engraving. There are traces of indentation with the stylus. It may be the drawing identified as such by Mariette (Abécédario, 115). Mariette considered that drawing to have been touched by Rubens himself and Jaffé (as noted by Byam Shaw, op. cit.) considers that the penwork in the Christ Church drawing is by Rubens. In my view it is hard to discern either the hand of Van Dyck or Rubens in the sheet and it should properly be considered a work from Rubens' studio.
3. For an extended discussion of these attributions and previous literature, see Vey 1962, 32–35.
4. Paris 1978, 105–110, nos. 108–113.
5. For the relationship between Rubens and Vorsterman, see Held 1982, 114–125.
6. Magurn 1955, 87 (letter no. 47).
7. Held 1986, 35.
8. d'Hulst and Vandenven, op. cit.

Rubens himself commented on the quality of these drawings (although he did not identify their author) in a letter of 30 April 1622 to Pieter van Veen. Rubens was experiencing great difficulties with Vorsterman, a brilliant engraver but a head-strong and even mentally unbalanced man.[5] "I am pleased," he wrote in Italian, "that you wish to have more of my prints; unfortunately we have almost made nothing for a couple of years, due to the caprices of my engraver, who has let himself sink to a dead calm, so that I can no longer deal with him or come to an understanding with him. He [Vorsterman] contends that it is his engraving alone and his illustrious name that gives the prints any value. To all this I can truthfully say that the designs are more finished than the prints, and done with more care. I can show these designs to anyone, for I still have them."[6]

Because of their particular function, these drawings are very highly finished and quite different in technique from any other drawings by Van Dyck. Close comparison with documented drawings is not, therefore, of great value, and as Julius Held has written, "unless some new evidence appears—which is not likely—Van Dyck's authorship will remain a matter for conjecture."[7] Bellori, however, is a reliable source for the events of Van Dyck's life, and it seems a reasonable hypothesis to attribute to Van Dyck some of those drawings used by Vorsterman and other engravers in prints which bear dates in the years around 1620 or can be documented to those years.

The Torments of Job is a drawn copy made for Vorsterman of the exterior of the left wing of the triptych with *Scenes from the Life of Job* that Rubens painted in 1612–1613 for the Church of Saint Nicholas in Brussels.[8] The painting was destroyed during the French bombardment of the city in 1695. Vorsterman's print, which measures 388 x 362 mm, is not dated but was probably made in about 1620. The drawing shows a looser and broader composition than that of the painting, as we know it from the painted copy in the Louvre [fig. 4], and, as was usual, was probably made from the *modello* rather than from the altarpiece itself. The handling of the black chalk shows some similarities to that in Van Dyck's drawing in this medium from studio models. Most authors—Hymans, Lugt, Vey, and, less positively, Held and d'Hulst and Vandenven—attribute it to Van Dyck. Van den Wijngaert, however, thought that it was by Vorsterman himself and Müller Hofstede and Renger argued that it was by Rubens. It is to be hoped that by including it in this exhibition and displaying it close to other drawings by Van Dyck in black chalk, the discussion about the attribution of this and the other drawings in this group can be advanced.

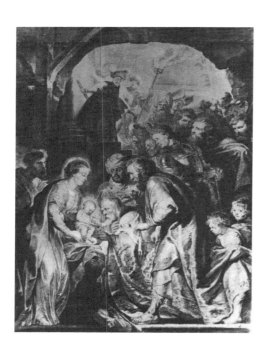

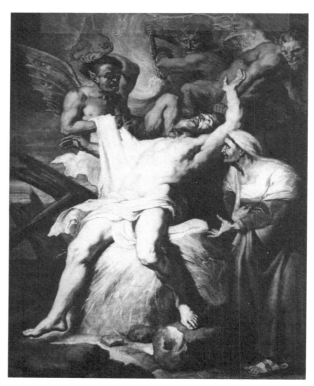

Fig. 3. Anthony van Dyck, *The Adoration of the Magi*. Black and red chalk, with brown and gray wash and highlights in white bodycolor, 568 x 420 mm. Musée du Louvre, Paris, Département des Arts graphiques (Vey 165)

Fig. 4. After Rubens, *The Torments of Job*. Canvas, 146 x 119 cm. Musée du Louvre, Paris

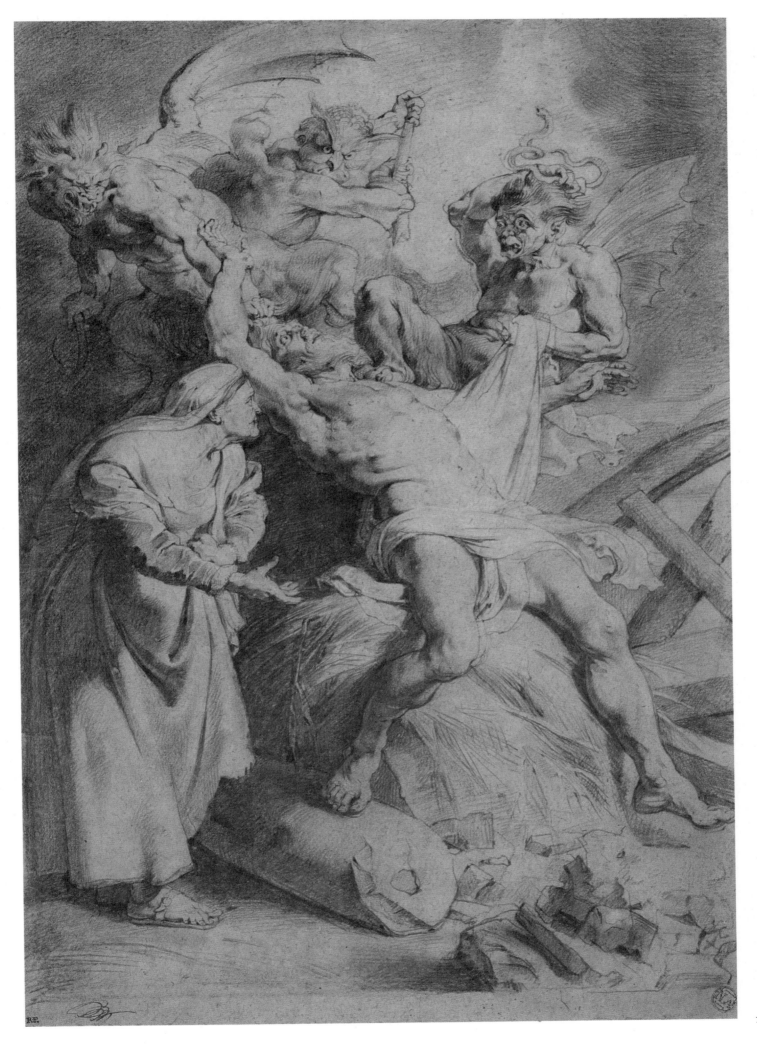

43
Studies of a Man on Horseback and Three Horses' Heads

c. 1620–1621

Pen and brown ink, point of brush, brown wash.
The lance held by the rider is drawn in black
chalk, 262 x 163 mm. In the lower part of the sheet
are color notes in Van Dyck's hand: *wit/ der neuse
incarnatie/ half farmelioenachtig/ grau*.

Verso: a modern inscription in graphite: *Antony
van dyk* and the number A302.

Watermark: a heart with a housemark above it

Rijksmuseum, Amsterdam, Rijksprentenkabinet
(inv. no. 1884.A302)

Vey 93
Exhibited in Fort Worth

PROVENANCE J. de Vos (1803–1878), Amster-
dam; his sale, Amsterdam, 22–24 May 1883, lot
153; acquired by the Rijksprentenkabinet (L.2228,
verso, lower left) through the Vereeniging Rem-
brandt (L.2135, verso, lower left) in 1884.

EXHIBITIONS Brussels 1910, no. 30; Rotterdam
1948–1949, no. 78; Paris 1949, no. 124; Brussels
1949, no. 117; Antwerp 1949, no. 112; Antwerp
1960, no. 48.

LITERATURE Moes 1913, II, 52; Delacre 1932, 96;
Delacre 1934, 144; Göpel 1940, 107; Van den Wijn-
gaert 1943, 185; Sandoz 1954, 28–35; Vey 1962,
no. 93; Boon 1965, 38, no. 44.

1. Carolyn Logan suggested to me the intriguing
possibility that as the same head seems to be
shown from two different points of view, it may
be drawn from a sculpture or a cast.

The helmeted rider who drives his lance at an unseen enemy or prey has been
loosely related by Vey to representations of Saint Martin and Saint George. He
noted similarities with the pose of Saint Martin in the altarpiece of *Saint Martin
Dividing His Cloak* at Zaventem [cat. 10, fig. 1]. The resemblance is slight, however,
and this animated group of horse and rider is more likely to be an independent
creation by Van Dyck which he was intending to use for a scene of battle or hunting.
Beneath, he made three studies of a horse's head, presumably from life.[1] The color
notes read: "white/ the nostrils flesh colored/ half cinnabar-like/ gray."

There are closely comparable drawings of horses in the Italian sketchbook,
notably those on folios 26 verso and 27 [figs. 1, 2]. This sheet should probably be
dated shortly before Van Dyck's departure for Italy, that is, in about 1620.

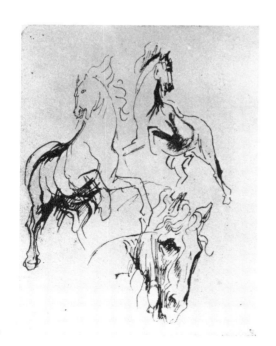

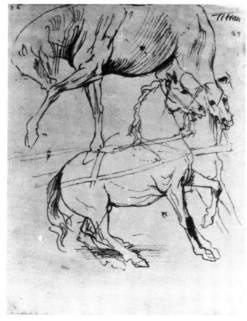

Fig. 1. Anthony van Dyck, Italian Sketchbook,
fol. 26*v*. The British Museum, London

Fig. 2. Anthony van Dyck, Italian Sketchbook,
fol. 27. The British Museum, London

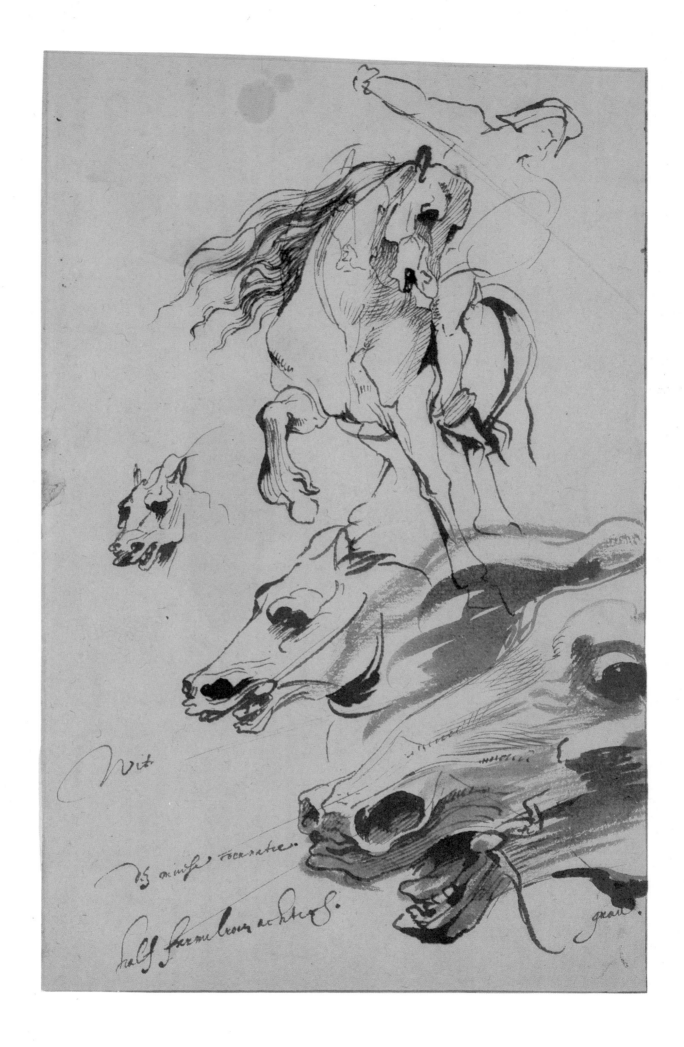

ITALY
1621–1627

44
Saint Matthew and the Angel

c. 1621–1627

Pen and brown ink, brown wash on light brown (formerly gray-blue) paper, 202 x 139 mm. Some water staining at the top left.

Verso: a house (apparently on fire) among trees. Pen and brown ink and gray and brown washes. Two pen inscriptions in Van Dyck's hand: in the top right-hand corner, two words, the upper one illegible, the lower *verbrandt* (burning); in the center of the sheet, two words, *bau[w?]/ rookt* (the building is smoking); bottom, center, in graphite, in a later hand: *Dyk*.

Watermark: none

Museum Boymans-van Beuningen, Rotterdam (inv. no. Van Dyck 16)

Vey 111

PROVENANCE F. J. O. Boymans (1767–1847), Utrecht; Museum Boymans (L.1857, lower right).

EXHIBITIONS Antwerp 1960, no. 60; Leningrad 1974, no. 25; Princeton 1979, no. 31.

LITERATURE Boymans 1852, no. 27 (as Van Dyck School); Boymans 1869, no. 134 (as Van Dyck School); Vey 1956A, 53; Vey 1962, no. 111.

1. All four paintings are oil on canvas and measure 82 x 63 cm. They were exhibited in Genoa 1955, cats. 33–36, as from the collection of the Marchesi F. and P. Spinola. In his review of the exhibition in the *Burlington Magazine* (97, 1955, 314), Millar commented that they were "a set of varied quality, but they contain passages of real brilliance and were probably painted early in the Italian years." They are nos. 357–360 in Larsen 1980. Susan Barnes has kindly informed me that she has not included them in her (unpublished) catalogue raisonné of Van Dyck's Italian period paintings, considering them to be the work of an Italian follower of Van Dyck.

In a private collection in Genoa there is a series of four paintings of the Evangelists.[1] They are shown in half-length, and Saint Matthew turns his head towards the angel who leans over his shoulder, pointing at his book, much as he does in this drawing. The four paintings are either by Van Dyck himself or, according to Vey, they are copies after Van Dyck by an Italian follower. Whatever the exact status of these paintings, and I have not seen them in the original, the similarities between the drawing and the *Saint Matthew* [fig. 1] suggest that they preserve the compositions of a series of Evangelists by Van Dyck probably painted during his Italian years.

On the verso is a drawing of a burning house, perhaps observed from nature. Van Dyck has written two words in Flemish which appear to be *bau[w?]* and *rookt*, which is perhaps meant to read, literally, "the building is smoking [i.e. on fire]."

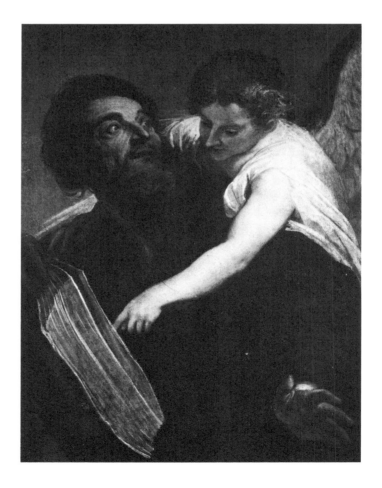

Fig. 1. Attributed to Anthony van Dyck, *Saint Matthew and the Angel*. Canvas, 82 x 63 cm. Collection of the Marchesi F. and P. Spinola, Genoa

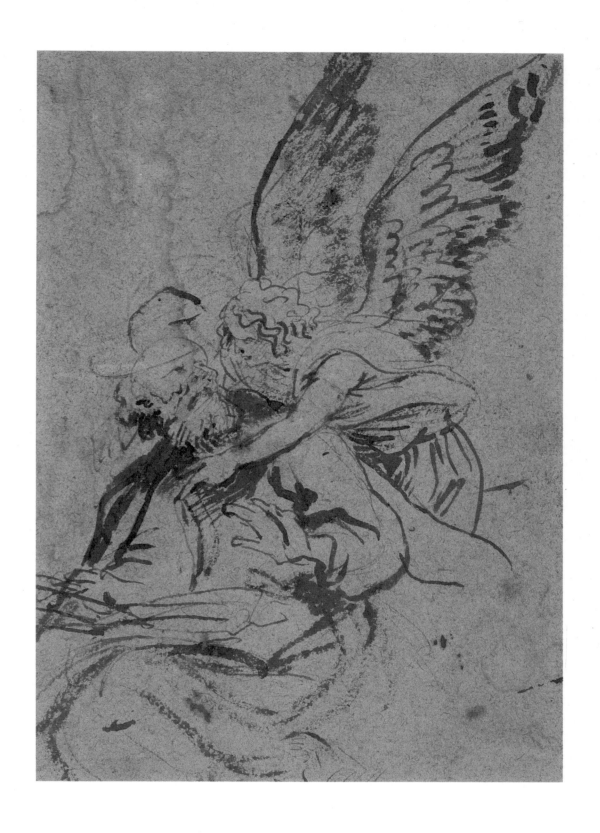

Cat. 44 verso

166

45
The Virgin and Child with Female Saints and Angels

1624

Pen and brown ink, 267 x 171 mm. Lower left, the paper has been torn and a new piece added (this was done at the latest during the eighteenth century, because Reynolds' stamp is on the addition). Some small abrasions in the center and in the lower right-hand quarter. The sheet is laid down on an English eighteenth-century printed almanac leaf.

Verso: Beneath the figure of the Virgin, which shows through from the recto, is the word, in pen: *orijgynel.*

Watermark: none

Liberna Collection, Hilversum

Vey 117

PROVENANCE J. Richardson the Elder (1665–1745), London (L.2183, lower right, on the original sheet); Thomas Hudson (1701–1779), London (L.2432); Sir Joshua Reynolds (1723–1792), London (L.2364, lower left, on the paper inserted in the area of the damage); Contessa R. Piatti-Lochis, Crocetta (L.2026c, on the mount); F. Asta (1900–1952), Venice (L.116a, lower left, on the original sheet); H. Fleischhauer (d. 1930), Stuttgart; Bernard Brenninkmeyer, London and Amsterdam.

EXHIBITION Antwerp 1960, no. 61.

LITERATURE Vey 1956B, 196–198; Vey 1962, no. 117; Bolton-Folmer 1989, no. 127.

1. Glück 1931, 155.
2. For a discussion of Van Dyck's paintings of Saint Rosalie, see Princeton 1979, 125–131 (with previous literature) and Z. Zaremba Filipczak, "Van Dyck's 'Life of St. Rosalie'," *Burlington Magazine* 131, 1989, 693–698.
3. In the Italian sketchbook. Adriani 1940, fol. 10.
4. Oldenbourg 1921, 23.

This is undoubtedly the most important surviving drawing from Van Dyck's Italian years. It is a compositional study for the right-hand side of the altarpiece of the *Madonna of the Rosary* which was commissioned from Van Dyck for the Oratorio del Rosario in Palermo, where it still hangs [fig. 1].[1] This was the most prestigious non-portrait commission he received during his stay in Italy. Although, as we know from Bellori, Van Dyck received the commission during his stay in Palermo in 1624 and presumably made this drawing at that time, he took the unfinished altarpiece with him back to Genoa, completing it in 1627. It was not installed in Palermo until the spring of 1628, when Van Dyck had returned to Antwerp.

The drawing, which shows Van Dyck's earliest thoughts on the representation of this subject, contains three of the principal groups in the altarpiece, the Virgin and Child, the angels, and the two standing female saints, Saints Rosalie and Catherine, squashed together on the sheet. The two figures on the far right were transformed in the altarpiece itself. As Van Dyck refined the composition, he made many more changes: he opened up, as he had presumably always intended to, the space between the Virgin and Child, the angels, and the saints; he made the central action of the altarpiece the handing of the rosary to Saint Dominic; and he introduced the dramatic figure of the child rushing out of the painting holding his nose against the stench of death, a motif he took from Caravaggio's *Martyrdom of Saint Matthew* in the Contarelli Chapel in San Luigi dei Francesi in Rome [fig. 2].

This commission was prompted by a particularly ferocious outbreak of plague in Sicily in 1624, which began in mid-May, shortly after Van Dyck's arrival on the island. In the months that followed it claimed the lives of many thousands of Sicilians, including the viceroy Emmanuel Philiberto of Savoy, who had invited the artist to the island in order to paint his portrait. On 14 July of that year the bones of the city's patron, Saint Rosalie, were fortuitously discovered in the grotto on Monte Pellegrino to which she had retired as a hermit and where she had died in about 1160. Her cult was enthusiastically promoted and her powers as an intercessor widely invoked. Van Dyck was commissioned to paint a number of pictures of the saint interceding for the city [fig. 3],[2] and in this altarpiece she is the saint in nun's habit who looks up at the Virgin and Child and gestures towards the boy (and the skull on the ground in front of him), who symbolizes the horrors of the plague. The saint in profile in front of her, with an elegantly attenuated figure, is Saint Catherine, who in the drawing is shown with her attribute of a wheel. Another female saint, holding an arrow, stands behind her. In the left-hand corner is a kneeling woman who has collected roses thrown by the angels. An angel in the top right-hand corner of the painting holds up a rosary, showing it to the Christ Child.

Van Dyck's composition is based on Venetian altarpieces, notably on Titian's *Assunta*, which he had seen and sketched in Venice.[3] There are also powerful reminiscences, particularly in the elegant figure of Saint Catherine, of Rubens' altarpiece for the Chiesa Nuova in Rome [fig. 5]. It recalls Saint Domitilla in the first version [fig. 4], which Van Dyck would have known well, as it hung over Rubens' mother's tomb in the Abbey of Saint Michael in Antwerp.[4]

Vey notes that there was a copy of this drawing on the Paris art market in 1954.

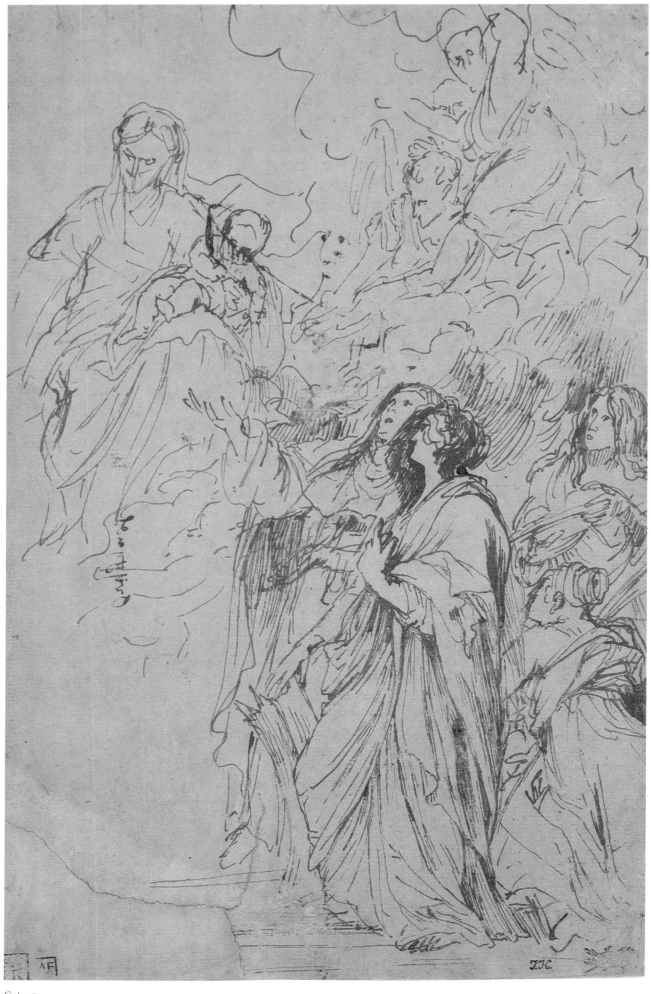

Cat. 45

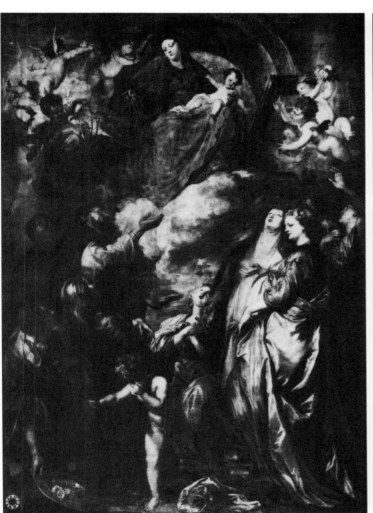

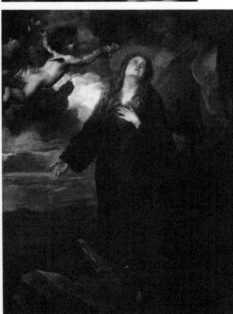

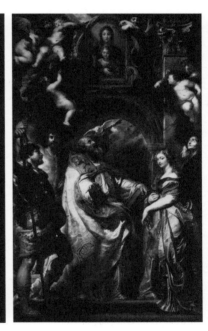

Fig. 1. Anthony van Dyck, *The Madonna of the Rosary*. Canvas, 397 x 278 cm. Oratorio del Rosario, Palermo

Fig. 2. Caravaggio, *The Martyrdom of Saint Matthew*. Canvas, 323 x 343 cm. Contarelli Chapel, San Luigi dei Francesi, Rome

Fig. 3. Anthony van Dyck, *Saint Rosalie in Glory Crowned by Two Angels*. Canvas, 117.2 x 88 cm. The Wellington Museum, Aspley House, London

Fig. 4. Peter Paul Rubens, *The Madonna della Vallicella Adored by Saints Gregory, Domitilla, Maurus, Papianus, Nereus, and Achilleus*. Canvas, 474 x 286 cm. Musée de Peinture et de Sculpture, Grenoble

Fig. 5. Peter Paul Rubens, *The Madonna della Vallicella Adored by Angels and Saints*. Oil on slate, 425 x 250 cm (central section), 425 x 280 cm (left and right sections). Santa Maria in Vallicella, Rome

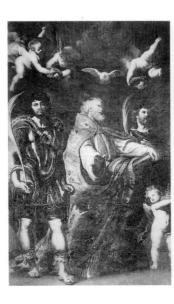

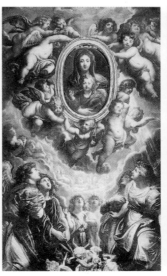

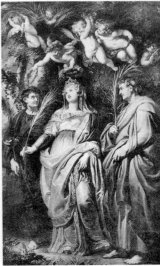

169

46
Christ and the Woman Taken in Adultery

c. 1621–1624

Pen and brown ink, 137 x 221 mm. Lower left, in Van Dyck's own hand: *Ant°. van Dyck F.*; lower right, in a later hand in pen: n.f.

Watermark: none

Stedelijk Prentenkabinet, Antwerp (inv. no. 377)

Vey 147

PROVENANCE R.d.V. collection (*RdV*, verso, lower left: not in Lugt); sale, Muller, Amsterdam, 19 January 1904, lot 99; M. Rooses (Antwerp, 1839–1914); Stedelijk Prentenkabinet (L.2045a, verso, center).

EXHIBITIONS Antwerp 1927, no. 30; Antwerp 1936, no. 70; Antwerp 1949, no. 74; Paris 1954, no. 111; Antwerp 1956, no. 603; Antwerp 1960, no. 56; Antwerp 1971, no. 8; Washington 1976–1978, no. 15.

LITERATURE De Bosschère 1910, 18–19; Delacre 1934, 189; Delen 1938, no. 377, pl. 71; Van den Wijngaert 1958, 30; Vey 1962, no. 147.

1. Canvas, 82.5 x 136.5 cm, inv. no. 114. Wethey 1969, I, no. 17. V. Oberhammer, "Christus und die Ehebrecherin. Ein Frühwerk Tizians," *Jahrbuch der Kunsthistorischen Sammlungen in Wien* 60, 1964, 101–136.
2. Speth-Holterhoff 1957, pls. 57–58.
3. For the early history of the painting, see Oberhammer, op. cit. It was mentioned in the Della Nave collection by Ridolfi (Ridolfi 1648, I, 201).
4. Adriani 1940. See, for example, the copies after Titian on fol. 6v, 12, 17, 18v, and 19.
5. This is how he signs his name on fol. 2 of the Italian sketchbook.

This is a free copy after a painting by Titian which is now in the Kunsthistorisches Museum in Vienna [fig. 1].[1] The painting, which today is considered to contain substantial workshop participation, was in the collection of Bartolomeo della Nave in Venice by 1636 and Van Dyck probably saw it there during his visit to the city in 1622–1623. Subsequently it was taken, with the rest of the Della Nave collection, to England. The greater part, including this painting, was sold to Archduke Leopold Wilhelm. The *Christ and the Woman taken in Adultery* can be seen in views of his gallery in Brussels,[2] and is illustrated in Teniers' *Theatrum Pictorium* of 1660.[3] This drawing, however, certainly dates from Van Dyck's years in Italy: the technique is precisely comparable with that of the Italian sketchbook [fig. 2].[4]

Van Dyck made many drawings after Titian in the Italian sketchbook, but very few such drawings on individual sheets survive. As in the sketchbook, he does not make a detailed copy but sketches the principal figures and indicates shadow with powerful shading. He also makes small changes: here he has altered the angle of the head of the figure on the far right and moved the man on his right closer to him. The gesture of the old man on Christ's left is made more emphatic, and the wall in the background has been omitted. His concern is not with detail but with the disposition of the figures. In view of the haste with which this drawing was made, it is perhaps surprising that he should sign it so prominently with his Italian signature "Antonio van Dyck."[5] He presumably gave it to a friend or acquaintance.

Fig. 1. Titian, *Christ and the Woman Taken in Adultery*. Canvas, 82.5 x 136.5 cm. Kunsthistorisches Museum, Vienna

Fig. 2. Anthony van Dyck, Italian Sketchbook, fol. 6v. The British Museum, London

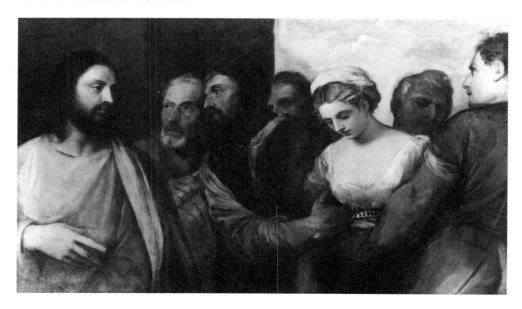

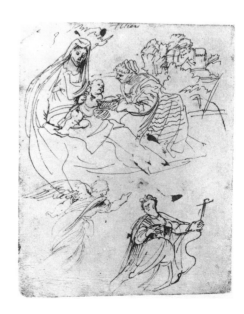

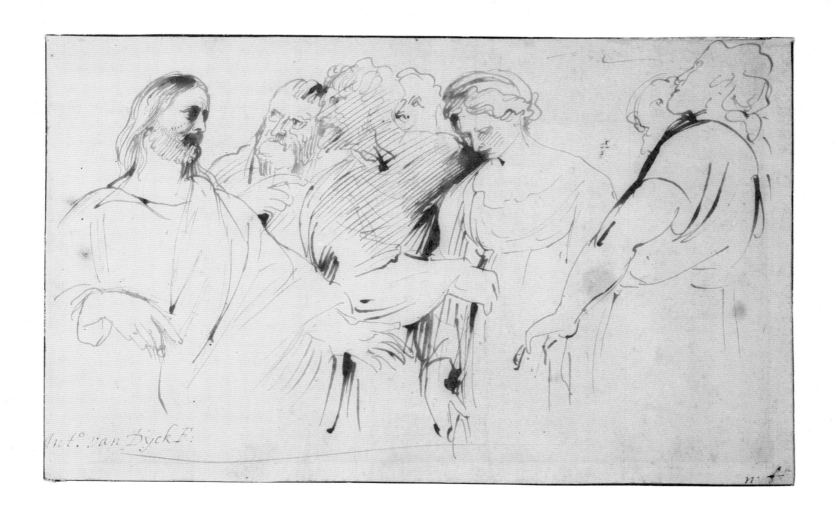

Ant.º van Dyck F:

171

47
A Woman in a Nun's Habit

c. 1621–1627

Pen and brown ink, 157 x 108 mm.

Verso: along the bottom edge of a piece of torn paper attached to the back of the drawing, is an old inscription in pen: *Ant*. Also along the bottom edge, in graphite: *van Dyck 'nun.' Purchased 20.814*.

Watermark: none

Museum of Fine Arts, Boston (inv. no. 20.814)

Vey 170

PROVENANCE H. Adams; Howard Wicklow (catalogue of 1873, no. 609); Mrs. Q. Shaw; Henry P. Quincy; purchased from Mrs. Henry P. Quincy, from the Frances Draper Colbourn Fund, 3 June 1920.

EXHIBITION Antwerp 1960, no. 66.

LITERATURE Vey 1957, 198–200; Vey 1962, no. 170.

1. Glück 1931, 187.
2. Glück 1931, 201.
3. Turin, Galleria Sabauda. Glück 1931, 299.

This composition shows a woman in the habit of a nun or abbess standing in front of a high-backed chair between two imposing columns, with a wooded landscape glimpsed in the background. The composition is very similar to those of the many portraits of the Genoese aristocracy Van Dyck painted during his years in the city. It was a type of portrait which had been created by Rubens during his stay in Italy. There are strong similarities between this drawing and, for example, the portraits of the *Marchesa Elena Grimaldi* in Washington [fig. 1][1] and *Paola Adorno, Marchesa Brignole-Sale*, in the Palazzo Rosso in Genoa [fig. 2].[2] No painting of this particular sitter is, however, known. Though Van Dyck must have made many drawings for his Genoese portraits, very few of them survive, although a black chalk drawing made for pose and costume is included in this exhibition [cat. 48]. This is the only compositional drawing in pen for a portrait (except those for Sir Robert and Lady Shirley and Sofonisba Anguissola in the Italian sketchbook) from Van Dyck's Italian years: perhaps the reason for making the drawing was the unfamiliarity of the costume. The subject herself might have asked for the drawing in order to give her an idea of what the painted portrait would look like. Not only does the pose and setting place this drawing firmly in Van Dyck's Italian period, but the graphic style is very similar to drawings in the Italian sketchbook. Later, after his return from Italy, Van Dyck was to portray the Infanta Isabella in nun's habit.[3]

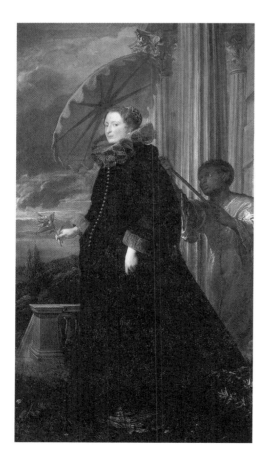

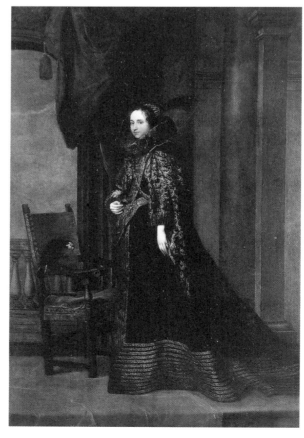

Fig. 1. Anthony van Dyck, *Marchesa Elena Grimaldi*. Canvas, 246 x 173 cm. National Gallery of Art, Washington. Widener Collection

Fig. 2. Anthony van Dyck, *Paola Adorno, Marchesa Brignole-Sale*. Canvas, 286 x 198 cm. Palazzo Rosso, Genoa

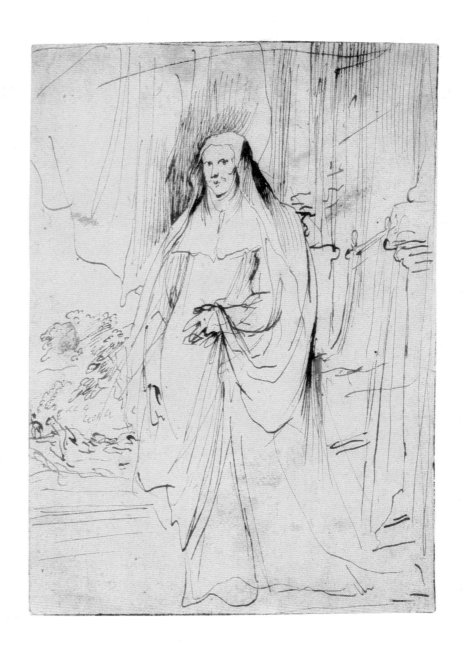

48
An Italian Nobleman

c. 1624–1627

Black chalk with white chalk highlights, on a light
gray (with a light lilac tint) paper. 409 x 251 mm.
A little faded. The white chalk has been worn
away in places. Trimmed along the bottom edge.
Inscribed, in pen, top left: *A.V.Dijck.*

Watermark: a double-headed eagle and above it a
housemark

Museum Boymans-van Beuningen, Rotterdam
(inv. no. V.13)

Vey 172

PROVENANCE P. H. Lankrink (1628–1692),
London (L.2090, bottom edge); J. Richardson the
Elder (1665–1745), London (L.2184, bottom edge);
Sir Joshua Reynolds (1723–1792), London (L.2364,
bottom edge); J. Thane (1748–1818), London
(L.1544, bottom edge); A. Beugo (early nineteenth
century), London (L.82, bottom edge); F. Koenigs
(1881–1941), Haarlem (L.1023a, verso, lower left);
D. G. van Beuningen; presented by him to the
museum in 1941.

EXHIBITIONS Antwerp 1927, no. 41; Rotterdam
1938, no. 263; Antwerp 1960, no. 65.

LITERATURE Van Gelder 1939, 11–12; Vey 1956A,
82; Vey 1962, no. 172.

1. Staatliche Kunstsammlungen, inv. no. GK121.

This is a study for the *Portrait of a Young Man* in Kassel [fig. 1].[1] It was drawn from
life and is a study for pose and costume rather than for the head, which Van Dyck
would have probably painted directly on the canvas. This drawing is an *aide-
mémoire*. It is possible that a servant posed in the clothes of the sitter. The painting is
certainly from Van Dyck's Italian years, probably from the period 1624–1627 when
he spent most of his time in Genoa, where this portrait was presumably painted.

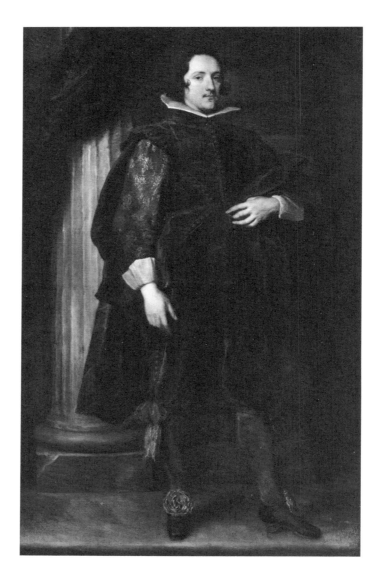

Fig. 1. Anthony van Dyck, *Portrait of a Young Man*.
Canvas, 200 x 124.2 cm. Staatliche Kunstsamm-
lungen, Kassel

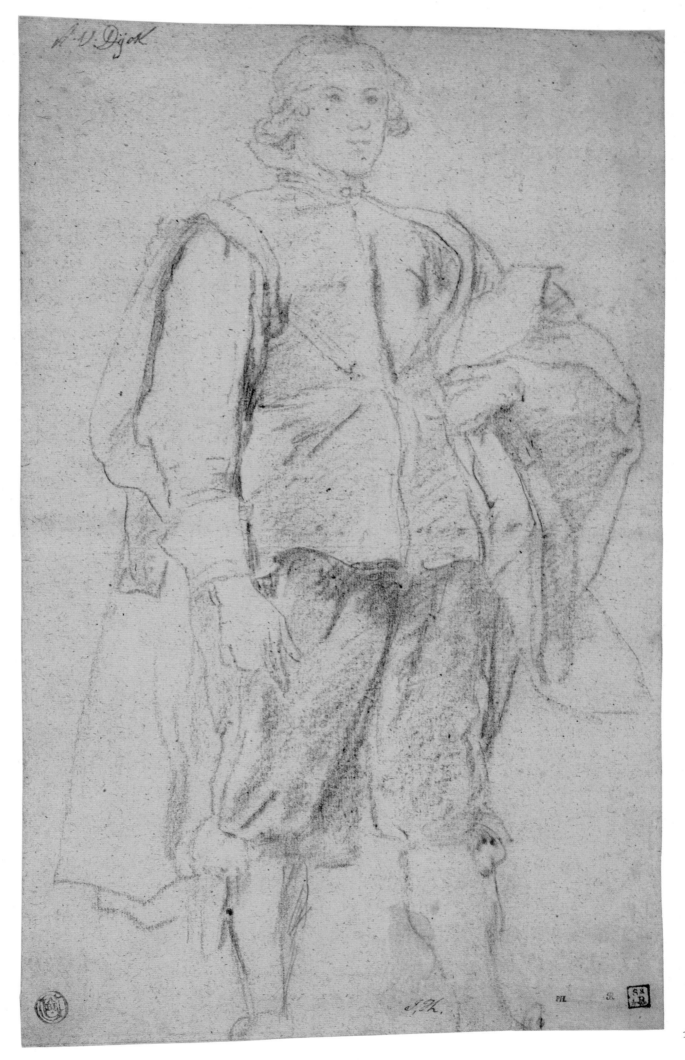

A. V. Dijck

175

49
The Crucifixion

c. 1627–1630

Pen with brown ink and brown wash, with highlights in white bodycolor on blue-gray paper, 271 x 195 mm. Squared up in pen. Trimmed on all four sides. In the top left corner is a tear which has been repaired: the squaring-up and the clouds have been continued over the addition in black chalk.

Verso: studies for *The Crucifixion*. Pen and brown ink over traces of black chalk, heightened with white bodycolour. There are three groups of figures. The first consists of three figures, the Virgin, Saint John and a third, weeping figure; the second shows Saint John reaching out to confort the Virgin at the foot of the Cross (which is indicated summarily); the third, which is at right angles above the other two groups, contains a crucified figure (presumably one of the thieves) with, beside him, Saint Longinus on horseback with his lance raised, seen obliquely from the back, with the head of another horseman and his horse's head behind.

Watermark: illegible (perhaps an armorial?)

British Museum, London, Department of Prints and Drawings (inv. no. 1910.2.12.207)

Vey 124

PROVENANCE N. A. Flinck (1646–1723), Rotterdam (L.959, lower right); G. Salting (1835–1909), London, by whom bequeathed to the British Museum (L.302, verso, top left).

EXHIBITION London 1912, no. 140.

LITERATURE Hind 1923, no. 5; Vey 1959, 19–20; Vey 1962, no. 124.

1. Glück 1931, 224 (Lille), 236 (1629; Antwerp), 240 (Saint Rombaut's, Mechelen), 242 (Church of Our Lady, Dendermonde), and 247 (1630; Saint Michael's, Ghent).
2. Glück 1931, 247.
3. For that altarpiece there is also a *modello* in oil on panel. Glück 1931, 246.

Van Dyck has drawn the body of Christ in two positions. He painted a number of altarpieces of the *Crucifixion* in the years following his return from Italy in 1627.[1] Although it is squared up, this drawing was not directly used for any of the known versions of the subject. In the group of the Virgin and Saint John (although on the other side of the Cross), the figure of the Magdalen kneeling to kiss the Cross, and the armed horsemen in the background, it is closest to the *Crucifixion* in Lille, which comes from the Church of the Recollets in that city. In that painting, however, the Cross is placed on the left and at an angle. The drawing has been lifted especially for this exhibition and three studies for groups of figures for the *Crucifixion* revealed on the verso. These vigorous pen drawings are strikingly similar to the groups of figures in a sheet of studies for the *Crucifixion* in the Ecole des Beaux-Arts, Paris (Vey 123). In particular the central group in the London drawing of Saint John reaching out towards the Virgin is very close to that on the left of the recto of the Paris sheet: this group is worked out in greater detail on the verso. Both drawings appear to be studies for the Lille *Crucifixion*. There are a number of other drawings for altarpieces of the *Crucifixion* from this period of Van Dyck's career. For example, there is a black chalk drawing for the body of Christ in the altarpiece of *Christ on the Cross surrounded by the Virgin and Saints* in the Church of Our Lady, Dendermonde [fig. 1], which is also in the British Museum [fig. 2]. Another drawing, in Rotterdam [fig. 3], for the *Crucifixion* in the Church of Saint Michael in Ghent [fig. 4],[2] is a detailed compositional study, carefully drawn in pen and then delicately washed, which appears as if it were made to be shown to the patrons.[3]

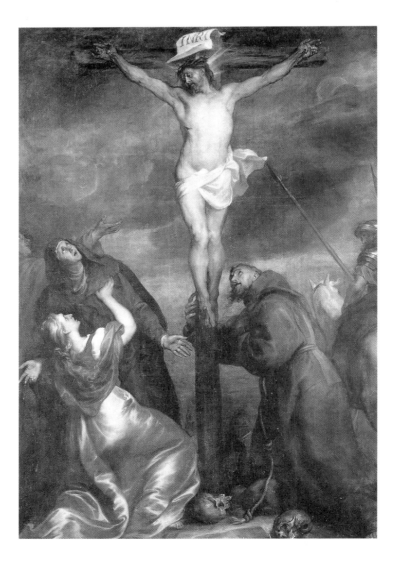

Fig. 1. Anthony van Dyck, *The Crucifixion*. Canvas, 382 x 270 cm. Church of Our Lady, Dendermonde

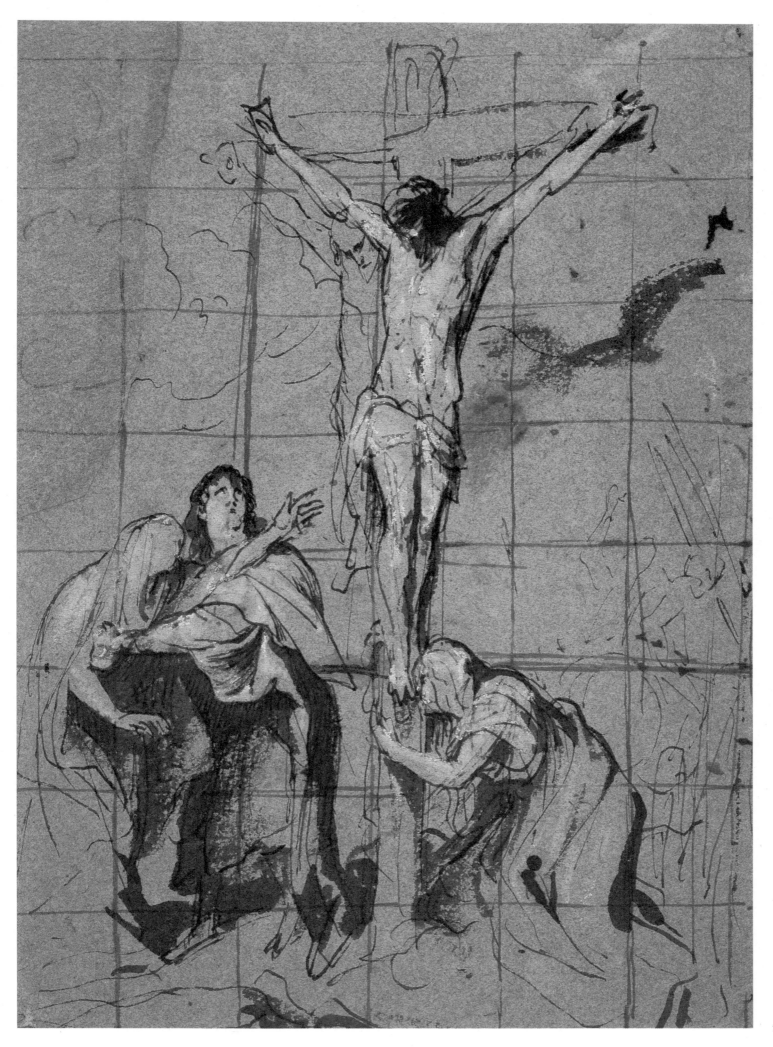

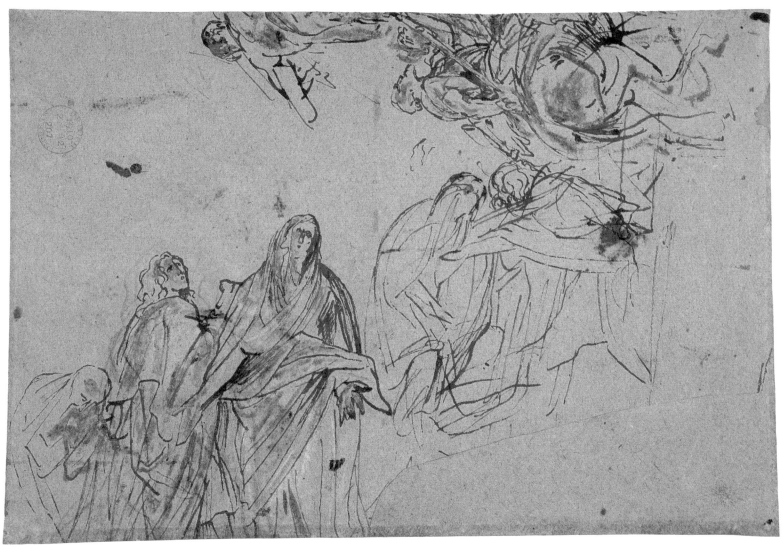

Verso

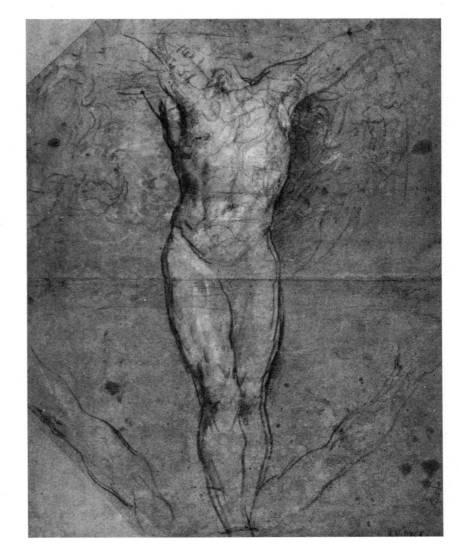

Fig. 2. Anthony van Dyck, *The Crucifixion*. Black chalk, with white chalk highlights, on blue paper, 565 x 439 cm. The British Museum, London (Vey 126)

Fig. 3. Anthony van Dyck, *The Crucifixion*. Pen and brown ink over black chalk, with brown wash, 300 x 250 mm. Museum Boymans-van Beuningen, Rotterdam (Vey 125)

Fig. 4. Anthony van Dyck, *The Crucifixion*. Canvas, 400 x 290 cm. Church of Saint Michael, Ghent

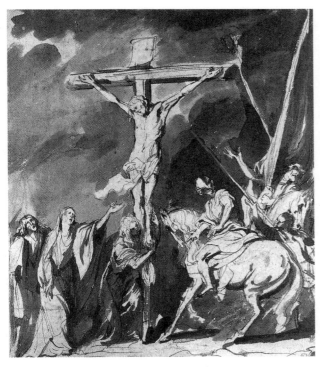

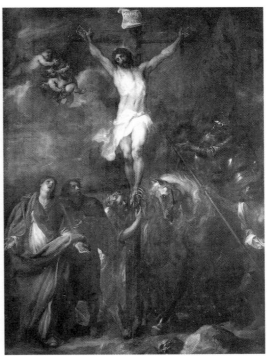

50
Studies for a Lamentation

c. 1627–1630

Black chalk, with white heightening, on blue paper (faded to greenish-grey), 533 x 451 mm. There is a horizontal fold in the middle. Lower left, an illegible pen inscription.

Watermark: none

British Museum, London, Department of Prints and Drawings (inv. no. 1875.3.13.45)

Vey 130

PROVENANCE P. H. Lankrink (1628–1692), London (L.2090, lower right); J. Richardson the Elder (1665–1745), London (L.2184, lower left); Thomas Hudson (1701–1779), London (L.2432, lower right).

EXHIBITION London 1984, no. 91.

LITERATURE Vasari Society, II, no. 27; Hind 1923, no. 7; Delen 1943A, no. 16; Delen 1949, no. 31; Vey 1962, no. 130.

1. Glück 1931, 244.
2. Paper on wood, 380 x 295 mm. Formerly in the Lion collection, Berlin (notes to Glück 1931, 244). Present whereabouts unknown.
3. Bock and Rosenberg 1930, 125, no. 1332.

These are studies made for the figure of Christ and the head of Saint John the Evangelist in *The Lamentation* [fig. 1], a painting which was in the Kaiser-Friedrich-Museum in Berlin but was destroyed in 1945.[1] In the painting Saint John is shown looking up, as he is on the right-hand side of this sheet. The composition was engraved by Paulus Pontius with a dedication to Van Dyck's sister Anna, who was a nun. The painting dates from the years immediately following Van Dyck's return from Italy in 1627.

Glück mentions an oil sketch for the head of the angel at Christ's feet but such a sketch (on paper pasted on wood) for the head of a subsidiary figure would be unusual and may be a copy.[2] A drawn copy after the painting in Berlin has wrongly been thought to be a preparatory drawing.[3]

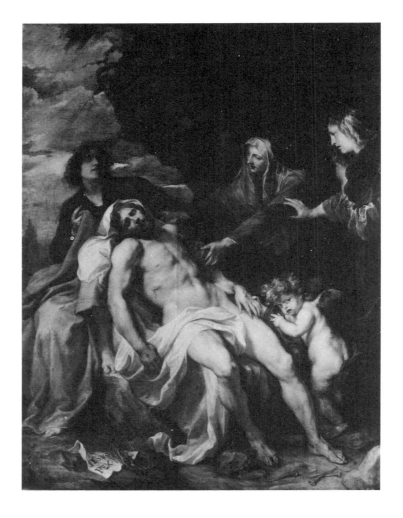

Fig. 1. Anthony van Dyck, *The Lamentation*. Canvas, 220 x 166 cm. Formerly Kaiser-Friedrich-Museum, Berlin

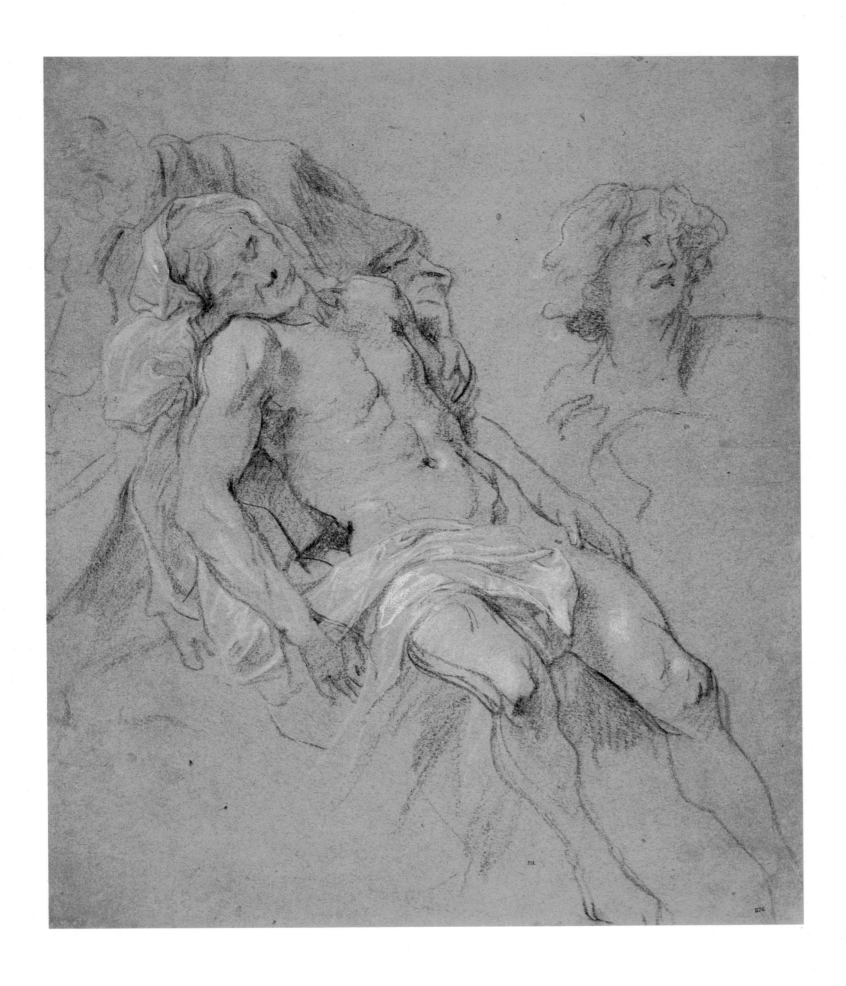

183

51
Diana and Endymion

c. 1629

Pen and point of brush, brown ink and brown
wash, heightened with white bodycolor, on
blue-gray paper, 190 x 228 mm. Lower left: L.2445.

Inscriptions on the old mount, now removed, in
pen and red ink: / 7 te, and in graphite in the hand
of the collector Jacob de Vos: K Dec 65.[1]

Watermark: not visible (laid down)

The Pierpont Morgan Library, New York
(inv. no. I, 240)

Vey 132

PROVENANCE William Young Ottley (1771–
1836), London; possibly his sale, London,
T. Philipe, 11–14 April 1804 (there were four Van
Dyck drawings in lot 430: "Van Dyck. Four
Narcissus ... Studies of Heads ... and two sheets
of pen sketches, one on both sides"); Samuel
Woodburn; Sir Thomas Lawrence (1769–1830),
London (L.2445, lower left) (not in 1835 exhibition
catalogue); Lawrence-Woodburn sale, Christie's,
London, 12–14 June 1860, lot 1211 ("Dyck
[A. van]—Venus supporting the dead body of
Adonis—pen and bistre wash"; to Seymour for
£1.4s.od.); presumably H. Danby Seymour,
London (but not in his sale, Sotheby's, London,
20 May 1875); Jacob de Vos Jbzn (1803–1882),
Amsterdam; his sale, Amsterdam, Roos, Muller ...,
22–24 May 1883, lot 145 ("Couple amoureux.
Croquis à la plume sur papier bleu—Hauteur 19,
largeur 22,5 cent. Collection Sir Thomas
Lawrence"; to Thibeaudeau for 510 fl.); Sir Francis
Seymour Haden (1818–1910), London (his name is
written in ink on the backing sheet); his sale,
Sotheby's, London, 15–19 June 1891, lot 546
("Venus and Adonis, pen and bistre"; to Fairfax
Murray for £4.4s.od.); Charles Fairfax Murray
(1849–1919), London; J. Pierpont Morgan.

EXHIBITIONS New York 1936, no. 71; New York
1939, no. 79 and 1940, no. 96; New York 1959,
no. 45; New York 1968–1969, no. 56; Paris
1979–1980, no. 30; New York 1981, no. 65.

LITERATURE Morgan 1905–1912, I, no. 240; Tietze
1947, 124; Vey 1962, no. 132; Eisler 1963,
pl. 43; Held 1964, 566; Stampfle 1991, no. 269.

1. 1865 was the date of one of the exhibitions in
Amsterdam organized by Arti et Amicitiae, at
which De Vos exhibited his drawings.
2. Canvas, 144 x 183 cm. Prado, Madrid. Glück
1931, 141. Painted in Antwerp in about 1620. For
the correct identification of the subject, see
E. McGrath, "Pan and the Wool," The Ringling
Museum of Art Journal, 1983, 52–69.
3. Glück 1931, 265; Washington 1990–1991, no. 54.

On this sheet there are two versions of the scene in which the goddess Diana, seeing
the sleeping shepherd Endymion, is bewitched by his beauty and kisses his cheek.
Vey considered the drawing higher up the sheet on the right to be by another hand,
but as Held pointed out, it is undoubtedly by Van Dyck himself. The artist presum-
ably began by making the larger drawing, which shows the goddess in the act of
kissing the shepherd. He used pen and then added wash and white bodycolor,
which models the figures with deep shadows and suggests the moonlight in which
the scene took place. The putto or cupid with the torch is also appropriate to the
night-time setting. The second drawing, in pen, shows alternative arrangements for
the two heads and for Endymion's pose. Van Dyck depicts the scene a moment
earlier, when Diana reaches out her hand to touch Endymion's cheek.

As far as is known, Van Dyck did not make a painting of this composition or,
indeed, of this subject. A painting in the Prado which had been thought to show
Diana and Endymion has recently been demonstrated to represent *Pan and Diana*.[2]
The drawing does, however, strongly recall the *Rinaldo and Armida* in Baltimore
[fig. 1],[3] and was probably made at about the same time as that painting which, as
we know from a letter from the artist to Endymion Porter, was ready for delivery to
Charles I in December 1629.

Fig. 1. Anthony van Dyck, *Rinaldo and Armida*.
Canvas, 236.5 x 224 cm. The Baltimore Museum
of Art

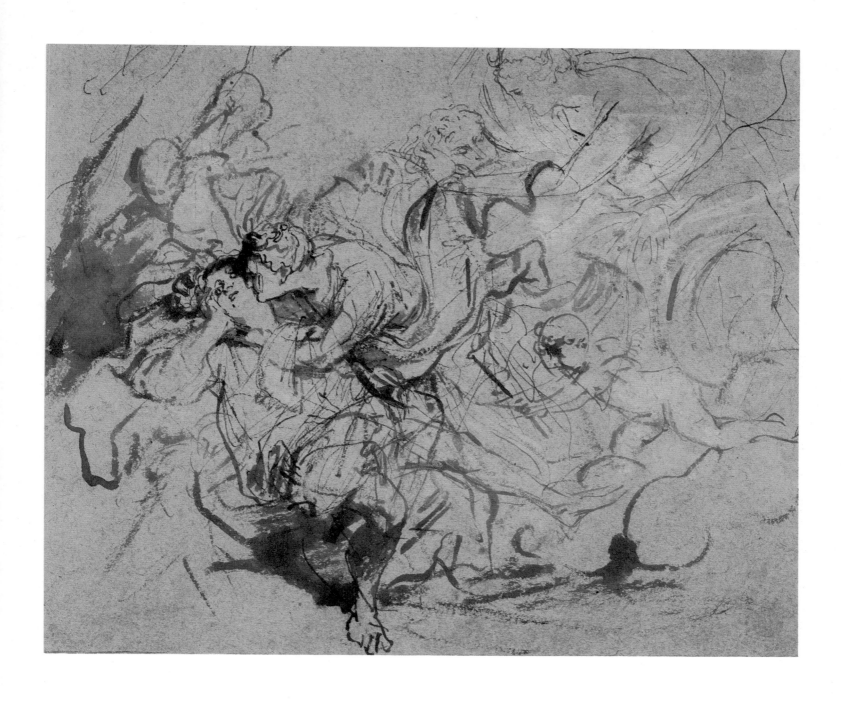

Anna van Thielen and Her Daughter, Anna Maria

1631–1632

Black chalk on (discolored) white paper,
317 x 263 mm. There are a few lines in pen
and brown ink in the woman's left sleeve. The
woman's left eye has been retouched, probably
by the artist himself. Lower right, an inscription
in pen: *P. P. Rubens.*

Watermark: a hunting horn within a shield
(not in Briquet)[1]

The Pierpont Morgan Library, New York
(inv. no. I.244)

Vey 185

PROVENANCE Jonathan Richardson the Elder
(1665–1745), London (L.2183, lower right);
Sir Thomas Lawrence (1769–1830), London
(L.2445, lower left) (not in the inventory or in the
Lawrence-Woodburn sales); Jacob de Vos Jbzn
(1803–1882), Amsterdam; his sale, Amsterdam,
Roos, Muller ..., 22–24 May 1883, no. 452 (as
Rubens, but with the note "Croquis magistral à la
pierre noire qui nous paraît plutot être de van
dyck, savoir une première idée pour le tableau du
Maître au Musée de Dresde. Hauteur 32, largeur
27 cent."); sold to Thibaudeau for Heseltine for
305 fl.); J. P. Heseltine (1843–1929), London; given
by him to Sir Frederick Leighton; Lord Leighton
(1830–1896), London (L.1741a, verso, lower right
hand corner); his sale, Christie's, London, 16 July
1896, lot 436 (to Fairfax Murray for £17.0s.0d.);
Charles Fairfax Murray (1849–1919), London;
J. Pierpont Morgan.

EXHIBITIONS Hartford 1960, no. 75; Paris
1979–1980, no. 31.

LITERATURE Morgan 1905–1917, I, no. 244; Glück
1931, 289; Vey 1962, no. 185; Stampfle 1991,
no. 270.

1. The watermark is reproduced in Paris
1979–1980, watermark no. 45.
2. Inv. no. 599.
3. Mauquoy-Hendrickx 1956, no. 36.
4. For a discussion of this inscription, see
Schlüter-Göttsche in *Nordelbingen*, 43, 1974,
104–105, fig. 4.
5. Alte Pinakothek, Munich. 1983 catalogue,
188–189.
6. H. Vlieghe, "Theodoor Rombouts en zijn gezin
geportretteerd door Van Dijck," *Leids Kunsthisto-
risch Jaarboek*, 8, 1989, 145–157.
7. Mauquoy-Hendrickx 1956, no. 61.
8. Vlieghe, op. cit.

This is a preparatory study for a portrait in the Alte Pinakothek in Munich [fig. 2].[2]
At one time the portrait was thought to show the wife and child of Andreas Colyns
de Nole (before 1590–1638), an Antwerp sculptor, as the companion portrait of a
man was supposed to show him [fig. 1]. In fact, the male portrait bears no resem-
blance to the engraved portrait of De Nole by Pieter de Jode the Younger after Van
Dyck in *The Iconography*.[3] Glück noted that on a drawn copy of the female portrait
by Jürgen Ovens in the Kunsthalle, Hamburg, is the inscription *bij mijn Heer Leers tot
Antwerpen*,[4] and so suggested that the portrait might show a member of the Leerse
family. Van Dyck painted Sebastian Leerse with his wife and son in a portrait in
Kassel. However, in the 1983 catalogue of the Alte Pinakothek, Ulla Krempel
tentatively identified the pair of portraits in Munich as representing the Antwerp
painter Theodoor Rombouts (1597–1637), his wife Anna van Thielen, whom he
married in 1627, and their daughter Anna Maria, who was born in 1628.[5] This
identification, which seems to me to be correct and has recently been persuasively
supported by Hans Vlieghe,[6] was based on the evidence of the 1698 inventory of
Duke Maximilian Emmanuel in which the portraits are listed as "2 Tableaux mit
einem Kind, Rombault, Mann und Weib" and the striking similarity between this
man and the portrait of Rombouts in *The Iconography* which was engraved by
Pontius.[7] Vlieghe has identified self-portraits and portraits of Anna van Thielen in
genre paintings by Rombouts.[8] Anna Maria is presumably three or four years old,
and the paintings therefore datable to 1631 or 1632.

The drawing is not just for pose and costume, as the head of the mother is
carefully modeled. Although Vey considered it to be the work of a later hand, the
alteration to the left eye may well be by Van Dyck himself. The girl is shown at a
different angle in the drawing, and there are outlines for alternative positions of her
head, which suggests that she was reluctant to sit still in the studio. The head is
marvelously alert and her pose a delightfully informal element in a carefully posed
portrait. Van Dyck had some difficulty with her mother's right sleeve, which shows
a number of changes. He did not include any details of dress or jewelry in the
drawing, but added these when completing the painting.

Fig. 1. Anthony van Dyck, *The Painter Theodoor
Rombouts*. Panel, 122.9 x 90.8 cm. Alte Pinakothek,
Munich

Fig. 2. Anthony van Dyck, *Anna van Thielen, Wife
of the Painter Theodoor Rombouts, and Her Daughter
Anna Maria*. Panel, 122.8 x 90.7 cm. Alte Pinako-
thek, Munich

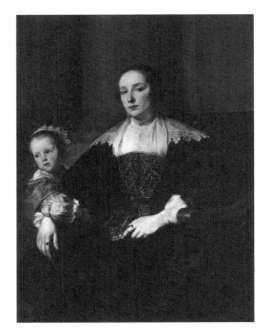

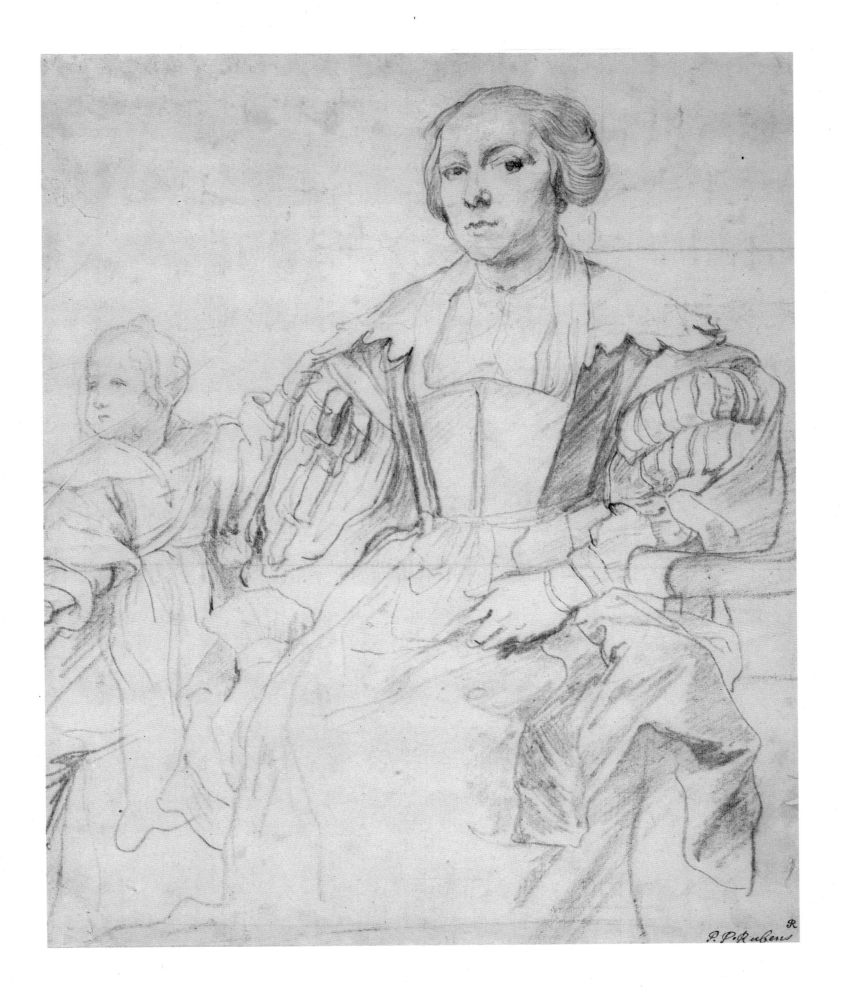

P. P. Rubens

53
Albert de Ligne, Prince of Barbançon and Arenberg, on Horseback

1628–1632

Pen with brown ink, 229 x 243 mm. Lower left, an inscription in pen in a later hand: *The Count of Arenberg by Vandyke.*

Verso: In the center of the sheet are a few pen lines which appear to show legs and feet on a pedestal. Towards the top right-hand corner is a black chalk drawing of a woman and another figure standing behind her. In the lower right-hand corner is a Venus Pudica in black chalk, which has been gone over in pen in a later, very clumsy hand. There is also an old inscription in pen: *Prins Mouris* [sic] *van Van Dijk. originael,* and beneath, on the right, in graphite: *12.*

Watermark: none

The Metropolitan Museum of Art, New York (inv. no. 40.91.16)

Vey 187

PROVENANCE The earls of Pembroke: at Wilton House since the eighteenth century; earl of Pembroke sale, Sotheby's, London, 5–6 and 9–10 July 1917, no. 378; purchased by Harold Hochschild from R. Ederheimer in 1923 (for $708); gift of Harold K. Hochschild, New York, 1940.

EXHIBITIONS Philadelphia 1950–1951, no. 50; Antwerp 1960, no. 88; *Flemish Drawings and Prints of the 17th Century,* Metropolitan Museum of Art, New York, 1970, no. 7; Springfield 1981–1982, no. 70.

LITERATURE Strong 1900, II, 70, no. 21; Leporini 1925, no. 226; Popham 1938, 50; Williams 1940, 156–157; Metropolitan Museum Drawings, II, New York, 1943, no. 2; Tietze 1947, 124, no. 62; Vey 1962, no. 187; Bean 1964, no. 82; Liedtke 1984, I, 85, fig. 17.

1. It bears the date 1630, which may well be correct. Glück 1931, 320. Formerly in the collection of the earl Spencer at Althorp.
2. Larsen 1980, no. 618.
3. G. Upmark, "Ein Besuch in Holland 1687, aus den Reiseschilderungen des schwedischen Architekten Nicodemus Tessin d. J.," *Oud Holland* 18, 1900, 201.

Albert de Ligne (1600–1674) was commander-in-chief of the Spanish forces in Bohemia, Westphalia, and the Netherlands. He was a distinguished soldier and was created a Knight of the Golden Fleece on 19 June 1627. He received the chain of the order at a ceremony in Brussels on 18 June 1628. In 1632 he was suspected, because of his friendship with Hendrick van den Bergh, of sympathizing with the Orange cause and was imprisoned in Antwerp from 1634 until 1642. He was a prominent member of the court of the archdukes in Brussels and was portrayed a number of times by Van Dyck. In the full-length portrait in the York City Art Gallery [fig. 3], he carries his key of office as chamberlain to the archdukes.[1] He is shown on horseback holding his commander's baton in his right hand and wearing the collar of the Order of the Golden Fleece in a life-size painting at Holkham Hall, Norfolk [fig. 2].[2] There is a preparatory pen drawing for that portrait in the British Museum [fig. 1], and it is likely that the present drawing was also made in connection with the portrait at Holkham. It may well show Van Dyck's first idea for the painting, with Arenberg facing in the opposite direction and with an attendant (or riding master) on foot beside him. The horse performs a *levade* as in the Holkham portrait. The Holkham picture must have been painted between Arenberg's having received the regalia of the Golden Fleece in June 1628 and Van Dyck's departure for England in March 1632.

Vey notes that in 1687 the Swedish architect Nicodemus Tessin the Younger was in Antwerp and there saw an equestrian portrait of Arenberg, presumably the painting now at Holkham, and wrote in his journal that it was "zimblich gedrehet von hinten gesehen fast in contraire actitude, gegen der zeychnungen die ich von Van Dyck habe,"[3] but there is no corroborative evidence that this drawing was in Tessin's collection.

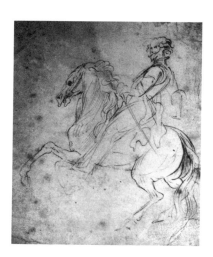

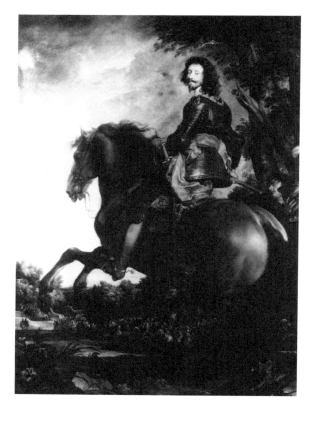

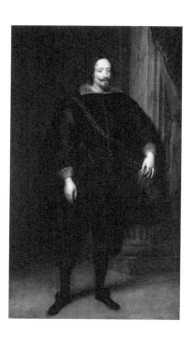

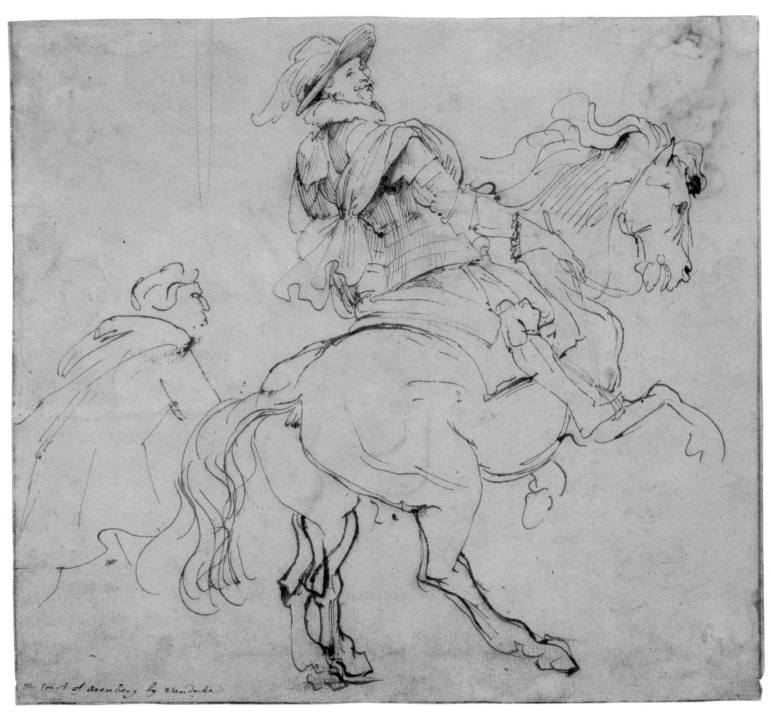

Fig. 1. Anthony van Dyck, *Albert de Ligne, Prince of Barbançon and Arenberg.* Pen and brown ink over black chalk, 191 x 152 mm. The British Museum, London (Vey 186)

Fig. 2. Anthony van Dyck, *Albert de Ligne, Prince of Barbançon and Arenberg, on Horseback.* Canvas, 315 x 240 cm. Collection of Viscount Coke, Holkham Hall, Norfolk

Fig. 3. Anthony van Dyck, *Albert de Ligne, Prince of Barbançon and Arenberg.* Canvas, 211.3 x 125 cm. City Art Gallery, York

Verso

In this exhibition there are eleven black chalk drawings for the series of portrait prints known as *The Iconography*. Ten of these drawings were made in Flanders or Holland between 1627 and 1635 and are included at this point in the chronological arrangement of Van Dyck's drawings [cats. 54–63]. The eleventh, the portrait of Inigo Jones, drawn in England between 1632 and 1634, is included at the end of the first English section [cat. 72].

The Iconography was a collection of portrait prints made after drawings and paintings by Van Dyck. The majority are engravings made by a variety of print-makers. This anthology of portraits of artists, soldiers, statesmen, administrators, and scholars, a conspectus of the most distinguished men and women of his time, went through many editions. Its complex publishing history is described in Mauquoy-Hendrickx's monograph.[1]

This monumental undertaking seems to have had relatively modest beginnings. In the years immediately following his return from Italy to Antwerp, Van Dyck made eighteen etchings of portraits of contemporaries, mostly artists. They show that his dexterity with pencil and brush extended, apparently effortlessly, to the etching needle [figs. 1, 2]. These etchings were probably made to be sold individually. Some were issued by the Antwerp publisher Martinus van den Enden (active 1630–1654), and it seems to have been on Van den Enden's initiative that Van Dyck made a further eighty portraits. Of these eighty there were three principal groups, the first of princes and military commanders, the second of statesmen and philosophers, and the third of artists and collectors. The last group was by far the largest, being fifty-two out of a total of eighty; the other two groups were of sixteen and twelve respectively. We know the enterprise was still under way in 1636, from a

Fig. 1. Anthony van Dyck, *Jan Snellincx*. Etching, 5th state

Fig. 2. Anthony van Dyck, *Lucas Vorsterman*. Etching, 2d state

Fig. 3. Paulus Pontius, after Van Dyck, *John of Nassau-Siegen*. Engraving, 4th state

Fig. 4. Paulus Pontius, after Van Dyck, *The Abbé Scaglia*. Engraving, 3d state

IOANNES SNELLINCX.
PICTOR HVMANARVM FIGVRARVM ANTVERPIÆ.
Ant. van Dyck pinxit.
Pet. de Iode fecit.
Cum privilegio.

LVCAS VORSTERMANS
CALCOGRAPHVS ANTVERPIÆ IN GELDRIA NATVS.
Ant. van Dyck fecit aqua forti.
.G.H.

letter written by Van Dyck to Franciscus Junius asking him to provide an appropriate Latin tag for the portrait of Sir Kenelm Digby.[2]

Antwerp was an important center for printmaking and publishing. Early in his career Rubens had recognized the commercial possibilities of reproductive prints of his work and had trained a group of talented engravers to a very high standard of printmaking. They included Paulus Pontius, the Bolswert brothers, Pieter de Jode the Younger, and, the most prodigiously gifted of all, the volatile Lucas Vorsterman. Rubens strictly controlled this process at every stage, supervising and correcting the proofs and vigorously protecting his copyright. Van Dyck followed his example and commissioned engravings of a number of his larger religious paintings, which could not only be sold at a profit but were a means of bringing his work to the attention of a wider public throughout Europe. For example, Vorsterman, to whose daughter Van Dyck had stood godfather in 1631, engraved *The Lamentation* which had been painted for the Abbé Scaglia in 1634.

Van Dyck's portrait drawings were made into prints by a number of different engravers and published by Van den Enden between 1636 and 1641. In the first group of princes and generals, two were engraved by Schelte à Bolswert, ten by Vorsterman, one by Pieter de Jode the Elder, two by Pieter the Jode the Younger, and one by Nicholas Lauwers. A number of the sitters—the Marqués de Leganes, Maria de' Medici, John, count of Nassau-Siegen [fig. 3], Thomas-Francis of Savoy-Carignan, and Spinola, for example—had already been painted by Van Dyck, but for such subjects as the generals of the Thirty Years' War—Gustavus Adolphus, Wallenstein, and Tilly—he had to make drawings after portraits by others.

Among the second group of statesman and philosophers, most had been painted by Van Dyck and were well known to him: they included Caspar Gevartius, Albertus Miraeus, the Abbé Scaglia [fig. 4], Peiresc (whom Van Dyck is said to have visited in Aix in 1625), Kenelm Digby (whose portrait was engraved in London by Robert van der Voerst [fig. 5]), and two portraits, those of Antonius Triest and Jan van der Wouwer, which Van Dyck began to etch himself. They were completed by

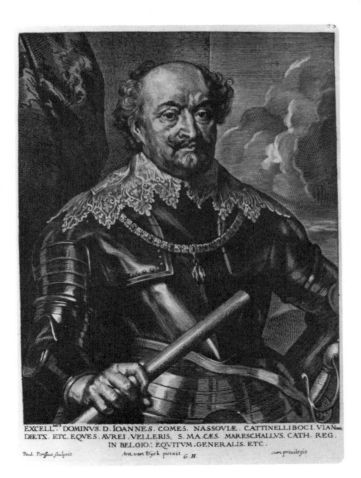

EXCELL.: DOMINVS. D. IOANNES. COMES. NASSOVIÆ. CATTINELLI BOCI. VIAN...
DIETS. ETC. EQVES. AVREI. VELLERIS. S. MA. CÆS. MARESCHALLVS. CATH. REG.
IN BELGIO: EQVITVM. GENERALIS. ETC.
Paul. Pontius sculpsit Ant. van Dyck pinxit G. H. cum privilegio

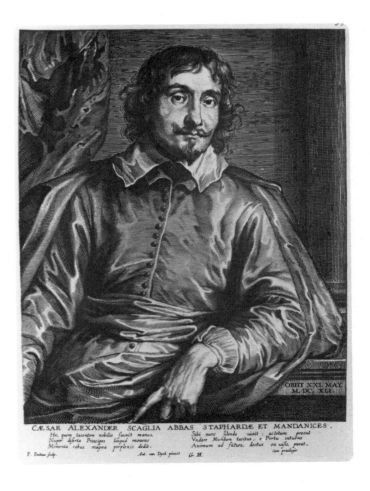

CÆSAR ALEXANDER SCAGLIA ABBAS STAPHARDÆ ET MANDANICES.
Hic, quem tacentem nobilis finxit manus. Sibi nunc filenda uastt : posthum præsens
Nuper liberts Principi lingua mouens Vultro Meridum tacitus : e Porta intuitus
Memento rebus magna perplexis dedit. Animum ad futura, lectus ex usste, paret.
P. Pontius sculp Ant. van Dyck pinxit G. H. cum privilegio

Pieter de Jode the Younger and Paulus Pontius, respectively. The third group included the leading artists and collectors of the day; among the artists were Adriaen Brouwer, Gaspar de Crayer, Gerard Honthorst, Cornelis van Poelenburgh, Daniel Mytens, Rubens [fig. 6], Hendrick van Steenwyck, Jan Wildens, Jacques Callot, Orazio Gentileschi, Jan Lievens, Joos de Momper, Lucas van Uden, Jacob Jordaens, Michiel van Mierevelt, Frans Francken, and Simon Vouet. Van Dyck had met and drawn a number of these artists in Holland and England. The portrait of Mierevelt was engraved in his hometown of Delft by his son-in-law Willem Jacobsz. Delff, and the portraits of two other Dutch artists were engraved in Holland by Willem Hondius. The portraits of Inigo Jones, Simon Vouet, and Robert van der Voerst were engraved by Van der Voerst in London. The engravers themselves were not ignored: as well as Van der Voerst, Paulus Pontius, Theodoor Galle, Pieter de Jode the Elder, and Lucas Vorsterman were included.

Van den Enden's edition did not have a title page, and the prints appear to have been published separately. The edition does not include the first eighteen etchings by Van Dyck himself, but all the engravings carry the legend *Ant. van Dyck pinxit*, which has been taken to mean that they are all after paintings by Van Dyck. This raises the question of the status of a large group of grisaille oil sketches, about forty of which are in the collection of the duke of Buccleuch at Boughton House. The Boughton sketches were in the collection of Sir Peter Lely. Although the attribution of these sketches to Van Dyck has been doubted by Vey,[3] it is my view that some of these are by Van Dyck himself and others by assistants working under his close supervision.[4] Van Dyck's black chalk drawings model the head in detail but rarely do more than sketch in the body: in certain cases, it was necessary to transform them into grisaille oil sketches as a guide to the engraver. What is absolutely certain is that Van Dyck was very closely involved in this enterprise, making the drawings, making and supervising the painting of the oil sketches, and closely monitoring the production of the prints through their early states. A number of early states have corrections and annotations by Van Dyck himself.[5]

Shortly after Van Dyck's death, the plates of the etchings and engravings were in

Fig. 5. Robert van der Voerst, after Van Dyck, *Sir Kenelm Digby*. Engraving, 4th state

Fig. 6. Paulus Pontius, after Van Dyck, *Peter Paul Rubens*. Engraving, 7th state

Fig. 7. Anthony van Dyck, reworked by Jacob Neefs, Title page of the *Centum Icones*, 1645–1646. Engraving

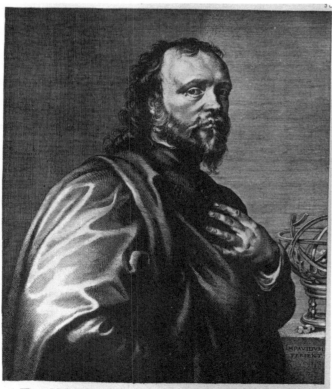

D. KENELMVS DIGBI EQVES
AVRATVS APVD CAROLV REGĒ MAGNÆ BRITANIÆ

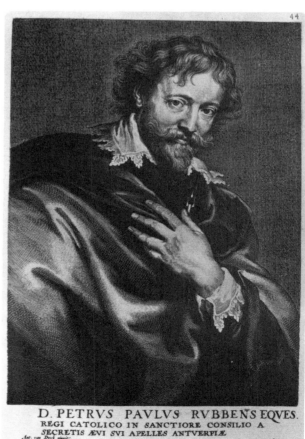

D. PETRVS PAVLVS RVBBENS EQVES.
REGI CATOLICO IN SANCTIORE CONSILIO A
SECRETIS ÆVI SVI APELLES ANTVERPIÆ

1. Mauquoy-Hendrickx 1956.
2. Carpenter 1844, 55–56.
3. Vey 1962, 49–50.
4. In Washington 1990–1991, 340, Held has written that "the best of the grisailles, particularly those at Boughton House, are not unworthy of the master himself." It is my intention to undertake an extended study of this group of oil sketches.
5. A number of these are at Chatsworth and are discussed by Peter Day in Eastbourne 1979.

the possession of another Antwerp publisher, Gillis Hendricx (a member of the Antwerp artists' guild from 1643/1644 to 1647). He added fifteen of the original eighteen etchings to the eighty prints of Van den Enden's edition and commissioned six more engravings after portrait paintings by Van Dyck from Schelte à Bolswert, De Jode, Pontius, and Vorsterman. This second edition, the so-called *Centum Icones*, contained one hundred portrait prints and appeared in 1645–1646 with a title page containing a portrait of Van Dyck above a pedestal bearing the title *Icones Principum Virorum Doctorum Pictorum, etc.* [fig. 7]. This title page used the plate on which Van Dyck had etched his self-portrait which was then reworked by Jacob Neefs. Subsequently there were many other editions of *The Iconography*, from different publishers, containing more and more portraits. The plates were acquired by the Louvre in 1851.

54
Hendrik van Balen

1627–1632

Black chalk, 243 x 198 mm.

Watermark: a hunting horn above a housemark

J. Paul Getty Museum, Malibu (inv. no. 84.GB.92)

Vey 257

PROVENANCE N. A. Flinck (1646–1723), Rotterdam (L.959, lower right); William, 2d duke of Devonshire, Chatsworth (inv. no. 998); by descent to the present duke; Chatsworth drawings sale, Christie's, London, 3 July 1984, lot 55.

EXHIBITIONS London 1949, no. 25; Nottingham 1960, no. 52; Antwerp 1960, no. 78; Eastbourne 1979, no. 33.

LITERATURE Vasari Society, IV, no. 23; Delacre 1932, 81–82; Delacre 1934, 15–16; Vey 1962, no. 257; Eisler 1963, 75; Kuznetsov 1970, 14, fig. 14; Goldner 1988, no. 87.

1. Mauquoy-Hendrickx 1956, no. 42.
2. Scholten 1904, no. 19.
3. Lugt 1949, I, no. 615.

The subject of this sensitive drawing in black chalk, Hendrik van Balen (1575–1632), was Van Dyck's teacher. Van Balen was dean of the Guild of Saint Luke in 1609, and in that year the young Van Dyck entered his studio as an apprentice. Van Dyck remained with Van Balen until he established himself as an independent artist in about 1616. Although Van Dyck's early style owes no apparent debt to Van Balen, it was from him that Van Dyck learned all the practical skills of his craft. This is a study for the engraving by Pontius in *The Iconography* [fig. 1].[1] Van Balen is shown with his left hand resting on the head of an antique statue; in the print this can be seen far more clearly. The print also shows a column behind Van Balen. In the fourth state there is an inscription which reads: *Pictor Antv: Humanarum Figurarum Vetustatis Cultor*. The drawing must have been made after Van Dyck's return from Italy and before his departure to England in March 1632. In July of that year Van Balen died.

Vey notes a copy in the Teyler Museum, Haarlem,[2] and another in the Louvre.[3]

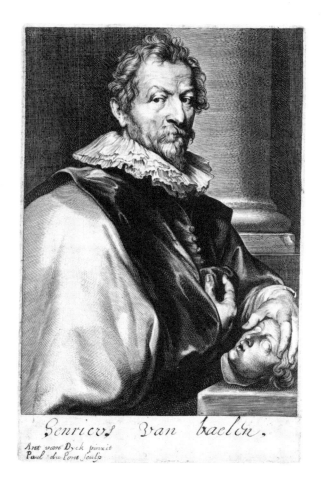

Fig. 1. Paulus Pontius, after Van Dyck, *Hendrik van Balen*. Engraving, 1st state

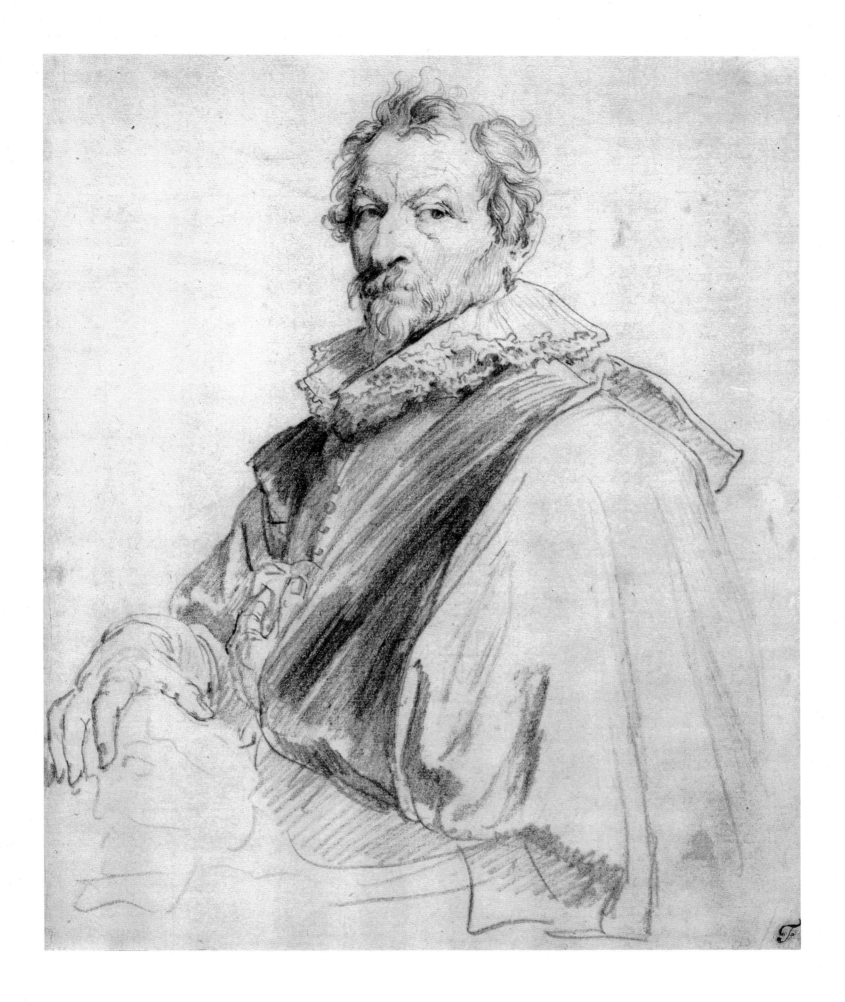

55
Pieter Brueghel the Younger

1627–1635

Black chalk, 245 x 198 mm. There is a fold in the
sheet on the right-hand side.

Watermark: not visible

Devonshire Collection, Chatsworth (inv. no. 995)

Vey 242

PROVENANCE Collection of N. A. Flinck
(1646–1723), Rotterdam (L.959, lower right);
William, 2d duke of Devonshire, Chatsworth;
by descent.

EXHIBITIONS London 1938, no. 586; Rotterdam
1948–1949, no. 84; Nottingham 1960, no. 49;
Antwerp 1960, no. 79; Manchester 1961, no. 76;
Washington 1961–1962, no. 80; London 1969,
no. 80.

LITERATURE Vasari Society, III, no. 17; Hind 1915,
10; Mayer 1923, pl. 1; Delacre 1932, 51–53,
69, pl. 15; Gerson and ter Kuile 1960, pl. 111; Vey
1962, no. 242.

1. Mauquoy-Hendrickx 1956, no. 2.
2. Black chalk, 254 x 180 mm, inv. no. 5908. Not in
Vey 1962. Published in Spicer 1985, pl. 24.
3. Antwerp 1949, no. 99.

Pieter Brueghel the Younger (Brussels 1564/1565–1638 Antwerp) had a long and
very successful career as a painter imitating both the style and often also the compo-
sitions of his father, Pieter the Elder. This portrait, one of the most outstanding black
chalk drawings for *The Iconography*, is substantially different in pose from the
etching which is by Van Dyck himself [fig. 2].[1] In the second state the print carries
the inscriptions *Petrus Bruegel Antverpiae Pictor Ruralium Prospectuum* and *Ant. van
Dyck fecit acqua forti*. In the print the body and head are moved round to face the
viewer and the position of both hands has been slightly altered. In the Hermitage
there is a second drawing by Van Dyck of Pieter Brueghel the Younger [fig. 1],
which is the preparatory study for the etching: it shows the exact pose of the print
and is lightly squared up and incised.[2] It is difficult to date either drawing with any
degree of precision; they were presumably made after Van Dyck's return from
Italy, and before Van Dyck went back to England after his extended stay in Flanders
in 1634–1635.

Vey lists three copies of the drawing. One, in the Teyler Museum in Haarlem, has
been said to be a preparatory drawing,[3] but is in fact a pen drawing after the print.

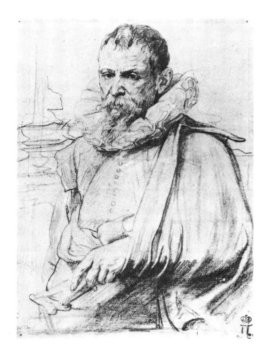

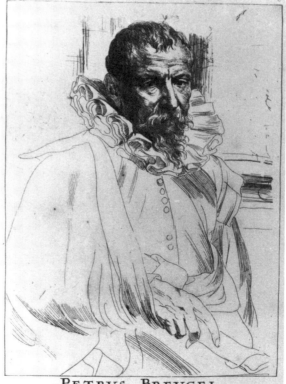

Fig. 1. Anthony van Dyck, *Pieter Brueghel the
Younger*. Black chalk, 254 x 180 mm. The State
Hermitage Museum, Leningrad

Fig. 2. Anthony van Dyck, *Pieter Brueghel the
Younger*. Etching, 3d state

PETRVS BREVGEL
ANTVERPIÆ PICTOR RVRALIVM ACTIONVM.

Ant van Dyck fecit aqua forti.　　G. H.

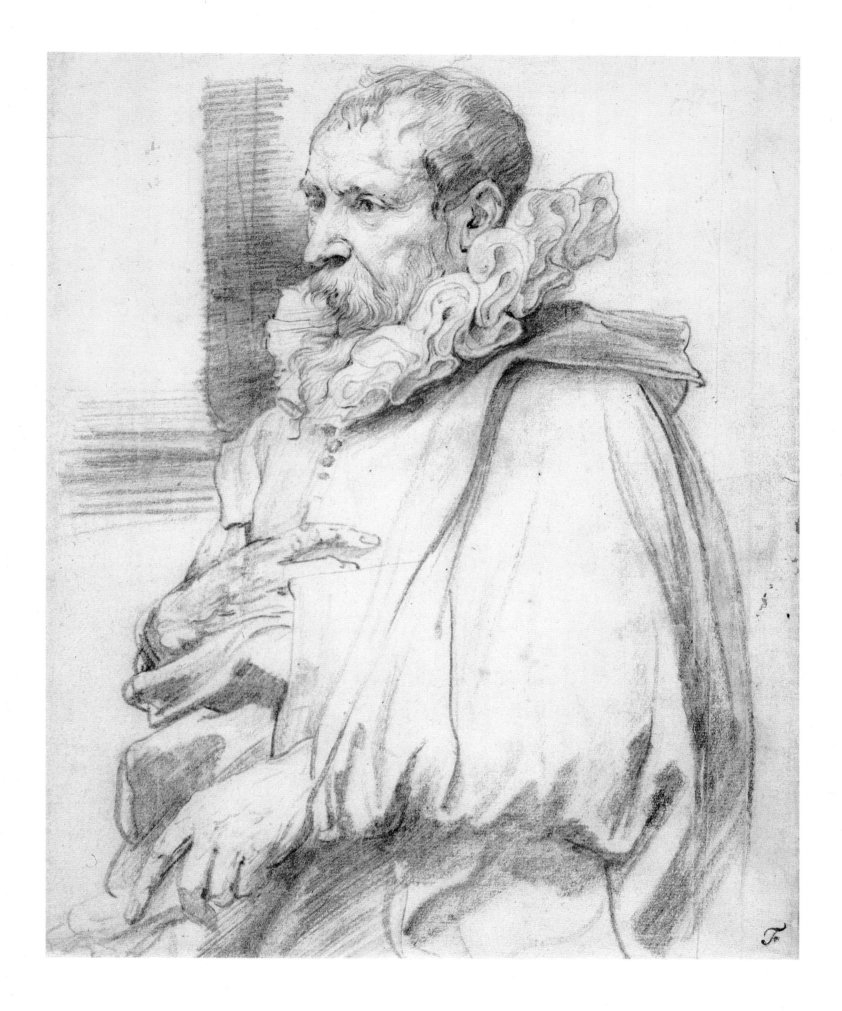

56
Erycius Puteanus

1627–1635

Black chalk, with brown wash, 242 x 173 mm. The hand is drawn again in black chalk in the space left for the inscription, just to the right of the word *Puteanus*. Lower center, in Van Dyck's own hand: *Puteanus*. Lower left, in Van Dyck's hand, in brown ink: *Van Dyck F*. In the center of the bottom edge, in another hand, in brown ink: *obit Ao 1646*. (Both these inscriptions have been trimmed along the bottom edge). The outlines have been indented by the engraver.

Watermark: not visible (laid down)

The British Museum, London, Department of Prints and Drawings (inv. no. 1895.9.15.1069)

Vey 255

PROVENANCE Thomas Hudson (1701–1779), London (L.2432, lower right, trimmed); J. Malcolm (1805–1893), London.

LITERATURE Cust 1900, 234, under no. 25; Rooses 1903, 138; Hind 1915, 25; Hind 1923, no. 32; Delacre 1932, 76–77; Delacre 1934B, 13; Vey 1962, no. 255.

1. Mauquoy-Hendrickx 1956, no. 36. The second state has the inscription: *Clarissimus Erycius Puteanus Historiographus/ Regius Professor Consiliarius Etc.*
2. North Carolina Museum of Art, inv. no. 52.9.95. 1983 catalogue, 135; Glück 1931, 270 (left).

Eerryk de Putte, whose Latin cognomen was Puteanus (Venlo 1574–1646 Louvain) was a historian and philologist at the University of Louvain. He had spent the years 1597–1606 in Italy, where he had the distinction of being the first foreign *Doctor* at the Biblioteca Ambrosiana in Milan.

This is a preparatory drawing for the print in *The Iconography* by Pieter de Jode [fig. 2].[1] It is in reverse, without any significant changes. The indentations of the engraver's stylus can be clearly seen on the surface of this sheet. There is a bust-length painted portrait of Puteanus by Van Dyck in Raleigh, North Carolina [fig. 1].[2] The sitter's head is at a slightly different angle; neither his hand nor his book is shown; and he is portrayed in front of a curtain rather than in his study. In the painted portrait, which is undoubtedly by Van Dyck, though it is badly abraded in the face and hair, Puteanus wears a medallion bearing the portrait of Philip IV of Spain, a declaration of his allegiance to the Hapsburgs.

Vey suspected the hand drawn with black chalk beside the inscription *Puteanus* to be the work of another draughtsman, but it seems consistent with the handling of black chalk elsewhere in this sheet.

The drawing must date from between Van Dyck's return from Italy and his departure to England after his extended stay in Flanders in 1635.

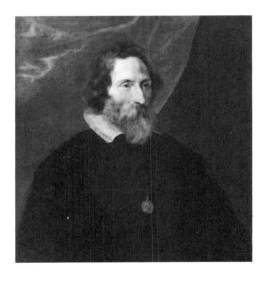

Fig. 1. Anthony van Dyck, *Erycius Puteanus*. Canvas, 75.2 x 67.8 cm. North Carolina Museum of Art, Raleigh

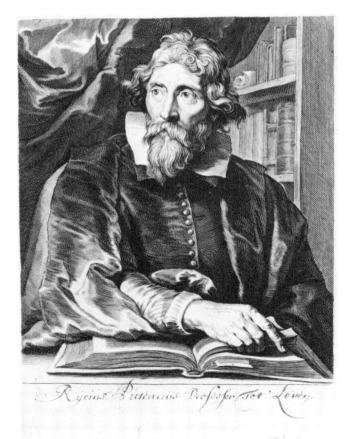

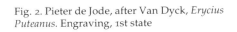

Fig. 2. Pieter de Jode, after Van Dyck, *Erycius Puteanus*. Engraving, 1st state

Putramus.

199

57
Jacob van Broeck

1627–1635

Black chalk with brown wash, 222 x 169 mm.
The outlines have been indented with a stylus.
There is an inscription by a later hand, lower right:
VAN DYK F:

Collection of Mr. and Mrs. Eugene Victor Thaw,
New York

[Not in Vey]

PROVENANCE Anon. sale, Christie's, London,
1 December 1970, lot 54; with William H. Schab
Gallery, New York, 1972; private collection,
Switzerland; Schab Gallery, New York, 1986.

LITERATURE Spicer 1985, 539 and n. 17, pl. 23.

1. Mauquoy-Hendrickx 1956, no. 44.
2. The identification of the sitter is discussed by
Mauquoy-Hendrickx 1956, 11–12.

This is a study for the engraving by Pontius in *The Iconography* [fig. 1].[1] The sitter is identified by an inscription in the second state, *Jacobus de Breuck*, and in the fourth state his profession and his hometown were added: *Architectus Montibus in Hannonia*. Jacob van Broeck was a well-known architect who was born in Mons between 1500 and 1540 and died in the same town in 1584. Of the fifty-two artists represented in *The Iconography* this would be the only sitter who was not a contemporary of the artist. However, Van Broeck seems to have had a nephew, also an architect, who is a very obscure figure. He would have been Van Dyck's contemporary, and it seems more likely that it was this Jacob van Broeck whom Van Dyck drew.[2] No painted portrait of this sitter by Van Dyck is known.

This sheet came to light only twenty years ago and is comparable with the portrait of Puteanus [cat. 56]. As there, the brown wash is used to model the sitter's beard and clothes and to accentuate the shadow on the left.

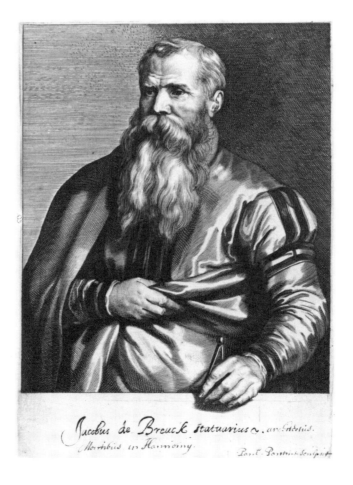

Fig. 1. Paulus Pontius, after Van Dyck, *Jacob van Broeck*. Engraving, 1st state

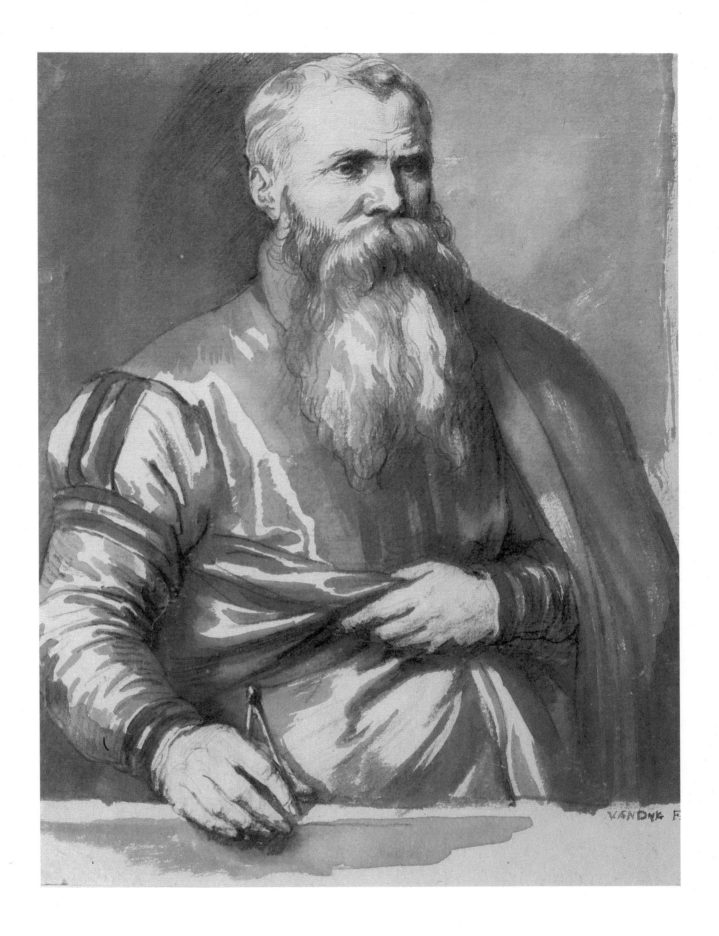

201

58
Adam van Noort

1627–1635

Black chalk, squared up, 264 x 179 mm. The outlines of the head have been gone over in black chalk by a later hand. Lower right, inscribed in graphite: *Adam van Ordt.*

Verso: in graphite: *Van Dijck* and *A299.*

Watermark: none

Rijksmuseum, Amsterdam, Rijksprentenkabinet (inv. no. 18840.A299)

Vey 244
Exhibited in Fort Worth

PROVENANCE J. de Vos Jbzn (1803–1878), Amsterdam (L.1450, verso, lower left) his sale, Amsterdam, Roos, Muller ..., 22–24 May 1883, lot 142; purchased by the Vereeniging Rembrandt (L.2135, verso, lower left) for the Rijksprenten-kabinet (L.2228, verso, lower left).

EXHIBITIONS Brussels 1910, no. 31; Antwerp 1949, no. 96.

LITERATURE Kleinmann, ill.; Beeldende Kunst, 3, 1916, 50, ill.; Delacre 1932, 68–69; Delacre 1934B, 8–9, pl. 2; Vey 1962, no. 244.

1. Mauquoy-Hendrickx 1956, no. 8. In the third state are the inscriptions: *Adamus van Noort/ Antverpiae Pictor Iconum* and *Ant. van Dyck fecit acqua forti.*
2. *Jordaens with the Van Noort Family*, c. 1615–1616. Canvas, 114 x 146.5 cm. Kassel, Staatliche Gemäldegalerie (GK107). d'Hulst 1982, 268, pl. 233.
3. *Portrait of Adam van Noort*, c. 1640. Canvas, 74.5 x 55.5 cm. Formerly Kaiser-Friedrich-Museum, Berlin (destroyed in 1945). d'Hulst 1982, 283, pl. 244.

Adam van Noort (Antwerp 1562–1641) was a history and portrait painter in Antwerp. This is a preparatory drawing for the etching by Van Dyck himself in *The Iconography* [fig. 1],[1] which is in reverse but contains no significant changes in the figure of the sitter, although a background which comprises a wall and a view of a cloudy sky has been added. The drawing must have been made in Flanders between 1627 and 1635.

Although described in the Antwerp Register of Painters as a *conterfeyter* and in the inscription on the *Iconography* print as *pictor iconum*, no portraits by Van Noort are known. His crowded religious compositions are in the tradition of Frans Floris. He was one of Rubens' teachers and another pupil was Jacob Jordaens, who married his daughter Catharina in 1616. Jordaens portrayed Van Noort in a family portrait in Kassel[2] and, as an old man, in a portrait formerly in Berlin.[3]

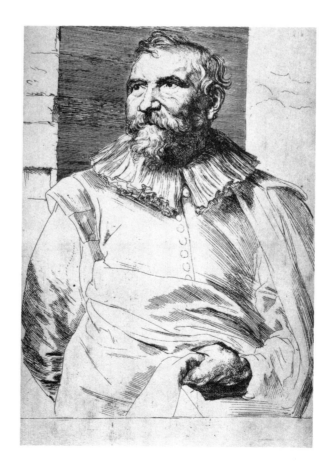

Fig. 1. Anthony van Dyck, *Adam van Noort.* Etching, 2d state

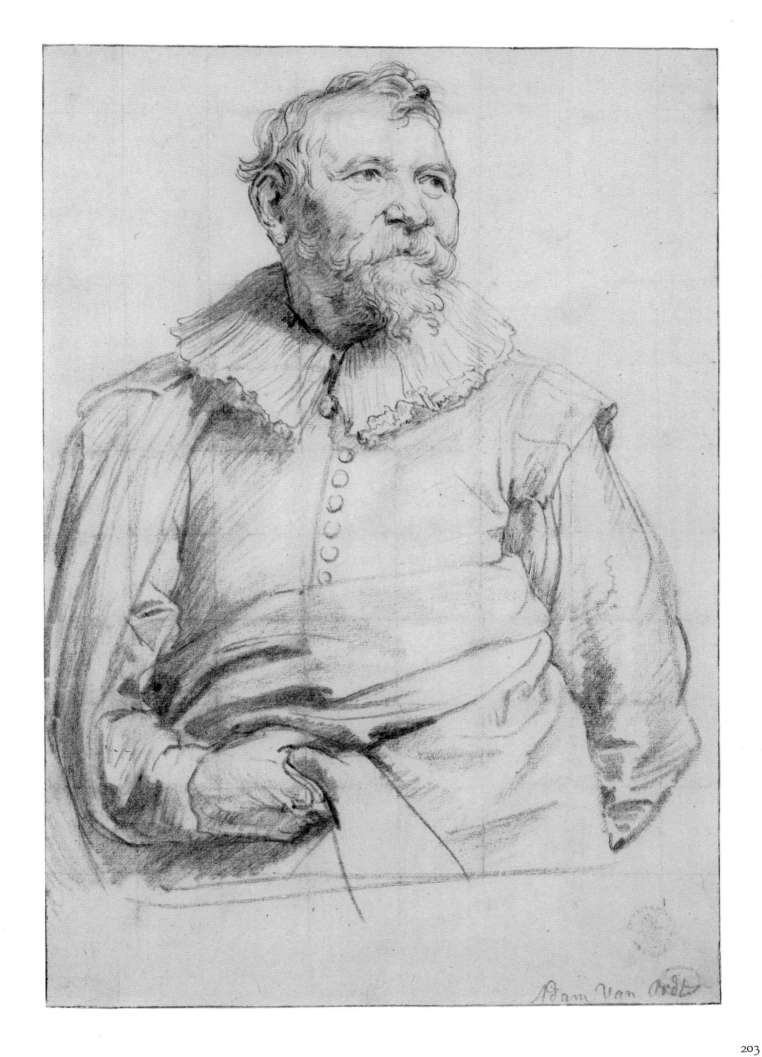

Adam van Noort

203

59
Cornelis van der Geest

1627–1635

Black chalk, 255 x 184 mm. Lower right, an inscription in pen: *CORNELIUS VANDER GEEST* and (in the hand of Count Tessin) the date *1780*.

Watermark: none

Nationalmuseum, Stockholm (inv. no. 1973/1863)

Vey 262

PROVENANCE P. Crozat (1665–1740), Paris; his sale, 1741, no. 848, to Tessin; Count C. G. Tessin (1695–1770), Stockholm; Royal Museum, Stockholm (which became the Nationalmuseum in 1866) (L.1638, lower right).

EXHIBITIONS Stockholm 1933, no. 42; Stockholm 1953, no. 152; Antwerp 1960, no. 84; New York 1969, no. 61.

LITERATURE Mariette 1741, 98, no. 848; Mariette, *Abécédario*, II, 202; Schönbrunner-Meder, IX, no. 1028; Rooses 1903, 138; Muchall-Viebrook 1926, no. 42, ill.; Delacre 1932, 95; Delen 1959, 57–71, ill.; Vey 1962, no. 262.

1. Mauquoy-Hendrickx 1956, no. 48. The fourth state bears the inscription *Artis Pictoriae Amator Antverpiae*.
2. Van der Geest's career as maecenas and collector is discussed at length in Held 1982, 35–64.
3. Held 1982, 59, n. 5.
4. National Gallery, London (inv. no. 55). Martin 1970, 34–37.
5. Black chalk, 183 x 140 mm.

This is a preliminary drawing for the engraving by Pontius of Van der Geest in *The Iconography* [fig. 1].[1] The print is reversed and shows no significant differences from this drawing. Cornelis van der Geest (Antwerp 1555–1638) was a wealthy merchant and a major patron of the arts in Antwerp.[2] His extensive art collection, which was particularly rich in works of the Antwerp school, is shown in a painting of 1628 by Willem van Haecht which is in the Rubenshuis in Antwerp [fig. 2]. Van der Geest is seen showing a *Virgin and Child* by Quentin Metsys to the Archdukes Albert and Isabella while the leading Antwerp artists of the day—among them, Rubens, Van Dyck, Jan Wildens, Frans Snyders, and Hendrik van Balen—look on. Van der Geest had been an important patron of Rubens in the years immediately following the artist's return from Italy in 1608. He secured for him the commission for the *Elevation of the Cross* triptych for the Church of Saint Walburga, of which Van der Geest was a *kerkmeester* (church warden). Shortly after Van der Geest's death in 1638, Rubens published an engraving of that altarpiece dedicated to "Heer Cornelis van der Geest, the best of men and the oldest of friends, in whom ever since youth he [Rubens] found a constant patron, and who in his life was an admirer of painting."[3] Van Dyck had painted Van der Geest in about 1620 in one of the most direct and effective portraits of his first Antwerp period.[4]

A partial copy of the drawing was in 1968 in the collection of Janos Scholz, New York.[5]

Fig. 2. Willem van Haecht, *The Cabinet of Cornelis van der Geest*. Panel, 104 x 139 cm. Rubenshuis, Antwerp

Fig. 3. Anthony van Dyck, *Cornelis van der Geest*. Panel, 37.5 x 32.5 cm. National Gallery, London

Fig. 1. Paulus Pontius, after Van Dyck, *Cornelis van der Geest*. Engraving, 5th state

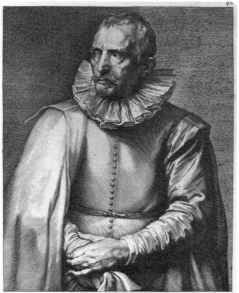

CORNELIVS VANDER GEEST
ARTIS PICTORIÆ AMATOR ANTVERPIÆ.

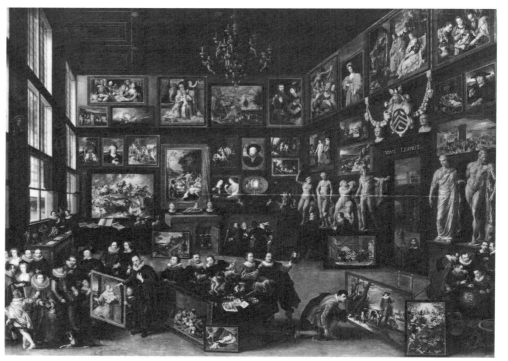

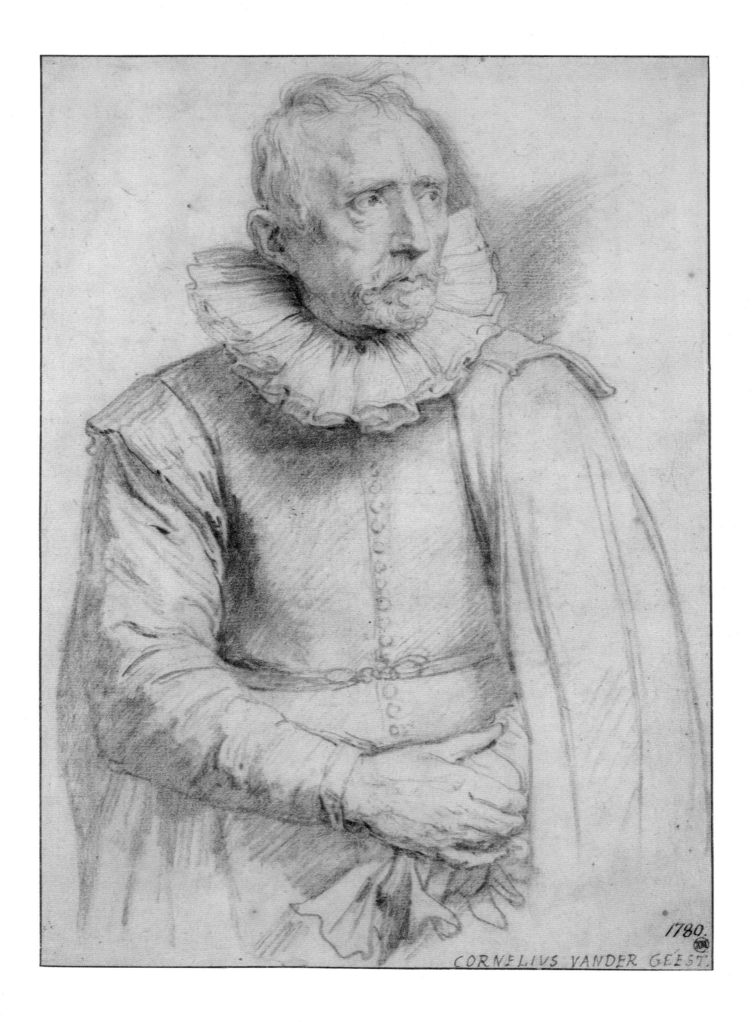

1780.

CORNELIVS VANDER GEEST.

60
Caspar Gevartius

1627–1635

Black chalk, 267 x 190 mm. The outlines have been incised in places by the engraver. Lower center, in pen: *CASPAR GEVARTIUS.*

Watermark: none

Graphische Sammlung Albertina, Vienna (inv. no. 17643)

Vey 263

PROVENANCE Albertina (L.174, lower left).

EXHIBITIONS Arts Council 1948, no. 45; Paris 1950, no. 101.

LITERATURE *Meister-Schule. Sammlung von Lithographien nach Original-Zeichnungen in der Sammlung Sr. K. H. des Erzherzog Albrecht in Wien* (Vienna, 1863), no. 8a (lithograph by Grandauer); Albrecht-Galerie, Vienna 1863, no. 153 (photograph by Jagermayer); Guiffrey 1882, 201; Schönbrunner-Meder, VII, no. 780; Rooses 1903, 138; Delacre 1932, no. 75; Delacre 1934B, 12–13; Delen 1943A, pl. 15; Vey 1962, no. 263.

1. Mauquoy-Hendrickx 1956, no. 49. In the third state is the inscription: *Clarissimus Vir Caspar Gevartius I. C. Antverpiae / Graphiarius Etc.*
2. The book, eventually published in 1642 (the year after the archduke's death and two years after Rubens' death), was entitled *Pompa Triumphalis Introitus Ferdinandi Austriaci Hispaniarum Infantis etc., in Urbem Antverpiam*. The arches and stages were illustrated in etchings by Theodoor van Thulden and their meanings explained with great classical erudition by Gevartius.
3. Hind 1923, no. 105.

This is a preliminary study for the portrait engraved by Pontius in *The Iconography* [fig. 1].[1] The print is in the opposite direction. Although the engraver appears to have incised through some of the outlines of this drawing on to the plate, there are a number of changes in the print in Gevartius' costume and there is an expanse of sky in the background.

Jan Caspar Gevaerts (Antwerp 1593–1666), whose Latin cognomen was Gevartius, was a philologist, Latin author, historian, and, from 1621 until 1662, secretary of the city of Antwerp. He was a close friend of Rubens and was responsible for the text of the volume commemorating the Pompa Introitus Ferdinandi which illustrated the triumphal arches and other temporary decorations erected to welcome the Archduke Ferdinand into Antwerp in 1635.[2]

This drawing must have been made in Flanders between 1627 and 1635. There is a copy in the British Museum.[3]

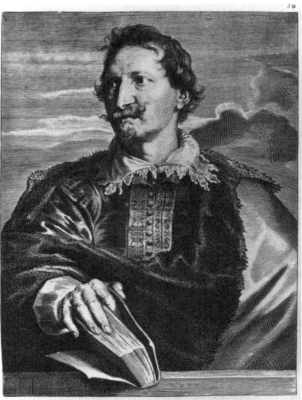

CLARISSIMVS VIR CASP GEVARTIVS I C ANTVERPIÆ GRAPHIARIVS ETC.

Ant van Dyck pinxit
Paul de Pont sculp

Cum privilegio

Fig. 1. Paulus Pontius, after Anthony van Dyck, *Caspar Gevartius*. Engraving, 5th state

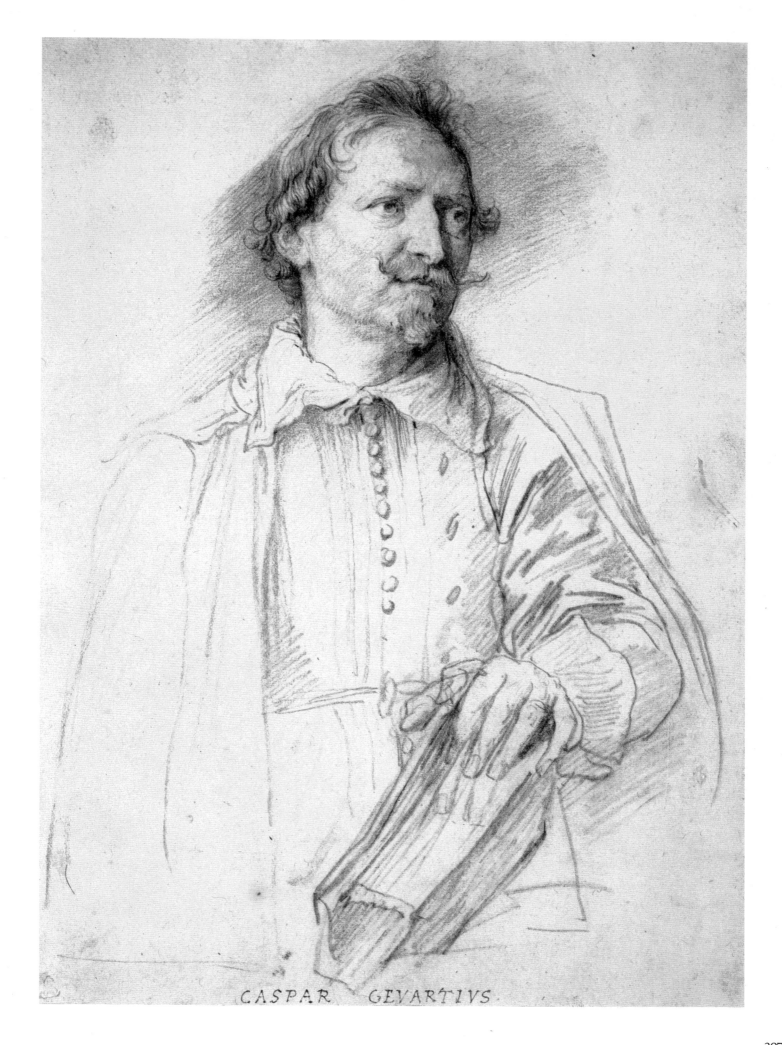

CASPAR GEVARTIVS

61
Karel van Mallery

1627–1635

Black chalk, 246 x 196 mm.
Watermark: none

Devonshire Collection, Chatsworth (inv. no. 1001)
Vey 277

PROVENANCE N. A. Flinck (1646–1723), Rotterdam (L.959, lower left); William, 2d duke of Devonshire, Chatsworth; by descent to the present duke.

EXHIBITIONS London 1938, no. 577; London 1949, no. 26; Nottingham 1960, no. 55; Washington 1962-1963, no. 81; London 1969, no. 81.

LITERATURE Rooses 1903, 138; Hind 1915, 33; Vasari Society, VIII, no. 24; Delacre 1932, 43–51, 91–92; Delacre 1934B, 21; Vey 1962, no. 277.

1. Mauquoy-Hendrickx 1956, no. 86. In the fifth state is the inscription *Calcographus Antverpiae*.
2. Glück 1931, 331. There is a studio version or copy of this painting in the Bayerische Staatsgemäldesammlungen, Munich (oil on canvas, 102 x 80 cm. Glück, notes to 331) and two further studio versions or copies at Knole (collection of Lord Sackville, oil on canvas, 105 x 90 cm. Glück 1931, notes to 331) and Woburn (collection of the duke of Bedford, oil on canvas, 70 x 60 cm. Glück 1931, notes to 331). Larsen (1980, no. 501) notes a further version (or copy) in an American private collection (oil on canvas, 95 x 82.5 cm. Sold at Christie's, London, 24 November 1967, no. 60, ill. Said to be from the Maag collection, Zurich).
3. These drawings are reproduced and described in Delacre 1932, pls. 7, 8, and 10.

This is a preliminary drawing for the engraving by Lucas Vorsterman in *The Iconography* [fig. 2].[1] The print is in the opposite direction and there is a broken column in the background. The drawing does not appear to have been incised by the engraver.

Karel van Mallery (Antwerp 1571–after 1635) was a draughtsman, engraver, and print dealer in Antwerp. He also worked for Parisian publishers, for whom he specialized in the illustration of devotional books. There is a painted portrait of Van Mallery by Van Dyck in the National Gallery in Oslo [fig. 1],[2] which shows the artist in exactly the same pose as in this drawing but is in the opposite direction and shows the broken column of the engraving. Vey suggested that Van Dyck may have based his painting on the print. Both painting and drawing were made between 1627 and 1635.

Vey notes copies of the drawing in the Ecole des Beaux-Arts in Paris, in the Teyler Museum in Haarlem, and in a private collection.[3]

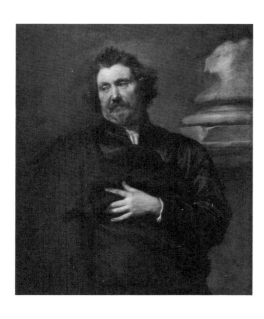

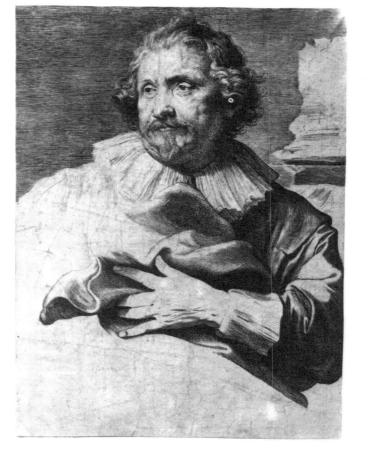

Fig. 1. Anthony van Dyck, *Karel van Mallery*. Canvas, 100 x 84 cm. National Gallery, Oslo

Fig. 2. Lucas Vorsterman, after Van Dyck, *Karel van Mallery*. Engraving, 1st state

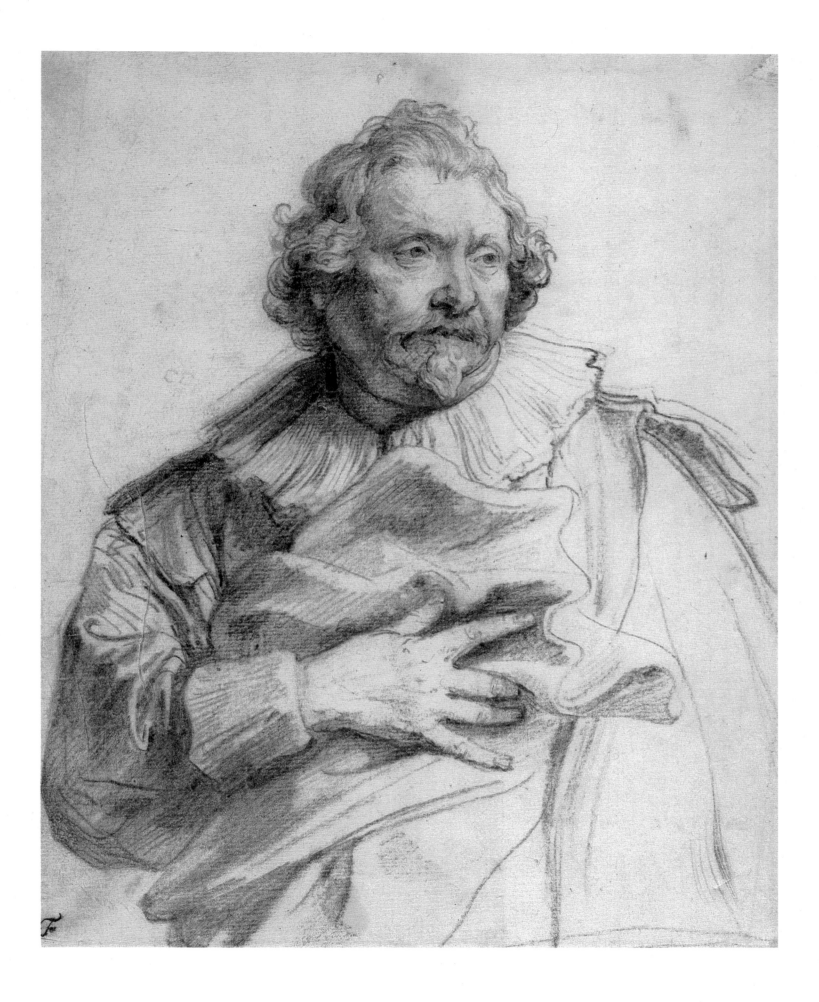

62
Don Carlos Coloma

1627–1635

Black chalk, with some white chalk highlights on forehead, nose, mouth and eye, on white paper (which has discolored and darkened), 246 x 187 mm. Lower left, an old inscription in pen: *1628*; lower right, in another hand, perhaps Ten Kate's,[1] in pen: *A. van Dyk*.

Verso: lower left hand corner, an inscription in graphite: N13FL/ PW.

Watermark: none

Fogg Art Museum, Harvard University, Cambridge, Mass. (Inv. no. 1961.150)

Vey 259

PROVENANCE Lambert ten Kate (1674–1751), Amsterdam; S. Feitama, Amsterdam; his sale, Amsterdam, 1758, no. 50; C. A. C. Ponsonby; F. Flameng (1856–1923), Paris; his sale, George Petit Gallery, Paris, 26–27 May 1919, no. 52, ill.; sold by Agnew to Paul J. Sachs (1878–1965), Cambridge, Mass.

EXHIBITIONS Pittsburgh 1933, no. 8; Buffalo 1935, no. 41; San Francisco 1940, no. 31; Cambridge, Mass., 1954, no. 28; Newark 1960, no. 34; Antwerp 1960, no. 83; Cambridge, Mass. 1965-1967, no. 20; Tokyo 1979, no. 44.

LITERATURE Mariette, *Abécédario*, IV, 201; Von Szwykowski 1859, 35; Cust 1900, 254, no. 23; Hind 1915, 18; Delacre 1932A, 20, 73; Delacre 1934B, 12; Mongan and Sachs 1946, no. 466, pl. 238; Vey 1962, no. 259.

This is a preliminary drawing for the engraving by Paulus Pontius in *The Iconography* [fig. 1].[2] The print is in the same direction and the body and the background have been fully worked up by the engraver. There Coloma is shown in armor, holding a commander's baton in his left hand, and in the background a rich, patterned curtain falls from the top right-hand corner. As in the portrait of Don Alvaro Bazán, marqués de Santa Cruz [figs. 2, 3],[3] Coloma sat for Van Dyck in his civilian clothes and Pontius added the martial elements.

Don Carlos Coloma (Alicante 1573–1637) was a Spanish general, statesman, and historian. He was in London between January and November 1630; it was his appointment as a special ambassador from the king of Spain to discuss peace terms with England that Rubens negotiated during his visit to London in 1629–1630. Coloma was briefed on the situation at the English court by the painter-diplomat before Rubens returned to Antwerp. He must have sat for Van Dyck between 1627 and 1635 in Flanders.

1. Van Gelder 1970, 177–178.
2. Mauquoy-Hendrickx 1956, no. 45. The inscription in the third state reads: *Dom Carolus. de. Columna. a. cons. stat. prim. a./ cubit. reg. mat. cath. magister. campi. gnalis. in. belg. etc.*
3. Mauquoy-Hendrickx 1956, no. 43. The preliminary drawing is in the Museum Boymans-van Beuningen, Rotterdam (Vey 258).

Fig. 1. Paulus Pontius, after Van Dyck, *Don Carlos Coloma*. Engraving, 1st state

Fig. 2. Anthony van Dyck, *Don Alvaro Bazán, Marqués de Santa Cruz*. Black chalk, 259 x 181 cm. Museum Boymans-van Beuningen, Rotterdam (Vey 258)

Fig. 3. Paulus Pontius, after Van Dyck, *Don Alvaro Bazán, Marqués de Santa Cruz*. Engraving, 4th state

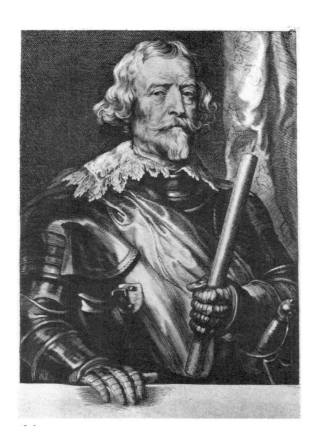

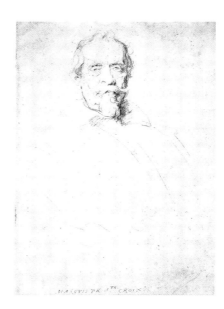

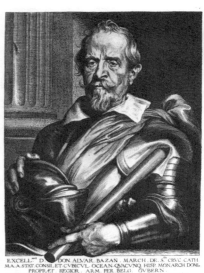

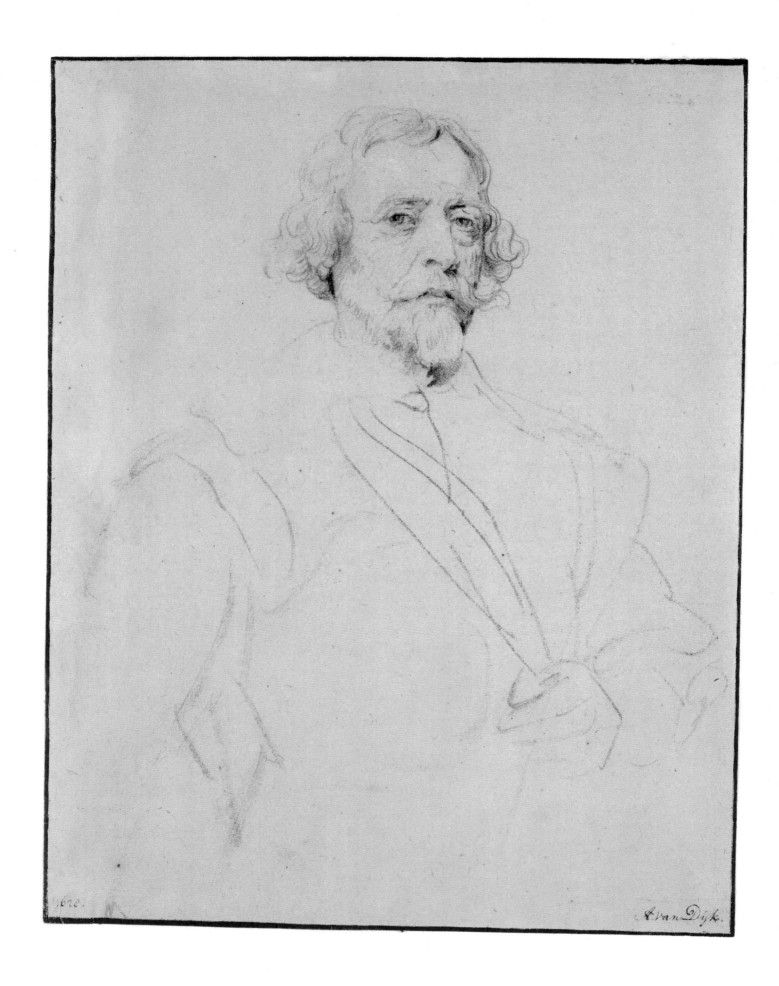

A. van Dijk.

211

63
Jan van Ravesteyn

1628–1629 or 1632

Black chalk, 252 x 201 mm. The profile of the face and nose have been strengthened, possibly by a later hand.

Graphische Sammlung Albertina, Vienna (inv. no. 17642)

Vey 265

PROVENANCE Albertina (L.174, lower left)

EXHIBITION Vienna 1966, no. 50.

LITERATURE Schönbrunner-Meder, VI, no. 606; Delacre 1932, 87–88; Van Gelder 1959, 50, pl. 9; Vey 1962, no. 265.

1. Mauquoy-Hendrickx 1956, no. 60. In the fifth state is the inscription: *Pictor Iconum Hagae Comitis.*

This is a preliminary drawing for the engraving by Pontius in *The Iconography* [fig. 1].[1] The print is in the opposite direction and contains no significant differences. Ravesteyn leans his right hand on a block of stone, and the background is very simple, consisting of the edge of a building and an expanse of sky.

Jan van Ravesteyn (The Hague c. 1570–1657) was a successful portrait painter in The Hague, patronized by members of the Orange family. Van Dyck made two visits to The Hague during his second Antwerp period, carrying out commissions for Frederik Hendrik, prince of Orange. He was there in 1628–1629 and in 1632, and Ravesteyn presumably sat for him during one of those visits.

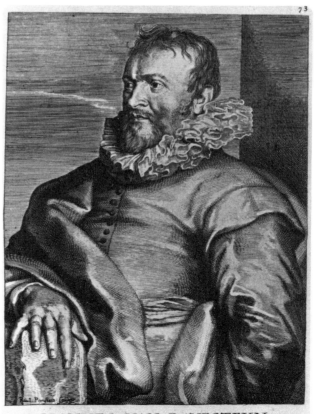

IOANNES VAN RAVESTEYN
PICTOR ICONVM HAGÆ· COMITIS.
Ant. van Dyck pinxit cum priuilegio
G. H.

Fig. 1. Paulus Pontius, after Van Dyck, *Jan van Ravesteyn.* Engraving, 5th state

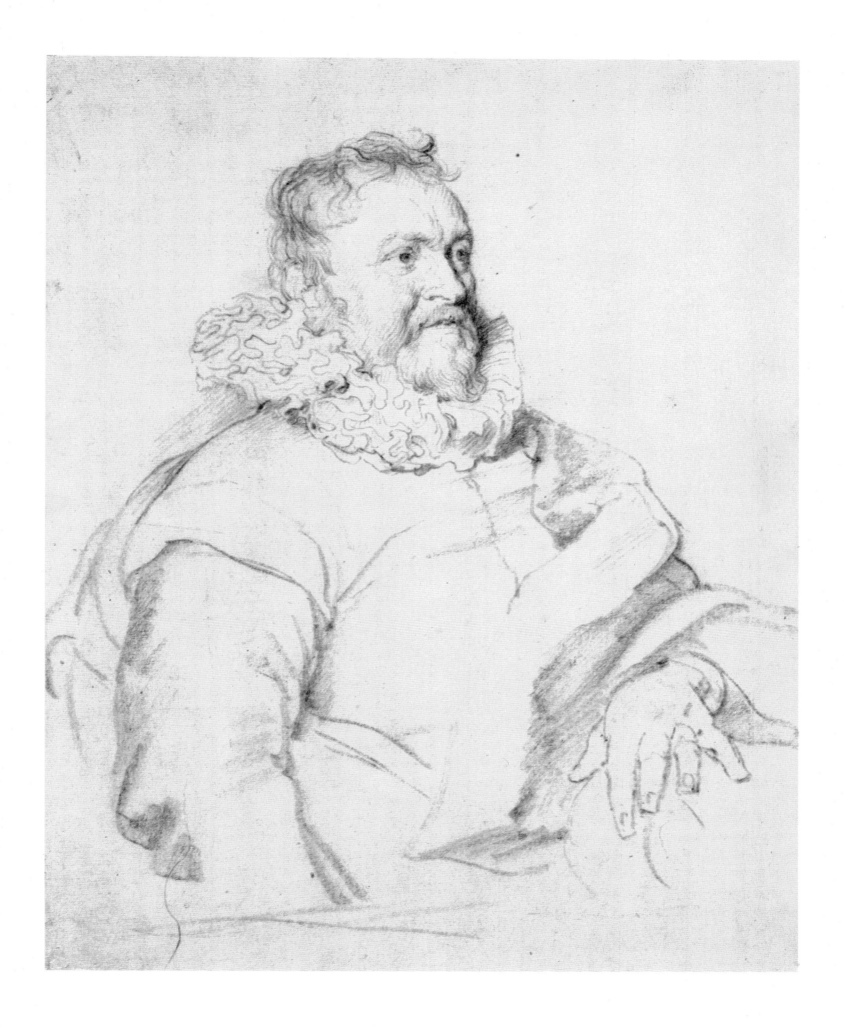

213

Endymion Porter and His Son Philip

c. 1632

Black chalk, with some white chalk highlights, on light brown paper, 318 x 242 mm. Water staining on the left. Trimmed on both sides. Lower left, an inscription in pen: *A.V.Dijck.*

Watermark: not visible (laid down)

The British Museum, London, Department of Prints and Drawings (inv. no. 1854.5.13.15)

Vey 210

PROVENANCE P. H. Lankrink (1628–1692), London (L.2090, center, towards the bottom); Jonathan Richardson the Elder (1665–1745), London (L.2183, lower right); Thomas Hudson (1701–1779), London (L.2432, lower left); Uvedale Price (1747–1829), Foxley.

EXHIBITIONS London 1956–1957, no. 548; Antwerp 1960, no. 97; London 1982–1983, no. 70; London 1987A, no. 50.

LITERATURE Waagen 1857 (supplement), 40; Finberg 1917, 7–8; Hind 1923, no. 51; *British Drawings*, I, no. 20; Vey 1962, no. 210.

1. For Endymion Porter's life and interest in and patronage of the arts, see G. Huxley, *Endymion Porter*, London, 1959, and W. Vaughan, *Endymion Porter and William Dobson*, Tate Gallery, London, 1970.
2. Glück 1931, 265; Washington 1990–1991, no. 59.
3. Glück 1931, 440; Washington 1990–1991, no. 73.

Endymion Porter (1587–1649) was a member of Charles I's court.[1] He was a Gentleman of the Bedchamber and acted as an agent for the king in diplomatic and artistic matters. A Catholic, he was a close personal friend of Van Dyck, whom he had met on the artist's first visit to London in 1620–1621. Porter and Kenelm Digby were both members of the Catholic group around the queen to which Van Dyck gravitated in his early years in England. It was Porter who acted as Charles' agent in commissioning from Van Dyck the *Rinaldo and Armida* [cat. 51, fig. 1],[2] a large-scale Titianesque painting which convinced Charles that he should invite Van Dyck to London on terms unprecedented in the history of royal patronage in Britain. As a mark of his friendship for Porter, Van Dyck painted a self-portrait with Endymion Porter, which is in the Prado [fig. 1].[3]

This is a study from life for the portrait of *The Family of Endymion Porter* [fig. 2], which shows Porter with his wife and three sons, of whom Philip is the youngest. In the drawing, Porter grasps a sword with his left hand; in the painting his hand is placed between his wife's head and a statuette of Pallas Athena. Philip had been born in 1628 and the drawing and painting must date from shortly after Van Dyck's arrival in England in 1632. Cat. 65 has two further studies for the family portrait.

Fig. 1. Anthony van Dyck, *Sir Endymion Porter and Van Dyck*. Canvas, 119 x 144 cm. Museo del Prado, Madrid

Fig. 2. Anthony van Dyck, *The Family of Endymion Porter*. Canvas, 127 x 216 cm. Collection of Mrs. Gervase Huxley

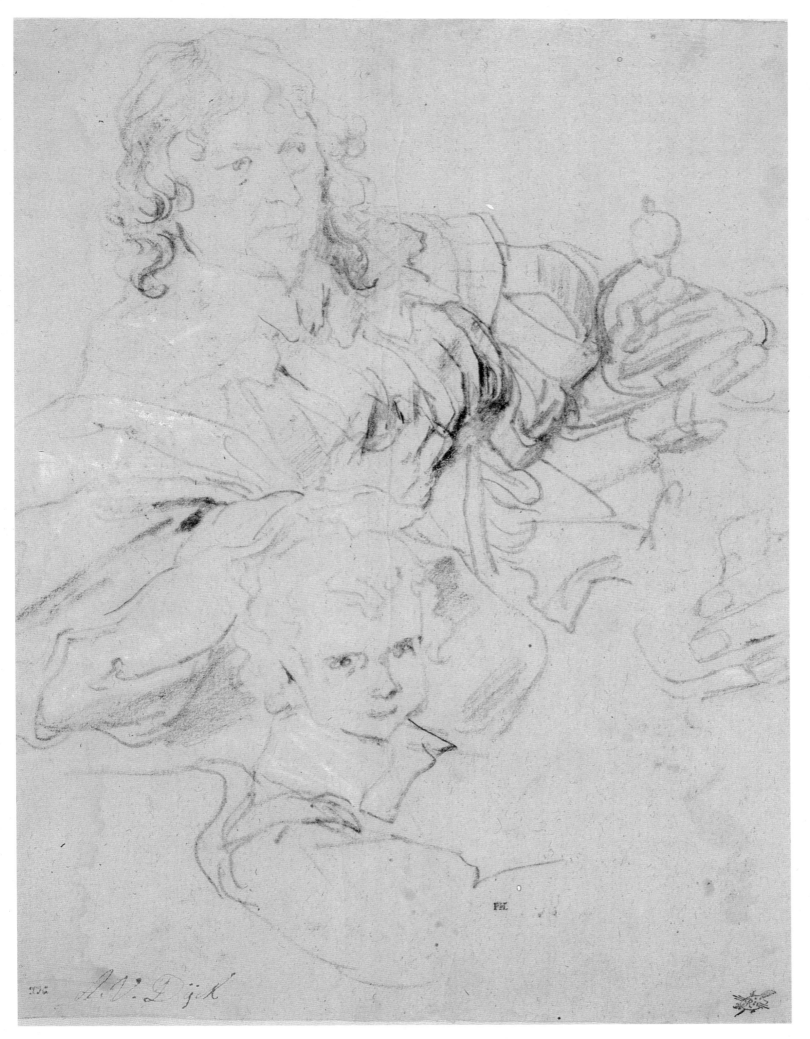

217

65
Philip Porter

c. 1632

Black chalk on light brown paper, 260 x 360 mm.

Verso: a study of the upper body and hands of George Porter. Black chalk.

Watermark: none

Statens Museum for Kunst, Copenhagen (inv. no. 6577)

[Not in Vey]

PROVENANCE Jonathan Richardson the Younger (1694–1771), London (L.2170, lower right).

EXHIBITION London 1982–1983, no. 87.

LITERATURE Müller Hofstede 1973, 157, pls. 24, 25.

1. See above, cat. 64, n. 4.

On the recto of this sheet Philip Porter, a child of about four years old, is studied from life posed with his right arm stretched out as he was shown in the portrait of *The Family of Endymion Porter*.[1] In the larger drawing he is shown bareheaded, with curls framing his face, while in the smaller he wears a bonnet. On the verso is a study for the pose and costume of the eldest of the three boys, George, who was born in 1620. He stands on his mother's left, holding his gloves in his hands. Cat. 64 is another study for the family portrait.

Philip Porter (1628–1655) was the third son of Endymion Porter, a courtier of Charles I and a close friend of Van Dyck.

Verso

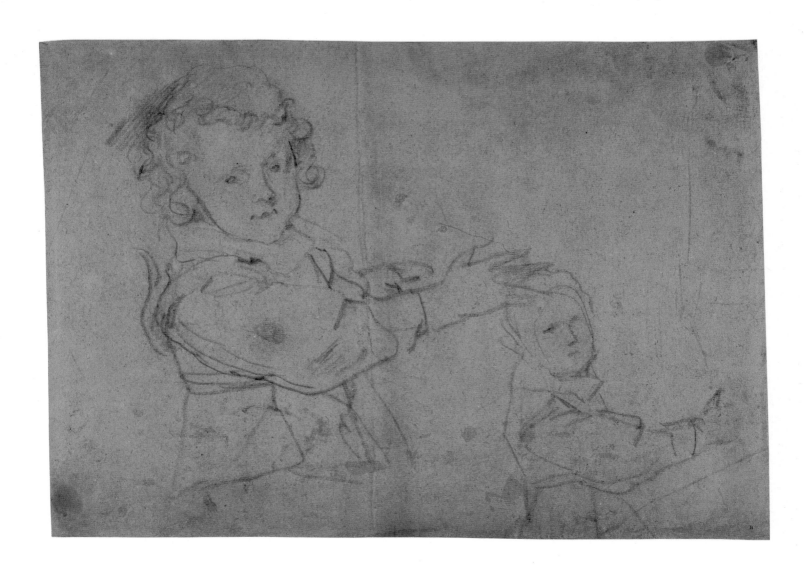

66
Queen Henrietta Maria with Her Dwarf, Sir Jeffrey Hudson

1633

Black chalk, with white chalk highlights, and touches of red and yellow chalks, on blue paper, 419 x 257 mm. Some abrasion in the queen's dress. Trimmed along the left edge. Lower left-hand corner, an inscription in pen: *A. van Dijck*.

Watermark: none

Ecole nationale supérieure des Beaux-Arts, Paris (inv. no. 34604)

Vey 206
Exhibited in Fort Worth

PROVENANCE E. Desperet (1804–1865), Paris (L.721, lower left); his sale, Paris, 6–7 June 1865, no. 223; A. Armand (1805–1888), Paris; P. Valton, Paris; presented by him in 1908 to the Ecole des Beaux-Arts (L.829, lower right).

EXHIBITIONS Paris 1947, no. 52; Paris 1981, no. 61.

LITERATURE Valentiner 1930, no. 47[1]; Vey 1962, no. 206; Eisler 1977, 116–118.

1. The entry is by G. Glück quoting the opinion of Ludwig Burchard.
2. Glück 1931, no. 373; Washington 1990–1991, no. 67.
3. Cust 1900, 107–108, illustrated facing 108.
4. He thought that the red and yellow was pastel rather than chalk.

This is a study for the portrait of Queen Henrietta Maria and her dwarf, Sir Jeffrey Hudson, in the National Gallery of Art, Washington [fig. 1].[2] It is specifically for the pose and dress of the queen; Sir Jeffrey's position, on the queen's right, is indicated with a few strokes of black chalk. Van Dyck has lightly sketched in black chalk the column and drapery behind the queen on the right, and the orange tree which stands behind her on a ledge on the left. In the painting she is resting her right hand on the pet monkey, Pug, who stands on Sir Jeffrey's left arm and shoulder. A second version of the painting, for which Van Dyck was paid in October 1633, was presented by the king to Lord Wentworth and is in the Fitzwilliam Collection.[3]

Henrietta Maria (1609–1669), the youngest daughter of Henri IV of France and Maria de' Medici, married Charles I in 1625. Jeffrey Hudson (1619–1682) entered the queen's service before 1630 and was a well-known figure at court.

Vey considered that the work in red and yellow chalks and some black chalk strengthening in the folds of the queen's dress were by a later hand.[4] In my view, the drawing is entirely by Van Dyck.

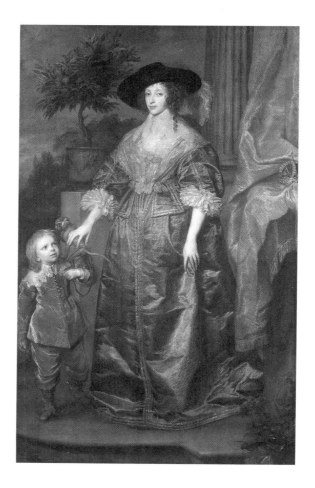

Fig. 1. Anthony van Dyck, *Queen Henrietta Maria with Sir Jeffrey Hudson*. Canvas, 215.1 x 134.8 cm. National Gallery of Art, Washington

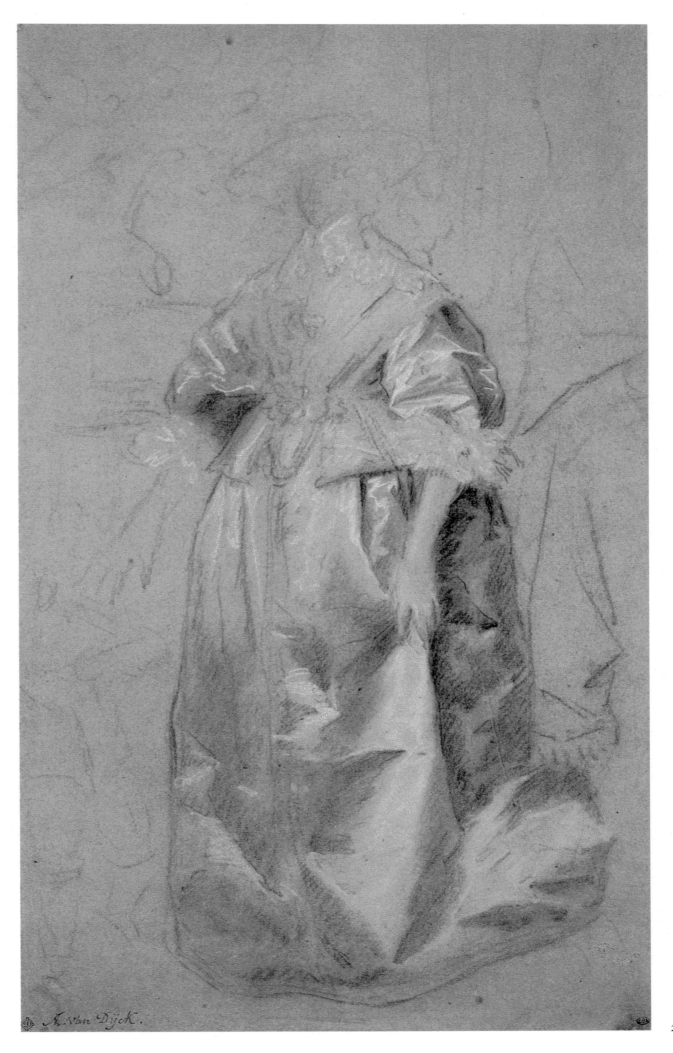

A. Van Dijck.

221

67
Charles I on Horseback

1633

Black chalk, with white chalk highlights, on blue paper, 398 x 283 mm. Abraded in the center of the sheet.

Watermark: none

The British Museum, London, Department of Prints and Drawings (inv. no. 1885.5.9.44)

Vey 207

PROVENANCE Jonathan Richardson the Elder (1665–1745), London (L.2184, center, at the bottom); Thomas Hudson (1701–1779), London (L.2432, twice, lower left and lower right); Sir Joshua Reynolds (1723–1792), London (L.2364, lower left); W. Russell (1800–1884), London; purchased by the British Museum in 1885.

EXHIBITIONS Antwerp 1960, no. 93; London 1982–1983, no. 68.

LITERATURE Cust 1900, 263; Rooses 1903, 139; Hind 1923, no. 46; Glück 1931, 372; Glück 1937, 221ff.; *British Drawings*, I, no. 27; Vey 1962, no. 207.

1. The painting bears the date 1633. For an extended discussion of this portrait (on which these remarks are based), see London 1982–1983, no. 11.
2. *Charles I and Queen Henrietta Maria with Their Two Eldest Children*. Oil on canvas, 302.9 x 255.9 cm (including additions of 31.7 at the top and 21.6 on the right). Royal Collection. Glück 1931, 371; London 1982–1983, no. 7.
3. *Charles I on Horseback*. Oil on canvas, 367 x 292.1 cm. Glück 1931, 381; Martin 1970, no. 1172, 41–47.
4. Oil on canvas, 335 x 580 cm.

This is a study for *Charles I on Horseback with Monsieur de Saint Antoine*, the great portrait of 1633 [fig. 1], which hung at the end of the Long Gallery at Saint James's Palace. It shows the king riding through a triumphal arch accompanied by his French riding master, Monsieur de Saint Antoine. The king is portrayed as ruler—he carries a baton and the royal arms are displayed prominently on the left—and as horseman. Horsemanship was an accomplishment associated with virtue and courage, essential requisites of a seventeenth-century prince.[1]

This hasty sketch was made in order to establish the disposition of the figures and the arch. It is the only compositional sketch of this type from the English period. There are no such sketches for other large-scale portraits such as the so-called "Great Peece,"[2] the equestrian portrait in the National Gallery, London,[3] or the *Portrait of the 4th Earl of Pembroke and his Family* at Wilton.[4]

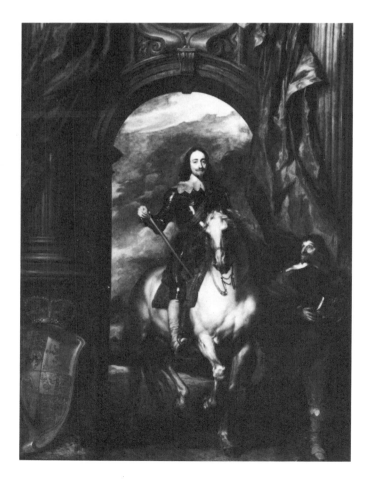

Fig. 1. Anthony van Dyck, *Charles I on Horseback with Monsieur de Saint Antoine*. Canvas, 368.4 x 269.9 cm. Collection of Her Majesty Queen Elizabeth II

222

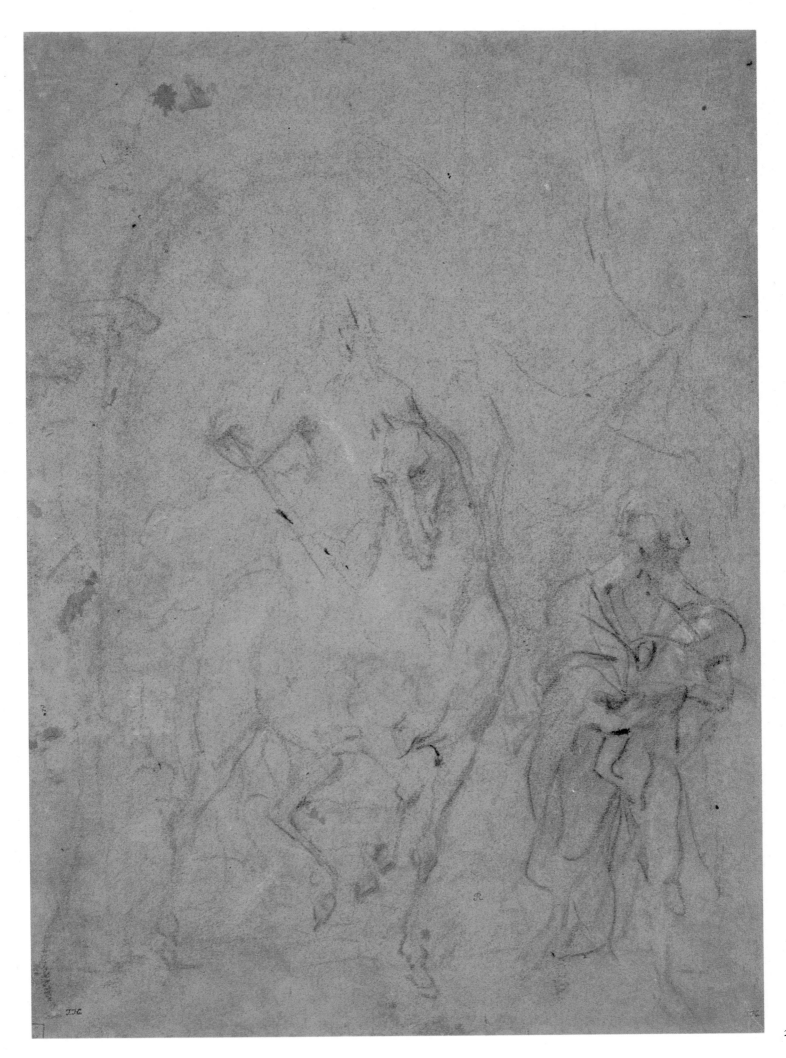

68
Studies of a Horse

1633

Black chalk, with white chalk highlights, on blue
paper, 429 x 366 mm. The sheet is made up of
three overlapping pieces of paper. Lower right, in
a later hand, an inscription in pen: *VIII*.

Watermark: none

The British Museum, London, Department of
Prints and Drawings (inv. no. 1874.8.8.22)

Vey 208

PROVENANCE Hugh Howard (1675–1737),
London; the earl of Wicklow; acquired by the
British Museum in 1874.

EXHIBITIONS London 1982–1983, no. 69; London
1987A, no. 51.

LITERATURE Hind 1923, no. 47; Glück 1931, 372;
Vasari Society (2d series), XV, no. 2; Göpel 1940,
107; *British Drawings*, I, no. 22; Vey 1962,
no. 208.

1. For a discussion of the painting, see above,
cat. 67. Millar (in London 1982–1983, no. 69) points
out that, although the drawing is almost certainly
for the king's horse, the horse in the *Equestrian
Portrait of the Marqués de Moncada* (Paris, Louvre.
Glück 1931, no. 420), which was painted in
Brussels in 1634–1635, is in the same position, as is
the horse in the *Equestrian Portrait of Giovanni Paolo
Balbi* (Fondazione Magnani Rocca, Parma). The
importance of the commission and the provenance
of the drawing all support the idea that this is a
study for the portrait of Charles I rather than for
either of these paintings.

This sheet contains two studies of a horse in the same pose as the horse bearing the
king in *Charles I on Horseback with Monsieur de Saint Antoine*, which was painted in
1633 and hung at Saint James's Palace [cat. 67, fig. 1].[1] Cat. 67 is a compositional
study for the same portrait. The sheet is made up of three separate pieces of paper
which Van Dyck himself may well have cut up and pasted together in order to
study the horse's anatomy. He seems to have deliberately shortened the back legs
in order to fit them onto the paper. On the right is a separate study of the raised
foreleg. There is a third preparatory drawing for the portrait, a study of the horse's
left foreleg, in the British Museum [fig. 1].

Fig. 1. Anthony van Dyck, *The Left Foreleg of a
Horse*. Black chalk on blue paper, 232 x 147 mm.
The British Museum, London (Vey 209)

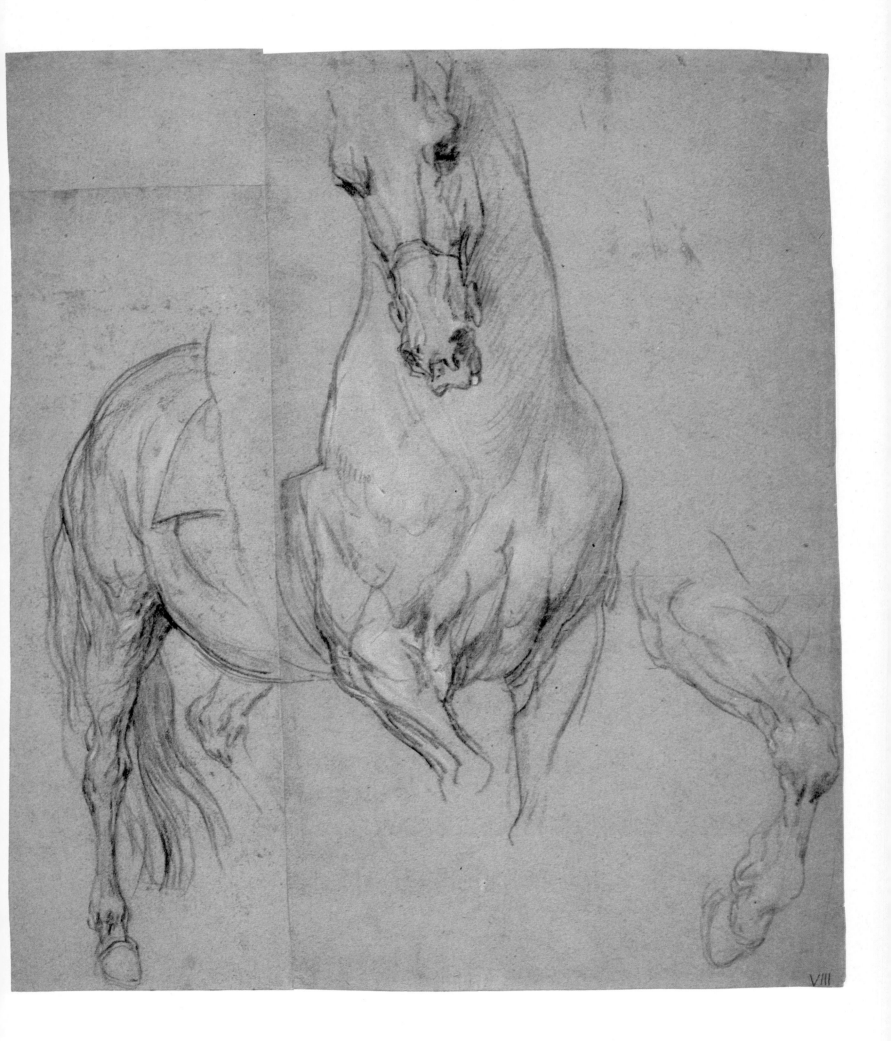

69
Portrait of King Charles I

c. 1633

Black chalk, 479 x 365 mm. There is a horizontal fold in the center.

Watermark: the sheet is pasted down and the watermark of a small elephant which can be seen is that of the backing sheet.

Rijksmuseum, Amsterdam, Rijksprentenkabinet (inv. no. 1887.A1162)

[Under Vey 204]
Exhibited in Fort Worth

PROVENANCE In the Terborch family estate, which was purchased en bloc by the Rijksmuseum in 1887.[1]

EXHIBITIONS London 1900, no. 222; Antwerp 1949, no. 105.

LITERATURE Vey 1962, under no. 204 (as a copy); Held 1964, 566 (as a possible original); Kettering 1988, II, 772, no. 21 (as a copy).

1. See Kettering, op. cit.
2. Oil on canvas, 272 x 212 cm. Musée du Louvre, Paris. Glück 1931, 377.
3. Glück 1931, 382; Millar 1963, no. 145.
4. This drawing—black chalk, 400 x 288 mm—is Vey no. 204 (as a copy). It is a stiff and mechanical copy on two pieces of paper which have been joined together.

This study of the head of Charles I does not accord exactly with any painted image of the king. He wears a hat of this type in the *Roi à la Ciasse* [cat. 89, fig. 1],[2] but his head is at a different angle. He is shown bareheaded but full face, and wearing this type of collar, in *Charles I on Horseback with Monsieur de Saint Antoine* [cat. 67, fig. 1] and in the *Charles I in Garter Robes* [fig. 1],[3] but in both those portraits he wears his hair longer.

This drawing was considered to be an original by Cust and the organizers of the exhibition in Antwerp in 1949. However, Vey considered it to be a copy either after a lost original or after another copy in the Fitzwilliam Museum, Cambridge.[4] Held, however, thought it superior to the Cambridge drawing and possibly the original. I consider it to be by Van Dyck, a carefully drawn head of the king from the life which was to be used, in slightly different forms, for a number of formal portraits made during Van Dyck's first years in England. Its careful and finished appearance —which misled Vey into considering it a copy—is comparable to that of the portrait of Anna van Thielen and her daughter Anna Maria [cat. 52].

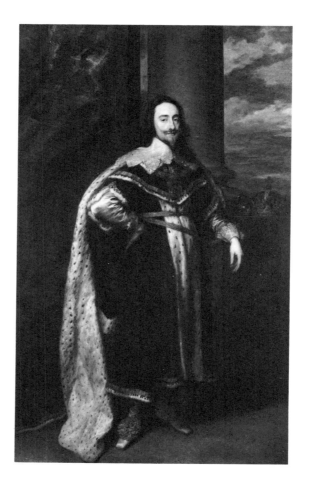

Fig. 1. Anthony van Dyck, *Charles I in Garter Robes*. Canvas, 245 x 152.5 cm. Collection of Her Majesty Queen Elizabeth II

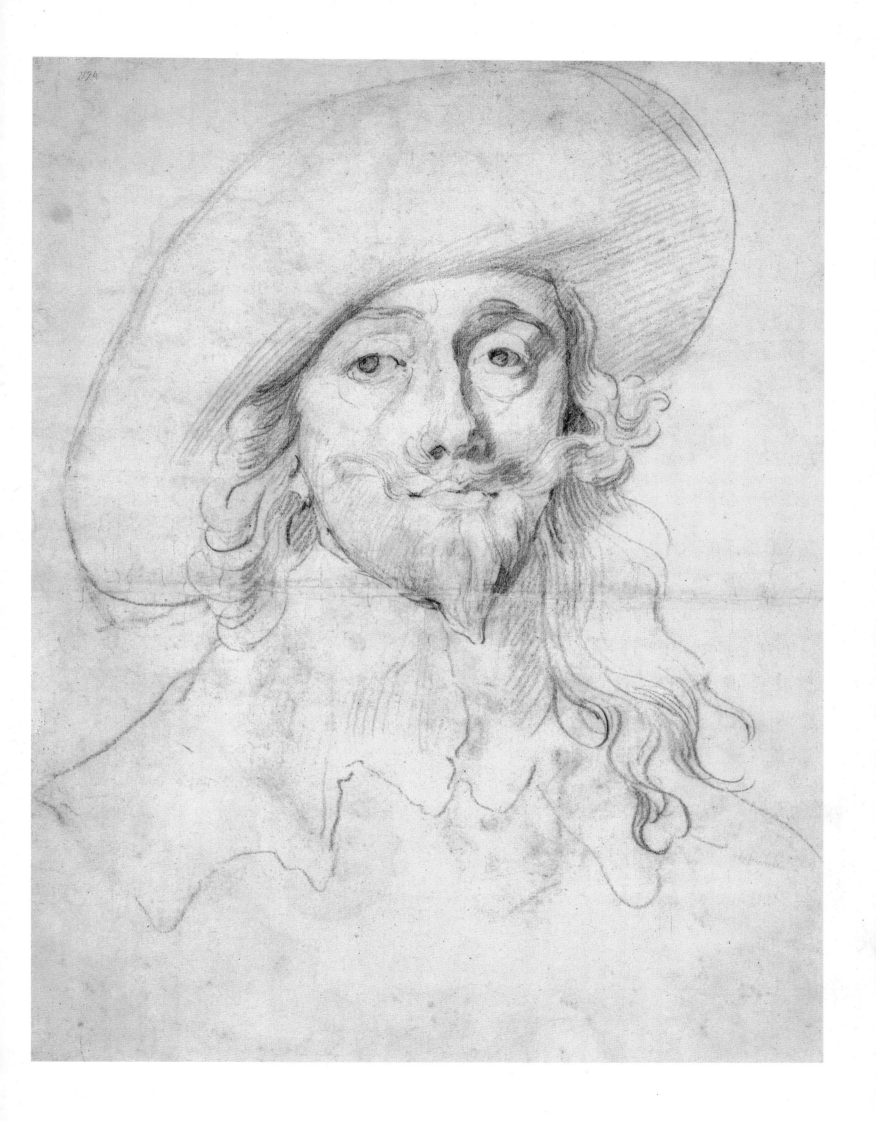

70
James Stuart, 4th Duke of Lennox

c. 1633

Black chalk, with white chalk highlights, on light brown paper, 477 x 280 mm. In the middle is a horizontal fold. A damage in the area of Stuart's left arm has been repaired.

Verso, top right, in ink: 6.

Watermark: none

The British Museum, London, Department of Prints and Drawings (inv. no. 1874.8.8.142)

Vey 214

PROVENANCE Hugh Howard (1675–1737), London; the earl of Wicklow; acquired by the British Museum in 1874.

EXHIBITIONS Antwerp 1960, no. 96; London 1987A, no. 48.

LITERATURE Cust 1900, 178; Rooses 1903, 139; Hind 1923, no. 54; Glück 1931, 109–111; *British Drawings*, I, no. 26; Vey 1962, no. 214; Liedtke 1984, 51.

1. Glück 1931, 411. For this portrait, see Liedtke 1984, 50–54; Washington 1990–1991, no. 66.
2. According to Millar in London 1982–1983, no. 48. The spear in the Kenwood portrait may allude to the boarhunt in which the dog saved Lennox's life. This incident probably took place during the duke's travels on the Continent in 1630–1633.
3. Glück 1931, 481 and 488.
4. Glück 1931, no. 409; London 1982–1983, no. 48.
5. Oil on canvas, 105 x 83 cm. Glück 1931, no. 410.

This is a preparatory study for the pose and costume in the full-length, life-size portrait of the duke, which is in the Metropolitan Museum of Art, New York [fig. 1].[1] Beside him stands a greyhound, which is said to have saved the duke's life,[2] and on whose head he rests his right hand. Cat. 71 is a sheet of studies for the dog.

James Stuart (1612–1655), who had succeeded his father as duke of Lennox in 1624, was created 1st duke of Richmond on 8 August 1641 by Charles I, of whom he was a loyal supporter. On 5 December that year he was appointed Lord Steward. A prominent member of the court, he was very close to the king and was entrusted with the arrangements for his burial in Saint George's Chapel, Windsor. Lennox received the Order of the Garter in November 1633. He wears the insignia of the order very prominently in the portrait: the silver star on his cloak; the enameled red and gold jewel, the lesser George, hanging from a green ribbon (which was blue when the picture was painted) on his chest; and the garter itself, which can be seen behind the black ribbon at his left knee. Lennox's admission into the Order of the Garter was probably the occasion for the commission of this portrait, as the insignia is so prominently displayed.

The duke sat for Van Dyck on a number of occasions, as did his wife, Mary Villiers, daughter of the duke of Buckingham, whom he married in 1637. There are two more full-length portraits of the duke[3] as well as a superb half-length portrait at Kenwood [fig. 2],[4] in which a greyhound is also prominently included, and another half-length, in which the duke is shown in the guise of Paris, in the Louvre.[5]

Fig. 1. Anthony van Dyck, *James Stuart, 4th Duke of Lennox*. Canvas, 215.9 x 127.6 cm. Metropolitan Museum of Art, New York, Marquand Collection

Fig. 2. Anthony van Dyck, *James Stuart, 4th Duke of Lennox*. Canvas, 99.7 x 160 cm. Kenwood House (The Iveagh Bequest), London

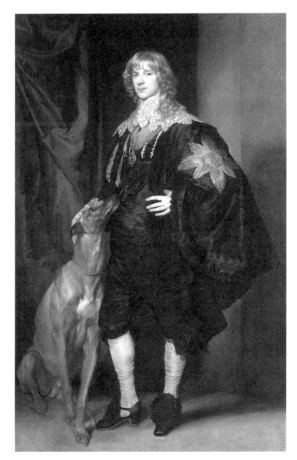

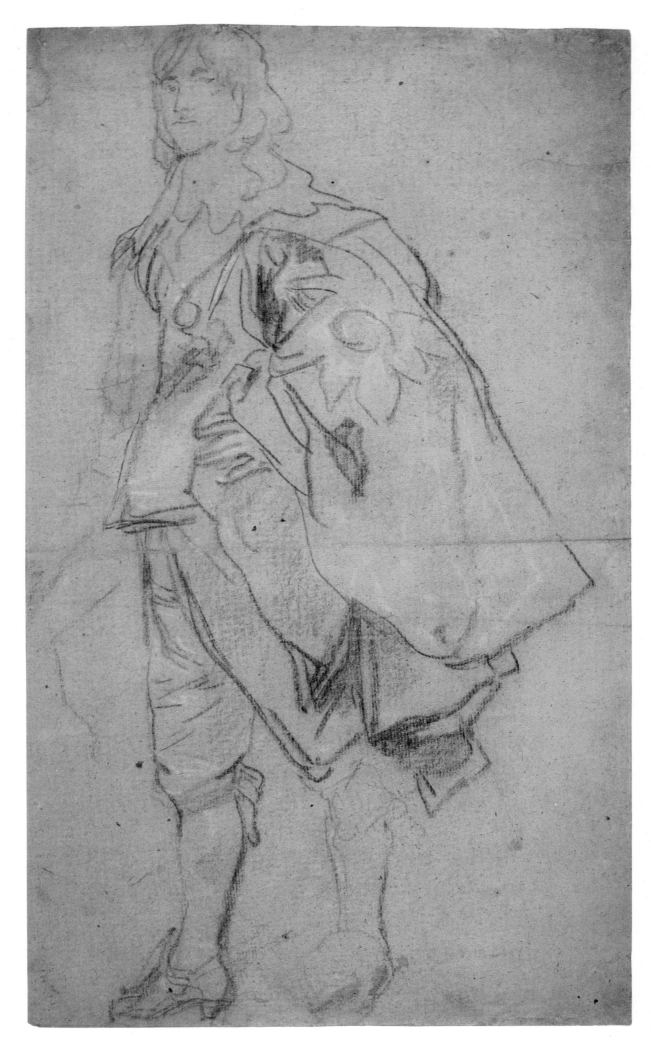

71
Studies of a Greyhound

c. 1633

Black chalk, with white chalk highlights, on light brown paper. Very lightly drawn in black chalk at the top in the center is a face (of a woman?) and beneath it, to the right, a profile. 470 x 328 mm. Damaged and restored in top right-hand corner.

Watermark: none

The British Museum, London, Department of Prints and Drawings (inv. no. 1874.8.8.141)

Vey 215

PROVENANCE Hugh Howard (1675–1737), London; the earl of Wicklow; acquired by the British Museum in 1874.

EXHIBITIONS Brussels 1965, no. 326; London 1987A, no. 49.

LITERATURE Cust 1900, 178; Vasari Society, II, no. 26; Hind 1923, no. 55; Glück 1931, 409–411; Delen 1943A, no. 19; Van Puyvelde 1950, pl. 45; *British Drawings*, I, no. 25; Vey 1962, no. 215; Liedtke 1984, 51.

These are preparatory studies for the greyhound in the *Portrait of James Stuart, 4th Duke of Lennox* in the Metropolitan Museum of Art, New York [cat. 70, fig. 1]. Cat. 70 is a study for the duke and the painting and the sitter are discussed in that catalogue entry.

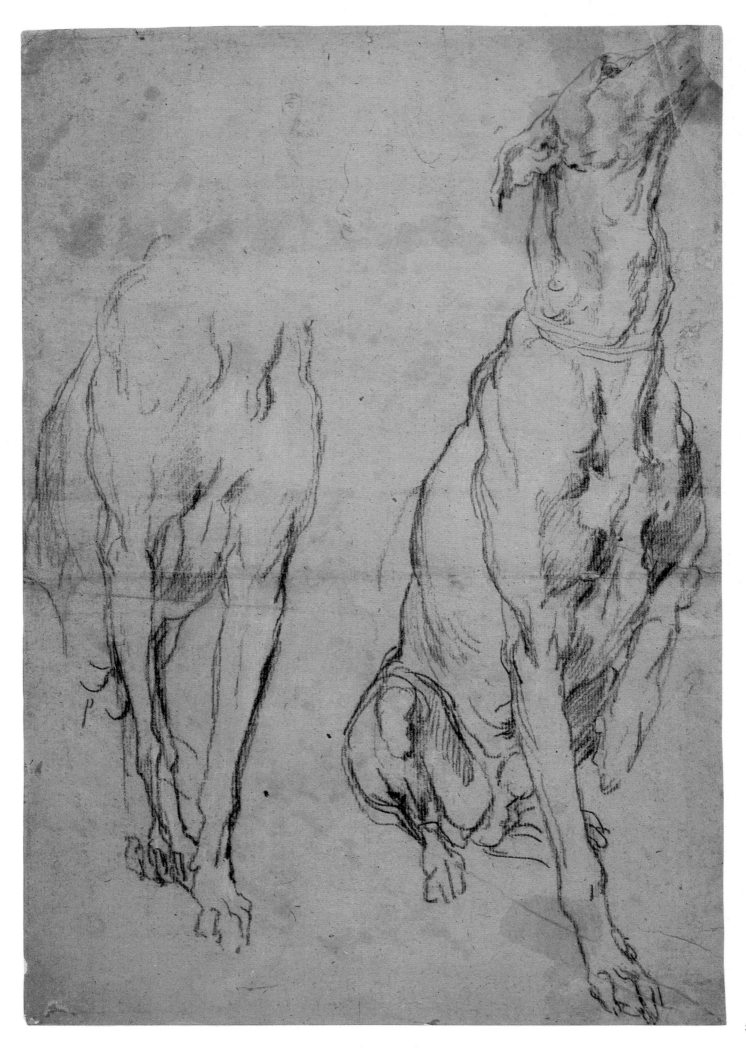

72
Inigo Jones

1632–1636

Black chalk, 242 x 198 mm. On the original mount is an inscription in Lord Burlington's hand: *Vandyke's original drawing, from which the print by Van Voerst was taken, in the Book of Vandyke's Heads. Given me by the duke of Devonshire. Burlington.*

Devonshire Collection, Chatsworth (inv. no. 1002A)

Vey 271

PROVENANCE N. A. Flinck (1646–1723), Rotterdam (L.959, lower right); purchased by William, 2d duke of Devonshire in 1723; given by the 3d duke to Richard Boyle, 3d duke of Burlington (1694–1753); after his death, as a consequence of the marriage of his daughter and heiress, Charlotte Boyle, to the future 4th duke of Devonshire, it returned to Chatsworth [1]; by descent to the present duke.

EXHIBITIONS Antwerp 1960, no. 87; Manchester 1961, no. 77; Washington 1962–1963, no. 82; *Festival Designs by Inigo Jones*, Victoria and Albert Museum, London, 1969; London 1969, no. 82 (ex-catalogue); New York 1989–1990 (ex-catalogue).

LITERATURE Cust 1900, 276, no. 105; Delacre 1932, 92–94; Vey 1962, no. 271.

1. See *Proceedings of the Walpole Society*, 12, 1924, 22–24.
2. Mauquoy-Hendrickx 1956, no. 72. In the third state is the inscription: *Celeberrimvs vir Inigo Jones praefectus architecturae magnae brittaniae regis etc.*
3. Glück 1931, 443 (left).
4. For Jones (with all previous literature), see New York 1989–1990.
5. Delacre 1932, pl. 25.

This is a preliminary drawing for the engraving by Robert van der Voerst in *The Iconography* [fig. 1].[2] Van der Voerst had been born in Deventer in 1597 and was active in Utrecht as a draughtsman and engraver in 1625–1626. Shortly afterwards he went to live in England, where he worked until his death, which took place before October 1636. Jones must have sat for Van Dyck in England, so the drawing must date from Van Dyck's period in England in 1632–1634 or from after his return from Flanders in the spring of 1635. The print is in the opposite direction and shows no significant alterations. (The drawing is not, however, incised by the engraver.) There is a painted portrait of Jones by Van Dyck in the Hermitage [fig. 2],[3] the head of which appears to be made from the life. It shows the architect at the same age and in the same pose, but omits the hands and the sheet of paper. The drawing may be based on that portrait or on another drawing made from the life.

Inigo Jones (London 1573–1652) was an architect and theatrical designer.[4] He made two extended journeys to Italy, and his study of Italian architecture, and particularly the work of Andrea Palladio, was immensely influential in the development of his own style. Among his most important buildings are the Queen's House, Greenwich, and the Banqueting House, Whitehall, London. He designed masques for the courts of James I and Charles I. This drawing was mounted in an album of Inigo Jones' theatrical designs at Chatsworth, from which it was removed in 1960.

There is a copy of this drawing at Weimar.[5]

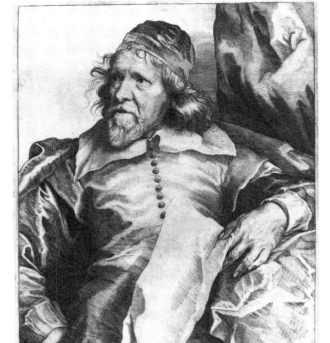

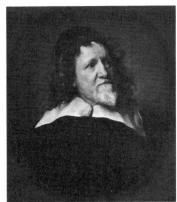

Fig. 1. Robert van der Voerst, after Van Dyck, *Inigo Jones*. Engraving, 3d state

Fig. 2. Anthony van Dyck, *Inigo Jones*. Canvas, 64 x 53 cm. The State Hermitage Museum, Leningrad

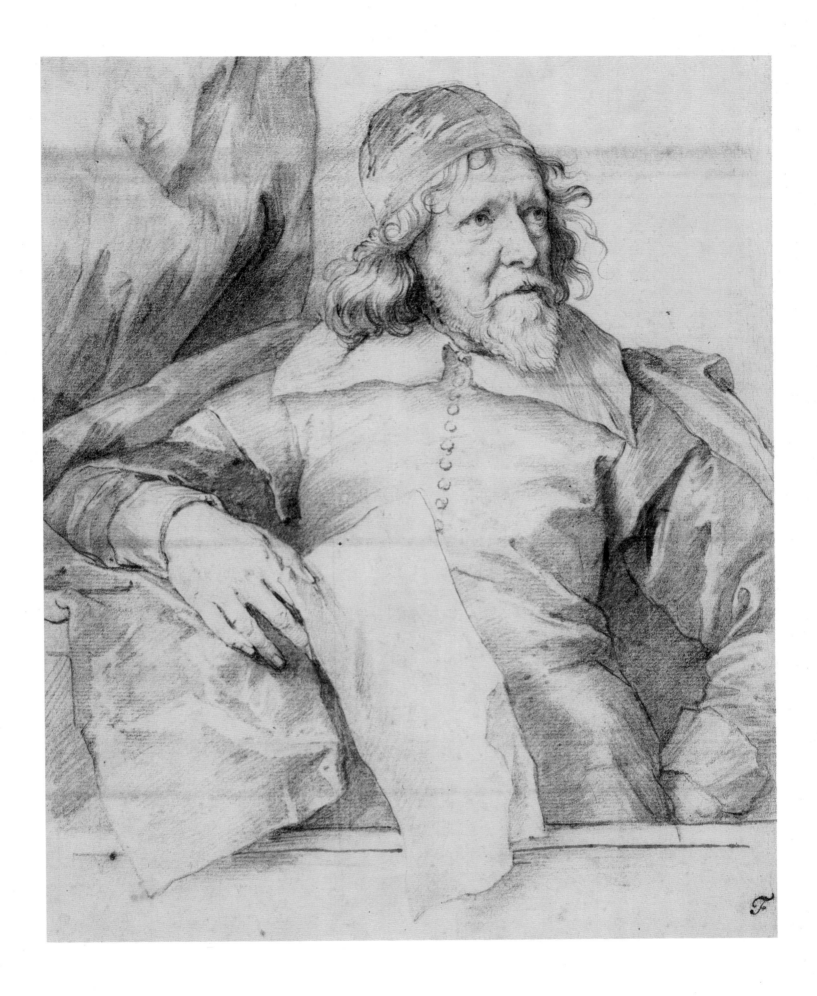

233

73
View of Rye from the Northeast

27 August 1633

Pen with brown ink and traces of brown wash, 202 x 294 mm. Lower right, in Van Dyck's own hand, in pen: *Rie del naturale li 27 d'Aug^to 1633— Ao vandyck* [cut off]; above, in Rijmsdijk's hand, in brown ink: *Rijmsdijk's Museum*.

On Richardson mount, at upper left, in graphite: *188*; at center, in Rijmsdijk's hand, in brown ink: *Sir A. Van Dyck*; at lower right: *Rye, a borough and cinque port/of Sussex*; at left, in another hand, in brown ink: *Born in Antwerp 1599* and in the same hand on the right: *Died in London 1641*. On the verso of the mount in the center at the top: P.97/ tk 13./ L.8 / G. (Richardson's pressmarks); above this, in another hand: *AIF*; lower right: L.2183, 2167.

Watermark: not visible (laid down on the Richardson mount)

The Pierpont Morgan Library, New York (inv. no. III,178)

Vey 288

PROVENANCE Jonathan Richardson the Elder (1665–1745), London (L.2183, lower right); Jan van Rijmsdijk (c. 1770), Bristol (L.2167, lower right); C. Fairfax Murray (1849–1919), London; J. Pierpont Morgan.

EXHIBITIONS New York 1939, no. 78 and 1940, no. 97; Baltimore 1941, no. 23; Worcester 1948, no. 43; New York 1953, no. 58; New York 1957, no. 92; Antwerp 1960, no. 100; Stockholm 1970, no. 63; London 1972, no. 122; Paris 1979–1980, no. 32; London 1982–1983, no. 81.

LITERATURE Morgan 1905–1912, III, no. 178; Vertue, 4, vol. 24, 114–115 and vol. 26, 1938, 60; Hind 1927, 292; Hind 1937, 484–485; Burchard 1938, 47–48; Wescher 1938, no. 27; Oppé 1941, 190; Vey 1956, 88, n. 7; Vey 1962, no. 288; Eisler 1963, pl. 44; Levey 1983, 106–107; Stampfle 1991, no. 272.

During Van Dyck's lifetime Rye, which is today a sleepy, small East Sussex town three miles from the sea, was a bustling port, well known for fishing and ship-building. It was also one of the principal ports for the channel crossing, lying opposite Dieppe on the north French coast. The most popular route from London to Paris in the seventeenth century was via Rye and Dieppe. Van Dyck presumably was attracted by the charm of this small town as he waited for the wind to change and sailing become possible. We do not know of a trip made by Van Dyck to the Continent in August 1633, but he may well have made such a trip, and sketched the town as he waited for a fair wind. Four drawings by Van Dyck showing views of Rye are known (Vey 288–291) of which two, this one and cat. 74, which shows the Ypres tower, one of the most prominent landmarks of the town, are included in this exhibition. There is a second view of the Ypres tower in the Fitzwilliam Museum, Cambridge [cat. 74, fig. 1] and a view of the Church of Saint Mary from the southeast in a drawing in the Uffizi [fig. 1]. The Uffizi drawing is dated 1634, so we know that Van Dyck was back in Rye in the following year, when he traveled to Flanders for an extended stay.

Van Dyck's view is taken from the northeast. It was probably drawn on or near the London road, about a quarter of a mile outside Rye. The town is dominated by the Church of Saint Mary on the top of the hill to the sides of which the small houses of the town cling. The Uffizi drawing is a more detailed view of the church. Below the church and a little to the left is the town's landgate, which was built in 1329, the original gate to the road to London and the only surviving city gate from the reign of Edward III; to the right of the gate is the chapel of the Austin friars; and to the far left, on the top of the hill, is the outline of the Ypres tower, one of the oldest surviving fortifications of the Cinque Ports, the medieval association of ports in Kent and Sussex formed for the defense of the English coast. To the far left, a ship is riding at anchor.

Wenzel Hollar copied this sheet in a delicate silverpoint drawing which is in the Huntington Library [fig. 2].[1] He etched this composition in 1659 in the upper left-hand corner of his map of Kent [fig. 3], acknowledging his source in the inscription: *Sir Anthony Van Dyck Delineavit*.[2]

1. R. R. Wark, *Early British Drawings in the Huntington Collection*, San Marino, 1969, 31, ill.
2. R. Pennington, *A descriptive catalogue of the etched work of Wenceslaus Hollar*, Cambridge, 1982, no. 665c.

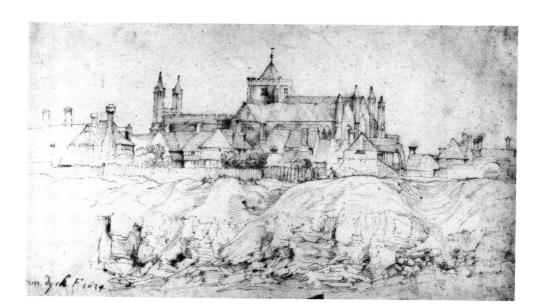

Fig. 1. Anthony van Dyck, *View of the Church of Saint Mary from the Southeast*, 1634. Pen and brown ink, 160 x 270 mm. Gabinetto Disegni e Stampe degli Uffizi, Florence (Vey 289)

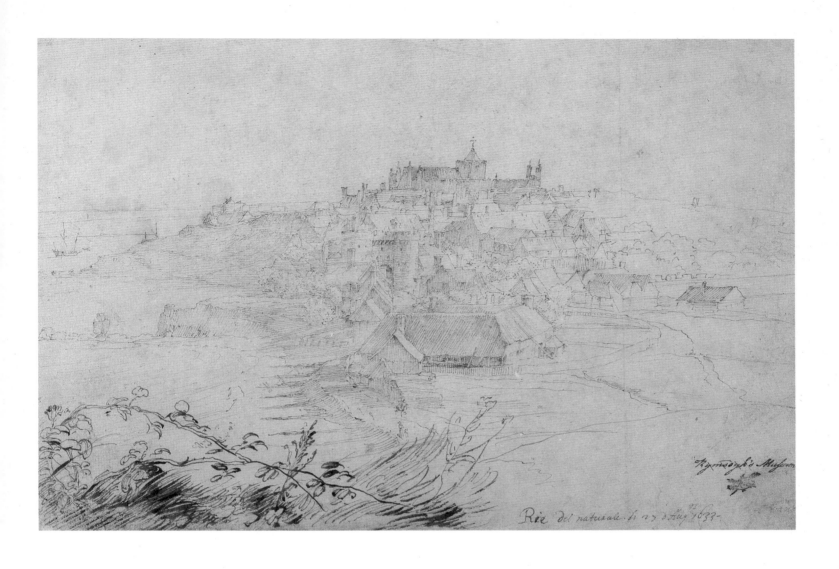

Rie del naturale li 27 o July 1633 -

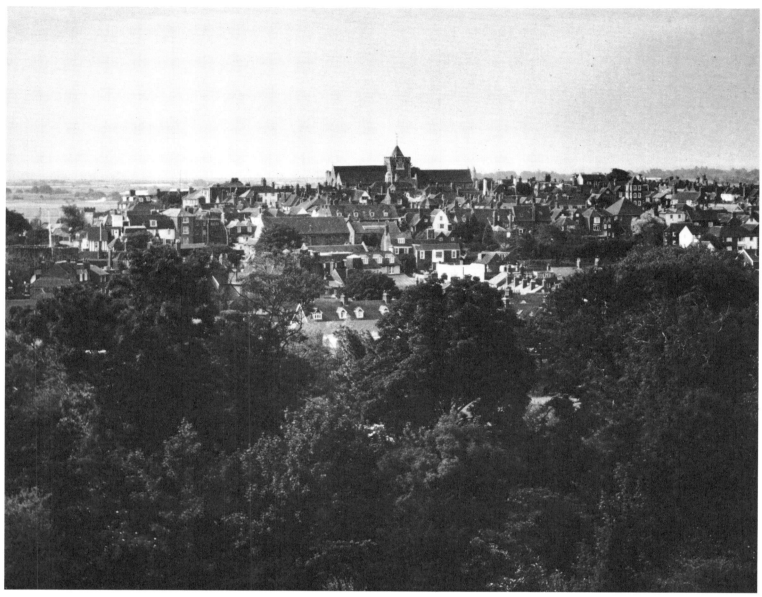

View of Rye (modern photograph)

Fig. 2. Wenzel Hollar, after Van Dyck, *View of Rye from the Northeast*. Silverpoint, 56 x 132 mm. Huntington Library and Art Gallery, San Marino

Fig. 3. Wenzel Hollar, after Van Dyck, Copy of Van Dyck's *View of Rye from the Northeast* in his map of Kent, 1659. Fitzwilliam Museum, Cambridge

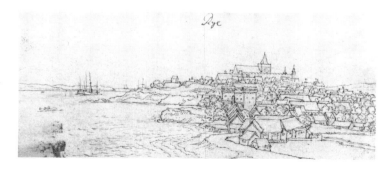

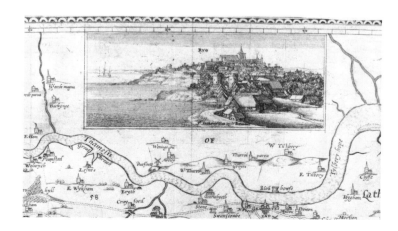

The Ypres Tower, Rye (modern photograph)

The Ypres Tower, Rye

1633–1634

Pen and brown ink on white (gray-toned) paper, 193 x 298 mm. Lower right, in Van Dyck's own hand, an inscription in pen: *A. vandyck*.

Watermark: none

Museum Boymans-van Beuningen, Rotterdam (inv. no. V.18)

Vey 291

PROVENANCE Count of Robiano; his sale, Muller, Amsterdam 15–16 June 1926, no. 368; Franz Koenigs (1881–1941), Haarlem (L.1023a, verso, lower left); D. G. van Beuningen; presented to the museum in 1941.

EXHIBITIONS Antwerp 1927, no. 44; Antwerp 1960, no. 102; Paris 1974, no. 31.

LITERATURE Hind 1937, 484–485; Burchard 1938, 47–48; Delen 1943A, no. 20; Vey 1956A, 88, pl. 17; Vey 1962, no. 291.

1. For the landscape prints of Giulio and Domenico Campagnola, see W. Strauss (ed.), *The Illustrated Bartsch*, New York, 1984, vol. 25, 463–516.
2. Hermitage, Leningrad, inv. no. 555. For a discussion of Van Dyck's portraits of Jabach, see Vey 1967, 157–189.
3. For Jabach's account of Van Dyck's procedure, recorded by De Piles, see above pp. 34–35.
4. Mauquoy-Hendrickx 1956, no. 156.

The Ypres tower is the citadel of the Norman fortress of Rye. It takes its name from its builder, William of Ypres, count of Kent. It is, with the castle at Dover, the oldest surviving fortification of the Cinque Ports. Van Dyck's drawing was presumably made on one of his two visits to Rye in 1633 and 1634. He took this view from a spot near the edge of the cliff. The choice of the view, with the prominence given to the sheep, recalls the prints of Giulio and Domenico Campagnola after Titian, with which Van Dyck was certainly familiar and which powerfully influenced his conception of landscape.[1]

A view of the Ypres tower and the house on the right can be seen in a portrait by Van Dyck of Everhard Jabach (Cologne 1618–1695 Paris), who was to become a great collector and patron of the arts [fig. 1].[2] Jabach was a friend of Van Dyck's and, according to De Piles, sat for the artist on three separate occasions.[3] Van Dyck used the Cambridge drawing of the Ypres tower [fig. 2] for this portrait, which probably dates from Jabach's stay in England in 1636–1637. It is not known why Jabach chose to include this building in his portrait. Rye was on the route from the Continent and was a prominent landmark whose medieval architecture may have made a great impression on Jabach, who came from Cologne, a town with many Romanesque churches and encircled by a massive medieval wall. For Jabach (and indeed for Van Dyck), it may have come to symbolize arrival in England. The portrait of the Antwerp goldsmith Theodoor Rasier in *The Iconography*,[4] which was engraved by Petrus Clouet [fig. 3], follows the Leningrad portrait of Jabach in every respect except the head, and so also includes the Ypres tower. The reason for this substitution is unclear.

Fig. 1. Anthony van Dyck, *Everhard Jabach*. Canvas, 113 x 91.5 cm. The State Hermitage Museum, Leningrad

Fig. 2. Anthony van Dyck, *The Ypres Tower*. Pen and brown ink, 189 x 298 mm. Fitzwilliam Museum, Cambridge (Vey 290)

Fig. 3. Petrus Clouet, after Van Dyck, *Theodoor Rasier*. Engraving, 3d state

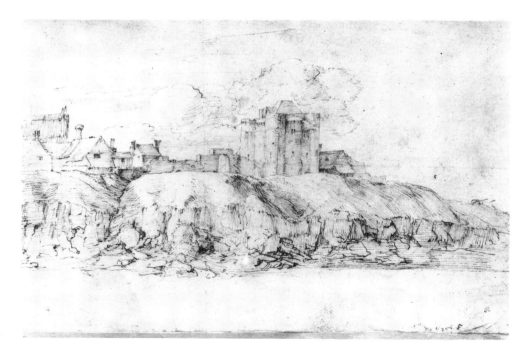

THEODORVS ROGIERS
ANTVERPIENSIS CÆLATOR IN ARGENTO

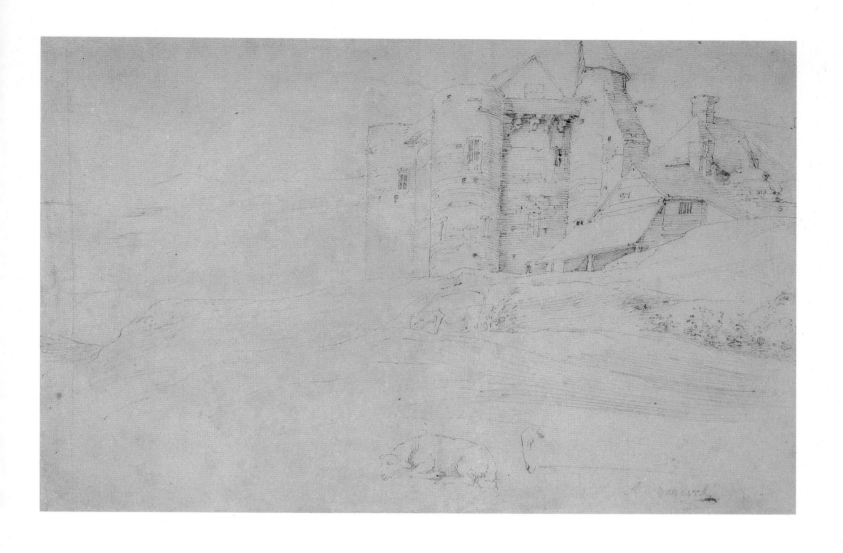

ANTWERP AND BRUSSELS

1634–1635

75
Count John of Nassau-Siegen

1634

Black chalk, with white chalk highlights, on blue paper, 458 x 315 mm.

Watermark: an R surmounted by a 4 (not in Briquet)[1]

The British Museum, London, Department of Prints and Drawings (inv. no. 1845.12.8.4.)

Vey 199

PROVENANCE Jonathan Richardson the Elder (1665–1745), London (L.2184, lower right); Thomas Hudson (1701–1779), London (L.2432, lower right); Sir Joshua Reynolds (1723–1792), London (L.2364, lower left).

LITERATURE Cust 1900, 176; Rooses 1903, 139; Hind 1923, no. 40; Vey 1962, no. 199.

1. It is the same watermark as that noted by Van Hasselt on the *Portrait of the Abbé Scaglia* by Van Dyck (Vey 192) in the Institut Néerlandais, Paris. For a drawing of the watermark, see London 1972, 175. It also appears on cat. 76.
2. Larsen 1980, no. 789.
3. There are a number of versions of this portrait, of which the best (although it includes substantial studio participation) seems to be the one in the collection of the prince of Liechtenstein at Vaduz [fig. 2] (Glück 1931, no. 428).
4. Black chalk, 450 x 380 mm.

This is a study for pose and costume made from life for the *Portrait of Count John of Nassau-Siegen and His Family* [fig. 1], which is in the collection of Viscount Gage at Firle Place in Sussex.[2] The portrait is dated 1634 (in a reliable old inscription on the painting) and was made in Flanders during Van Dyck's stay in that year. Cat. 76 is a study for the countess and her eldest son in the same portrait.

Count John of Nassau-Siegen (1585–1638), a member of the Catholic branch of the Nassau-Siegen family, was a commander in the Spanish army in the Netherlands. Van Dyck also painted the count full-length in armor, with his commander's baton in his right hand.[3]

This drawing was engraved by Bernard Baron in 1761. Vey notes an eighteenth-century drawn copy of the painting at Firle in the collection of the queen of the Netherlands.[4]

Fig. 1. Anthony van Dyck, *John of Nassau-Siegen and His Family*, 1634. Canvas, 292.5 x 265 cm. Collection of Viscount Gage, Firle Place, Sussex

Fig. 2. Anthony van Dyck, *John of Nassau-Siegen in Armor*. Canvas, 202 x 122 cm. Collection of the Prince of Liechtenstein, Vaduz

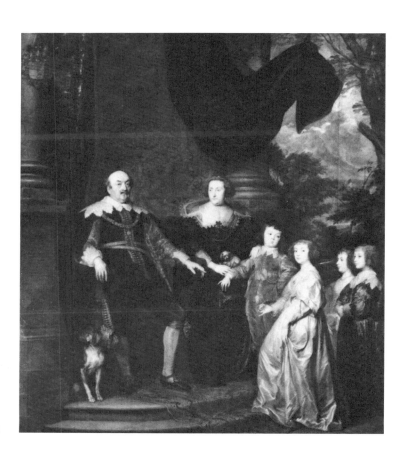

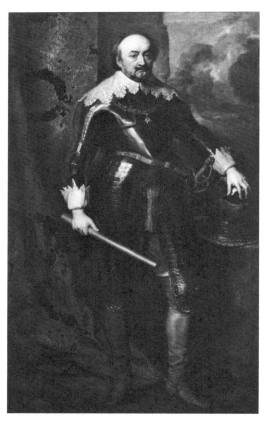

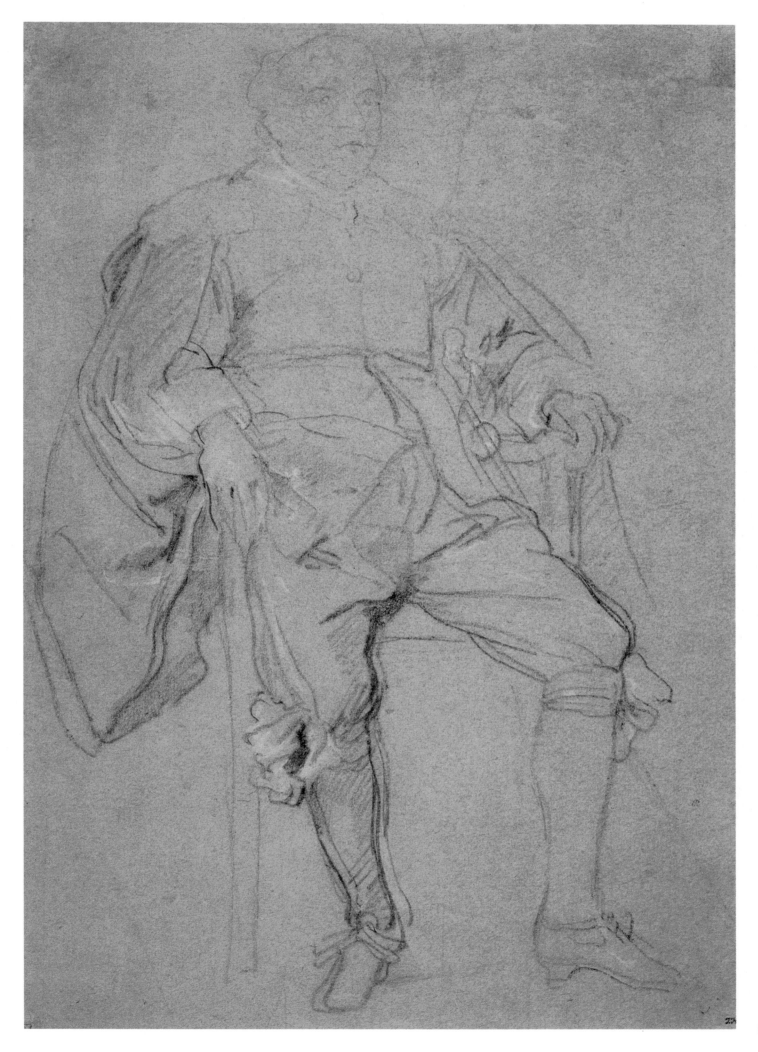

243

76
Countess Ernestine of Nassau-Siegen with Her Son Johann Franz Desideratus

1634

Black chalk, with white chalk highlights, on blue paper, 443 x 280 mm. Lower right-hand corner damaged and restored. There is a horizontal fold across the center of the sheet.

Verso: (turned through 180 degrees) *Quentijn Simons*. Black chalk, with white chalk highlights.

Watermark: an R surmounted by a 4 (not in Briquet)[1]

The British Museum, London, Department of Prints and Drawings (inv. no. 1874.8.8.139)

Vey 200

PROVENANCE Hugh Howard (1675–1737), London; the earl of Wicklow; acquired by the museum in 1874 (L.302, verso, top right).

LITERATURE Hind 1923, no. 42; Glück 1931, notes to 343; Göpel 1940, pl. 14 (verso); Vey 1962, no. 200.

1. It is the same watermark as on cat. 75 (see n. 1).
2. Mauquoy-Hendrickx 1956, no. 144. Meyssens, an Antwerp publisher, added thirty-four portraits to his edition of *The Iconography* which appeared c. 1650. See Mauquoy-Hendrickx 1956, I, 60–63.
3. Mauquoy-Hendrickx 1956, no. 174.
4. 1977 cat., no. 242. Glück 1931, no. 343.

The Countess Ernestine was the daughter of Duke Lamoral de Ligne and had married Count John of Nassau-Siegen in 1618. She is seen here with her eldest son, Johann Franz Desideratus. Like cat. 75, this is a study for the *Portrait of Count John of Nassau-Siegen and His Family*, which is at Firle Place, Sussex [cat. 75, fig. 1]. In the painting the young Johann inclines his head to his left towards his three sisters but otherwise his pose is as in the drawing, with his arm resting in his mother's lap, where a small dog is also sitting. As in the case of Count John, Van Dyck appears to have painted another, different portrait of the countess. That painting was used for the engraving of her by Michael Natalis [fig. 1] in Jan Meyssens' *Iconography*.[2]

On the verso is a preparatory drawing for a portrait of Quentijn Simons, a history painter, who was born in Brussels in 1592 and married there in 1628. His date of death is not known. He is included in *The Iconography* in an engraving by Pieter de Jode.[3] This drawing is a study for the portrait of Simons by Van Dyck in the Mauritshuis, The Hague [fig. 2],[4] which shows him in the same pose—his hands are in exactly the same position—and costume. The fact that this portrait drawing is on the reverse of the preparatory study for the Firle painting, which is dated 1634, makes it a reasonable presumption that this drawing and the painting in The Hague are also from that year.

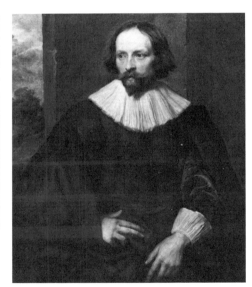

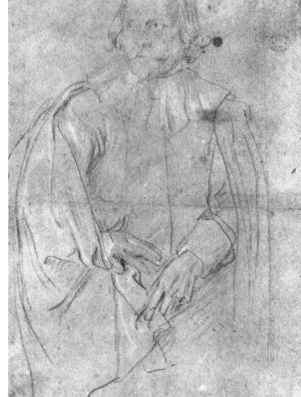

Fig. 1. Michael Natalis, after Van Dyck, *Countess Ernestine of Nassau-Siegen*. Engraving, 2d state (from Jan Meyssens' *Iconography*)

Fig. 2. Anthony van Dyck, *Quentijn Simons*. Canvas, 88 x 84 cm. Mauritshuis, The Hague

Verso

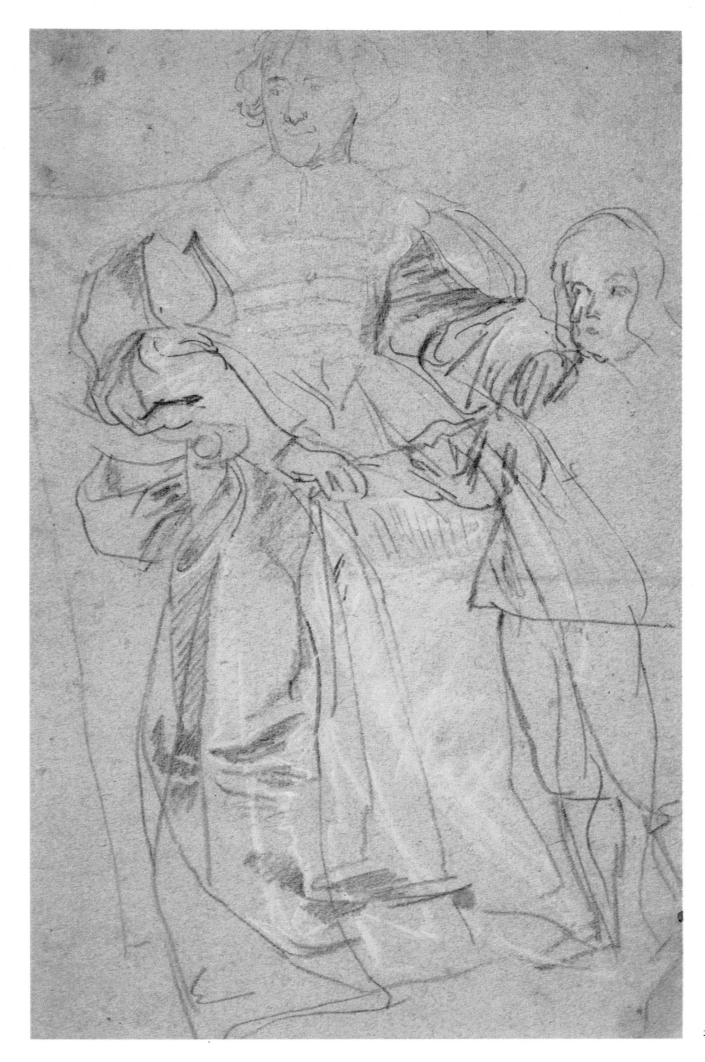

245

77
Justus van Meerstraeten

1634–1635

Black chalk, with white chalk highlights, on gray-blue paper, 338 x 223 mm.

Watermark: not visible (laid down)

Christ Church, Oxford (JBS 1385)

Vey 202

PROVENANCE J. Guise (1682/1683–1765), Oxford.

EXHIBITIONS London 1938, no. 615; Rotterdam 1948–1949, no. 92; London 1960, no. 19; Antwerp 1960, no. 109; Liverpool 1964, no. 13; Washington 1972–1973, no. 96.

LITERATURE Colvin 1907, no. 22; Schaeffer 1909, XXIX; Bell 1914, 43; Glück 1931, 416; Vey 1962, no. 202; Byam Shaw 1976, no. 1385.

1. Staatliche Kunstsammlungen, inv. no. GK126. Glück 1931, 416.
2. Staatliche Kunstsammlungen, inv. no. GK127. Glück 1931, 417.
3. For the bust of the Pseudo-Seneca, see W. Prinz, "The Four Philosophers by Rubens and the Pseudo-Seneca in Seventeenth-Century Painting", *The Art Bulletin* 55 (1973), 410ff., and Muller 1989, 151 (with previous literature). Its inclusion in this portrait indicated Van Meerstraeten's adherence to the Stoicism of Justus Lipsius, the great scholar of Seneca, which was much admired in the Antwerp humanist circle in which both Rubens and Van Meerstraeten moved.

Justus van Meerstraeten was Raadpensionaris, the most senior civilian official, in the government of the Spanish Netherlands in Brussels. He died in 1639. This is a study for the portrait of Van Meerstraeten at Kassel [fig. 1].[1] With the pendant portrait of his wife, Isabella van Assche [fig. 2],[2] it dates from Van Dyck's stay in Flanders in 1634–1635. In the painting, as in the drawing, Van Meerstraeten is shown with his right hand resting on a book, identified by a slip of paper as the *Digesta*, a legal compendium, while beside it on the table is the well-known antique bust thought to represent Seneca, one version of which was in Rubens' collection and was prominently displayed at his house.[3] In the background on the right is a landscape glimpsed through the window. Vey surmised that the drawing may once have been wider and have included the objects on the left. As Byam Shaw has noted, this is unlikely: not only is there no evidence that the sheet has been cut, but the format of the portrait is consistent with that of other portraits drawn from life during the 1630s. The bust and the landscape (which is echoed by a landscape in the portrait of Isabella) were presumably added at Van Meerstraeten's request after the sitting.

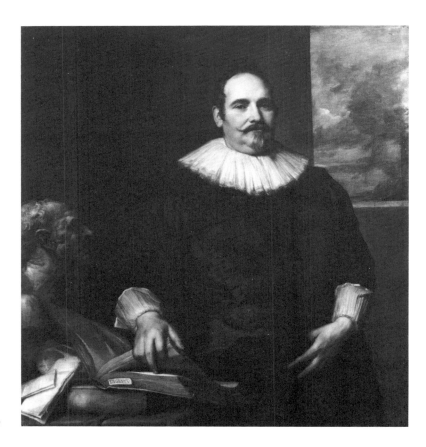

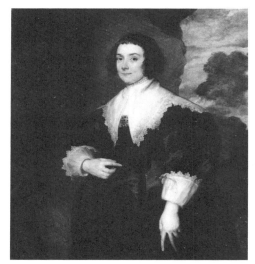

Fig. 1. Anthony van Dyck, *Justus van Meerstraeten*. Canvas, 119.3 x 109.5 cm. Staatliche Kunstsammlungen, Kassel

Fig. 2. Anthony van Dyck, *Isabella van Assche, Wife of Justus van Meerstraeten*. Canvas, 107.5 x 97.5 cm. Staatliche Kunstsammlungen, Kassel

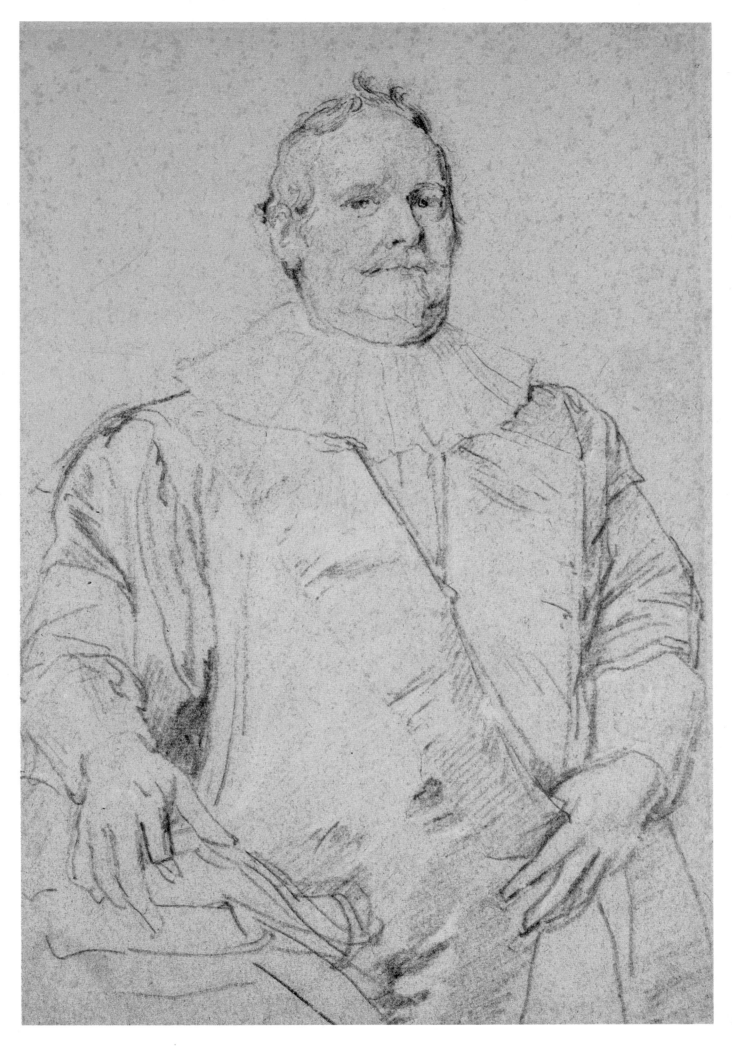

247

78
Portrait of a Woman

1630–1632 or 1634–1635

Black chalk, with white chalk highlights, on blue-gray paper (which has discolored and now appears brownish in tone), 501 x 300 mm. It is rubbed in the area of the sitter's right hand. Top edge, in the center, a small tear. Halfway down the left edge, a damage has been repaired. Lower right, an inscription in pen in a later hand: *A.V.Dyck.*

Watermark: not visible (laid down)

The Metropolitan Museum of Art, New York (inv. no. 1972. 118. 279)

Vey 188

PROVENANCE P. H. Lankrink (1628–1692), London (L.2090, lower right); Jonathan Richardson the Elder (1665–1745), London (L.2184, lower right); Thomas Hudson (1701–1779), London; Sir Joshua Reynolds (1723–1792), London (L.2364, lower left); Baron L.A. de Schwiter (1805–1889), Paris (L.1768, lower right); his sale, Féral, Paris, 20–21 April 1883, no. 31; F. Madrazo (1815–1894); Pierre Dubaut (b. 1886), Paris (L.2103b, verso of backing sheet); T. F. Ryan (b. 1851), New York (L.2431, lower left); Nathan Chaikin, New York; Walter C. Baker, New York; bequest of Walter C. Baker, 1971.

EXHIBITIONS Antwerp 1949, no. 103; Antwerp 1960, no. 108; *Flemish Drawings and Prints of the 17th Century*, New York, Metropolitan Museum of Art, 1970, no. 5.

LITERATURE Vey 1962, no. 188.

1. Alte Pinakothek. 1983 cat., no. 368. Glück 1931, 315.
2. Alte Pinakothek. 1983 cat., no. 367. Glück 1931, 314.

This is a study for the pose, costume, and hands of a full-length oil portrait of a woman, which is in Munich [fig. 2].[1] The hands are drawn separately, and on a far larger scale, on the top right-hand side of the sheet. In Munich there is also a companion portrait of the husband [fig. 1];[2] both of them date from towards the end of Van Dyck's second Antwerp period, or possibly from his stay in Flanders in 1634–1635. The costumes in this drawing and in the two painted portraits are certainly Flemish rather than English.

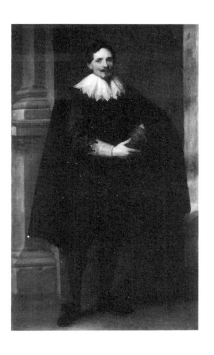

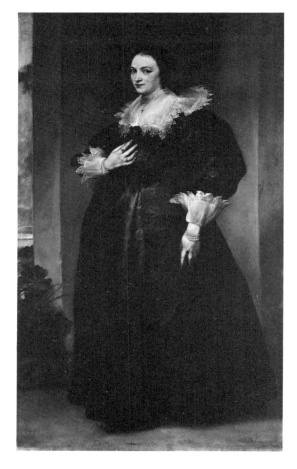

Fig. 1. Anthony van Dyck, *Portrait of a Man.* Canvas, 203 x 121 cm. Alte Pinakothek, Munich

Fig. 2. Anthony van Dyck, *Portrait of a Woman.* Canvas, 204 x 121 cm. Alte Pinakothek, Munich

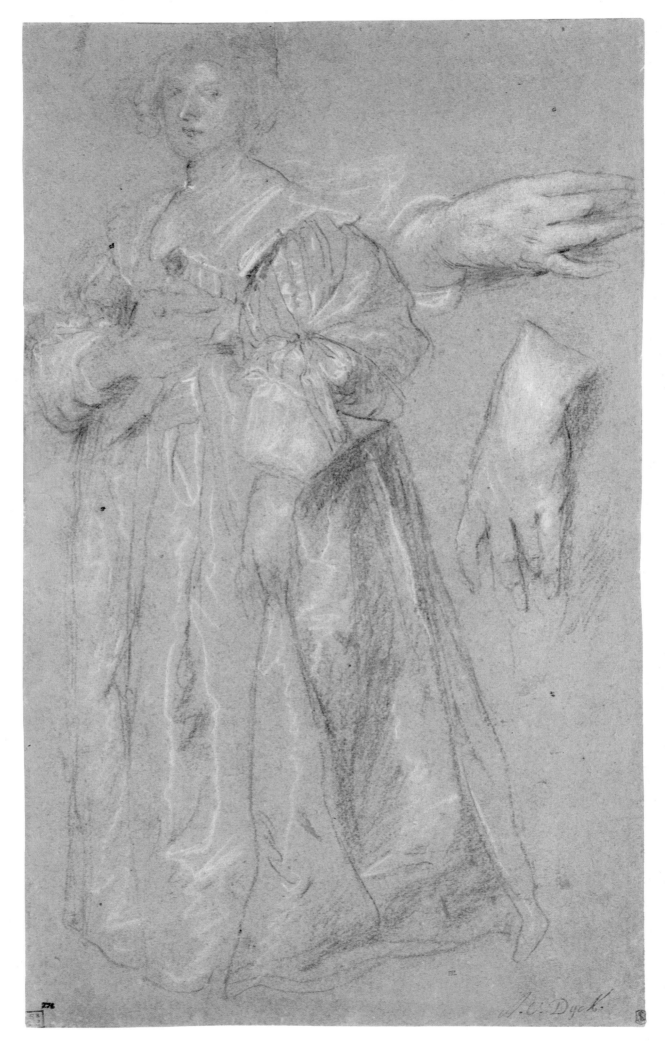

A Woman Looking Up

1634–1635

Black chalk, with white chalk highlights, on blue paper, 444 x 318 mm. There is a vertical fold in the sheet one quarter of the way from the left edge. The sheet is pasted down and the verso is not visible.

Watermark: not visible

Staatliche Museen Preussischer Kulturbesitz, Berlin, Kupferstichkabinett (KdZ 6524)

Vey 142

PROVENANCE J. Noll; his sale, Prestel, Frankfurt, 7–8 October 1912, no. 115.

EXHIBITION Antwerp 1960, no. 76.

LITERATURE Bock and Rosenberg 1930, 125, no. 6524; Winkler 1951, 142; Vey 1962, no. 142.

1. Hollstein 1949, VI, 129, no. 847.
2. Canvas, 153.5 x 254 cm. Glück 1931, 364; *Tesoros del Museo de Bellas Artes, Bilbao,* 1989–1990, no. 13, ill.
3. Hoogewerff 1949, 157–162, pl. 1.
4. Glück 1931, 365.
5. Glück 1931, 367. For the dating of the painting, see Monballieu 1973.

This is a study for the head and chest of the Virgin in *The Lamentation*, a composition engraved (in reverse) by Franciscus van den Wijngaerde [fig. 1].[1] There are a number of painted versions of this composition. One, which was formerly in the collection of the duke of Newcastle at Clumber, was recently purchased by the Museum of Fine Arts in Bilbao.[2] Others are in the Museum of Fine Arts in Boston, the Thuélin Collection in Paris, and the Kunstmuseum in Basle. In my view, judging on the basis of good photographs, the original is in a private collection in Rome [fig. 2].[3]

The strongly idealized head and the pose with eyes raised pleadingly to heaven display the powerful influence of Bolognese artists, especially of Guido Reni, whose work Van Dyck had studied during his years in Italy. The painting, horizontal in format and with grieving angels in addition to the Virgin and the Magdalen, is very similar in conception and in style to *The Lamentation* in the Alte Pinakothek in Munich [fig. 3], painted on panel and dated 1634[4] and also *The Lamentation* in Antwerp [cat. 80, fig. 1], which was painted for the Abbé Scaglia in 1635.[5] Both the painting and this drawing should therefore be dated to Van Dyck's stay in Flanders in 1634–1635.

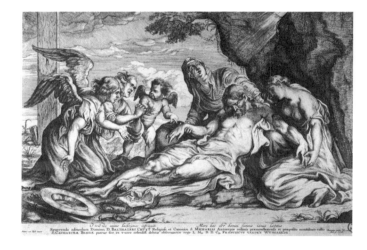

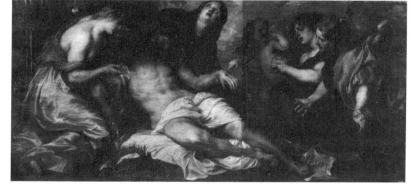

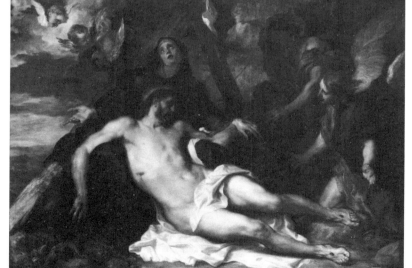

Fig. 1. Franciscus van den Wijngaerde, after Van Dyck, *The Lamentation.* Engraving

Fig. 2. Anthony van Dyck, *The Lamentation.* Canvas, 120 x 254 cm. Private collection, Rome

Fig. 3. Anthony van Dyck, *The Lamentation,* 1634. Panel, 108.7 x 149.3 cm. Alte Pinakothek, Munich

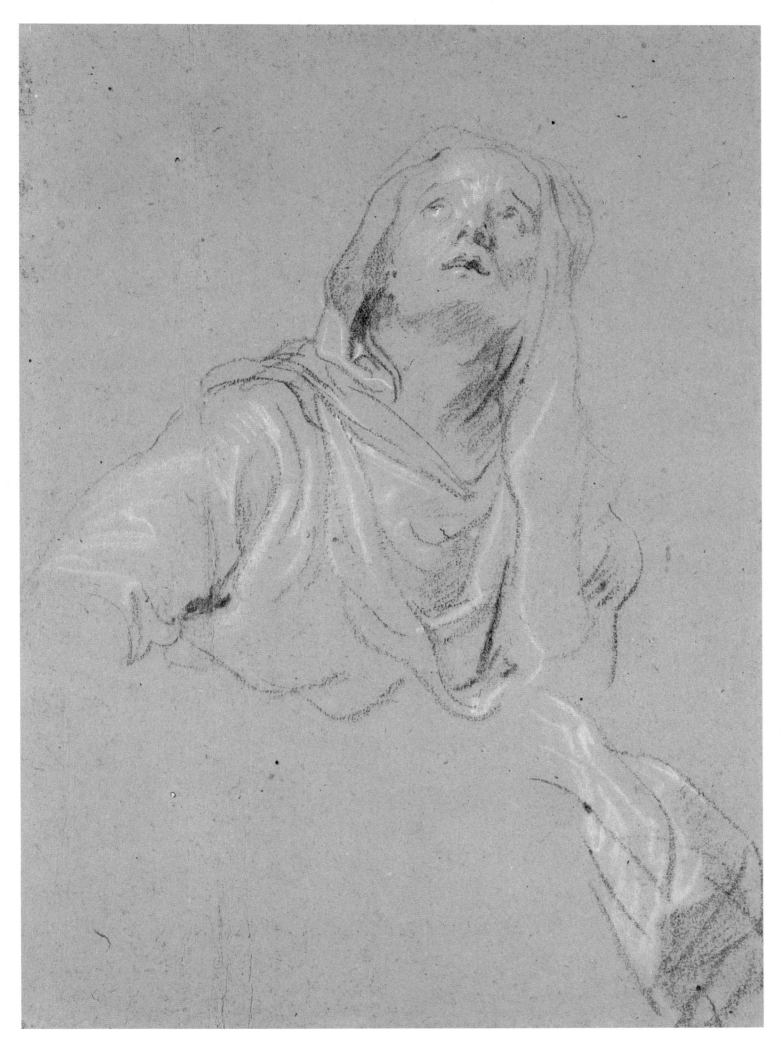

80
Study for the Dead Christ

1635

Black chalk, with white chalk highlights, on
gray-blue paper, 275 x 393 mm.

Watermark: not visible (laid down)

The Pierpont Morgan Library, New York
(inv. no. I, 243).

Vey 141

PROVENANCE Possibly in the sale of Samuel van
Huls, former burgomaster of The Hague; his sale,
The Hague, Swart, 14 May 1736, Album M, 17,
lot 535 ("Antoine van Dyck. Un Christ mort et un
St. Jerome"); William Young Ottley; possibly his
sale, London; T. Philipe, 11–14 April 1804, one of
three in lot 429 ("Dead Christ, black chalk, on blue
paper, heightened; St. John Preaching ...; and
another"); George William Reid (1819–1887),
London; his sale, George William Reid, Esq.,
F.S.A., late keeper of Prints and Drawings at the
British Museum, Sotheby's, London, 26 February–
1 March 1890, lot 585 (to Fairfax Murray for 6
shillings); Charles Fairfax Murray (1849–1919),
London; J. Pierpont Morgan.

EXHIBITIONS New York 1957, no. 93; Princeton
1979, no. 50; Paris 1979–1980, no. 33; New York
1981, no. 67.

LITERATURE Morgan 1905, I, no. 243; Vey 1962,
no. 141; Monballieu 1973, 263–264, fig. 10;
Stampfle 1991, no. 273.

1. Oil on canvas, 114 x 207 cm. Glück 1931, 367.
For the dating of the painting, the circumstances
of its commission and the altarpiece of the Seven
Sorrows, see Monballieu 1973. Washington
1990–1991, no. 79.
2. Glück 1931, 426; Monballieu 1973, 252, fig. 2;
Washington 1990–1991, no. 70. Scaglia was also
included in *The Iconography* in an engraving by
Pontius (Mauquoy-Hendrickx 1956, no. 64).
3. Glück 1931, 366; Martin 1970, no. 4889.
4. This was first suggested in Hoogewerff 1949,
160, and again in Princeton 1979, no. 50.

This is a study, perhaps made from a model posed in the studio, for the body of
Christ in *The Lamentation* which is today in the Museum at Antwerp.[1] The painting
was commissioned from Van Dyck in 1635 during his stay in Flanders by the Abbé
Cesare Alessandro Scaglia, who had been a diplomat in the service of the House of
Savoy. Scaglia's career ended when his fiercely anti-French policies caused him to
fall from favor. He retired for a time in Brussels and was an important patron of Van
Dyck during the years 1634–1635, commissioning from him a full-length portrait
[fig. 2][2] and a religious painting, *The Abbé Scaglia Adoring the Virgin and Child*
[Introduction, fig. 22],[3] in addition to *The Lamentation*.

 The Lamentation was part of an altarpiece, probably the predella, in the Chapel
of Our Lady of the Seven Sorrows in the Church of the Recollets in Antwerp. The
abbé retired to the church in September 1637 and was buried there in 1641. The
altarpiece was not installed in the chapel until 1637, and it has been suggested that
the painting was executed in England in 1636 or 1637 and sent back to Antwerp.[4]
Monballieu has argued, correctly in my view, that it is more likely that the painting
was made in 1635 when Scaglia was suffering from an extended illness which he
was not expected to survive. It was installed in the church later when Scaglia had
retired there. It is very close in composition and style to *The Lamentation*, dated 1634,
in Munich [cat. 79, fig. 3].

 In this drawing Van Dyck shows Christ's left arm in three alternative positions.
The original position was presumably the lowest, as this has white chalk heighten-
ing, which is then drawn over in black chalk by the two higher positions. Van Dyck
returned to this first position in the painting, in which Saint John is shown lifting
the arm to show the wound in the hand to two grieving angels. It is essentially a
study of the body from neck to knees. The head, which in the painting is heavily
bearded, is only indicated, and the ankles and feet are not shown.

Fig. 1. Anthony van Dyck, *The Lamentation*.
Canvas, 114 x 207 cm. Koninklijk Museum voor
Schone Kunsten, Antwerp

Fig. 2. Anthony van Dyck, *The Abbé Scaglia*.
Canvas, 200 x 123 cm. Collection of Viscount
Camrose

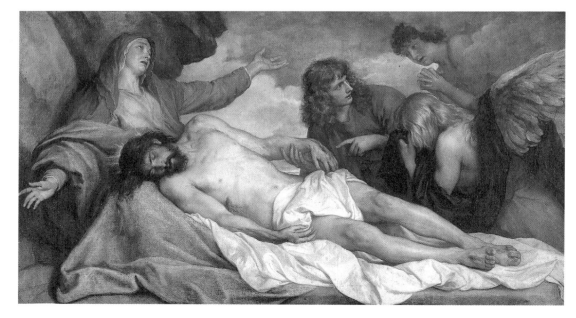

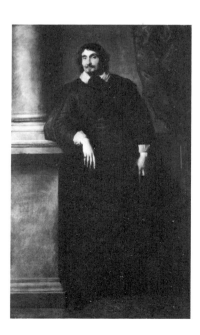

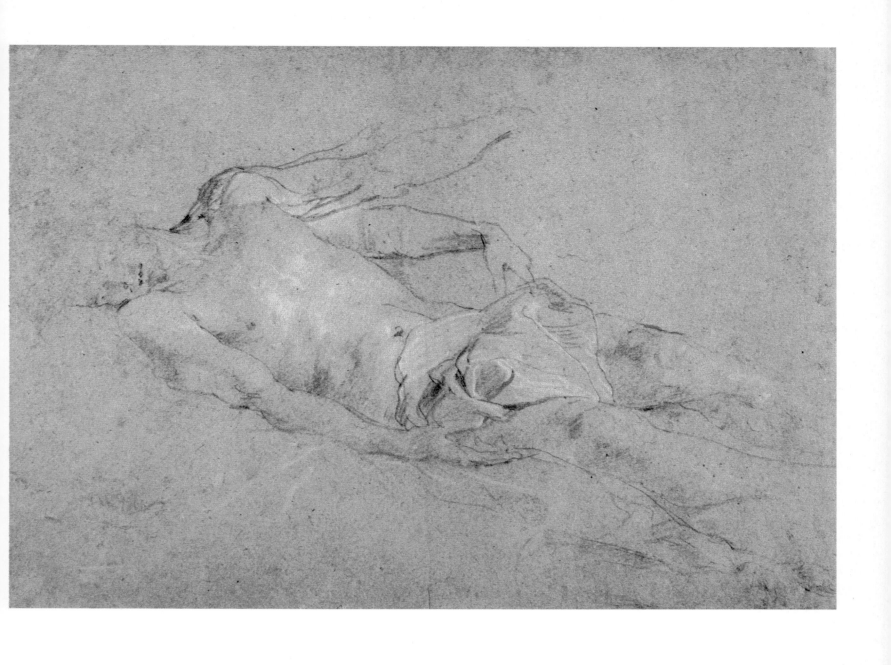

81
Thomas Howard, 2d Earl of Arundel

c. 1635–1636

Black chalk, with white chalk highlights, on green-gray paper. 480 x 356 mm. A horizontal and a vertical fold. Damage below his left hand. Lower left, an inscription in pen, in a later hand: *A.V.Dyck.*

Watermark: none

The British Museum, London, Department of Prints and Drawings (inv. no. 1854.5.13.16)

Vey 225

PROVENANCE Uvedale Price (1747–1829), Foxley; anon. sale, Sotheby's, London, 4 May 1854, lot 284; bought by W. B. Tiffin for the British Museum in 1854.

EXHIBITIONS London 1956–1957, no. 546; Antwerp 1960, no. 112; Oxford 1985, no. 10; London 1987A, no. 45.

LITERATURE Waagen 1857, 40; Rooses 1903, 139; Hind 1923, no. 53; Delen 1943A, pl. 21; Delen 1949, no. 32; *British Drawings*, I, no. 21; Vey 1962, no. 225.

1. For the life of Arundel and his patronage of the arts, see Hervey 1921, Howarth 1985, and Oxford 1985–1986.
2. Quoted by Hervey 1921, 175.
3. Alte Pinakothek, 1983 cat., no. 352. Oldenbourg 1921, 200.
4. Quoted by Hervey 1921, 176.

Thomas Howard, 2d earl of Arundel (1586–1646), Earl Marshal, was a prominent member of the court and one of the leading English collectors of the day. He was later to be called by Horace Walpole "the Father of *Vertu* in England."[1] At James I's court, Arundel was a member of the cultivated and highly sophisticated circle around Henry, Prince of Wales. He was an artistic mentor to the prince, whose tastes in turn were influential on those of his younger brother Charles, who ascended the throne as King Charles I in 1625. In 1616 Arundel had been admitted to the Privy Council and in 1621 was created Earl Marshal (an office traditionally vested in his family of which his father had been stripped), which carried with it responsibility for all court ceremonial.

Arundel formed a remarkable collection of paintings and antiquities using his wife's large fortune—she was the heiress of the earl of Shrewsbury—as well as his own. When Rubens was in England in 1629, he expressed his astonishment at the riches of the collection: he was reported to have described the earl as "one of the four Evangelists and a great upholder of our art."[2] At the houses in London and Sussex which bore his name, Arundel gathered scholars and artists around him. The philosopher and antiquarian Franciscus Junius of Heidelberg served as his librarian and wrote his famous study of classical painting, *De Pictura Veterum*, published in 1637, while in Arundel's household. Among the artists who enjoyed Arundel's patronage were Inigo Jones [cat. 72] and Daniel Mytens, born in Delft in about 1590, who had moved from The Hague to London at Arundel's request by 1618.

Van Dyck was in Rubens' studio when Lady Arundel was in Antwerp and had her portrait painted by Rubens [fig. 1].[3] In that portrait, the man who stands behind her is probably Francesco Vercellini, the earl's Venetian secretary, and in a letter of 17 June 1620 the secretary wrote to the earl that "Van Dyck is still with Signor Rubens and his works are hardly less esteemed than those of his master. He is a young man of twenty-one years, his father and mother very rich, living in this town, so that it will be difficult to get him to leave these parts, especially since he sees the good fortune that attends Rubens."[4] Van Dyck did, however, come to England

Fig. 1. Peter Paul Rubens, *Alatheia Talbot, Lady Arundel*. Canvas, 261 x 265 cm. Alte Pinakothek, Munich

Fig. 2. Anthony van Dyck, *Thomas Howard, 2d Earl of Arundel*. Canvas, 113 x 80 cm. The J. Paul Getty Museum, Malibu

Fig. 3. Anthony van Dyck, *The Earl of Arundel with His Grandson, Lord Maltravers*. Canvas, 144.8 x 119.4 cm. Collection of the Duke of Norfolk, Arundel Castle, Sussex

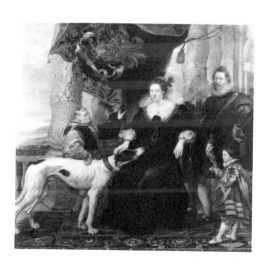

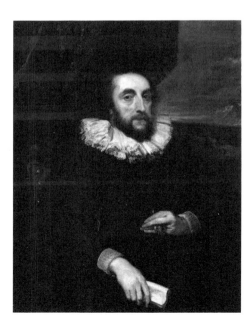

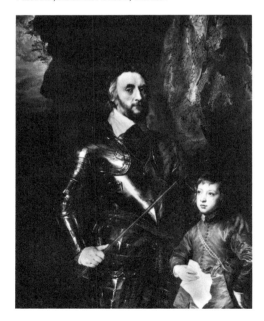

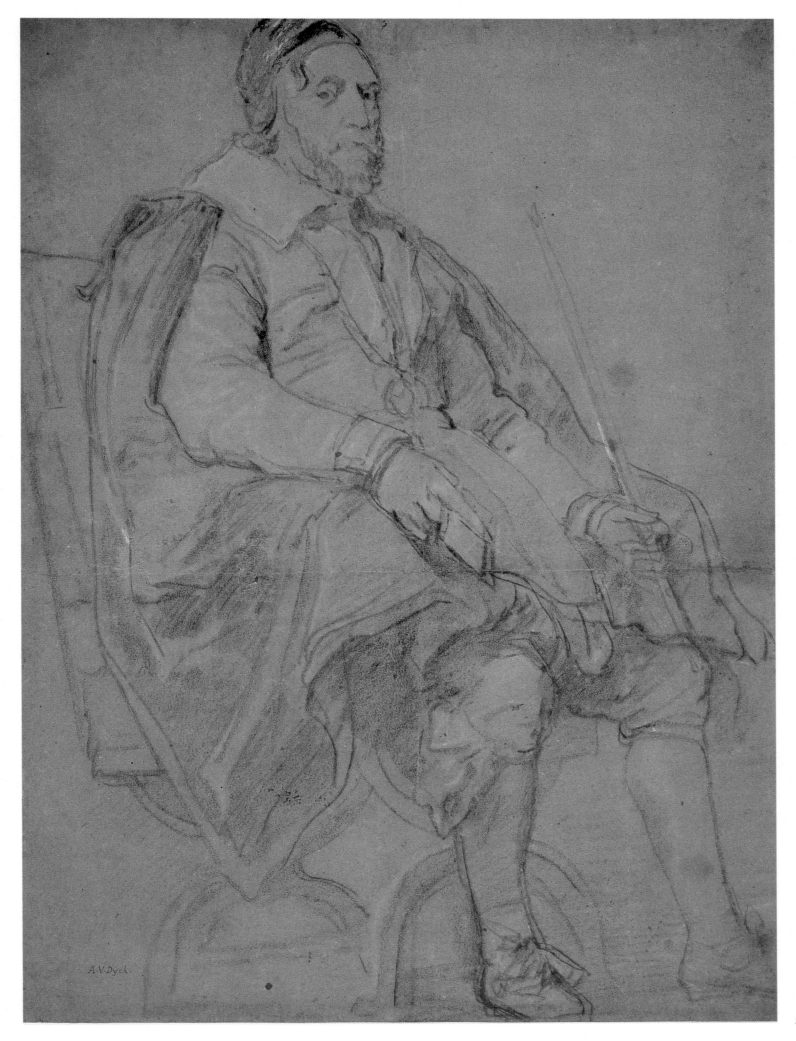

A.V.Dyck.

257

5. Howarth 1990.
6. Glück 1931, 124; London 1982–1983, no. 2.
7. For Van Dyck's itinerary in Italy, see Brown 1982, 61ff.
8. Glück 1931, 473; Washington 1990–1991, no. 76.
9. Oil on canvas, 139.7 x 212.7 cm. Collection of the duke of Norfolk, Arundel Castle. Glück 1931, 472 (illustrating the version in Vienna); London 1982–1983, no. 59.
10. Watercolor, 39.8 x 62.8 cm. Dated 1643 and inscribed *An. VANDYKE Inv*, private collection. London 1972, no. 134; Oxford 1985–1986, no. 11. (This is a copy, in oil on copper, in the collection of the duke of Norfolk at Arundel Castle.)
11. Inv. no. 563, cat. no. D.IX.22. This seventeenth- or early eighteenth-century drawing is certainly not by Van Dyck but may record a lost composition by him. See discussion in Vey 1962, 296, and Rowlands 1970. The drawing in the British Museum published by Rowlands is not, in my view, by Van Dyck.

shortly afterwards, apparently at the invitation not of Arundel but of Viscount Purbeck.[5]

Of the three paintings that can be satisfactorily placed in Van Dyck's English period, one is the bust-length portrait of Arundel, which is now in the Getty Museum [fig. 2].[6] Arundel was responsible for obtaining for Van Dyck his "passe to travaile for 8 months" in February 1621, which allowed him to leave England and, after a stay in Antwerp, go to Italy. Once arrived in Italy in the late summer of 1622, Van Dyck joined the entourage of Lady Arundel in Venice. He remained with her until March 1623, when she left Turin on her way to Genoa to begin the journey back to England.[7] It is hardly surprising, therefore, that Van Dyck painted several portraits of the earl and his family during his second English period. These include the tender *Portrait of the Earl of Arundel with His Grandson, Lord Maltravers* [fig. 3],[8] painted in about 1635, and the so-called "Madagascar Portrait" of the earl and countess, painted in 1639.[9]

In this drawing Arundel is shown seated in an armchair, wearing a cap, with his rod of Earl Marshal in his hand. He is seen from below, as if raised on a dais or at the top of a flight of steps. It appears that Van Dyck was working on an ambitious family portrait of the earl and his family in about 1635–1636, but the details of the composition are unknown. It has been claimed that the composition is shown in a watercolor of 1643 by Philip Fruytiers,[10] but it is unlikely that Van Dyck was responsible for such a clumsy composition. It is more likely that a drawing in the Stedelijk Prentenkabinet in Antwerp preserves the general arrangement of this family portrait [fig. 4],[11] although there Arundel is seen seated facing the viewer directly, his head bent slightly to the right to receive a paper from Lord Maltravers. It is probable that the present drawing was made, from life, in connection with this plan for a large-scale portrait of the earl and countess, their children and grand-children.

Fig. 4. After Anthony van Dyck (?), *The Earl of Arundel and His Family*. Pen and brown ink, with brown wash, 220 x 311 mm. Stedelijk Prentenkabinet, Antwerp

82
A Child, Full-Length, at Its Mother's Knee

c. 1635–1637

Black chalk, with white chalk highlights, on blue paper, 422 x 268 mm. Lower left: L.2184; L.2432; L.2364.

Verso: two studies of forearms. Black chalk. Inscription, in pen, lower left: *A.V.Dyck.*

National Gallery of Canada, Ottawa
(inv. no. 30953)

[Not in Vey]

PROVENANCE Jonathan Richardson the Elder (1665–1745), London (L.2184, lower right); Thomas Hudson (1701–1779), London (L.2432, lower left); Sir Joshua Reynolds (1723–1792), London (L.2364, lower left); anon. sale, Christie's, London, 3 April 1984, lot 96; Luca Baroni, Colnaghi's, London; purchased by the National Gallery of Canada, 1990.

1. Quoted above, Introduction, p. 35.

This fine black chalk drawing, which has recently come to light, is a study for the figure of a child, presumably standing at its mother's knee, in a double or family portrait from Van Dyck's English period. No painting that includes this figure is known, and the work may not have been carried out. On grounds of style, this sheet should be dated around 1635–1637.

On the verso are two studies of powerful forearms, presumably made from a male model in the studio. They do not appear to be related to any known painting from the English period. De Piles notes that, according to Jabach, "as far as the hands are concerned, he had in his studio people in his employ of both sexes who served as models."[1]

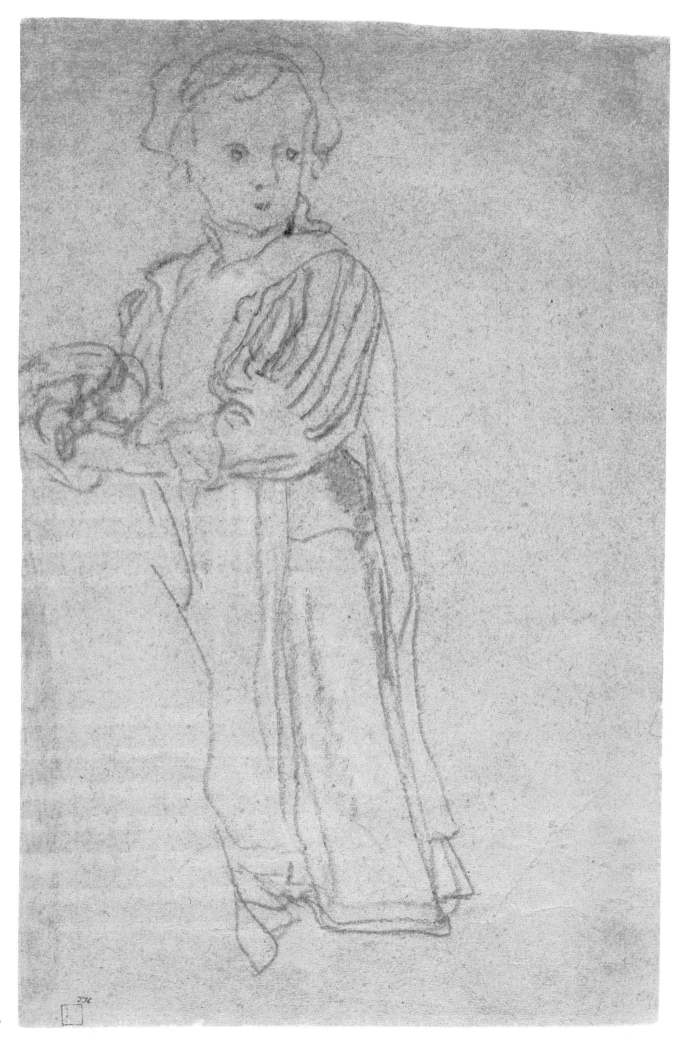

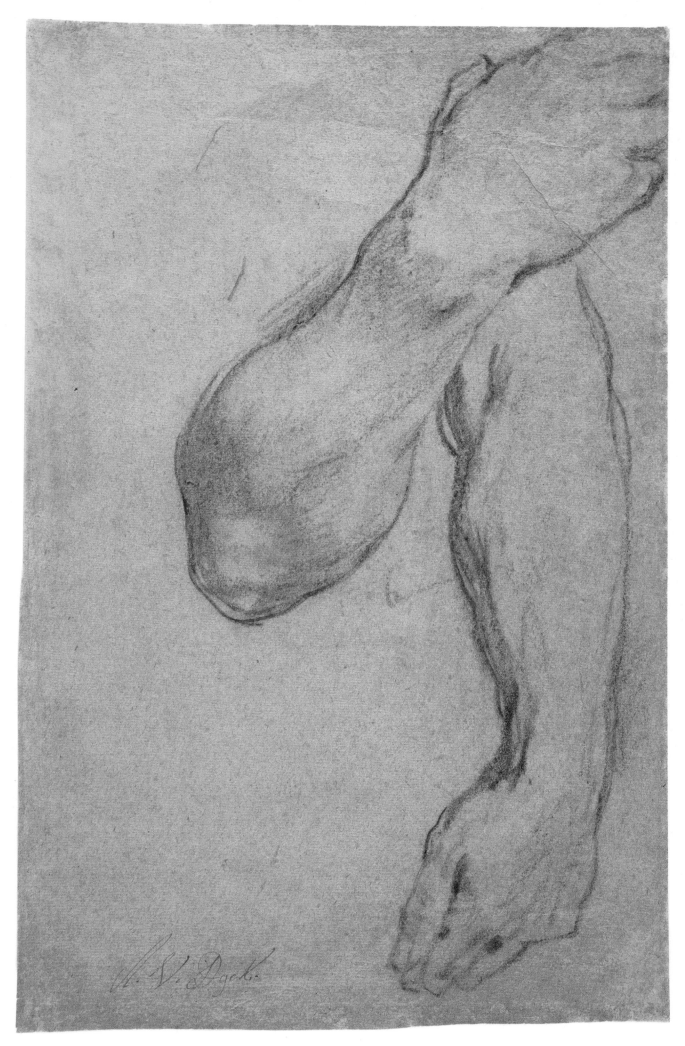

83
Lady Anne Wentworth

c. 1636–1637

Black chalk, with white chalk highlights, on light brown paper, 347 x 229 mm. Top left-hand corner damaged and restored. Lower right: L.1958.

Watermark: not visible (laid down)

The Victoria and Albert Museum, London (inv. no. D–908–1900)

Vey 237

PROVENANCE Bequeathed by Miss Emily F. Dalton to the Victoria and Albert Museum (L.1958, lower right) in 1900.

EXHIBITIONS Antwerp 1960, no. 116; London 1982–1983, no. 73.

LITERATURE Reitlinger 1921, no. 81; Wortley 1931, 103–107; *Portrait Drawings*, Victoria and Albert Museum, London, 1953, pl. 7; Vey 1962, no. 237.

1. As Millar notes in London 1982–1983, this family portrait has been largely neglected in the literature since Wortley's 1931 article (see also the letter from C. H. Collins Baker in the *Burlington Magazine* 59, 1931, 254). It appears to be for the most part by Van Dyck himself, and the existence of two preparatory drawings by him supports this idea.

This is a study for the figure of Lady Anne in the *Portrait of the Cleveland Family* at Wrotham Park [fig. 1],[1] which was painted in about 1636–1637. Lady Anne Wentworth (1623–1697) was the daughter of Thomas Wentworth, earl of Cleveland. In July 1638, at the age of fifteen, she married John Lovelace, 2d Baron Lovelace of Hurley.

There is a second preparatory drawing for this family portrait, for the figure of Anne Crofts, countess of Cleveland, Lady Anne's mother [fig. 2].

Fig. 1. Anthony van Dyck, *Thomas Wentworth, Earl of Cleveland and His Family*. Canvas, 150 x 246 cm. Private collection

Fig. 2. Anthony van Dyck, *Anne Crofts, Countess of Cleveland*. Black chalk, with white chalk highlights, on light brown paper, 451 x 286 mm. The British Museum, London (Vey 236)

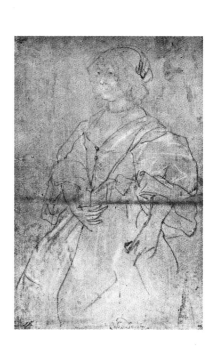

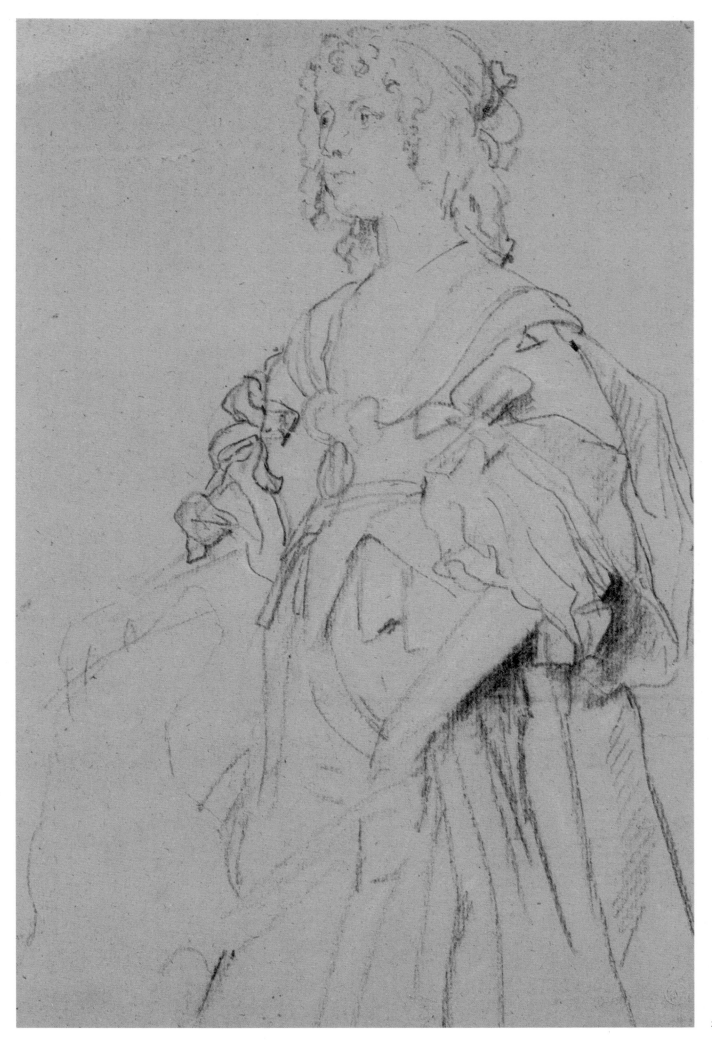

James II as Duke of York

1637

Black chalk, with white chalk highlights, on blue paper, 445 x 333 mm. Torn and repaired at top edge. A horizontal fold in the center. Inscribed on the mount, in Richardson's hand: *Van Dyck*, and again in a later eighteenth-century hand to the right. On the back of the mount is the number 21, presumably Richardson's shelf mark.

Watermark: not visible (laid down)

Christ Church, Oxford (JBS 1386)

Vey 239

PROVENANCE Jonathan Richardson the Elder (1665–1745), London (L.2184, lower right); J. Guise (1682/1683–1765), Oxford; bequeathed by him to Christ Church (L.2754, on the mount).

EXHIBITIONS Antwerp 1960, no. 117; London 1972, no. 116; London 1982–1983, no. 75.

LITERATURE Passavant 1836, 2, 140; Waagen 1854, 3, 49; Bell 1914, 43 (as Princess Mary); Vey 1962, no. 239; Millar 1963, 99; Byam Shaw 1976, no. 1386.

1. Glück 1931, 385; Millar 1963; London 1982–1983, no. 26.
2. Glück 1931, 384; London 1982–1983, no. 27; Washington 1990–1991, no. 101.

This is a study from life for the figure of James II (1633–1701), when duke of York, for the group portrait in the Royal Collection, *The Five Eldest Children of Charles I* [fig. 1], painted in 1637,[1] which originally hung in the king's breakfast chamber at Whitehall. On the top right-hand side of the sheet, Van Dyck has drawn, on a larger scale, the child's head. The duke, who was born on 14 October 1633, has not yet, unlike his older brother Charles, started to wear breeches and is shown in the painting wearing an orange petticoat. In the painting the duke folds his hands across his stomach. There is a drawing for the figure of the Prince of Wales in the painting [fig. 2] and, unusually, a study in oil on canvas for Princess Elizabeth and Princess Anne, the two youngest children [fig. 3].[2] This marvelously animated painting is presently on loan to the National Gallery of Scotland at Edinburgh.

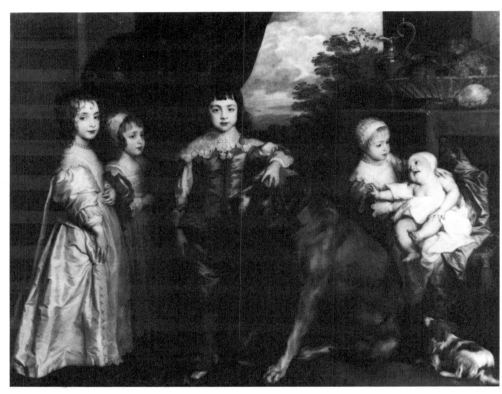

Fig. 1. Anthony van Dyck, *The Five Eldest Children of Charles I*. Canvas, 133.4 x 151.8 cm. Collection of Her Majesty Queen Elizabeth II

Fig. 2. Anthony van Dyck, *Charles II as Prince of Wales*. Black chalk on blue paper, 462 x 305 mm. Collection of Her Majesty Queen Elizabeth II, Royal Library, Windsor Castle (Vey 238)

Fig. 3. Anthony van Dyck, *Princess Elizabeth and Princess Anne*. Canvas, 30 x 42 cm. British Rail Pension Fund, on loan to the National Gallery of Scotland, Edinburgh

Landscape Drawings and Watercolors

1. References to these inventory mentions are given in Vey 1962, 52.
2. One is on fol. 1 and is illustrated in Adriani 1940. There are also two further drawings, a seascape and a landscape, on fol. 84v and 95v of the Italian sketchbook, which are not illustrated by Adriani, who considered them to be by a later hand. Following Vey (1962, 52), I believe them to be by Van Dyck himself.
3. Vey 1962, no. 282.
4. Ibid., nos. 283–286. Vey considers that no. 285 (which is in the Kunsthalle, Hamburg) is a copy, but in my view this sheet (which bears Flinck's mark) could well be by Van Dyck himself. Haverkamp-Begemann informs me that he too considers this drawing to be by Van Dyck.
5. Vey 1962, nos. 284, 285, and 286.
6. Ibid., no. 283. It is signed in the bottom right-hand corner and dated 162 (the final digit has been cut off).
7. Ibid., no. 287. This drawing was sold at Sotheby's, London, 21 March 1973, no. 8, ill., and is now in the Bibliothèque Royale, Brussels.
8. Washington 1990–1991, no. 62.
9. Adler 1982, no. 19.
10. Ibid., no. 58.
11. Ibid., no. 57.
12. See the discussion under cat. 86.
13. A. Wied, "Lucas van Valckenborch," *Jahrbuch der Kunsthistorischen Sammlungen in Wien* 67 (1971), 119–231.
14. There is a group of landscapes in bodycolor on blue paper, six of which bear old inscriptions attributing them to Van Dyck. Two of this group, in the Yale University Art Gallery, are inscribed *Wouters*, and a third, in the British Museum, is inscribed on the old mount: *I. Rademaker fecit.* The attribution of this group has been much discussed. Hind 1923, nos. 86–87, and Oppé 1941 considered them to be by Van Dyck, but this was correctly rejected by Vey 1962, nos. 56–57. Held 1964, 566, suggested an attribution to Frans Wouters, whose name is on the Yale sheets. Wouters was in England between 1637 and 1641 and came under the influence of Van Dyck. (The most recent discussion, which summarizes the previous arguments, is in London 1987, no. 59, cat. 85.)

Landscape was not a major preoccupation of Van Dyck, and no painted landscapes by him survive, although a number are recorded in early inventories.[1] There are, however, a small group of landscape drawings and watercolors that appear to date from the last decade of his life. With the exception of those like cats. 73 and 74, which are dated or can be documented to a particular year, they are very difficult to date with any degree of precision and have been grouped together in this section of the catalogue.

Van Dyck had little interest in landscape in the earlier part of his career. There are no landscape drawings from his first Antwerp period, and from the Italian years, we possess only a few, very slight drawings in the Italian sketchbook[2] and one sheet which bears the inscription *fuori di Genova/quarto* in Van Dyck's hand and has been identified as a view of the village of Quarto dei Mille near Genoa [fig. 1].[3] There is a small group of three or four drawings from his years in Antwerp after his return from Italy.[4] These are disparate, including two (or three) which are very Flemish in character [figs. 2, 5],[5] and another which if it were not signed would probably not be attributed to Van Dyck [fig. 3]. Its striking composition, long, curling pen lines and very bold application of wash recall Bolognese landscape drawings rather than those made in Antwerp in the 1620s.[6]

In 1632 Van Dyck made the delicate and precise pen drawing of Antwerp viewed from across the Scheldt [fig. 4].[7] His remaining landscape drawings and watercolors can be usefully divided into three groups. There are the topographically accurate views—"del naturale," as he wrote on one [cat. 73]—notably the pen drawings of the town of Rye in Sussex and its medieval buildings. These caught Van Dyck's eye as he waited to cross the Channel. Secondly, there are the studies of individual motifs in nature, like a clump of plants [cat. 85], a group of farm buildings [cat. 86] or two entwined trees [cat. 87]. These drawings may well have been made with a view to incorporating the motifs into the background of portraits or history paintings. Finally, there is a small group of watercolors of extensive landscapes and trees [cats. 89, 90]. These also possess certain similarities to backgrounds in paintings: for example, the trees which can be seen above Henrietta Maria's hand as she presents the king with a laurel wreath in the double portrait at Kroměříž[8] are very like those in his watercolors [cats. 89, 91]. Equally, they may have been done for their own sake, in response to the beauty of the countryside.

In landscape, as in every other aspect of his art, Van Dyck's great mentors were Rubens and Titian. It may well have been Rubens' renewed interest in landscape in the early 1630s that prompted Van Dyck's fascination with the subject. The *Landscape with Rocky Paths* in the British Museum [fig. 5], Van Dyck's only landscape containing prominent foreground figures, recalls Rubens' *Landscape with a Cart* in Leningrad[9] and the related paintings in Rotterdam[10] and London [fig. 6].[11] This was not, however, a direction which Van Dyck was to follow.

Van Dyck had carefully studied Venetian landscape drawings and prints, particularly those by Titian and Giulio and Domenico Campagnola.[12] The beautiful pen drawing of farm buildings on the edge of a wood in the British Museum [fig. 7] and another, also in pen, of farm buildings on the side of a gentle slope with an extensive vista in the background [cat. 86] are powerfully influenced by Venetian drawings showing bucolic foreground figures set off against a backdrop of picturesque half-timbered farm buildings.

Van Dyck's greatest contribution to the depiction of landscape was, however, in his few watercolors. Watercolor is a technique used by landscape artists in Flanders and Germany in the late sixteenth century: Lucas van Valckenborch (c. 1535–1597) was a notable exponent.[13] Van Dyck, however, handled the technique with a new boldness and immediacy and these landscape watercolors, unique at the time both in their technique and in the freshness of their vision, were to be very influential on the development of what was in the eighteenth and nineteenth centuries to become a peculiarly English art form.[14]

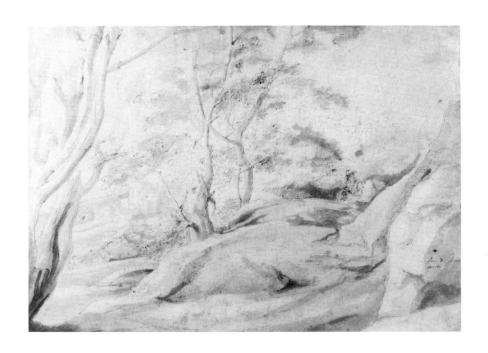

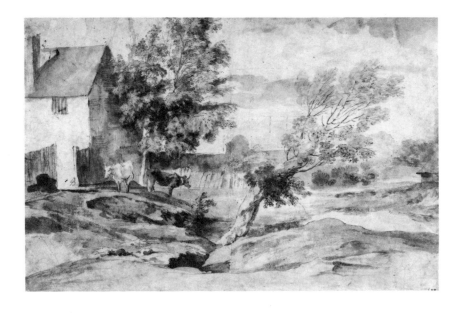

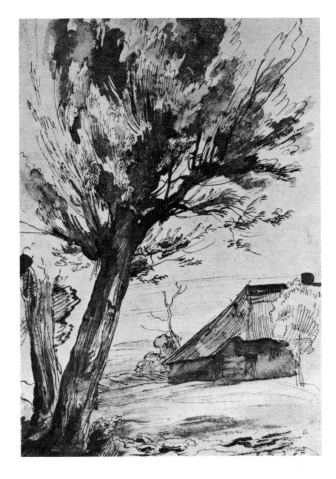

Fig. 1. Anthony van Dyck, *Landscape near Genoa*. Pen and brown ink and point of brush, with brown and gray wash, 273 x 370 mm. Collection of Her Majesty Queen Elizabeth II, Royal Library, Windsor Castle
(Vey 282)

Fig. 2. Anthony van Dyck, *Farm Buildings in a Meadow*. Pen and brown ink, with brown wash and brown, green, and blue watercolors, 280 x 406 cm. The British Museum, London (Vey 284)

Fig. 3. Anthony van Dyck, *Landscape with Farm Buildings*. Pen and brown ink, with brown wash, 297 x 198 mm. Private collection, Switzerland
(Vey 283)

267

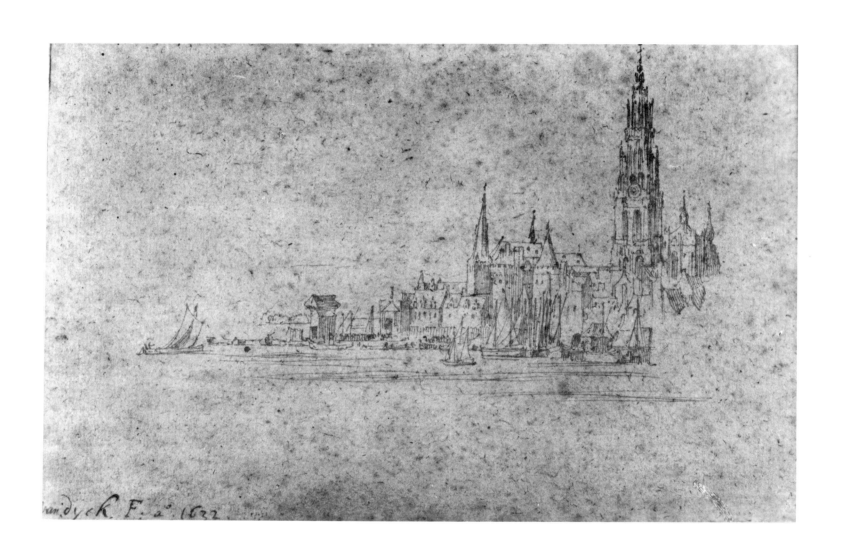

Fig. 4. Anthony van Dyck, *Antwerp, Seen from Across the Scheldt*, 1632. Pen and brown ink, with brown wash, on gray paper, 152 x 228 mm. Bibliothèque Royale, Brussels (Vey 287)

268

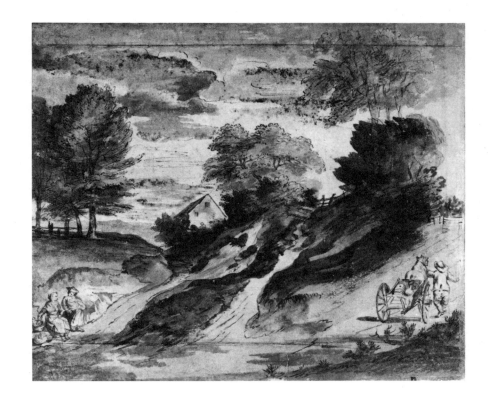

Fig. 5. Anthony van Dyck, *Landscape with Rocky Paths*. Point of brush, with green, blue, and brown watercolors and pen with brown ink and brown wash, 237 x 277 mm. The British Museum, London (Vey 286)

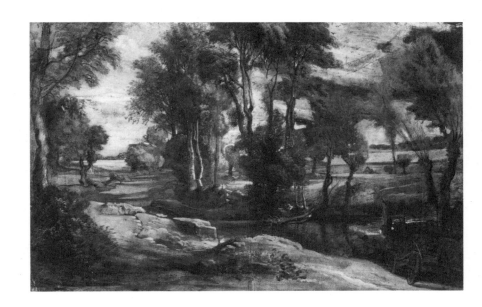

Fig. 6. Peter Paul Rubens, *A Wagon Fording a Stream*. Black chalk and oil on paper, backed on canvas, 46.5 x 70 cm. National Gallery, London

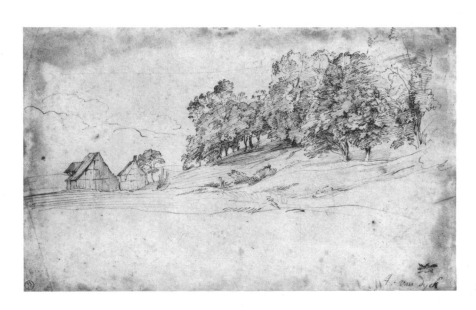

Fig. 7. Anthony van Dyck, *A Wooded Slope with Farm Buildings*. Pen and brown ink, 189 x 299 mm. The British Museum, London (Vey 293)

85
Plant Studies

1630–1641

Pen with brown ink and brown wash, 213 x 327 mm. Lower right-hand corner, an inscription, in pen, in Van Dyck's own hand: *A. vandijck.* At the top on the right, also in pen, is an inscription in Flemish identifying the plants: *on bord cron semel / soufissels nettels gras trilegras / nyghtyngale on dasy / foerren.*

Watermark: a bunch of grapes

The British Museum, London, Department of Prints and Drawings (inv. no. 1885.5.9.47)

Vey 296

PROVENANCE Jonathan Richardson the Elder (1665–1745), London (L.2184, lower right); W. Russell (1800–1884), London (L.2648, lower right).

EXHIBITIONS London 1877–1878, no. 1014; London 1949–1950, no. 37; London 1982–1983, no. 84; London 1987, no. 55.

LITERATURE Hind 1923, no. 85; *British Drawings*, I, no. 34; Vey 1962, no. 296.

1. The plants were identified, with expert opinion which he acknowledges, by Vey.
2. The other drawing [fig. 1] is a study of oak leaves, needle furze, and *Mercurialis annua.*
3. Glück 1931, 377.
4. In London 1982–1983.
5. Glück 1931, 463; Washington 1990–1991, no. 87.

The inscription is certainly seventeenth-century and may be in Van Dyck's own hand. It is a mixture of Flemish and English, as if written by a Flemish speaker with a shaky grasp of English. It reads: *on the edge*, and then identifies the varieties of plants: greater celandine (probably the leaves on the far left), *Chelidonium maius* or corn sowthistle; *Sonchus arvensis*, (the large thorny leaves in the center foreground); stinging nettle, *Urtica dioica*, the plants in the background; grass; quaking-grass, *Briza media* (the blades of grass in the foreground?); herb Robert, *Geranium robertianum* (which cannot, however, be identified firmly in the drawing); daisy, *Bellis perennis* (on the right at the top); lady fern, *Athyrium filix femina* (lower right).[1]

This is one of only two known studies of plants by Van Dyck [fig. 1].[2] He often included groups of plants in the foreground of portraits during his second Antwerp and English periods. For example, the *Roi à la Ciasse* [cat. 89, fig. 1][3] contains plants in the foreground. They include on the left, as Millar pointed out,[4] what is probably a common burdock, *Arctium pubens*, repeated in almost exactly the same form (and also on the left) in the *Portrait of the Duke of Hamilton* [fig. 2].[5] This suggests that Van Dyck had a group of drawings which formed a pattern book for plants which he introduced into portraits to suggest the countryside and provide visual incident in the foreground.

Vey tentatively dated this sheet to the first half of the 1630s because of the mingling of languages, but it could equally well have been made a few years later.

Fig. 1. Anthony van Dyck, *Plant Studies.* Pen and brown ink, with brown wash over black chalk with gray wash, 169 x 144 mm. Fondation Custodia (Coll. F. Lugt), Institut Néerlandais, Paris (Vey 297)

Fig. 2. Anthony van Dyck, *The Duke of Hamilton.* Canvas, 218.4 x 129.5 cm. Collection of the Prince of Liechtenstein, Vaduz

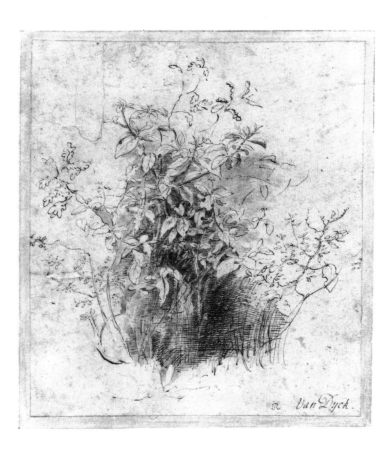

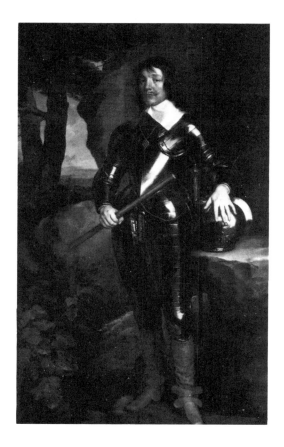

86
Landscape with Farm Buildings

1632–1641

Pen with brown ink, 222 x 322 mm (the sheet has been trimmed unevenly).

On the verso of the backing sheet is the inscription in pen: *no. 278*, and at the top right is an old inscription in Italian giving Van Dyck's dates and places of birth and death.

Watermark: none

Private collection

Vey 300

PROVENANCE Baron Milford (1744–1823), Haverford, Pembrokeshire (L.2687, in the center of the verso of the backing sheet); Sir John Philipps, Bart. (d. 1949), Haverford, Pembrokeshire; Dr. and Mrs. Francis Springell, Portinscale, Cumberland; Hazlitt, Gooden and Fox, London.

EXHIBITIONS London 1953A, no. 285; London 1953–1954, no. 489; London 1959, no. 44; Antwerp 1960, no. 105; Edinburgh 1965, no. 30; *English Drawings*, Hazlitt, Gooden and Fox, London 1990, no. 1.

LITERATURE Vey 1962, no. 300.

This landscape is very carefully composed, with the tree in the foreground balancing the buildings farther away on the right, yet in its individual parts it appears to be based on direct observation. Van Dyck must have combined these two elements with a painting in mind, perhaps intending to place this scene in the background of a portrait. The composition, with its foreground gnarled tree trunk and the distant view of farm buildings, strongly recalls landscape drawings by Titian [fig. 1] and Domenico Campagnola [fig. 2].

According to Vey, Burchard considered that this sheet belonged with the views of Rye [cats. 73 and 74] of 1633 and 1634. The technique, however, is not strikingly similar, and the looseness of the draughtsmanship might suggest a date later in the 1630s.

Fig. 1. Titian, *Wooded Cliff with Distant Houses.* Pen and brown ink, 248 x 267 mm. National Gallery of Scotland, Edinburgh

Fig. 2. Domenico Campagnola, *Landscape with Two Boys.* Pen and brown ink, 182 x 272 mm. The British Museum, London

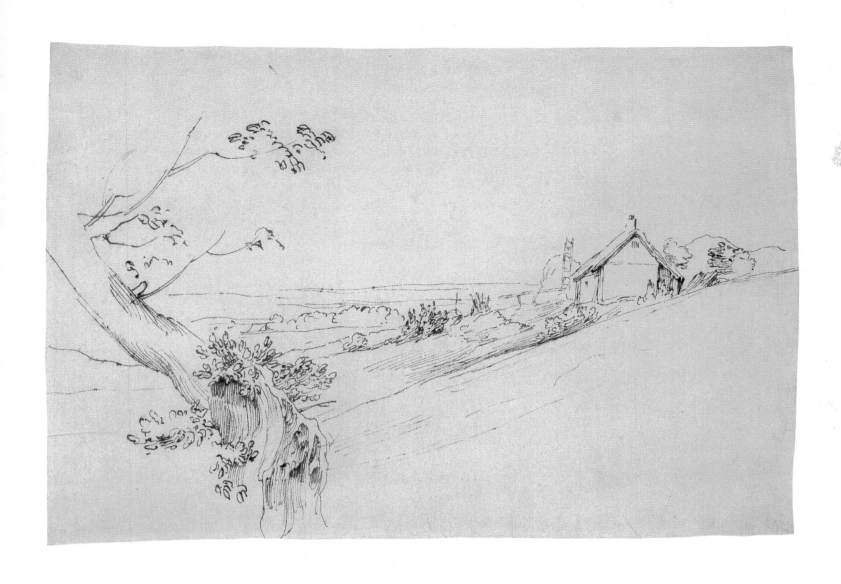

87
Two Entwined Trees

1632–1641

Pen with brown ink, with watercolor wash, 278 x 360 mm. Cut at the top edge. Lower left, an inscription in pen by a later hand: *A.V.Dyck.*

Watermark: none

Collection of the Prince of Liechtenstein, Vaduz

Vey 301

PROVENANCE Sir Joshua Reynolds (1723–1792), London (L.2364, lower left); W. Mayor (d. 1874), London (*A brief chronological description of a collection of original drawings ... formed by the late William Mayor ...,* London, 1875, no. 441) (L.2799, lower right); Dr. A. Stix (b. 1882), Vienna (L.2317a, verso, lower left); Anton Schmid (b. 1904), Vienna (L.2330b, lower left).

EXHIBITION Antwerp 1960, no. 106.

LITERATURE Vey 1957, 206; Vey 1962, no. 301.

1. Berlin 1975, nos. 41–49. These drawings were reattributed to Pieter Bruegel the Elder by Arndt (K. Arndt, "Pieter Brueghel d. Ä. und die Geschichte der Waldlandschaft," *Jahrbuch der Berliner Museen* 14, 1972, 69–121).
2. In portraying the complex patterns made by the roots and branches of trees, Savery worked in a Bruegelian tradition. See, for example, Spicer 1979, nos. C56, E1 and E44.
3. Staatliche Kunstsammlungen (inv. no. GK123). Glück 1931, 303.

This delicate study of two intertwined trees recalls drawings and etchings of forest landscapes by Pieter Bruegel the Elder [fig. 1][1] and Roelandt Savery [fig. 2].[2] While Van Dyck's choice of this motif may have been influenced by those artists, the drawing would seem to have been made from nature. As far as we are aware, this drawing was not used in a painting by Van Dyck, although a similar motif can be found in the background of the *Portrait of Sebastian Leerse with His Wife and Son* in Kassel [fig. 3].[3]

Fig. 1. After Pieter Bruegel the Elder, *Forest Landscape with Wild Animals.* Pen and brown ink, 346 x 258 mm. The British Museum, London

Fig. 2. Roelandt Savery, *The Uprooted Tree.* Etching. The British Museum, London

Fig. 3. Anthony van Dyck, *Sebastian Leerse with His Wife and Son.* Canvas, 110 x 162 cm. Staatliche Kunstsammlungen, Kassel

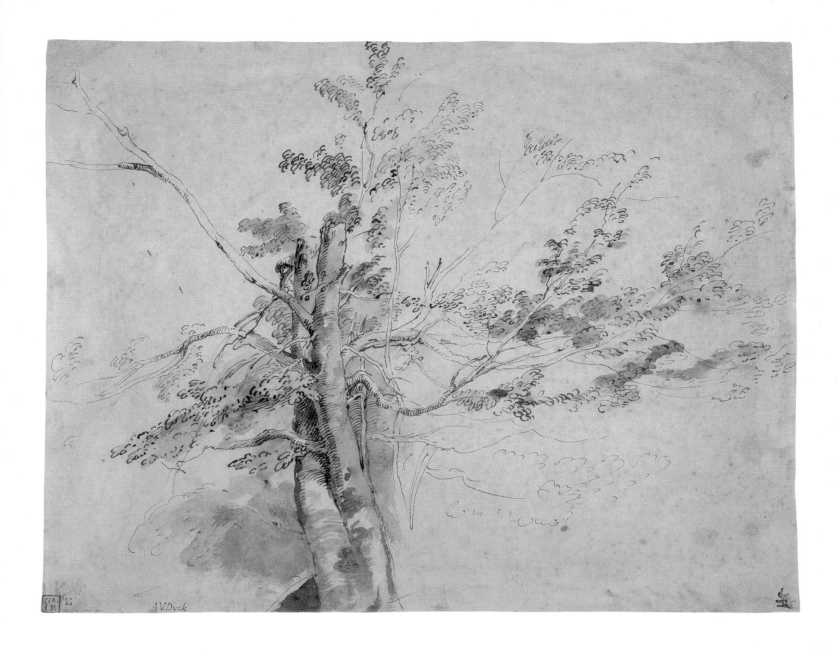

AVDyck

275

88
Trees and Bushes

1632–1641

Pen with brown ink, and brown wash, 201 x
261 cm. Lower right, an inscription in pen, in Van
Dyck's own hand: *A: van dyck.*

National Gallery of Art, Washington
(inv. no. 1970.14.1)

Vey 302

PROVENANCE P. H. Lankrink (1628–1692),
London (L.2090, lower right); Jonathan Richardson
the Elder (1665–1745), London (L.2183, lower
right); Thomas Hudson (1701–1779), London
(L.2432, lower left); Sir Joshua Reynolds (1723–
1792), London (L.2364, lower left); the Earls
Cowper; Lady Lucas, London; Mrs. Spencer Loch,
London; her sale, Christie's, London, 1 July 1969,
lot 68.

EXHIBITIONS London 1927, no. 592; Washington
1978, no. 61.

LITERATURE Vasari Society (2d series), I, no. 6;
Tolnay 1943, no. 189; Van Gelder 1942, no. 3; Van
Gelder 1948, no. 6; Vey 1962, no. 302.

This carefully constructed and delicately washed landscape may well have been one
of a number of drawings made by Van Dyck that were to be used when a landscape
background was required for a portrait.

According to Jaffé, whose opinion is quoted in the 1969 sale catalogue, the
drawing dates from the early 1630s.

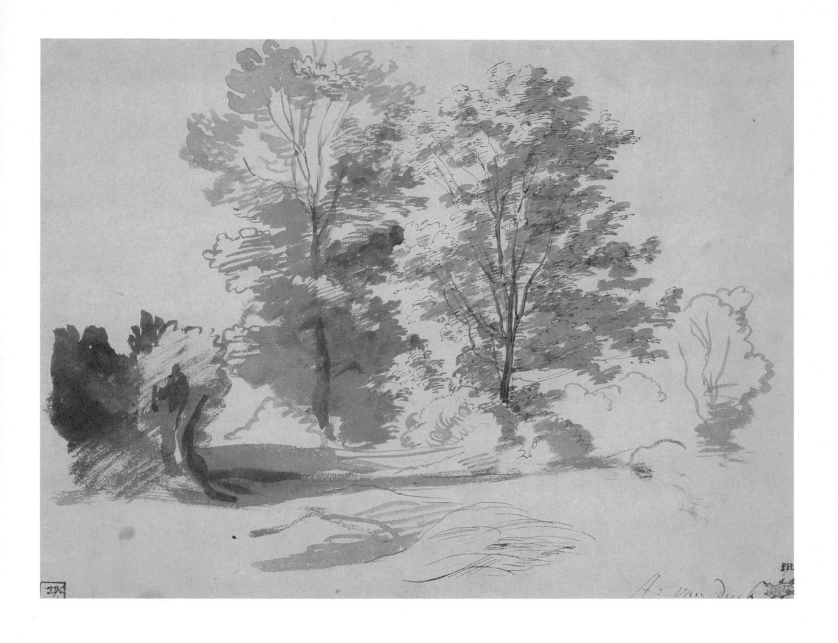

A Wood Near a Harbor

1635–1641

Brush with dark green, ocher-green, yellow-green and brown water- and bodycolor, and pen with brown ink, 189 x 266 mm.

Barber Institute of Fine Arts, Birmingham University, Birmingham

Vey 304
Exhibited in Fort Worth

PROVENANCE Jonathan Richardson the Elder (1665–1745), London (L.2184, lower right); Arthur Pond (1701–1758), London (L.2038, verso); Sir William Fitzherbert; purchased from him by the Barber Institute in 1939.

EXHIBITIONS London 1938, no. 578; Rotterdam 1948–1949, no. 93; Paris 1949, no. 133; Brussels 1949, no. 126; Antwerp 1949, no. 113; London 1953, no. 279; London 1953–1954, no. 475; Antwerp 1960, no. 104; Brussels 1965, no. 324; London 1972, no. 120; London 1982–1983, no. 86; London 1986, no. 11.

LITERATURE Popham 1938, 20; Van Gelder 1938, no. 6; Oppé 1941, 190; *Handbook of the Barber Institute of Fine Arts*, 1949, 19; Van Puyvelde 1950, pl. 46; Barber Institute catalogue, Birmingham, 1952, 138; Gerson and Ter Kuile 1960, pl. 110B; Vey 1962, no. 304; Barber Institute catalogue, Birmingham, 1983, 37; Levey 1983, 106ff.

1. See Popham 1938 and Oppé 1941.
2. In London 1986.

This view through a wood towards a port, where the masts of ships can be glimpsed, was made in watercolor, a technique used by Van Dyck for a small group of landscapes which are usually dated to his last years.[1] Cats. 90 and 91 also belong to this group. This particular sheet shows a port and recalls the drawings of Rye [cats. 73, 74]. It too may have been made as Van Dyck waited at one of the Channel ports for a fair wind to take him to the Continent.

It has been pointed out that in a general way this landscape resembles the vista in the lower left-hand corner of the *Roi à la Ciasse* [fig. 1].[2] As that portrait dates from about 1635, a dating of 1633–1634 has been proposed for this drawing. The resemblance, however, is not close enough to suggest a direct relationship and it should be noted that the technique of cats. 73 and 74 which can be firmly dated to 1633–1634 is quite different.

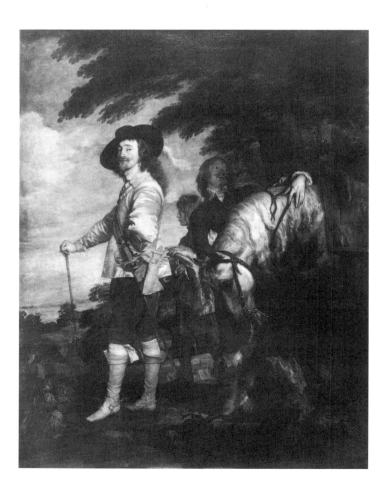

Fig. 1. Anthony van Dyck, *"Le Roi à la Ciasse."* Canvas, 272 x 212 cm. Musée du Louvre, Paris

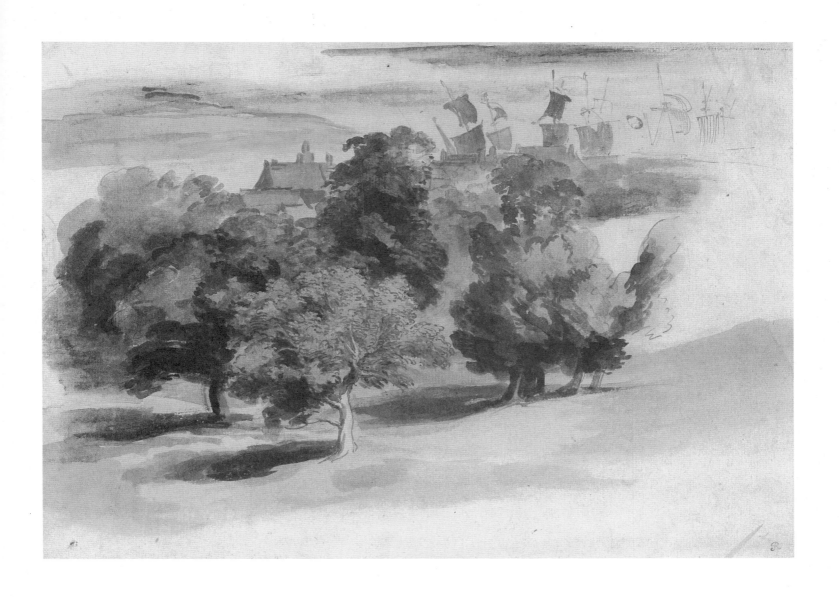

90
Hilly Landscape with Trees

1635–1641

Pen with brown ink and brush with gray, blue, and green watercolor, 228 x 330 mm.

Verso, on the lower right, turned through 180 degrees, an inscription in pen in a later hand, perhaps Flinck's: *16 lanschappen van van Dyck*.

Devonshire Collection, Chatsworth (inv. no. 1003)

Vey 306

PROVENANCE Although it does not bear the mark of Nicholas Flinck (1646–1723), Rotterdam, it seems probable that this landscape (like cat. 91) was among the drawings bought from Flinck by the 2d duke of Devonshire.

EXHIBITIONS London 1938, no. 584; Rotterdam 1948–1949, no. 94; Paris 1949, no. 134; London 1949, no. 27; Genoa 1955, no. 102; Nottingham 1960, no. 57; Antwerp 1960, no. 120; Manchester 1961, no. 78; Washington 1962–1963, no. 83; London 1969, no. 83; Munich 1972–1973, no. 37.

LITERATURE Hind 1932–1933, 63–65; Oppé 1941, 190; Vey 1962, no. 306.

1. Vey 1962, nos. 304–307.

Placed in the center of this sheet, the landscape seems not to be so obviously constructed as others by Van Dyck, nor as fragmentary. It appears to be a view observed from nature and drawn for its own sake rather than for incorporation in the background of a portrait or a history painting. Houses and a square tower, perhaps a church tower, can be glimpsed in the far distance. Like the other watercolors in this group [which include cats. 89 and 91], it probably dates from Van Dyck's last years in England.

The inscription is certainly seventeenth-century and may be by Flinck. It suggests that this was one of a group of sixteen similar landscapes, presumably all in watercolor, by Van Dyck. Only five of this type are known today,[1] and of these three are included in this exhibition [cats. 89–91].

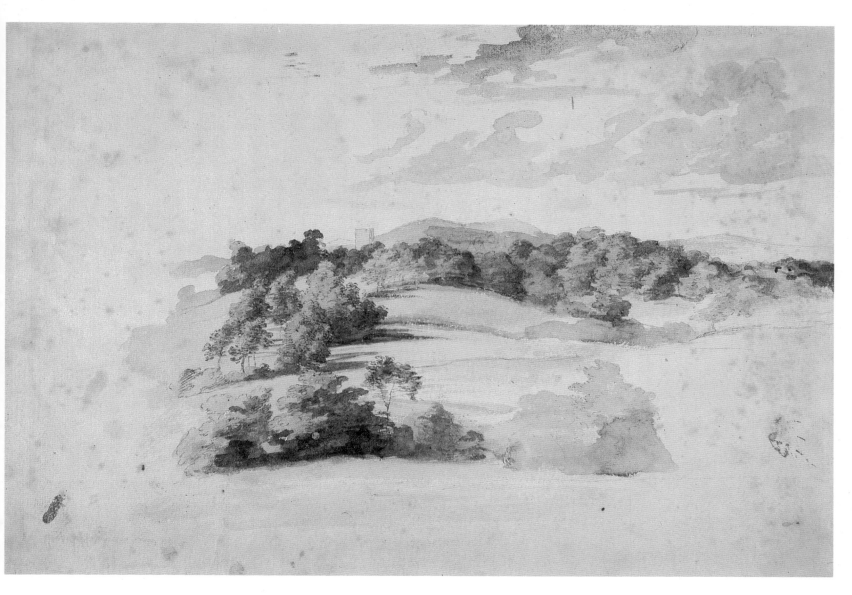

Inscription on the verso

91
Landscape with a Tall Tree

1635–1641

Pen and brown ink and brown, gray, and blue watercolor, 189 x 363 mm. The sheet has three vertical folds at regular intervals; to judge by these it may have been slightly cut on the left edge.

Watermark: none

J. Paul Getty Museum, Malibu (inv. no. 85.GG.96)

Vey 307

PROVENANCE N. A. Flinck (1646–1723), Rotterdam (L.959, lower left); William, 2d duke of Devonshire; by descent to the present duke; his sale, Christie's, London, 3 July 1984, lot 58 (bought Shickman, New York).

EXHIBITIONS London 1949, no. 29; Genoa 1955, no. 104; Nottingham 1960, no. 58; Antwerp 1960, no. 121; Washington 1962–1963, no. 84; London 1969, no. 84; London 1972, no. 121; Tokyo 1975, no. 80; Jerusalem 1977, no. 29.

LITERATURE Vey 1962, no. 307; Goldner 1988, no. 88.

1. Glück 1931, 408; London 1982–1983, no. 42.

This apparently unfinished watercolor of a landscape dominated by a single tall tree and with a small house on the right belongs to a group of watercolor landscapes, which also includes cats. 89 and 90, made during Van Dyck's later years in England. Some, like cat. 90, seem to have been made for their own sake, while others, like the present example, show motifs in nature that may have been intended to be incorporated into the backgrounds of portraits. This watercolor is similar to the landscape in the background of *A Young Woman as Erminia* at Blenheim [fig. 1].[1] In the painting this landscape is telescoped, with the tree and the house side by side, the house on the left. The portrait at Blenheim probably dates from about 1637–1638.

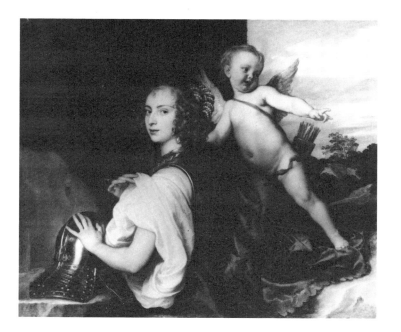

Fig. 1. Anthony van Dyck, *A Young Woman as Erminia*. Canvas, 109.2 x 129.5 cm. Collection of the Duke of Marlborough, Blenheim Palace, Oxfordshire

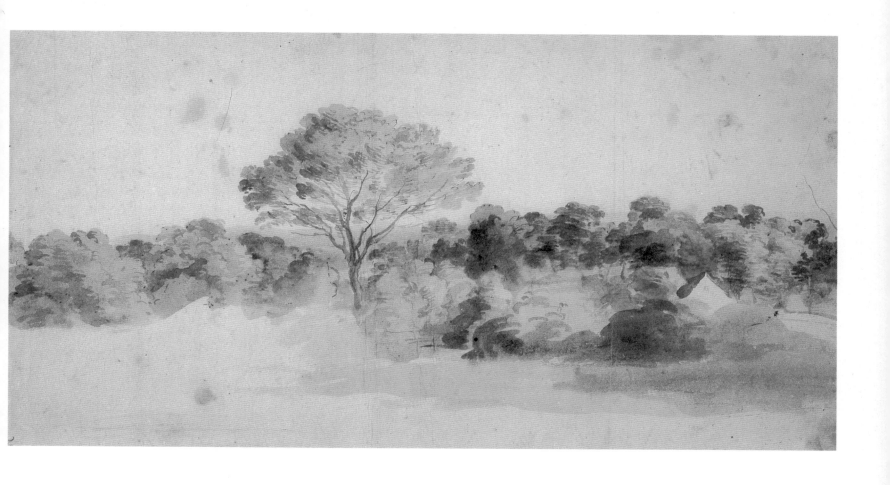

Bibliography

BOOKS AND ARTICLES

Adler 1982
W. Adler, *Landscapes.* Corpus Rubenianum Ludwig Burchard. Part XVIII, vol. 1. London, 1982.

Adriani 1940
G. Adriani, *Anton van Dyck: Italienisches Skizzenbuch.* Vienna, 1940 (2d ed., 1965).

Antal 1923
F. Antal, "Zwei flämische Bilder der Wiener Akademie." *Jahrbuch der Preussischen Kunstsammlungen* 44 (1923), 57–72

Bacou 1978
R. Bacou et al., *Collections I: Dessins de la Collection Everard Jabach acquis en 1671 pour la Collection Royale.* Paris, 1978 (ouvrage dactylographié).

Bacou and Calvet 1968
R. Bacou and A. Calvet, *Dessins du Louvre, Ecoles Allemande, Flamande et Hollandaise.* Paris, 1968.

Baker 1931
C. H. Collins Baker, "Van Dyck and the Wentworths." *Burlington Magazine* 59 (November 1931), 254.

Balis 1986
A. Balis, *Landscapes and Hunting Scenes.* Corpus Rubenianum Ludwig Burchard. Part XVIII, vol. 2. Oxford, 1986.

Banks 1931
M. A. Banks, "The Radeke Collection of Drawings." *Bulletin of the Rhode Island School of Design* 19 (1931), 63ff.

Bean 1964
J. Bean, *100 European Drawings in the Metropolitan Museum of Art.* New York, 1964.

Bell 1914
C.F. Bell, *Drawings by the Old Masters in the Library of Christ Church.* Oxford, 1914.

Bellori 1672
G.P. Bellori, *Le Vite de' pittori, scultori et architetti moderni.* Rome, 1672.

Benesch 1938
O. Benesch, "Zur Frage der frühen Zeichnungen Van Dycks." *Die Graphischen Künste* (1938), 3, 19–31.

Benesch 1957
O. Benesch, "Die Grossen flämischen Maler als Zeichner." *Jahrbuch der Kunsthistorischen Sammlungen in Wien* 53 (1957), 9–32.

Bock and Rosenberg 1930
E. Bock and J. Rosenberg, *Staatliche Museen zu Berlin: Die Zeichnungen alter Meister im Kupferstichkabinett: Die niederländischen Meister.* M. J. Friedländer, ed. 2 vols. Berlin, 1930.

Bolten and Folmer 1989
J. Bolten and A. T. Folmer-von Oven, *Liberna Foundation: Catalogue of Drawings.* Hilversum, 1989.

Boon 1965
K. Boon, *Selected Drawings: Rijksprentenkabinet.* Amsterdam, 1965.

De Bosschère 1910
J. de Bosschère, "De techniek der Antwerpse Teekenaars, eenige Teekeningen uit het Museum Plantin-Moretus." *Onze Kunst* 18 (1910), 18ff.

Boymans 1852
Catalogus van teekeningen in het Museum te Rotterdam gesticht door Mr. F. J. O. Boymans. Rotterdam, 1852.

Boymans 1869
Beschrijving der teekeningen in het Museum te Rotterdam gesticht door Mr. F. J. O. Boymans. Rotterdam, 1869.

Boymans 1927
Catalogus der Schilderijen, teekeningen en Beeldbouwwerken tentoongesteld in het Museum Boymans te Rotterdam. Rotterdam, 1927.

Bredius 1915
A. Bredius, *Künstler-Inventare: Urkunden zur Geschichte der holländischen Kunst des XVI., XVII. und XVIII. Jahrhunderts.* 7 vols. The Hague, 1915–1922.

British Drawings
E. Croft-Murray, P. Hulton, and C. White, *Catalogue of British Drawings.* Vol. 1. Department of Prints and Drawings, The British Museum. London, 1960.

Brown 1982
C. Brown, *Van Dyck.* Oxford, 1982.

Brown 1990
C. Brown, "Anthony van Dyck's Andromeda Chained to a Rock: a New Acquisition by the Los Angeles County Museum," H. Weston and D. Davies, eds., *Essays in Honour of John White.* University College, London, 1990, 23–27.

De Bruyn 1930
E. de Bruyn, *Trésor de l'art flamand du Moyen Age au XVIIIᵉ siècle: Mémorial de l'exposition d'art flamand ancien à Anvers 1930.* Vol. 2. Paris, 1932.

Buisman 1924A
H. Buisman, *Teyler's Museum, Haarlem: Veertig teekeningen van oude Meesters.* Leipzig, 1924.

Buisman 1924B
H. Buisman, ed., *Handzeichnungen alter Meister der holländischen Schule mit Einschluss einiger flämischer Blätter.* Leipzig, 1924.

Burchard 1932
L. Burchard, *Rubens ähnliche Van-Dyck-Zeichnungen.* Sitzungsberichte der Kunstgeschichtlichen Gesellschaft. Berlin, 1932.

Burchard 1938
L. Burchard, "A View of Rye by Anthonie Van Dyck." *Old Master Drawings* 12 (March 1938), 47–48.

Burchard and d'Hulst 1963
L. Burchard and R.-A. d'Hulst, *Rubens Drawings.* 2 vols. Brussels, 1963.

Buschmann 1916
P. Buschmann, "Rubens en Van Dyck in het Ashmolean Museum te Oxford." *Onze Kunst* 29 (January–June 1916), 1–24, 41–51.

Byam Shaw 1976
J. Byam Shaw, *Drawings by Old Masters at Christ Church, Oxford.* 2 vols. Oxford, 1976.

Carpenter 1844
W. H. Carpenter, *Pictorial Notices: Consisting of a Memoir of Sir Anthony van Dyck.* London, 1844.

Colvin 1907
S. Colvin, *Drawings of the Old Masters in the University Galleries and the Library of Christ Church, Oxford.* 1903–1907. 3 vols.

Cust 1900
L. Cust, *Anthony van Dyck: An Historical Study of His Life and Works.* London, 1900.

Cust 1902
L. Cust, *A Description of the Sketch-book by Sir Anthony van Dyck Used by Him in Italy, 1621–27 and Preserved in the Collection of the Duke of Devonshire, K.G., at Chatsworth.* London, 1902.

Delacre 1932A
M. Delacre, *Recherches sur le rôle du dessin dans l'iconographie de Van Dyck.* Mémoires de l'Académie Royale de Belgique. [2d series]. Brussels, 1932.

Delacre 1932B
M. Delacre, "Note sur l'édition actuelle du Sketch-Book de van Dyck." *Bulletin de l' Académie Royale de Belgique* 14 (1932).

Delacre 1934A
M. Delacre, *Le Dessin dans l'oeuvre de Van Dyck.* Mémoires de l'Académie Royale de Belgique. 2d series. Brussels, 1934.

Delacre 1934B
M. Delacre, *Recherches sur le rôle du dessin dans l'iconographie de Van Dyck. Notes complémentaires.* Mémoires de l'Académie Royale de Belgique, Classe des Beaux-Arts. Brussels, 1934.

Delen 1930
A. J. J. Delen, "Antony van Dyck — The Carrying of the Cross — Antwerp, Museum Plantin-Moretus." *Old Master Drawings* 5 (December 1930), 58–59, pl. 39.

Delen 1931
A. J. J. Delen, "Un dessin inconnu d'Antoine van Dyck représentant le Portement de la Croix." *Revue Belge d'Archéologie et d'Histoire de l'Art* 1 (July 1931), 193–199.

Delen 1938
A. J. J. Delen, *Cabinet des Estampes de la Ville d'Anvers: Catalogue des dessins anciens: Ecoles flamande et hollandaise.* 2 vols. Brussels, 1938.

Delen 1941
A. J. J. Delen, *Het Stedelijk Prentenkabinet van Antwerpen.* Antwerp, 1941.

Delen 1943A
A. J. J. Delen, *Antoon van Dijck, Een Keuze van 29 Tekeningen.* Antwerp, 1943.

Delen 1943B
A. J. J. Delen, *Teekeningen van Vlaamsche Meesters.* Antwerp, 1943.

Delen 1949
A. J. J. Delen, *Flämische Meisterzeichnungen.* Basle, 1949.

Delen 1959
A. J. J. Delen, "Cornelis van der Geest." *Antwerpen* 5 (1959), 57–71.

Denucé 1932
M. J. Denucé, *The Antwerp Art-Galleries, Inventories of the Art-Collections in Antwerp in the 16th and 17th Centuries* [De Antwerpsche "Konstkamers." Inventarissen van Kunstverzamelingen te Antwerpen in de 16e en 17e eeuwen]. The Hague, 1932.

Dyce 1874
Dyce Collection, *A Catalogue of the Paintings ... bequeathed by the Rev. Alexander Dyce.* London, 1874.

Eisenmann 1890
O. Eisenmann, *Ausgewählte Handzeichnungen alter Meister aus der Sammlung Edward Habich zu Cassel.* 3 vols. Lübeck, 1890.

Eisler 1963
C. Eisler, *Drawings of the Masters: Flemish and Dutch Drawings from the 15th to the 18th Century.* New York, 1963.

Eisler 1977
C. Eisler, *Paintings from the Samuel H. Kress Collection: European Paintings excluding Italian.* Oxford, 1977.

Finberg 1917
A. E. Finberg, "Two Anonymous Portraits by Cornelius Johnson." *Walpole Society* 6 (1917–1918), 1–13.

Fodor 1863
Beschrijving der Schilderijen ... in het Museum Fodor te Amsterdam. Amsterdam, 1863.

Van Gelder 1938
J. G. van Gelder, "Boomstudies uit vroegere eeuwen." *Beeldende Kunst* 25 (1938), no. 3.

Van Gelder 1939
J. G. van Gelder, "Anthonie van Dyck — Study of an Italian Nobleman Standing." *Old Master Drawings* 14 (June 1939), 11–13.

Van Gelder 1942
J. G. Van Gelder, "Teekeningen van Anthonie van Dyck." *Beeldende Kunst* 28 no. 8 (1942), no. 3.

Van Gelder 1948
J. G. van Gelder, *Anthonie van Dyck Teekeningen.* Antwerp, 1948.

Van Gelder 1959
J. G. van Gelder, "Anthonis van Dyck in Holland in de zeventiende eeuw." *Bulletin des Musées Royaux des Beaux-Arts* 1–2 (March–June 1959), 43–86.

Van Gelder 1961
J. G. van Gelder, "Van Dijcks Kruisdraging in de St.-Pauluskerk te Antwerpen." *Bulletin Koninklijke Musea voor Schone Kunsten, Brussel* 1–2 (March–June 1961), 43–86.

Van Gelder 1970
J. G. van Gelder, "Lambert ten Kate als Kunstverzamelaar." *Nederlands Kunsthistorisch Jaarboek* 21 (1970), 139–186.

Gerson and Ter Kuile 1960
H. Gerson and E. H. ter Kuile, *Art and Architecture in Belgium, 1600–1800.* Harmondsworth, 1960.

Glück 1931
G. Glück, *Van Dyck: Des Meisters Gemälde.* Klassiker der Kunst. Stuttgart and Berlin, 1931.

Glück 1937
G. Glück, "Van Dyck's Equestrian Portraits of Charles I." *Burlington Magazine* 70 (May 1937), 211–217.

Goldner 1988
G. Goldner, *European Drawings I: Catalogue of the Collections. J. Paul Getty Museum.* Malibu, 1988.

Göpel 1940
E. Göpel, *Ein Bildnisauftrag für Van Dyck: Antonis van Dyck, Phillip le Roy und die Kupferstecher.* Frankfurt, 1940.

Guiffrey 1882
J. Guiffrey, *Antoine van Dyck, sa vie et son oeuvre.* Paris, 1882.

Haverkamp-Begemann 1990
E. Haverkamp-Begemann, "Van Dyck and The Brazen Serpent." *Master Drawings* 28 (Autumn 1990), 296–302.

Held 1964
J. S. Held, Review of H. Vey, Die Zeichnungen Anton van Dycks. *Art Bulletin* 46 (1964), 565–568.

Held 1980
J. S. Held, *The Oil Sketches of Peter Paul Rubens: A Critical Catalogue.* 2 vols. Princeton, 1980.

Held 1982
J. S. Held, *Rubens and His Circle: Studies by Julius Held.* A. W. Lowenthal, D. Rosand, and J. Walsh, eds. Princeton, 1982.

Held 1986
J. S. Held, *Rubens: Selected Drawings.* 2d ed. Oxford, 1986.

Hervey 1921
M. Hervey, *The Life, Correspondence and Collections of Thomas Howard, Earl of Arundel.* Cambridge, 1921.

Hind 1915
A. M. Hind, "Van Dyck: His Original Etchings and His Iconography." *Print Collector's Quarterly* 5 (April 1915), 2–37, 220–252.

Hind 1923
A. M. Hind, *Catalogue of Drawings by Dutch and Flemish Artists ... in the British Museum.* Vol. 2: *Drawings by Rubens, Van Dyck and Other Artists of the Flemish School of the XVIIth Century.* London, 1923.

Hind 1927
A. M. Hind, "Van Dyck and English Landscape." *Burlington Magazine* 51 (December 1927), 292–297.

Hind 1932–1933
A. M. Hind, "A Landscape Drawing Attributed to Van Dyck." *British Museum Quarterly* 7 no. 3 (1932–1933), 63–65.

Hind 1937
A. M. Hind, "Van Dyck's Landscape Drawings." *The Illustrated London News,* 20 March 1937, 484–485.

Hoet 1752
G. Hoet, *Catalogus of Naamlyst van Schilderyen (met derselver Prijsen).* 3 vols. Amsterdam, 1752.

Hollstein 1949
F. W. H. Hollstein, *Dutch and Flemish Etchings, Engravings and Woodcuts, c. 1450–1700.* Vol. 1–. Amsterdam, 1949–.

Hoogewerff 1949
G. J. Hoogewerff, "Een 'Nood Gods' door Van Dijck geschilderd." *Miscellanea Leo van Puyvelde.* Brussels, [1949], 157–162.

Howarth 1985
D. Howarth, *Lord Arundel and His Circle.* New Haven and London, 1985.

Howarth 1990
D. Howarth, "The Arrival of Van Dyck in England." *Burlington Magazine* 132 (October 1990), 709–710.

d'Hulst 1982
R.-A. d'Hulst, *Jacob Jordaens.* London, 1982.

d'Hulst and Vandenven 1989
R.-A. d'Hulst and M. Vandenven, *The Old Testament.* Corpus Rubenianum Ludwig Burchard. Part III. London, 1989.

Hymans 1893
H. Hymans, *Lucas Vorsterman. Catalogue raisonné de son oeuvre ...* Brussels, 1893.

Jaffé 1959
M. Jaffé, "The Second Sketch Book by Van Dyck." *Burlington Magazine* 101 (September 1959), 317–321.

Jaffé 1966
M. Jaffé, *Van Dyck's Antwerp Sketchbook.* 2 vols. London, 1966.

Jaffé 1989
M. Jaffé, *Rubens: Catalogo Completo.* Milan, 1989.

Jaffé 1990
M. Jaffé, "Van Dyck's 'Venus and Adonis'." *Burlington Magazine* 132 (October 1990), 696–703

Jessop 1887
Ed. A. Jessop, *The Autobiography of Roger North.* London, 1887.

Kettering 1988
A. Kettering, *Drawings from the Ter Borch Studio Estate in the Rijksmuseum.* 2 vols. Amsterdam, 1988.

Kleinmann
H. Kleinmann, *Handzeichnungen alter Meister der Holländischen Malerschule.* Haarlem, n.d.

Kuznetsov 1970
Y. Kuznetsov, *I disegni dei Maestri: Capolavori fiamminghi e olandesi.* Milan, 1970.

Labbé 1987
J. Labbé, L. Bicart-Sée, and F. Arquié-Bruley, *La Collection Saint Morys au Cabinet des Dessins du Louvre.* 2 vols. Paris, 1987.

Lahrkamp 1982
H. Lahrkamp, "Der 'Lange Jan': Leben und Werk des Barockmalers Johann Bockhorst aus Munster." *Zeitschrift Westfalen* 60 (1982), 3–184.

Larsen 1980
E. Larsen, *L'Opera completa di Van Dyck, 1626–1641.* 2 vols. Milan, 1980.

Larsen 1988
E. Larsen, *The Paintings of Anthony van Dyck.* 2 vols. Freren, 1988.

Lavallée 1917
P. Lavallée, "La collection des dessins de l'Ecole des Beaux-Arts." *Gazette des Beaux-Arts* 13 (1917), 265–283.

Leporini 1925
H. Leporini, *Die Stilentwicklung der Handzeichnung XIV. bis XVIII. Jahrhundert.* Vienna, 1925.

Leporini 1928
H. Leporini, *Die Künstlerzeichnung.* Berlin, 1928.

Levey 1983
M. Levey, "London: 'Van Dyck in England' at the National Portrait Gallery, 1982–1983." *Burlington Magazine* 125 (February 1983), 106–110.

Liedtke 1984
W. Liedtke, *Flemish Paintings in the Metropolitan Museum of Art.* 2 vols.
New York, 1984.

Lippmann 1910
F. Lippmann, *Zeichnungen alter Meister im Kupferstichkabinett der Koningl.
Museen zu Berlin.* 2 vols. Berlin, 1910.

Lugt (L.)
F. Lugt, *Les Marques de collections de dessins et d'estampes.* Amsterdam 1921;
Supplément. The Hague, 1956.

Lugt 1925
F. Lugt, Review. *La Revue d'Art* (1925), 157.

Lugt 1927
F. Lugt, *Les Dessins des écoles du Nord de la Collection Dutuit.* Paris, 1927.

Lugt 1931
F. Lugt, "Beiträge zu dem Katalog der niederländischen Handzeichnungen
in Berlin." *Jahrbuch der Preussischen Kunstsammlungen* 52 (1931), 36–80.

Lugt Répertoire
F. Lugt, *Répertoire des catalogues de ventes.* 4 vols. The Hague, 1938–1988.

Lugt 1949
F. Lugt, *Musée du Louvre. Inventaire général des dessins des écoles du nord.
Ecole flamande.* 2 vols. Paris, 1949.

Magurn 1955
R. S. Magurn, ed. and trans. *The Letters of Peter Paul Rubens.* Cambridge,
Mass., 1955.

Mariette 1741
P. J. Mariette. *Description sommaire des desseins des grands maistres d'Italie ...
du cabinet de feu M. Crozat.* Paris, 1741.

Mariette, *Abécédario*
P. J. Mariette, *Abécédario de P. J. Mariette, et autres notes inédites de cet amateur
sur les arts et les artistes.* P. de Chennevières and A. de Montaiglon, eds.
6 vols. Archives de l'art français. Paris, 1851–1860.

Martin 1970
G. Martin, *National Gallery Catalogues: The Flemish School circa 1600–
circa 1900.* London, 1970.

Mauquoy-Hendrickx 1956
M. Mauquoy-Hendrickx, *L'Iconographie d'Antoine van Dyck. Catalogue
Raisonné.* Académie Royale de Belgique. Mémoire 9. Brussels 1956.

Mayer 1923
A. L. Mayer, *Anthonis van Dyck.* Munich, 1923.

Meder 1923
J. Meder, *Albertina-Faksimile. Handzeichnungen vlamischer und holländischer
Meister des XV–XVII Jahrhunderts.* Vienna, 1923.

Menotti 1897
M. Menotti, "Van Dyck a Genova." *Archivio storico dell'arte.* 2d series,
3 (1897), 208–308, 360–397, 432–470.

Michel 1900
E. Michel, *Rubens, sa vie, son oeuvre et son temps.* Paris, 1900.

Millar 1963
O. Millar, *The Tudor, Stuart and Early Georgian Pictures in the Collection of
Her Majesty the Queen.* 2 vols. London, 1963.

Moes 1913
E. W. Moes, *Les Dessins, Mémorial, Trésor de l'art belge au XVIIe siècle.* 2 vols.
Brussels and Paris, 1913.

Monballieu 1973
A. Monballieu, "Cesare Alessandro Scaglia en de 'Bewening van Christus'
door A. Van Dijck." *Jaarboek van het Koninklijk Museum voor Schone Kunsten*
(1973), 247–268.

Mongan and Sachs 1946
A. Mongan and P. Sachs, *Drawings in the Fogg Museum of Art.* 2d ed.
Cambridge, Mass., 1946.

Morel d'Arleux 1797–1827
*Inventaire des Dessins du Louvre établi par Morel d'Arleux, conservateur au
Cabinet des Dessins du Louvre de 1797 à 1827.* 9 vols. (ms.).

Morgan 1905–1912
*J. Pierpont Morgan Collection of Drawings by the Old Masters Formed by
C. Fairfax Murray.* 4 vols. London, [1905]–1912.

Muchall-Viebrook 1926
T. Muchall-Viebrook, *Flemish Drawings of the 17th Century.* London, 1926.

Muller 1989
J. M. Muller, *Rubens: The Artist as Collector.* Princeton, 1989.

Müller Hofstede 1961
J. Müller Hofstede, "Zur Ausstellung von Zeichnungen und Ölskizzen Van
Dycks in Antwerpen und Rotterdam." *Pantheon* 19 (1961), 150–152

Müller Hofstede 1973
J. Müller Hofstede, "New Drawings by Van Dyck." *Master Drawings*
11 (Spring 1973), 154–159.

Müller Hofstede 1989
J. Müller Hofstede, "Neue Beiträge zum Oeuvre Anton van Dycks."
Wallraf-Richartz Jahrbuch 48–49 (1987–1988), 123–186.

Oldenbourg 1921
R. Oldenbourg. *P. P. Rubens: Des Meisters Gemälde.* Klassiker der Kunst.
Berlin and Leipzig, 1921.

Oppé 1931
P. Oppé, "Studies: Recto for the Picture of the Brazen Serpent in the
Prado; Verso, for a Picture of the Mystic Marriage of St. Catherine and
Tracing from the Recto." *Old Master Drawings* 5 (March 1931), 70–71, pl. 53.

Oppé 1941
P. Oppé, "Sir Anthony van Dyck in England." *Burlington Magazine*
79 (December 1941), 186–191.

Parker 1938
K. T. Parker, *Catalogue of the Collection of Drawings in the Ashmolean Museum.*
2 vols. Oxford, 1938.

Passavant 1836
J.D. Passavant, *Tour of a German Artist in England, with Notices of Private
Galleries and Remarks on the State of Art.* 2 vols. London, 1836.

Pauli 1908
G. Pauli, "Zeichnungen Van Dycks in der Bremer Kunsthalle." *Zeitschrift
für bildende Kunst* 19 (1908), 84ff.

Pauli 1924
G. Pauli, *Zeichnungen alter Meister in der Kunsthalle zu Hamburg.*
Prestel-Gesellschaft 8. Frankfurt, 1924.

Popham 1938A
A. E. Popham, "Seventeenth-Century Art in Europe at Burlington House.
2. The Drawings." *Burlington Magazine* 72 (January 1938), 13–20.

Popham 1938B
A. E. Popham, "A Drawing by Sir Anthony van Dyck." *British Museum
Quarterly* 12 no. 2 (April 1938), 49–50.

Van Puyvelde 1940
L. van Puyvelde, "Van Dyck's *St. Martin* at Windsor and at Saventhem."
Burlington Magazine 77 (August 1940), 37–42.

Van Puyvelde 1950
L. van Puyvelde, *Van Dyck.* Brussels and Paris, 1950.

Recueil 1729
*Recueil d'Estampes d'après les plus beaux tableaux et les plus beaux dessins qui
sont en France.* Paris, 1729.

Reitlinger 1921
H. Reitlinger, ed., *A Selection of Drawings by Old Masters in the Museum ...
Collections.* London, 1921.

Renger 1974–1975
K. Renger, "Rubens Dedit Dedicavitque. Rubens' Beschäftigung mit der
Reproduktionsgrafik. I. Teil: Der Kupferstich." *Jahrbuch der Berliner Museen*
16 (1974), 122–175; "II. Teil: Radierungen und Holzschnitte — Die
Widmungen." *Ibid.* 17 (1975), 166–213.

Richmond 1932
E. J. Richmond, "The Radeke Collection of Drawings." *Bulletin of the Rhode
Island School of Design* 20 (October 1931), 14–15.

Ridolfi 1648
C. Ridolfi, *Le Maraviglie dell'arte ...* 2 vols. Venice, 1648.

Rooses 1892
M. Rooses, *L'Oeuvre de P. P. Rubens.* 5 vols. Antwerp, 1886–1892.

Rooses 1903
M. Rooses, "De Teekeningen der Vlaamsche Meesters." *Onze Kunst*
2 (1903), 133ff.

Rowlands 1970
J. Rowlands, "Sketch for a Family Group by Van Dyck." *Master Drawings*
8 (Spring 1973), 162–166.

Russell 1926
A. G. B. Russell, "Study (in reverse) for the Picture of The Brazen Serpent
in the Prado, Madrid." *Old Master Drawings* 1 (June 1926), 8.

Sandoz 1954
M. Sandoz, *Autour de Van Dyck: 1 – Cavalier, Dessin, Dibutade 1* (Fascicule
spécial du Bulletin des Amis des Musées de Poitiers). 1954.

Schaeffer 1909
E. Schaeffer, *Van Dyck. Des Meisters Gemälde.* Klassiker der Kunst 13.
Stuttgart and Leipzig, 1909.

Schapelhouman 1979
M. Schapelhouman, *Tekeningen van Noord- en Zuidnederlandse kunstenaars
geboren voor 1600.* Amsterdams Historisch Museum, Amsterdam, 1979.

Scholten 1904
H. J. Scholten, *Musée Teyler à Haarlem: Catalogue Raisonné des dessins des
écoles française et hollandaise.* Haarlem, 1904.

Schönbrunner-Meder
Handzeichnungen alter Meister aus der Albertina und anderen Sammlungen.
12 vols. Vienna, 1896–1908.

Smith 1829–1842
J. Smith, *A Catalogue Raisonné of the Works of the Most Eminent Dutch, Flemish
and French Painters.* 9 vols. London, 1829–1842.

Speth-Holterhoff 1957
S. Speth-Holterhoff, *Les peintres flamandes de cabinets d'amateurs au XVI^e siècle*. Brussels, 1957.

Spicer 1979
J. Spicer, *The Drawings of Roelandt Savery*. Ph.D. diss. Yale University, 1979, 2 vols. UMI. Ann Arbor, Mich., 1979.

Spicer 1985
J. Spicer, "Unrecognized Studies for Van Dyck's *Iconography* in the Hermitage." *Master Drawings* 23–24 (Winter 1985–1986), 537–544.

Stechow 1960
W. Stechow, "Anthony van Dyck's *Betrayal of Christ*." *Minneapolis Institute of Art Bulletin* 49 (January–June 1960), 4–17.

Stewart 1979
J. Douglas Stewart, "'Van Dyck as religious artist' at the Art Museum, Princeton University." *Burlington Magazine* 121 (July 1979), 466–468.

Strong 1900
S. L. Strong, *Reproductions in Facsimile of Drawings in the Collection of the Earl of Pembroke*. 2 vols. London, 1900.

Stubbe 1967
W. Stubbe, *Hundert Meisterzeichnungen aus der Hamburger Kunsthalle*. Hamburg, 1967.

Von Szwykowski 1859
I. von Szwykowski, *Anton van Dyck's Bildnisse bekannter Personen*. Leipzig, 1859.

Tietze 1947
H. Tietze, *European Master Drawings in the United States*. New York, 1947.

Tolnay 1943
C. de Tolnay, *History and Technique of Old Master Paintings*. New York, 1943.

Valentiner 1930
W. R. Valentiner, *Das unbekannte Meisterwerk*. Berlin, 1930.

Vasari Society
The Vasari Society for the Reproduction of Drawings by Old Masters. I, 1905–1915; II, 1920–1935.

Vertue
George Vertue "Vertue Note Books." *Walpole Society* 18 (1930), 20 (1932), 22 (1934), 24 (1936), 26 (1938), 29 (1947), 30 (1955).

Vey 1956A
H. Vey, "De Tekeningen van Anthonie van Dyck in het Museum Boymans." *Bulletin Museum Boymans* 7 (1956), pp. 82–91.

Vey 1956B
H. Vey, "Anton van Dycks Ölskizzen." *Bulletin Koninklijke Musea voor Schone Kunsten* 5 (1956), 167–208.

Vey 1958
H. Vey, *Van-Dyck-Studien*. Cologne, 1958.

Vey 1962
H. Vey, *Die Zeichnungen Anton van Dycks*. 2 vols. Brussels, 1962.

Vey 1967
H. Vey, "Die Bildnisse Everhard Jabachs." *Wallraf-Richartz Jahrbuch* 29 (1967), 157–187.

Vlieghe 1972
H. Vlieghe, *Saints*. 2 vols. Corpus Rubenianum Ludwig Burchard. Part VII. London, 1972–1973.

Waagen 1854
G. F. Waagen, *Galleries and Cabinets of Art in Great Britain*. 3 vols. London, 1854 (Supplementary volume, London, 1857).

Wescher 1938
P. Wescher, *Alte Städte in Meisterzeichnungen aus fünf Jahrhunderten*. Frankfurt, 1938.

Wethey 1969
H. Wethey, *The Paintings of Titian: Complete Edition*. 3 vols. London [1969–1975].

White 1960
C. White. "Van Dyck Drawings and Sketches." *Burlington Magazine* 102 (December 1960), 510–514.

Van den Wijngaert 1940
F. van den Wijngaert, *Inventaris der Rubeniaansche Prentkunst*. Antwerp, 1940.

Van den Wijngaert 1943
F. van den Wijngaert, *Antoon van Dyck*. Antwerp, 1943.

Van den Wijngaert 1945
F. Van den Wijngaert, "P. P. Rubens en Lucas Vorsterman." *De Gulden Passer* 23 (1945), 179–180.

Williams 1940
H. W. Williams Jr., "A Gift of Prints and Drawings: The Drawings." *Metropolitan Museum of Art Bulletin* 35 (1940), 156–157.

Winkler 1948
F. Winkler, *Flämische Zeichnungen*. Berlin, [1948].

Winkler 1951
F. Winkler, *Die Grossen Zeichner*. Berlin, [1951].

Wortley 1931
C. Stuart Wortley, "Van Dyck and the Wentworths." *Burlington Magazine* 59 (September 1931), 103–107.

EXHIBITION CATALOGUES

Amsterdam 1963
Fodor 100 Jaar. Museum Fodor, Amsterdam, 1963.

Antwerp 1927
Teekeningen en Prenten van Antwerpse meesters der XVIIe eeuw. Antwerp, 1927.

Antwerp 1930
Exposition internationale, coloniale, maritime et d'Art flamande. Antwerp, 1930.

Antwerp 1936
Teekeningen en Prenten van Antwerpsche Kunstenaars. Antwerp, 1936.

Antwerp 1949
Van Dyck Tentoonstelling. Koninklijk Museum voor Schone Kunsten, Antwerp, 1949.

Antwerp 1956
Scaldis. Antwerp, 1956.

Antwerp 1971
Rubens en zijn tijd: Tekeningen uit Belgische verzamelingen. Rubenshuis, Antwerp, 1971.

Antwerp 1990
Jan Boeckhorst. Antwerp, Rubenshuis; Münster, Westfälisches Landesmuseum, 1990.

Antwerp 1960
Antoon van Dyck. Tekeningen en Olieverfschetsen. Rubenshuis, Antwerp; Museum Boymans-van Beuningen, Rotterdam, 1960 .

Arts Council 1948
Old Master Drawings from the Albertina. Arts Council, London, 1948

Baltimore 1941
Landscape Painting from Patinir to Hubert Robert. Johns Hopkins University, Baltimore, 1941.

Berlin 1964
Meisterwerke aus dem Museum in Lille. Berlin-Dahlem, Staatliche Museen, Kupferstichkabinett, 1964.

Berlin 1975
Pieter Brueghel d. Ä. als Zeichner. Berlin-Dahlem, Staatliche Museen, Kupferstichkabinett, 1975.

Bologna 1965
Plantin-Rubens: Arte grafica e tipografica ad Anversa nei secoli XVI e XVII. Bologna, 1965.

Brussels 1910
Exposition de l'Art ancien. L'art belge au XVII^e siècle. Brussels, 1910.

Brussels 1949
Dessins de Jan van Eyck à Rubens. Musée Royal, Brussels, 1949.

Brussels 1965
Le Siècle de Rubens. Musées Royaux des Beaux-Arts de Belgique, Brussels, 1965.

Buffalo 1935
Master Drawings. Albright Art Gallery, Buffalo, 1935.

Cambridge 1958
Seventeenth Century Flemish Drawings and Oil Sketches. Fitzwilliam Museum, Cambridge, 1958.

Cambridge, Mass. 1954
Dutch and Flemish Drawings. Cambridge, Mass., 1954.

Cambridge, Mass. 1965–1967
Memorial Exhibition ... Paul J. Sachs. Cambridge, Mass., 1965–1966; New York, 1966–1967

Cologne 1975
Deutsche und Niederländische Zeichnungen aus der Sammlung Everard Jabach im Louvre, Paris. Cologne, 1975.

Eastbourne 1984
Drawings and Etchings by Anthony Van Dyck 1599–1641: An Exhibition of the Artist's Original Portrait Drawings and Their Related Engravings from the Devonshire Collection, Chatsworth. Towner Art Gallery, Eastbourne, 1984.

Edinburgh 1965
Old Master Drawings from the Collection of Dr. and Mrs. Francis Springell. National Gallery of Scotland, Edinburgh, 1965.

Genoa 1955
100 Opere di Van Dyck. Palazzo dell'Academia, Genoa, 1955.

Hartford 1948
The Life of Christ. Wadsworth Atheneum, Hartford, Conn., 1948.

Hartford 1960
The Pierpont Morgan Treasures. Wadsworth Atheneum, Hartford, Conn., 1960.

Jerusalem 1977
Old Master Drawings: A Loan from the Collection of the Duke of Devonshire.
Israel Museum, Jerusalem, 1977.

Leningrad 1974
*Tekeningen van Vlaamse en Hollandse meesters uit de 17e eeuw uit Belgische en
Hollandse musea en uit het Institut Néerlandais te Parijs.* Leningrad,
Hermitage; Moscow, Pushkin Museum; Kiev, Museum of Western and
Oriental Art, 1974.

Leicester 1952
Old Master Drawings. Leicester, 1952.

Liverpool 1964
Fifty Drawings from Christ Church. Walker Art Gallery, Liverpool, 1964.

London 1835A
*The Lawrence Gallery: First Exhibition: A Catalogue of One Hundred Original
Drawings by Sir Anthony van Dyke and Rembrandt van Ryn, collected by Sir
Thomas Lawrence, late President of the Royal Academy.* Royal Academy of
Arts, London, 1835.

London 1835B
*The Lawrence Gallery: A Catalogue of One Hundred Original Drawings by
Sir P. P. Rubens, collected by Sir Thomas Lawrence, late President of the Royal
Academy.* Royal Academy of Arts, London, 19835.

London 1912
Exhibition of Drawings and Sketches by Old Masters. The British Museum,
London, 1912.

London 1927
Catalogue of the Loan Exhibition of Flemish and Belgian Art, a Memorial Volume.
Royal Academy of Arts, London, 1927.

London 1938
*17th Century Art in Europe, an Illustrated Souvenir of the Exhibition of 17th
Century Art in Europe at the Royal Academy of Arts.* London, 1938.

London 1943
Drawings from the Witt Collection. Victoria and Albert Museum, London,
1943.

London 1949
Old Master Drawings from Chatsworth. Arts Council, London, 1949.

London 1949–1950
The Beginnings of English Topographical and Landscape Drawing. The British
Museum, London, 1949–1950.

London 1950
Treasures of Oxford. Goldsmith's Hall, London, 1950.

London 1952
Old Master Drawings ... from the Collection of Sir Bruce Ingram. Colnaghi,
London, 1952.

London 1953A
Drawings by Old Masters. Royal Academy of Arts, London, 1953.

London 1953B
Drawings from the Witt Collection. Arts Council, London, 1953.

London 1953–1954
Flemish Art 1300–1700. Royal Academy of Arts, London, 1953–1954.

London 1956–1957
British Portraits. Royal Academy of Arts, London, 1956–1957.

London 1958
Drawings from the Witt Collection. Courtauld Institute Galleries, London,
1958.

London 1959
Drawings by Old Masters from the Collection of Dr. and Mrs. Francis Springell.
Colnaghi, London, 1959.

London 1960
Paintings and Drawings from Christ Church, Oxford. Matthiesen Gallery,
London, 1960.

London 1969
Old Master Drawings: A Loan Exhibition from the Devonshire Collection.
Royal Academy of Arts, London, 1969.

London 1970
Drawings from the Teyler Museum, Haarlem. Victoria and Albert Museum,
London, 1970.

London 1972
The Age of Charles I: Painting in England, 1620–1649. Tate Gallery, London,
1972.

London 1973
Old Master Drawings from Chatsworth. Victoria and Albert Museum,
London, 1973.

London 1977–1978
Flemish Drawings from the Witt Collection. Courtauld Institute Galleries,
London, 1977–1978.

London 1982–1983
Van Dyck in England. National Portrait Gallery, London, 1982–1983.

London 1983
Mantegna to Cézanne: Master Drawings from the Courtauld. The British
Museum, London, 1983.

London 1984
Master Drawings and Watercolours in the British Museum. The British
Museum, London, 1984.

London 1986
Master Drawings in the Barber Institute. Morton Morris, London, 1986.

London 1987A
Master Drawings from the Woodner Collection. Royal Academy of Arts,
London, 1987.

London 1987B
Drawings in England from Hilliard to Hogarth. The British Museum, London;
Yale Center for British Art, New Haven, 1987.

Manchester 1961
Old Master Drawings from Chatsworth. Manchester 1961.

Manchester 1962
Master Drawings from the Witt and Courtauld Collections. Whitworth Art
Gallery, Manchester, 1962.

Munich 1972–1973
Das Aquarell 1400–1950. Munich, 1972–1973.

Newark 1960
Old Master Drawings. Newark Museum, Newark, N.J., 1960.

New London 1936
Fourth Anniversary Exhibition: Drawings. Lyman Allen Museum, New
London, Conn., 1936.

New York 1939
*Illustrated Catalogue of an Exhibition Held on the Occasion of the New York
World's Fair.* The Pierpont Morgan Library, New York, 16 May–31 October
1939.

New York 1953
Landscape Drawings and Water-Colors, Bruegel to Cézanne. The Pierpont
Morgan Library, New York, 1953.

New York 1957
Treasures from the Pierpont Morgan Library Fiftieth Anniversary Exhibition.
Traveling exhibition from The Pierpont Morgan Library, New York, 1957.

New York 1959
Great Master Drawings of Seven Centuries. M. Knoedler and Co., New York,
1959.

New York 1968–1969
Gods and Heroes: Baroque Images of Antiquity. Wildenstein and Co., New
York, 1968–1969.

New York 1969
Drawings from Stockholm. New York, Metropolitan Museum of Art; Boston,
Museum of Fine Arts; Chicago, Art Institute, 1969.

New York 1981
European Drawings, 1375–1825. The Pierpont Morgan Library, New York,
1981.

New York 1989–1990
Inigo Jones: Complete Architectural Drawings. Drawings Center, New York;
Frick Art Museum, Pittsburgh; Royal Academy of Arts, London,
1989–1990.

Nottingham 1957
Paintings and Drawings from Chatsworth. Department of Fine Art, University
of Nottingham, 1957.

Nottingham 1960
Paintings and Drawings by Van Dyck. Department of Fine Art, University of
Nottingham, 1960.

Ottawa 1980
The Young Van Dyck. National Gallery of Canada, Ottawa, 1980

Oxford 1985
*Patronage and Collecting in the Seventeenth Century: Thomas Howard, Earl of
Arundel.* Ashmolean Museum, Oxford, 1985.

Paris 1879
Dessins de Maîtres Anciens. Ecole des Beaux-Arts, Paris, 1879.

Paris 1947
*Exposition de dessins, livres illustrés et xylographies de l'Ecole nationale
supérieure des Beaux-Arts. Art flamand des XVe, XVIe, XVIIe siècles.* Ecole
nationale supérieure des Beaux-Arts, Paris 1947.

Paris 1949
De van Eyck à Rubens: Les maîtres flamands du dessin. Bibliothèque Nationale,
Paris, 1949.

Paris 1950
150 Chefs d'oeuvre de l'Albertina de Vienne. Bibliothèque Nationale, Paris,
1950.

Paris 1952A
Choix des Dessins: Musée Boymans-van Beuningen, Rotterdam. Paris, 1952.

Paris 1952B
Dessins Flamands du XVIIe siècle. Musée du Louvre, Paris, 1952.

BIBLIOGRAPHY

Paris 1954
Anvers, ville de Plantin et de Rubens. Paris, 1954.
Paris 1959
Dessins de Pierre-Paul Rubens. Musée du Louvre, Paris, 1959.
Paris 1974
Dessins flamands et hollandais du dix-septième siècle. Institut Néerlandais, Paris, 1974.
Paris 1978
Rubens, ses maîtres, ses élèves. Musée du Louvre, Paris, 1978.
Paris 1979–1980
Rubens and Rembrandt in Their Century: Flemish and Dutch Drawings of the 17th Century from The Pierpont Morgan Library. Institut Néerlandais, Paris; Koninklijk Museum voor Schone Kunsten, Antwerp; The British Museum, London; The Pierpont Morgan Library, New York, 1979–1980.
Paris 1981–1982
De Michel-Ange à Géricault: Dessins de la donation Armand-Valton. Ecole nationale supérieure des Beaux-Arts, Paris; J. Paul Getty Museum, Malibu; Hamburger Kunsthalle, 1981–1982.
Philadelphia 1950–1951
Masterpieces of Drawing: Diamond Jubilee Exhibition. Philadelphia, 1950–1951.
Pittsburgh 1933
Old Master Drawings. Pittsburgh, 1933.
Pittsburgh 1987–1988
Old Master Drawings from Chatsworth: A Loan Exhibition from the Devonshire Collection. Frick Art Museum, Pittsburgh; Cleveland Museum of Art; Kimbell Art Museum, Fort Worth; Los Angeles County Museum of Art; Center for the Fine Arts, Miami, 1987–1988.
Prague 1969
Drie eeuwen Nederlandse Tekenkunst. Národní Galerie, Prague, 1969.
Prague 1979
Treasures from Rotterdam. Národní Galerie, Prague, 1979.
Princeton 1979
Van Dyck as Religious Artist. Art Museum, Princeton University, 1979.
Providence 1983
Old Master Drawings from the Museum of Art, Rhode Island School of Design, Providence, Rhode Island. Museum of Art, Rhode Island School of Design, Providence; Minneapolis Institute of Art; Toledo Museum of Art; Lowe Art Museum; Art Gallery of Ontario, Toronto; Baltimore Museum of Art; Hood Museum, Dartmouth College, 1983.
Recklinghausen 1959
Die Handschrift des Künstlers. Recklinghausen, 1959.
Richmond 1979–1980
Treasures from Chatsworth: The Devonshire Inheritance. Virginia Museum of Fine Arts, Richmond; Kimbell Art Museum, Fort Worth; The Toledo Museum of Art; San Antonio Museum; New Orleans Museum of Art; Palace of the Legion of Honour, San Francisco, 1979–1980.
Rome 1977
Rubens e l'incisione nelle collezioni del Gabinetto Nazionale delle Stampe. Rome, 1977.
Rotterdam 1938
Meesterwerken uit vier eeuwen. Rotterdam, 1938.
Rotterdam 1948
Tekeningen van Jan van Eyck tot Rubens. Museum Boymans-van Beuningen, Rotterdam, 1948.
Rotterdam 1961–1962
150 tekeningen ... uit de verzameling ... Ingram. Museum Boymans-van Beuningen, Rotterdam; Rijksprentenkabinet, Amsterdam, 1961–1962.
San Francisco 1940
Golden Gate International Exposition: Master Drawings. Fine Arts Palace, San Francisco, 1940.
Springfield 1981–1982
Glorious Horsemen. Equestrian Art in Europe, 1500–1800. Museum of Fine Arts, Springfield, Mass.; J. B. Speed Art Museum, Louisville, Kentucky, 1981–1982.
Stockholm 1933
Exposition d'un choix des dessins du XVe au XVIIIe siècle. Stockholm, 1933.
Stockholm 1953
Dutch and Flemish Drawings in the Nationalmuseum and Other Swedish Collections. Nationalmuseum, Stockholm, 1953.
Stockholm 1970
Drawings from the Pierpont Morgan Library, New York. Nationalmuseum, Stockholm, 1970.
Tokyo 1975
Old Master Drawings from Chatsworth. National Museum of Western Art, Tokyo, 1975.
Tokyo 1979
European Master Drawings in the Fogg Art Museum. National Museum of Western Art, Tokyo, 1979.

Vancouver 1988–1989
Master Drawings from the National Gallery of Canada. Vancouver Art Gallery; National Gallery of Art, Ottawa; National Gallery of Art, Washington, 1988–1989.
Venice 1976
Disegni di Tiziano e della sua cerchia. Fondazione Cini, Venice, 1976.
Vienna 1930
Drei Jahrhunderte flämische Kunst. Sezession, Vienna, 1930.
Vienna 1949
Die schönsten Meisterzeichnungen. Albertina, Vienna, 1949
Vienna 1966
Handzeichnungen und Aquarellen. Die Technik der grossen Meister. Vienna, 1966.
Washington 1959–1960
Old Master Drawings from the Collection of Sir Bruce Ingram. Cat. for traveling exhibition, The Smithsonian Institution, Washington D.C., 1959–1960.
Washington 1962–1963
Old Master Drawings from Chatsworth. Cat. for traveling exhibition, The Smithsonian Institution, Washington D.C., 1962–1963.
Washington 1969–1970
Old Master Drawings from Chatsworth, II. Cat. for traveling exhibition, International Exhibitions Foundation, Washington D.C., 1969–1970.
Washington 1972–1973
Old Master Drawings from Christ Church, Oxford. National Gallery of Art, Washington; Philadelphia Museum of Art; The Pierpont Morgan Library, New York; Cleveland Museum of Art; Saint Louis Art Museum; International Exhibitions Foundation, Washington D.C., 1972–1973.
Washington 1976–1978
Antwerp Drawings and Prints. Cat. for traveling exhibition, The Smithsonian Institution, Washington D.C., 1976–1978.
Washington 1978
Master Drawings. National Gallery of Art, Washington D.C., 1978.
Washington 1990–1991
Anthony van Dyck. National Gallery of Art, Washington D.C., 1990–1991.
Worcester 1948
Art of Europe during the Sixteenth and Seventeenth Centuries. Worcester Art Museum, Worcester, Mass., 1948.
Zurich 1947
Petit Palais. Kunsthaus, Zurich 1947.

List of Works Exhibited

Index

Photo Credits

Photos are to be credited to owners of works of art except as indicated below:

p. 49 fig. 2, cat. 5 fig. 2, cat. 10 fig. 1, cat. 25 fig. 3, cat. 59 fig. 2, A.C.L., Brussels; cat. 45 fig. 2 Alinari, Florence; p. 26 fig. 2, cat. 3 fig. 1, cat. 16v, cat. 31r/v, cat. 32v, cat. 39 figs. 1, 5, p. 51 fig. 4 Jörg P. Anders Photoatelier, Berlin; cat. 21 fig. 1, cat. 52 figs. 1, 2, cat. 78 figs. 1, 2, cat. 81 fig. 1, Artothek, Peissenberg; cat. 3, Ph. Bernard; cat. 45, Joep Bessem, Amsterdam; cat. 55 fig. 1, Bibliothèque Royale, Brussels; cat. 23, cat. 30, cat. 37, cat. 60, cat. 63, Bildarchiv der Österreichische National-bibliothek, Vienna; cat. 2, cat. 35, Cathy Carver; cat. 1 fig. 1, Charles Choffet, Besançon; cat. 8 fig. 1, A. C. Cooper, London; cat. 5, cat. 10 fig. 5, cat. 13 fig. 2, cat. 14, cat. 38v, p. 51 fig. 7, p. 128 fig. 1, Photographic Survey, Courtauld Institute of Art, London; p. 26 fig. 4, p. 28 fig. 9, p. 119 fig. 6, p. 51 fig. 8, cat. 8 fig. 4, Frequin-Photos, Voorburg; cat. 25 fig. 1, Vladimir Fyman, Prague; cat. 73 pp. 236, 237, Peter Greenhalf, Rye; cat. 81 fig. 4, B. Huysmans; p. 26 fig. 5, B. P. Keiser, Braunschweig; cat. 61 fig. 2, Jacques Lathion; p. 28 fig. 7, Lichtbildwerkstätte "Alpenland", Vienna; p. 51 figs. 5, 6, Claudio Lion, Turin; cat. 80 fig. 1, Hugo Maertens, Bruges; cat. 28, Musées de la Ville de Paris (Pierrain); cat. 65, Hans Petersen, Hornbaek; cat. 75 fig. 1, Edward Reeves, Lewes; cat. 5 fig. 1, cat. 6 fig. 3, cat. 33, cat. 39, cat. 42, cat. 42 fig. 4, cat. 89 fig. 1, Réunion des Musées nationaux, Paris; p. 49 fig. 1, cat. 43, cat. 54 fig. 1, cat. 56 fig. 1, cat. 57 fig. 1, cat. 74 fig. 3, Rijksmuseum-Stichting, Amsterdam; cat. 86 fig. 1, Tom Scott, Edinburgh; cat. 10 fig. 3, Sotheby's, London; p. 119 fig. 3, S.P.A.D.E.M., Paris; cat. 18, Jim Strong, New York; cat. 29, University of Oxford; cat. 75 fig. 2, Atelier Walter Wachter, Schaan; cat. 34, Elke Walford, Hamburg; cat. 89 fig. 1, Jeremy Whitaker, Headley